SHAKESPEARE, THE MOVIE

Shakespeare, the Movie brings together an impressive line-up of contributors to consider how Shakespeare has been adapted on film, TV, and video, and explores the impact of this popularization on the canonical status of Shakespeare. The essays explore the transformation of Shakespeare by a newly technologized culture, from cultural icon to pop-culture product.

Addressing the interplay between the discourses of Shakespeare criticism, film studies, performance studies, and cultural studies, the essays in this volume open up a range of questions about spectatorship, originals and adaptations, and the appropriations of popular culture.

Taking a fresh look at the Bard and his place in the movies, *Shakespeare, the Movie* includes a potlatch of what is presently available in film format to the Shakespeare student or scholar, ranging across BBC television productions, filmed theatre productions, and full screen adaptions by Kenneth Branagh and Franco Zeffirelli.

Contributors: Lynda E. Boose, Richard Burt, Peter S. Donaldson, Katherine Eggert, Robert Hapgood, Donald K. Hedrick, Diana E. Henderson, Barbara Hodgdon, Tony Howard, James N. Loehlin, Laurie E. Osborne, Kenneth S. Rothwell, Ann Thompson, Valerie Wayne, Susan Wiseman.

Lynda E. Boose is Professor of English and Women's Studies at Dartmouth College. **Richard Burt** is Associate Professor of English at the University of Massachusetts.

SHAKESPEARE, THE MOVIE

Popularizing the plays on film, TV, and video

Edited By
Lynda E. Boose
Richard Burt

London and New York

First published 1997
by Routledge
11 New Fetter Lane, London EC4P 4EE

Simultaneously published in the USA and Canada
by Routledge
29 West 35th Street, New York, NY 10001

© 1997 Lynda E. Boose Richard Burt (editorial matter),
contributors (individual essays)

Typeset in Garamond by Keystroke, Jacaranda Lodge, Wolverhampton
Printed and bound in Great Britain by
Biddles Ltd, Guildford and King's Lynn

British Library Cataloguing in Publication Data
A catalogue record for this book is available from the British Library

Library of Congress Cataloging in Publication Data
Shakespeare, the Movie : popularizing the plays on film, TV, and video
/ edited by Lynda E. Boose, Richard Burt.
p. cm.
Includes bibliographical references and index.
1. Shakespeare, William, 1564–1616—Film and video adaptations.
2. English drama—Film and video adaptations. 3. Television
adaptations. 4. Film adaptations. I. Boose, Lynda E., 1943– .
II. Burt, Richard, 1954– .
PR3093.S545 1997
791.43'6–dc21 97–312
CIP

ISBN 0–415–16584–9 (hbk)
ISBN 0–415–16585–7 (pbk)

CONTENTS

CONTENTS

PLATES

CONTRIBUTORS

Lynda E. Boose is Professor of English at Dartmouth College. She is co-editor of *Fathers and Daughters* (1989) and the author of numerous articles on Shakespeare and Renaissance drama. She is currently fnishing a study that is centered on the early modern period, but will extend beyond it into a cultural history of the figure of the shrew or scold. E-mail address: (lynda.boose@dartmouth.edu)

Richard Burt is Associate Professor at the University of Massachusetts, Amherst. He is the author of *Licensed by Authority: Ben Jonson and the Discourses of Censorship*, co-editor of *Enclosure Acts: Sexuality, Property and Culture in Early Modern England* (1993), editor of *The Administration of Aesthetics: Censorship, Political Criticism, and the Public Sphere* (1994), and a member of the editorial board of *English Literary Renaissance*. He was recently a Fulbright Scholar affiliated with the Free University and Humboldt University in Berlin, Germany, and is now completing a book, *Unspeakable Shaxxxspeares: Kiddie Culture, Queer Theory, and Academic Fantasy*. E-mail address: (burt@english.umass.edu)

Peter S. Donaldson holds the Ann Fetter Friedlaender Chair of Humanities at MIT University and serves as Director of the Shakespeare Electronic Archive and Head of the Literature Faculty. He is the author of *Machiavelli and the Mystery of State* (1988) and *Shakespearean Directors, Shakespearean Films* (1990). E-mail address: (psdlit@mit.edu)

Katherine Eggert is Assistant Professor of English at the University of Colorado, Boulder. She has published articles on Spenser and Shakespeare and is currently completing a book entitled *Showing like a Queen: Female Authority and Literary Experiment in Spenser, Shakespeare, and Milton*. E-mail address: (eggert@ spot.Colorado.edu)

Robert Hapgood is Professor Emeritus of English at the University of New Hampshire. He is the author of *Shakespeare the Theatre Poet* (1990) and numerous articles on Shakespeare in performance, including recent studies of Welles's *Chimes at Midnight* and Kurasowa's Shakespeare films. Currently, he is at work on an edition of *Hamlet* for the Cambridge "Shakespeare in Production" series.

Donald K. Hedrick is Professor of English at Kansas State University, where he has directed the graduate program in Cultural Studies, and where he has taught Shakespeare, Renaissance, film, and cultural studies. In addition, he has published in these areas and in the areas of architectural history, modern poetry, and language and cultural theory. He is currently writing a book on early modern value and co-editing a collection on dissident appropriations of Shakespeare. E-mail address: (hedrick@ksu.edu)

Diana E. Henderson is Associate Professor of Literature at MIT where she also teaches in the Film and Media Studies program. She is the author of *Passion Made Public: Elizabethan Lyric, Gender, and Performance* (1995) and of a number of articles on early modern drama and lyrics. Her essay is part of a larger project entitled *Uneasy Collaborations: Transforming Early Modern English Drama Across Time and Media.* E-mail address: (dianah@mit.edu)

Barbara Hodgdon, Ellis and Nelle Levitt Distinguished Professor of English at Drake University, is the author of *The End Crowns All: Closure and Contradiction in Shakespeare's History* (1991) and *Henry IV, Part Two in Performance* (1996). She is the editor of *Henry IV, Part Two: Texts and Contexts* (1996) and of the new Arden *The Taming of the Shrew* (1997). She is currently writing a book entitled *Restaging Shakespeare's Cultural Capital.* E-mail address: (bh841r@acad.drake.edu)

Tony Howard teaches at the University of Warwick and has written on Shakespearean films by Garde, Olivier, Welles, and others. His publications include *Arts of War* co-edited with John Stokes. E-mail address: (ensat@snow.csv.warwrcik.ac.uk)

James N. Loehlin is Assistant Professor of Drama at Dartmouth College. He is a director and actor specializing in Renaissance drama and the author of *Shakespeare in Performance: Henry V* (1996). He holds graduate degrees from Oxford and Stanford. E-mail address: (james.loehlin@dartmouth.edu)

Laurie E. Osborne, Associate Professor of English at Colby College, has recently published *The Trick of Singularity: "Twelfth Night" and the Performance Editions* (1996). She is currently writing on women in the theater audience. E-mail address: (leosborn@colby.edu)

Kenneth S. Rothwell, Professor Emeritus at the University of Vermont, is the co-author of *Shakespeare on Screen* (1990). As the film consultant of the Shakespeare Association of America, he directed the three-day Shakespeare on Film festival in April 1996. He is currently working on a short history of Shakespeare in moving images. E-mail address: (krothwell@zoo.uvm.edu)

Ann Thompson is Professor of English and Head of English Department at Roehampton Institute, London. She edited the New Cambridge *The Taming of the Shrew* and is one of the General Editors of the Arden Shakespeare (third

series) for which she is also co-editing *Hamlet* with Neil Taylor. She is General Editor of a series of books on feminist criticism of Shakespeare forthcoming from Routledge and co-editor with Sasha Roberts of *Women Reading Shakespeare: 1660–1900* (forthcoming from Manchester University Press). E-mail address: (annt@max.roehampton.ac.uk)

Valerie Wayne is Professor of English at the University of Hawaii at Manoa. She has edited *The Matter of Difference: Materialist Feminist Criticism of Shakespeare* (1991) and Edmund Tilney's *The Flower of Friendship: A Renaissance Dialogue Contesting Marriage* (1992). She is General Editor for *The Complete Works of Thomas Middleton* and is preparing an edition of *Cymbeline* for the Arden series. E-mail address: (vwayne@hawaii.edu)

Susan Wiseman is a lecturer in English at the University of Warwick. E-mail address: (swiseman@sas.ac.uk)

INTRODUCTION
Shakespeare, the movie
Lynda E. Boose and Richard Burt

In the wake of the recent shift from literary studies to cultural studies, few critics now believe that representations can be vehicles for universal truths divorced from the time and culture that created them. Rather than divide an original Shakespeare off from subsequent adaptations, critics are now more likely to deconstruct that opposition, to see the first production simply as part of a continuum that encompasses all subsequent versions, including even heretical ones that unapologetically rewrite the Bard. Moreover, since recent textual work has compelled Shakespearean scholarship to divest itself of the belief that "the text" has any knowable original or is itself a stable entity, to judge a film based on a Shakespeare play according to how closely or how well it adheres to the (presumed) Shakespeare text is to invoke a criterion implicitly dependent on a referent no longer there.

Shakespeare, the Movie includes a generic potlatch of what is presently available in filmic (usually video) format to the Shakespeare student or scholar. On the less contestable end of the spectrum of meaning encompassed by our implicit definition of "Shakespeare on film,"[1] the collection includes BBC television productions, filmed theater productions, and full screen adaptations like Kenneth Branagh's. It also includes films like Zeffirelli's that, eschewing Branagh's more lineal kind of textual adaptation, deliberately whittle down and then cut and paste the sixteenth-century narrative in order to tell and sell a story more amenable to contemporary viewers. In terms of films that reconstruct a Shakespeare narrative in some new realm of the imaginary, the collection has welcomed innovations such as the animated Shakespeares that reformulate radically truncated texts into images no longer tied to their origin in an actor's body and its representation of the real. Yet, in the largest sense, a discourse about "Shakespeare on film" encompasses an even broader reference that extends even to films with a wholly different representational economy and market strategy – films like Arnold Schwarzenegger's *The Last Action Hero*, in which Shakespeare is neither the underlying text nor even the source of the plot, but only the reference to a film within the film.

In addressing the interplay between the discourses of Shakespeare criticism, film studies, performance criticism, and cultural studies, the essays in this

1

volume implicitly open up questions about Shakespeare's status as legitimating author–function, about the relation between original and adaptation, about youth culture and pedagogy, and finally, about the relation between the popular as hip and the popular as politically radical. Given the significance of the American money that lies behind so much of contemporary, even British-made film, it also seems viable to ask what kind of aesthethic best defines not only productions referred to in this collection but the flood of new Shakespeare films coming out even as *Shakespeare, the Movie* goes to press. Is the cultural partnership behind these films merely the latest vehicle of American cultural imperialism? Is it destined to lead to a dumbed-down Shakespeare rewritten in the idiom of mass culture? Or might it, alternatively, work to produce some new kind of post-colonial critique of English high culture?

Classifying a film as belonging to "the popular" implicitly defines it inside a cultural dichotomy, within which the antithesis (never acknowledged as "the elite") is usually read as "the classical." In one widely held view, popularization functions as a vehicle for the transmission of subversive or transgressive recodings of Shakespeare, whereas a film that is widely recognized as classical carries with it a kind of stable universality.[2] But what is meant by either term, popular and classical, is not nearly so obvious as might be imagined. What techniques does a filmmaker invoke in a classical film (black and white rather than color, for instance)? What kind of relationship between actor and Shakespeare is assumed within the "classical" model – close and embodied? Cool and distant? If the "classical" is meant to refer to a work that supposedly transcends the cultural signs that date it, how well do any of the classically "classic" Shakespeare films actually reflect such a presumed stability?

What, one might ask, would now set off a popularizer from other Shakespeare filmmakers of the day? Did Olivier and Welles, to take two obvious examples, consciously strive to popularize? How is one to differentiate between popularizers like Branagh and Zeffirelli? Or is it possible that, in the politics of the present marketplace, making a "popular" Shakespeare film will increasingly necessitate an aesthetic that derives from neither the radical nor the hip (sites where the cultural elite are in fact quite comfortable), but from the bourgeois realm of mass culture, where popularization is likely to determine translation away from either language or narratives that radiate their origin in Shakespeare's century? Presumably, at one time it was the classics that were the big-budget extravaganzas, while those labelled popular were low-budget items conceived of as drive-in movie fodder. In the wake of the financial reorganization of film and the way the bottom line so thoroughly controls production, teen-targeted, popular film has rocketed into the huge-budget model, while – up until the very recent Jane Austen fueled and Merchant-Ivory underwritten revival of period film – anything considered "classical" had become equated with a kind of artsy-fartsy cultural elitism that was bound not to make money and was something thus left to the independent film producer aiming at the art houses or the Sundance film festival. Thus, as the twentieth century nears its close, just where the film industry will take

Shakespeare seems quite up for grabs, the multiple possibilities best illustrated by the enormously different aesthetics, languages, and indeed narratives of the three most recent films released before *Shakespeare, the Movie* went to press: Trevor Nunn's *Twelfth Night*, Baz Luhrmann's *William Shakespeare's Romeo and Juliet*, and Al Pacino's *Looking for Richard*.

Collectively, the essays in this volume explore and may themselves even illustrate both the pleasures and the problems that popularization presents for any cultural criticism of Shakespeare on film, TV, and video. The first two essays focus on the increasing importance Hollywood plays in present film productions of Shakespeare's plays, even those that are made far away from Los Angeles. Concentrating on the directions in Shakespeare film that have emerged in especially the 1990s, the collection's two editors in "Totally Clueless?: Shakespeare Goes Hollywood in the 1990s" offer an overview of the many film sites where Shakespeare began appearing in the last decade of the twentieth century. Yet, as Boose and Burt point out, in spite of his new ubiquity, Shakespeare's lease in America is now, as it has always been, fraught with ambivalence: for, in a paradoxical trend that may have implications for the teaching of Shakespeare, at precisely the moment when desire to film his plays has never seemed stronger, his name has simultaneously become regarded as a marketing liability. In the second essay, Barbara Hodgdon focuses her energies on two recent made-for-television *Othellos*, the Janet Suzman (1987) and Trevor Nunn (1989) productions, and reads the two in terms of how they circulate and re-mediate metanarratives of race and gender as well as cultural tropes of assimilation and domestic violence. Framed by the O. J. Simpson trial – which also re-mediates *Othello* as a made-for-television-event – the essay explores how the discourses surrounding these representations work to secure specatatorly pleasures by keeping *Othello*, and Othello, in place.

The next set of essays focus on film whose heritage is, in one way or another, transnational. Donald Hedrick, in "War is Mud: Branagh's Dirty Harry V and the Types of Political Ambiguity," illustrates how directing has become politics and how war has become theatricalized. By using mud as the chief image marking the film's ideological structure, Branagh's *Henry V* ensures its American market-ability by giving equal justification to a reading of the film associated with a pro-war, Clint Eastwood vigilantism and a reading that reinforces an anti-war critique of American foreign policy. Next up is James Loehlin's discussion of the witty use that directors Richard Loncraine and Ian McKellan make of film quotation in their transformation of *Richard III*. In "'Top of the World, Ma': *Richard III* and Cinematic Convention," Loehlin examines the way the film modernizes the history it tells by appropriating the cinematic codes of genres like the British heritage film and the American gangster movie. Robert Hapgood develops further the focus on a transnational Shakespeare, turning to the international reception of Zeffirelli in his essay, "Popularizing Shakespeare: The Artistry of Franco Zeffirelli." Hapgood discusses Zeffirelli's film versions of *The Taming of the Shew* (1966), *Romeo and Juliet* (1968), and *Hamlet* (1990) and

suggests that Zeffirelli has achieved a compelling rapport with worldwide audiences by inviting identification with leading characters and their vulnerabilities, by holding true to his conception of the core of the originals, by accentuating youthfulness and timeliness, and by embracing the motion picture medium in its full range of sensory appeals.

The next two essays address more specifically the very different kinds of audiences a transnational Shakespeare may have, in one case, a post-colonial Indian audience and in another, children. Valerie Wayne argues in "*Shakespeare Wallah* and Colonial Specularity" that the film *Shakespeare Wallah* presents Shakespeare's plays as sites of cultural conflict associated with the end of the British Raj in post-colonial India. Her essay analyzes the specular positions of Indian audiences in the film as they watch Shakespearean productions staged by a British touring company. From their hybrid position as former British and newly independent subjects, the audiences offer not only approval, but mimicry, resistance, and total disruption of the performances of the Shakespearean text. Laurie E. Osborne addresses to *Shakespeare, the Animated Tales*, a joint British and Russian venture. These animated versions had to negotiate what to cut in terms of what were famous lines of Shakespeare in Russia as opposed to what were famous lines in England. (Lines like "Alas, poor Yorick" and "O, brave new world" had to be restored by English members of the production team.) In her essay on these cartoons, "Poetry in Motion: Animating Shakespeare," Osborne argues that distinctive tension between stillness and motion enables *Shakespeare, the Animated Tales* to foreground the interrelations between textual cuts in the play and film editing. With cel animation, stop-action puppetry, and painted animation, the first series of the *Tales* represents the elisions they make in Shakespeare's texts even as they introduce late twentieth-century youth to Shakespeare framed through film cuts and strategies.

What follows are two essays on very different *King Lear*s. In "When Peter Met Orson: The 1953 CBS *King Lear*," Tony Howard argues that although the Peter Brook–Orson Welles's film remains an important document in the development of these two directors' brilliant careers, when Peter met Orson Shakespeare met television, and the outcome was less than serendipitous. For Howard, the 1953 Brook–Welles collaboration on a live television broadcast of *King Lear* stands as a brave but flawed attempt to work radically within the context of a commercial medium and adapt the aesthetics of English Renaissance theater to those of the television screen. Concentrating on the map that dominates the dramaturgy of the play's second scene and the ways in which *King Lear* films have staged it, Kenneth S. Rothwell's "In Search of Nothing: Mapping *Lear*" takes the reader on a journey through social meaning that spans the various *Lear* films from the 1909 Vitagraph print to the postmodern absence of the object in Jean-Luc Godard's transgressive 1987 "twisted fairy tale" of a *King Lear*.

The final group of essays is concentrated on the ways in which gender and sexuality define and/or have been defined by, through, and in, the relationship between various films and their links to Shakespeare. In her essay, "A *Shrew* for

4

the Times," Diana Henderson maintains that *The Taming of the Shrew*'s frequent representation on film and video during periods of antifeminist backlash is more than coincidental. Although adapters have long strived to make the story more palatable by creating the illusions of subjectivity for Katherine and an erotic bond between the principals, the problematic nature of the changes themselves suggests the need for an aesthetic that will offer an alternative to textual fidelity in filming Shakespeare. In the next essay, "Shakespeare in the Age of Post-Mechanical Reproduction: Sexual and Electronic Magic in *Prospero's Books*," Peter S. Donaldson maintains that *Prospero's Books* gives recent feminist and pyschoanalytical readings of *The Tempest* as a story about Prospero's attempts to control female sexuality and appropriate the birth-giving powers of the maternal body a technological inflection, associating Prospero's magic with the power of digital media to create enhanced illusions of life. Because the film relies so heavily on digital image technologies and foregrounds their workings, *Prospero's Books* is not only a reading of *The Tempest*, but also a metadigital or meta-computational allegory. It links new media to the wonder-working technologies of the Renaissance. In Lynda E. Boose's essay, "Grossly Gaping Viewers and Jonathan Miller's *Othello*," the focus is on the voyeuristic position the BBC/PBS made-for-television film constructs for its audience. In the Miller film, both gender and sexual relationship are visually defined through costume rhyming, lighting technique, and the quotation of seventeenth-century paintings. And while the production's *tour de force* moment of compelling the audience to peer into a mirror to see the bed ultimately fails through its reduction to television sized screens, the film quite consciously works to create us as grossly gaping voyeurs, led into complicity with Desdemona's murder by an Iago who is visualized on screen as merely a younger member of the Venetian patriarchy. In "Age Cannot Wither Him: Warren Beatty's Bugsy as Hollywood Cleopatra," Katherine Eggert argues that Beatty's film – exactly the kind of production that *Antony and Cleopatra* necessarily spawned in Hollywood – uncannily though unconsciously reproduces the characters and plot of Shakespeare's play. Fascinated with its Cleopatra as *femme fatale* and sexual object, the Beatty film veers from representing her in Shakespeare's terms as directorial presence. Meanwhile, Beatty's own career, a template for reflecting cultural anxiety about American masculinity, actually constructs him as a new filmic Cleopatra. Ann Thompson's "Asta Nielsen and the Mystery of *Hamlet*" explores one of the many instances wherein Hamlet has been performed by women, on stage and screen. Asta Nielsen, Danish star of the silent cinema, formed her own production company in 1920 and made *Hamlet* as her first film. Unlike other women who played Hamlet as a man, Nielsen played Hamlet as a woman disguised as a man, drawing on the thesis put forward in Edward P. Vining's 1881 *The Mystery of Hamlet*. Using evidence from all three texts of the play, Vining argued that Hamlet became more "feminine" with each revision. Vining's book can be seen as indicative of Victorian anxiety about Hamlet's lack of virility, while Nielsen's film can be seen to celebrate androgyny. Susan Wiseman's "The Family Tree

Motel: Subliming Shakespeare in *My Own Private Idaho*" acknowledges that Shakespeare may not save a critique of American masculinity, but he does authenticate the decidedly different cultural narrative of the paternal and filial street bonds of gay hustlers versus those of inherited privilege and social legitimacy, a narrative that the film self-consciously invokes within the scenes it so self-consciously quotes – via Orson Welles's *The Chimes at Midnight* – from the *Henry IV* and *Henry V* plays. The collection's closing essay discusses gay versus queer representations in Shakespeare film. Focusing on three straight, mall movies in which Shakespeare is a signifier of gay sexuality, Richard Burt's essay, "The Love That Dare Not Speak Shakespeare's Name: New Shakesqueer Cinema," argues that straight films in which gayness is represented may paradoxically prove more disorienting than self-identified gay representations of Shakespeare.

The essays speak for themselves and need no further prologue.

NOTES

1 For filmographies, see McKernan and Terris 1994 and Rothwell 1990.
2 On Shakespeare, see Patterson 1990; Weimann 1978, 1996; and on Shakespeare and film, see Collick 1989; Holderness 1985; and Pearson and Uricchio 1990. For work by an unsophisticated and, in our view, unaccountably influential critic, see Fiske 1990. For more thoughtful examples of a cultural studies approach to popular culture, see Grossberg 1992; Bourdieu 1984; and Bennet 1986.

REFERENCES

Bennet, Tony (1986) "The 'Politics' of the Popular and Popular Culture," in *Popular Culture and Social Relations*, ed. Tony Bennet *et al.*, Philadelphia: Open University Press, 6–21.

Bourdieu, Pierre (1984) *Distinction: A Social Critique of the Judgment of Taste*, trans. Richard Nice, Cambridge, MA: Harvard University Press.

Collick, John (1989) *Shakespeare, Cinema, and Society*, Manchester: Manchester University Press, 98–106.

Fiske, John (1990) "Popular Culture," in *Critical Terms for Literary Study*, ed. Frank Lentrichhia and Thomas McLaughlin, Chicago: University of Chicago Press.

Grossberg, Lawrence, Cary Nelson and Paula Treichler eds (1992) *The Cultural Studies Reader*, New York: Routledge.

Holderness, Graham (1985) "Radical Potentiality and Institutional Closure: Shakespeare in Film and Television," in *Political Shakespeare: New Essays in Cultural Materialism*, ed. Jonathan Dollimore and Alan Sinfield, Manchester: Manchester University Press.

McKernan, Luke and Olwen Terris (1994) *Walking Shadows: Shakespeare in the National Film and Television Archive*, London: British Film Institute.

Patterson, Annabel (1990) *Shakespeare and the Popular Voice*, Oxford: Basil Blackwell.

Pearson, Roberta E. and William Uricchio (1990) "How Many Times Shall Caesar Bleed in Sport? Shakespeare and the Cultural Debate About Moving Pictures," *Screen* 31:3, 243–61.

Rothwell, Kenneth S. and Annabelle Henkin Melzer (1990) *Shakespeare on Screen: An International Filmography and Videography*, New York and London: Neal-Schuman Publishers.

Weimann, Robert (1978) *Shakespeare and the Popular Tradition: Studies in the Social Dimension of Dramatic Form and Function*, ed. Robert Schwartz, Baltimore: Johns Hopkins University Press.
—— (1996) *Authority and Representation in Early Modern Discourse*, ed. David Hillman, Baltimore: Johns Hopkins University Press.

1

TOTALLY CLUELESS?
Shakespeare goes Hollywood in the 1990s
Lynda E. Boose and Richard Burt

A short sequence in the 1995 summer film comedy *Clueless* (dir. Amy Heckerling) offers what might be considered a mini-allegory of Shakespeare's circulation within the popular culture of the 1990s. Based on Jane Austen's *Emma*, the film narrates the coming of age of "Cher," a Beverly Hills high school ingenue and media-savvy teen queen who reformulates the pleasures of discourse into side-by-side telephone conversations conducted on mobile telephones. In the manipulation of cultural capital as a means for asserting status, Cher (Alicia Silverstone) clinches her superiority inside of a contest that defines itself through Shakespeare. When her stepbrother's excessively Harvard girlfriend misattributes "to thine own self be true" to Hamlet and Cher corrects her, the girlfriend then rejects Cher's substitution of "that Polonius guy" and slams home her apparent victory with the smugly dismissive line, "I think I remember *Hamlet* accurately." But Cher beats her, point, set, and match, with the rejoinder that while she, by comparison, may not know her *Hamlet*, she most certainly does know her Mel Gibson!

We begin with *Clueless* because it complicates present moves in cultural studies about Shakespeare. With its Los Angeles location and youth market for Shakespeare, *Clueless* offers an opportunity for certain kinds of questions. For openers, just who is its Shakespeare joke on – the girlfriend, Cher, or just whom? Just what is the high-status cultural currency here, and how does "Shakespeare" function as a sign? Does the fact that Cher knows *Hamlet* not via the pre-supposed Shakespearean original but only via Mel Gibson's role in Zeffirelli's movie signify her cultural illiteracy – or her literacy? Or does this exchange perhaps point us away from any presumptive original, be it Jane Austen's or Shakespeare's, and direct us instead toward a focus on just its mediating package, what might be called the Hollywoodization of Shakespeare in the 1990s? In a postmodern way that effectively mocks all the presumed distinctions between high and low culture, *Clueless* does not merely relocate high culture to a low site (Los Angeles): after all, this is Beverly Hills, not the Valley, and no one is more vigilant than Cher and her friends about maintaining standards and eschewing tastelessness. Instead, *Clueless* elaborates on films like *L.A. Story* (dir. Steve Martin, 1991) in which Steve Martin begins by reciting a speech in praise of L.A.

8

that parodies John of Gaunt's deathbed speech to Richard II, substituting "this Los Angeles" for the concluding words, "this England"; and on Jean-Luc Godard's *Lear* (1987), in which William Shakespeare Junior the Fifth goes to Hollywood to produce his ancestor's plays, which end up being edited by Woody Allen. Like these two films, *Clueless*'s repeated reference to technologies such as movies, televisions, mobile phones, head sets, car radios, CDs, computerized wardrobes, intercoms, and other devices that record, transmit, amplify, and likewise reshape meaning formulate the mediating power of Los Angeles as the contemporary site where high/low distinctions are engaged in endlessly resignifying themselves.

Cher's recoding of *Hamlet* could be located in a wider range of 1990s *Hamlet*(s). The *Hamlet* created by the 1990s wasn't big just among the literati – he was so big that he was making guest appearances in all sorts of unexpected places, with different implications of its gendered reception. In 1991, Oliver Stone cast the Kennedy assassination through the lens of *Hamlet* in *JFK*. In 1994, Danny DeVito and the US Army found *Hamlet* to be the perfect force for transforming wimps and misfit soldiers into the STRAK army company that concludes *Renaissance Man* (dir. Penny- Marshall) reaffirming the male bond in "Sound Off" lyrics that inventively substitute "Hamlet's mother, she's the Queen" for the usual female object of cadenced derision. Similarly, Disney's 1994 *The Lion King* (dir. Roger Allers and Ron Minkoff), reworked *Hamlet* for a younger generation. In 1995, Kenneth Branagh released his *A Midwinter's Tale*, a film about a provincial English production of *Hamlet*, and then in 1996 and 1997 his own full-length and abridged versions of *Hamlet*.

Ultimately, however, it was Arnold Schwarzenegger's 1992 film, *The Last Action Hero* (dir. John McTiernan), that most clearly allegorized the transformation of Hamlet from melancholy man into an image that could be valued by the young male consumers to whom the newly technologized violence of the 1990s was being played. In a displacement explicitly fictionalized as the direct product of a young male viewer's contemporary fantasies of masculinity, on screen the image of Olivier hesitating to kill the praying Claudius literally dissolves into a Schwarzenegger Hamlet who is actively engaged in "taking out the trash" of the something-rotten Denmark into which he is thrust. And in a clever bit of metatheatricality, the substitution of Schwarzenegger, America's highest paid actor of the early 1990s, is situated as the ultimate insurance that movie houses will stay open and movies will keep on playing. Kids like the film's ardent young filmviewer will keep right on getting sucked into the action-packed worlds of heroically imagined male violence that is both promulgated by American film and simultaneously guarantees the industry its seemingly unassailable hegemony. Though ironic, it is nonetheless true that the *Hamlet*(s) of the 1990s construct a world even more obsessively masculine than did the *Hamlet*(s) that preexisted any articulated feminist critique of popular culture. Mel Gibson as Hamlet means *Hamlet* as *Lethal Weapon Four*. But Mel also means Hamlet as Hollywood Hunk, an object of desire who, like Glenn Close's Gertrude, projects

an image implicitly accessible to female and male viewers alike.[1] Zeffirelli's film may well be *Lethal Weapon Four*, but Hamlet-as-Mel suggests Shakespeare's prince as a 1990s model of unrestrictedly appropriatable desire, and it was through an appropriation of Mel-as-Hamlet that Cher triumphs over her truly clueless adversary, eventually winning a college guy (read: Harvard Law) boyfriend at the film's close.

Rather than assessing the various new *Hamlet*-sites in terms of possibilities for contradictory readings or as evidence anew of an American cultural imperialism, we are more interested in the critical developments that such a proliferation may signal. In the wake of the present displacements of book and literary culture by film and video culture and the age of mechanical reproduction by the age of electronic reproduction, the traditional literary field itself has already, to some extent, been displaced as an object of inquiry by cultural studies. And the Shakespeare moment in *Clueless* perhaps interests us for the very way it enacts this displacement, invoking the high status literary text only to dismiss it in favor of the actor's performance. For Shakespeare studies, what the transition from a literary to an electronic culture logically presages is exactly what, in fact, seems to be happening: an increased interest in the strategies of performance accompanied by a decreased focus on the poetic and rhetorical, the arena where New Criticism once so powerfully staked its claim.[2] If Michael Berube (1995) is right in assessing that the move to cultural studies primarily involves taking a less serious relation to criticism and its subjects, then Shakespeare (and Renaissance) Studies appears to be following suit, its dialogue lightening up a bit. New ways of reading the transvestism of the Renaissance stage, for example, are being discovered by contextualizing the cross-dressed Shakespeare heroine alongside pop culture figures like Michael Jackson and Madonna (see Garber 1992, 1995) and films like *The Crying Game* (dir. Jordan, 1992; see Crewe 1995).

It could be said that this shift to a cultural studies approach opens new possibilities for a kind of Shakespeare criticism with wider appeal to a non-academic public (which presumes, of course, that the Shakespearean academic necessarily wants such a popular audience.) It must also be said, however, that the shift raises a number of new questions, many of which relate to the new influence that Hollywood, Los Angeles, and American capitalism are already exerting on the popularization of Shakespeare. The media in 1990s America – film, video, television, and advertising – seemed suddenly prepared to embrace the Bard with all the enthusiasm (and potentially crushing effect) that such whole-hearted American embraces have come to harbinger for much of the world. Thus the question of potential diminishment that has always been raised about putting Shakespeare on film reappears, reinvigorated by the very technologies that make Shakespeare more accessible. We have yet to imagine how Shakespeare will be staged on the Internet, but for many of those who, unlike Cher, do know their Shakespeare, the transfer from "live" theater to the absent presence of the technologically produced filmic (or digitized) image invites a

distinct ambivalence much like that which betrays the voice of *New York Times* writer Frank Rich, here writing in 1996 about Fredericke Warde, the star of the recently rediscovered silent 1912 *Richard III*. Noting that Warde blamed what he perceived as a "fall off" of Shakespeare theatrical productions on schools and literary societies for turning acting texts into objects of intellectual veneration, Rich, for whom the discovery of this venerable old Shakespeare film seems to have acted as catalyst for his own lament for a lost golden age, characterizes Warde as a thoroughly clueless innocent, someone who "didn't have a clue that movies were harbingers of a complete cultural transformation that would gradually lead to the desensitized pop media environment of today."[3]

In the larger sense, however, Shakespeare's disappearance, his status as ghost-writer, precedes the 1990s. In some ways, the present historical moment only clarifies the way Shakespeare has always already disappeared when transferred onto film. Taken on their own terms, films like Greenaway's *Prospero's Books*, Derek Jarman's *Tempest*, and Godard's *Lear* involve not merely the deconstruction of Shakespeare as author but his radical displacement by the film director; and the interest in any of these films could legitimately be said to lie less in its relation to Shakespeare's play than in its relation to the director's own previous *oeuvre*. Even films which adapt the Shakespeare script as faithfully as does Branagh's *Much Ado About Nothing* speak within a metacinematic discourse of self-reference in which, through film quotation, they situate themselves in reference as much to other films as to a Shakespeare tradition.[4]

Yet judging from the commentary and the advertising matrix surrounding the release of the most recent Shakespeare adaptations, the fact that Shakespeare is the author seems to be becoming not only increasingly beside the point but even a marketing liability – an inference that *Los Angeles Times* movie critic David Gritten quite clearly picks up from the voices of both the director and producer of Ian McKellen's 1995 *Richard III*:

> Here on the set of *Richard III*, a film adaptation of one of the world's best known plays starring a bunch of distinguished classical actors, it comes as a surprise that everyone is trying to play down the S-word. The S-word? That stands for "Shakespeare." He's the guy who wrote *Richard III* some four hundred years ago, in case you weren't quite sure. In truth, the people behind this *Richard III* . . . are hoping to attract those very people who aren't quite sure of the film's provenance. "I'm encouraging everyone working on this film not to think of it as Shakespeare," says director Richard Loncraine. "It's a terrific story, and who wrote it is irrelevant. "We're trying to make the most accessible Shakespeare film ever made," says producer Lisa Katselas Pare.
>
> (Gritten 1995: 39, 41)

The similar trend that Don Hedrick points out in an essay in this collection – that any mention of Shakespeare is exactly what was under avoidance in the marketing of Branagh's *Henry V* – is a truism equally applicable to Zeffirelli's

Hamlet. Likewise, Gus Van Sant (1993: xxxviii) notes about the making of *My Own Private Idaho* that while the foreign producers wanted to put in as much Shakespeare as possible the American producers wanted to cut out as much as possible.[5] Yet just when we might assume that the Bard's name was truly a marketing liability or that veneration of Shakespeare had come to be regarded in popular contexts as uncool,[6] the notably cool film director Baz Luhrmann put out a new *Romeo and Juliet* that is unquestionably situated in the pop culture, made-for-teens film market and is called *William Shakespeare's Romeo and Juliet*.[7]

The popularization of Shakespeare on film, video, and television – which began inside the stalwartly liberal tradition of noblesse oblige attempting to bring culture to the masses – now finds itself, in America at least, in a strictly market-responsive milieu in which literary knowledge is in general a decidedly low capital, frequently mockable commodity, caught within the peculiarly American ambivalence about intellectualism, and therefore to be eschewed at all costs. When Gus Van Sant imports the various Hal and Falstaff scenes from the *Henry IV* and *Henry V* plays and sticks them into *My Own Private Idaho*'s world of contemporary Portland gay hustlers and street dwellers, neither the film nor the characters speaking the lines register any acknowledgment that they are drawing upon Shakespeare. If this film is a Shakespeare spin-off, no one has to admit knowing it. But as a market screening device, the omission must have worked, since only those people who had read the Henriad or read commentary on the film in specifically "intellectual" magazine and review venues seemed conscious of any Shakespeare connection. The same might be said of *L.A. Story*. While many members of the audience may have have picked up the allusions to *Hamlet* and other Shakespeare plays, only a Shakespearean would have read the movie as a rewriting of the play. Likewise, the connection between *Clueless* and Jane Austen's *Emma* got intentionally excluded from the film's promotional packet and was left to become known via strategically leaked news items designed to be circulated by word of mouth to intrigue the elite without turning off the intended teen market.

But while pride in anti-intellectualism has long roots as an American tradition and is a force which the 1980s and 1990s have seen assume a renewed political ascendancy, quite the opposite has historically been true of British cultural life, where Shakespeare and the English literary tradition have long been a rallying point of national superiority. The quotation of Shakespeare lines seems, in fact, to be used in Britain as a special, high-status kind of sub-language, a signalling code of sorts that regularly shows up in the language of even British detective novels. It is thus frankly impossible to imagine the making of a British film like *Clueless* in which success would be correlated with a pride in *not* knowing one's Shakespeare. Nonetheless, the apparent dominance of Hollywood capitalism so thoroughly determines the market that Britain's famous Shakespearean actors now find even themselves playing roles within plays which require that they "not think of [the play] as Shakespeare."

12

But Hollywood's relationship to Shakespeare is marked by more than just the avoidance of the S-word. When Gus Van Sant turned to the Shakespeare narrative that he then consciously veiled in *My Own Private Idaho*, he even approached it through a layered mediation, essentially rewriting not Shakespeare's second tetralogy but Orson Welles's version of the second tetralogy, *Chimes at Midnight*. Van Sant's film thus participates in a peculiarly American norm by which Hollywood, up until Branagh's box office successes of the early 1990s, chose to maintain a significant distance from the direct – or "straight Shakespeare" – adaptational model that made both Olivier and Welles famously associated with all that was once included in the meaning of "a Shakespeare film." And while American television has shown some "straight" American versions of Shakespeare that do not modernize the verbal idiom or rewrite the story (most notably, televised versions of filmed theatrical productions, such as the American Conservatory Theater's famous 1971 *The Taming of the Shrew*), apparently the last instance in which a definably Hollywood film seriously tried to produce Shakespeare straight was Stuart Burge's 1970 *Julius Caesar* – itself an attempt to remake Joseph Mankiewicz's far more successful 1953 *Julius Caesar*. And although Japanese, German, Russian, Swedish (and etc.) straight Shakespeare films apparently feel perfectly comfortable doing Shakespeare with casts made up from their own national back lots, when Hollywood has made that same commitment, the casting list betrays a special American insecurity in its inevitable compulsion to import a large number of Royal Shakespeare Company actors to surround the American star.

Perhaps because Shakespeare is such a signifier for British cultural superiority, America's relationship to the Bard has frequently been marked by all the signs of a colonized consciousness. All in all, the preferred American approach to Shakespeare has been decidedly oblique; up until the sudden, Branagh-inspired boom in straight Shakespeare of the mid-nineties, Hollywood has distinctly felt more comfortable reworking Shakespeare into new, specifically American narratives such as Woody Allen's *A Midsummer Night's Sex Comedy* (1982) or Paul Mazursky's *Tempest* (1982), for example. America's best made for film Shakespeare productions may, in fact, be the musicals *Kiss Me, Kate* (dir. George Sidney, 1953) and *West Side Story* (dirs. Robert Wise and Jerome Robbins, 1961), where the Bard is recreated within a particular theatrical idiom that is thoroughly home-grown.

Even on the English side of the Atlantic, where Shakespeare has been apotheosized into the primary signifier for patriotism, nationhood, and national culture, the end of a tradition of turning Shakespeare plays into big fuss, high culture, capital-letter films has already been allegorized in the film *The Playboys* (dir. Gillies MacKinnon, 1992). An Irish acting troupe touring Ireland in the 1940s witnesses its Americanized production, part *Othello*, part adaptation of *Gone With the Wind*, be displaced and their troupe broken up by the arrival of the real thing, the Hollywood movie and a newly opened movie house in the town they have just played. To be sure, the late 1980s saw the English tradition

of Shakespeare film refurbished by Kenneth Branagh into an enterprise comparable in energy to that of the 1940s when Sir Laurence Olivier was making *Richard III, Henry V, Hamlet*, and, in 1955, starring in Stuart Burges's *Othello*. But what Branagh has done is infuse the filming of Shakespeare with a marketeer's sense of popular culture. In his productions, high and low culture meet in moments where Shakespeare's scripts get subtly reframed inside of references to Hollywood pop culture: Branagh's adaptation actually rewrites *Henry V* as Clint Eastwood's "dirty Harry,"[8] and his *Much Ado about Nothing* opens with a witty visual evocation of *The Magnificent Seven*.

The sudden contemporary renaissance in filmed Shakespeare is British-led, but by 1995 even British casting practices had changed to reflect the exigencies of market capitalism. Following in the direction that Zeffirelli had been the first to seize upon, the new British productions were now promoting their global commerciality through a mixture of what has been derisively referred to as a cast made up of "British actors" and "American stars."[9] Branagh's 1989 *Henry V* had been filmed with a British cast. But by the time of *Much Ado About Nothing*, the British principals were surrounded by American pop film stars that made brothers out of America's most popular black actor (Denzel Washington) and America's most popular teen heart-throb (Keanu Reeves). There were, admittedly, some problems with casting Americans: in Branagh's *Much Ado*, Don John's line about Hero, "She's a very forward March chick," was cut for fear that Keanu Reeves would appear to be reverting to American slang rather than reciting Shakespeare.[10] And as Alan Bennett, who, when making a film of his play *The Madness of George III*, had to retitle it as *The Madness of King George* because American backers feared their audiences would think they had missed the first two parts, ruefully comments: "apparently . . . there were many moviegoers who came away from Branagh's film of *Henry V* wishing they had seen its four predecesssors" (1995: xix). Yet the trend of using American stars continues, sometimes with particularly fortuitous implications that suggested new levels of narrative. In a production released in 1995, the presence of American actors Annette Bening and Robert Downey, Jr in Richard Loncraine's World War II-era rewrite of *Richard III* provided a fitting way for the film to mark Edward IV's queen, Elizabeth, and her brother, Lord Rivers, as distinctive outsiders to the royal family, and, through dress and hair-style, encourage visual allusions that suggested Bening-cum-Elizabeth, outsider wife to Edward IV, as that famous American divorcee and outsider wife to another King Edward, Wallis Simpson. By 1995 Branagh, too, had gone American: Hollywood's Lawrence Fishburne played the Noble Moor to Branagh's Iago; and in 1996 Branagh's *Hamlet* included such box office draws as Billy Crystal (first gravedigger), Robin Williams (Osric), Charlton Heston (the Player King), and Jack Lemmon (Marcellus). Yielding to the implicit logic of such casting, Baz Luhrmann simply invited the stars of his *Romeo and Juliet* "to speak the famous lines in their own American accent."[11]

In what seems relatively new to British filmed Shakespeare (albeit certainly not to staged productions), the plays were also being cut loose from the tradition

of the pseudo-"Elizabethan" setting and relocated in the viewer's own milieu: a 1991 British film of *As You Like It* featured Rosalind in levis, and 1995 saw Britain rehistoricizing its own history by taking *Richard III* into the modernized territory that 1980s stage productions of the histories (especially the English Shakespeare Company's "Wars of the Roses" extravaganza) had shown to be highly viable. Thus, shortly after Great Britain solemnly celebrated the fifty-year anniversary of the end of World War II, *Richard III* replayed that history by reinscribing it into the cycle of dark days that had eventually led to the Tudor triumph, British mythology now promising an Elizabeth (II) for an Elizabeth (I). By the end of 1995, it was increasingly clear that the trademarks of pop culture were determining the productions of not only such well-known popularizers as Zeffirelli, but had caught up with the Shakespeare industry at large and were putting it into the fast lane. According to the *L.A. Weekly's* review of the 1995 *Othello*:

> Writer-director Oliver Parker has opted for a spin on *Othello* that would make Shakespeare himself dizzy. With more pop than poetry, more snap than savvy, this variation of the tragedy finds the ever-appealing Lawrence Fishburne center court. . . . The production may be trashy and too fast by half – it makes Mel Gibson's galloping *Hamlet* seem sleepy – but the tenderness in Fishburne's eyes is startling. . . . While there's nothing wrong in mucking around with the classics when it comes to adaptations, the selectiveness of Parker's approach puzzles. Why, for instance, is there something so creepy and so very O.J. in the initial love scene between Othello and Desdemona . . . ?
>
> (Dargie 1995: 67)

Similarly, Margo Jefferson noted that Shakespeare's "metaphors and cadence . . . passions, convictions, and conflicts must meet up with ours in a world of rock, rap, gospel, and schlock pop, all just a radio station away from Prokofiev and Mozart. Shakespeare must adjust to city street and suburban mall English" (1996: C11). All in all, the message from the mid-nineties would seem to be that Shakespeare was busting out all over: Branagh having shown Hollywood that there was a market, production money seemed suddenly to be flowing; Branagh released his complete, uncut *Hamlet* (1996); Trevor Nunn – having demonstrated his entitlement on stage by directing big bucks productions of *Les Miserables* and *Cats* – directed a new *Twelfth Night* that debuted at Telluride (1996); another *Romeo and Juliet* in addition to Baz Lurhrmann's 1996 production was on its way out; the Loncraine/McKellen *Richard III* (1994) had broken new ground in terms of reframing Shakespeare inside of pop-culture strategies; and, using an inventive new format for producing a Shakespeare film, Al Pacino had allegorized his own experience of playing *Richard III* in a documentary called *Looking for Richard* (1996).

Just how Hollywood's new interventions in a territory hitherto tacitly

conceded to the Brits must look to the newly colonized former colonizer forms the potential subtext for Ian McKellen's remark about the difficulty he had in finding producers in Hollywood to fund the kind of *Richard III* film he wanted to make: "Of course, if Ken or Mel, or best of all Arnie or Sly were cast as Richard, it would have been easier" (McKellen 1996: 25–6). Baz Luhrmann (an Australian) put "William Shakespeare" in the title of his *William Shakespeare's Romeo and Juliet*, almost as if to insist on its authenticity. And as if to emphasize some kind of essential difference between the English kind of Shakespeare and the kind implicitly associated with American models, the Telluride announcement for Trevor Nunn's *Twelfth Night* (1995) asserts, with a barely concealed sneer: "the film succeeds in part due to Nunn's decision to ignore the box office lure of Hollywood stars, and to cast all the parts with out-standing British actors who can actually speak Shakespeare's lines with proper cadence and clarity."[12] Perhaps because he rightly sensed that strategies such as the above would fail, Kenneth Branagh made a more canny compromise, casting American stars not as leads but in multiple cameo parts for his 1996 *Hamlet*.[13] In these terms, the film promo that was most risky of all is that for Adrian Noble's *A Midsummer Night's Dream* (1996), the cast was made up not of Hollywood stars but a core of the same actors who played in the (1995) Royal Shakespeare Production. Perhaps for this reason the film's US release was delayed.

However much a British director might wish to preserve a British Shakespeare, American production money is the hidden engine that drives Britain's Shakespeare films. The disappointing overall outcome of the 1980s televised BBC Shakespeare series was due, at least in part, to Time-Life Corporation's determination to produce televised "classics" that would exhibit a uniform fidelity to imagined assumptions about Shakespeare's text and times.[14] Doing "culture" for an educational enterprise apparently provoked one extreme of the American colonial response. But Hollywood hegemony over the global market combined with the new, bottom-line-only mentality of the 1990s may now threaten Shakespeare from quite another direction. In light of Hollywood's 1995 decision to revise the heavy puritanism and somber morality of *The Scarlet Letter* (dir. Roland Joffe, 1995) into a film that would be more fun for an audience and would get rid of that "downer" of a Hawthorne ending, can a film of Nathum Tate's *King Lear*, in which Demi/Cordelia lives and marries Bruce/Edgar be far behind?

Of all the films of the 1990s, some of the most innovative come from an avant-garde tradition whose energies are infused both by popular culture and an international mode of film production. Through avant-garde filmmaker Peter Greenaway's very attempt to unpack the place that intellectual and aesthetic elitism has played in Western culture, *Prospero's Books* (1990), forms in many ways an important investigation of the idea of "the popular." A meditation on *The Tempest*, the film reproduces Shakespeare's play as caviar to the general and grants few if any concessions to the popular; Greenaway's revision of *The*

Tempest relocates Prospero in the image of the elite filmmaker bidding farewell to a tradition that he himself, as technological magus, participates in destroying. In a science fiction bound together by a technologically produced iconography of western culture stretching from the pages of Renaissance humanism to computer-generated models of virtual reality, the revels seen as ending in this latest rendition of Shakespeare's final play are played out as a kind of intellectualized, nostalgic farewell to even the existence of a culture that might be called learned or elite. The book disintegrates, and before us we see a virtual meltdown of all that symbolizes the learned tradition, even the word itself. Yet in a kind of acknowledgment – indeed, almost an allegory – of the end of the twentieth century's new culture and its new possessors, it is Caliban, its implied inheritor, who reaches into the flood and saves the First Folio from the literary armageddon on screen before us. Meanwhile, at the margin, orchestrating the deluge, stands the figure of the maker – the Gielgud who is Prospero who is Shakespeare who is Peter Greenaway – mournfully bidding culture – at least as he and we have hitherto imagined it – into oblivion. Elite reproductions, whether avant-garde or devoted to the "classics," as well as popular productions, then, meet in the disappearing of Shakespeare.

Dealing with specifically filmic reproductions or appropriations of Shakespeare means that "the popular" must be thought through not only the media and institutions in which Shakespeare is now reproduced – mass culture, Hollywood, celebrity, tabloid – but above all, youth culture. For as Shakespeare becomes part of pop culture and Shakespearean criticism (especially film criticism) follows suit, both move into an arena increasingly driven by a specifically youth culture, and Hollywood has clearly picked up on that fact. The animated versions already released for more than a dozen of the plays and scheduled for additional releases are only the most literal version of this development. Clearly playing to the potent consumerism of what is recognized as a notoriously visual subculture, all four of the so-called "big" tragedies have recently been reproduced in sophisticated comic-book form, appropriate for college students; major Shakespeare critics are turning their talents to readings of MTV videos; and teen idols like Keanu Reeves are being lifted out of movies like *Bill and Ted's Excellent Adventure* (dir. Stephen Herek, 1989) to play Van Sant's modern-day Prince Hal in America's contemporary Shakespearorama.[15] But the production that went the furthest in enunciating itself as a teen film was the 1996 production of *William Shakespeare's Romeo and Juliet*, orchestrated by a director whose claim to fame rested in his previous direction of *Strictly Ballroom* (1992) and starring Leonardo DiCaprio as Romeo (star of the sit-com "Growing Pains," co-star of *What's Eating Gilbert Grape* [dir. Lasse Hallstroem, 1994] and star of *Basketball Diaries* [dir. Scott Kalvert, 1995]) plus Clare Danes (star of MTV's "My So-Called Life") as Juliet. Two journalists (Maslin 1996: C12; Corliss 1996: 89–90) compared the film to an MTV rock video; MTV News did a segment on it; MTV itself aired a half-hour special on the film three times the week before its United States release; and, also the week before release, the film sponsored the TV show "My So-Called

Life," ads blaring forth clips from the soundtrack CD with music by bands such as Garbage, Radiohead, Everclear, and Butthole Surfers. As has become standard for all films, even a website was announced.[16] Perhaps the ultimate statement of just how thoroughly *William Shakespeare's Romeo and Juliet* had constructed itself as a youth culture film lay in the way it was market-tested. At the screened tests done at U.C. Berkeley the summer before its opening, studio moguls handed out market surveys that specifically asked that those who filled them out be only those viewers who were thirty-nine or younger.[17] The marketing campaign proved successful: *Romeo and Juliet* came in first at the box office the week of its release in the United States.[18]

Yet the strategies of casting teen idols and the co-construction of youth culture as popular culture were themselves part of the box office stroke mastered some time ago by Zeffirelli in both *Romeo and Juliet* and *The Taming of the Shrew*. Indeed, as Robert Hapgood aptly suggests in an essay that is part of this collection, if Zeffirelli's *Hamlet* was less of a success than were his earlier Shakespeare films, it was because his *Hamlet* was far less oriented to a young audience. In all American-made film versions of *Romeo and Juliet*, the culture has inscribed itself into forms of racial tension replayed within an ethnically marked youth culture, as in *West Side Story, Valley Girl* (dir. Martha Coolidge 1988), *Love Is All There Is* (dir. Joseph Bologna and Renée Taylor 1996) and the Luhrmann production, which was set in a Cuban-American community, Verona Beach. The trend toward making films directed almost exclusively at youth culture is a global one, and the 1987 Finnish-made film, *Hamlet Goes Business* (dir. Aki Kaurismaki), confirms its relevance through the film's staging of Ophelia's suicide: after gazing at a photo of Hamlet, Ophelia drowns herself in a bathtub while listening to a teen pop lyric in which the boyfriend wishes only to make up with his girlfriend so that all his dreams will be fulfilled. Yet while the inventiveness of some of these popularizations should rightly be applauded, at some point the devolution of Shakespeare to pop culture/youth culture (for which we may also read masculine culture) must give some critics, particularly feminists, pause: if we may read the increasing portrayal of regressively stupid white males (*Forest Gump* [dir. Robert Zemekis, 1994] and *Dumb and Dumber* [dir. Peter Farallay, 1994]) as a kind of Hollywood pandering to the anti-intellectual machismo of its adolescent buyer, just what kind of an American *Hamlet* is destined to succeed Mel Gibson's action hero is indeed a topic to puzzle the will.

Given that popularization is linked to youth culture, the crucial question for cultural critics rests, finally, with the pedagogical implications of Shakespeare's popularization on film, TV, and video. Popularization has meant the proliferation of representations, on the one hand, and thus an enlargement of what can be legitimately studied as part of the Shakespeare canon. But it has also meant the disappearance of (what was always the illusion of) a single, unified Shakespeare whose works could be covered. Students in today's average, college-level Shakespeare course are now more often shown select scenes from two or more versions of a given play than they are a single production in its entirety

(productions like the 1980s BBC Shakespeare renditions, initially aired on a PBS series, that were ultimately designed and marketed specifically for classroom purpose). CD-Rom editions of the plays necessarily further this fragmentation.[19] With film and/or digital image as the version through which Shakespeare is primarily known, Shakespeare's accessibility is guaranteed, but along with this move to film comes a perhaps inevitable new sense of Shakespeare's reproduction, one which offers certain challenges to cultural criticism of Shakespeare as it is now practiced.

Consider, once again, the scene of Shakespeare pedagogy as narrated in *The Last Action Hero*. In this film, the kid who plays hookey in order to see action films starring Schwarzenegger grudgingly returns to class in time to hear his teacher regaling the students with the pleasures of *Hamlet*. The scene offers a bit of caviar to the theater-going elite in the private knowledge that the teacher is being played by Joan Plowright, Olivier's wife of many years and herself a renowned Shakespearean actress. The in-joke is included, but it is at the same time made purely extraneous to the pleasures of *The Last Action Hero*, where pleasure is distinctly located in the smash-bang thrills of pop culture. As the truant takes his seat and the teacher informs the students that they may recognize the actor, Sir Laurence Olivier, from his work in a television commercial or from playing Zeus in *Clash of the Titans* (dir. Desmond Davis, 1981), the relevance of Shakespeare seems most vividly represented by the comically outmoded 16mm projector through which the old Olivier film is being shown. The old-fashioned, dated feel of Olivier's film may be accounted for, at least in part, by the way the scene in *The Last Action Hero* marks a new relation between the plays and their audience, one in which the aura that pervaded the filmed Shakespeare "classics" is gone, and, with it, the sense of embodied intimacy between the audience and Shakespeare himself. The displacement of Olivier by Arnold Schwarzenegger marks the disappearance of an older sense of the actor as someone who actually knew Shakespeare, who communed with him, understood his mind, and perhaps at times even thought that he himself was Shakespeare.

Nonetheless, this film marks neither the unequivocal triumph of a new American cultural imperialism nor the displacement of a Shakespeare understood to be English by one who has become brashly American. As much as the film would seem to dismiss Shakespeare, it may also be understood as playing out one more version of the way that America, through the aesthetic medium that is as peculiarly American as the stage is English, tries to come to terms with its own, unregenerate fascination with the Bard of Avon. As apparently irrelevant as *The Last Action Hero* would seem to make Shakespeare, in this and all such recent filmic moments in which the Bard is suddenly invoked, William Shakespeare is still somehow a necessary signifier. He is that which must be posited and the debt that must be acknowledged before – and in order for – popular culture to declare itself so unindebted to the S-guy that it may get on with the production of itself and its own narratives.

NOTES

1 The issue of just whose sexual fantasies Gibson's image plays to is itself an example of the contradictory impulses that the culture's new sophistication about media now allows. On the one hand, in vehement defense of the hunky hero's body as an object for female fantasies only, Mel's spokesMEN have gone so far as literally to deny the right of any fanzines (the new, technologized fan magazine produced by fans and circulated on Internet) to produce gay narratives about Gibson – the narratives that are, of course, encouraged by the distinctly homoerotic overtones of the male part-nered relationship in the *Lethal Weapon* film series – overtones that have indeed become progressively more blatant as the rejection of them has become simultane-ously more vocal. For more on Mel, see Hodgdon (1994). If there is any gender equality to be offered at all, it is probably to be found only in the newly explicit bisexuality of pop culture's film star images that sexualize us all into universal con-sumers. In particular, see Marjorie Garber's chapter on "Bi-sexuality and Celebrities" (1995).

2 It appears that Shakespeare's legitimacy, at least in the United States, depends on his status as screen writer rather than playwright. In a program on Shakespeare in the weekly television series *Biography This Week*, with interviews of British scholars like Andrew Gurr and Stanley Wells, the narrator concluded by remarking that "Shakespeare is now Hollywood's hottest screenplay writer" (broadcast November 9, 1996, on A&E). And Al Pacino's *Looking for Richard*, which includes footage of Pacino at the reconstructed Globe and interviews of Branagh and Gielgud, nevertheless focuses on the American film stars acting in the play.

3 See Rich (1996): Rich goes on to say, "But if audiences inevitably giggle a bit at the 1912 *Richard III*, they should also look at it as a window on an even more distant past when Americans didn't have to be spoon fed a great dramatist but were united in their passion for one who gave them characters who mirrored their own complex humanity, not to mention sublime poetry, along with the requisite dose of sex and violence. Exciting as this extraordinary find is [i.e., the movies], we will see in its frames the ghosts of something far larger that we have lost."

We would add as well that the use of American film stars in Shakespeare film productions is nothing new. Witness the Max Reinhardt *A Midsummer Night's Dream* with James Cagney and Mickey Rooney or the Joseph Mankiewicz *Julius Caesar* with Marlon Brando; and of course, there is a long tradition of Shakespeare burlesques in America and elsewhere. See Levine (1988). What has changed, in our view, is the reception of American stars in Shakespeare, both among the viewing public and academia. Moreover, the present moment of Shakespeare reproduction includes new spin-off products from films in addition to videos, many of which are regularly cross-referenced: CD-Roms; laserdiscs; soundtrack CDs; MTV specials; Internet websites.

4 The opening sequence with its quotation from *The Magnificent Seven* of the four riders galloping abreast, for example.

5 Hollywood's skepticism about Shakespeare is of course nothing new. Shortly before his death in 1984, Richard Burton commented "Generally if you mention the word Shakespeare in Hollywood, everybody leaves the room, because they think he's box office poison" (Levine 1988: 53). As we make clear, the Brits' responses to this skepticism differ in the 1990s.

6 That it is uncool is clearly the message in John Power's (1996) review of Al Pacino's *Looking for Richard*: "Through it all, the movie spotlights Pacino's dewy eyed rever-ence for Shakespeare, which is touching in its unadorned dweebiness . . . Most stars would sooner die than look this uncool."

7 Several months prior to opening, the Luhrmann film had apparently been market

tested on the summer Shakespeare classes at U.C. Berkeley. According to one of the teachers, the questionnaire the viewers were asked to respond to actually included a query that asked "whether the Shakespeare language in the film had bothered you or not." Our thanks to Grace Ioppulo for telling us about the market survey.

8 See Don Hedrick's essay in this collection.

9 Consider that as recently as the mid-1980s the notion of casting Hollywood rather than British actors in Shakespeare film was still a joke. In *Dead Poets Society*, a teacher played by Robin Williams mimics Marlon Brando playing Antony in *Julius Caesar* (which Brando had done) and John Wayne as Macbeth (a conjunction apparently only imagined, to our knowledge).

10 Our thanks to Lance Duerfahrd for bringing this change to our attention.

11 See "Production Notes," http://web.idirect.com/-claire/rjintor.html, 2.

12 John Storey, Telluride publicist.

13 The Nunn strategy distancing his film from American efforts went wholly lost on the American journalists/publicists. The *New York Times* ran a full-page ad with a blurb from a critic comparing it favorably to "To Wong Foo" and "The Birdcage," a comparison that was, in fact, echoed by *Time* Magazine's David Ansen (Ansen 1996) and in the film's own website.

14 Even the BBC felt the pressure of contemporary popular English culture. Roger Daltrey, lead singer of The Who, played Dromio in *The Comedy of Errors*, and John Cleese of *Monty Python* played Petruchio in *The Taming of the Shrew*.

15 The choice for defining pop film's Shakespearean daughter is another face familiar from L.A. teen films, Molly Ringwald, who played both Miranda in Mazursky's *Tempest* and Cordelia in Godard's *Lear*.

16 An ad for a website appears on the video of the Parker *Othello*, and a website address appeared at the end of movie theater trailers of Branagh's *Hamlet*.

17 According to one teacher, the questionnaire included a query that asked "whether the Shakespeare language in the film bothered you or not." For other adolescent responses, see Smith 1996. Of course, age may take its revenge on youth through the use of Shakespeare. Consider the rehabilitation and recovery of George III and with him the institution of the monarchy through the use of *King Lear* and *Henry IV, Part 2* in the 1994 film of *The Madness of King George* (dir. Nicholas Hytner).

18 E! Television, November 4, 1996.

19 From MLA and Shakespeare Association conventions of the past few years, many academics are familiar with the brilliant scholarly tool into which Pete Donaldson has turned the multi-media, multi-production model. See also Al Braunmuller's excellent CE-edition of *Macbeth*. Further electronic Shakespeare can be found in the CD-Roms released by Fox International of *William Shakespeare's Romeo and Juliet* and Castle Rock Entertainment of Oliver Parker's *Othello*. In 1997, Stephen Greenblatt's Norton edition of Shakespeare was published both as a book alone and as a book with a CD-Rom (one CD-Rom for students and another for professors).

REFERENCES

Ansen, David (1996) "It's the 90s, So the Bard Is Back," *Time*, November 4, vol. 128, no. 19, 73–4.

Bennett, Alan (1995) *The Madness of King George*, New York: Random House.

Berube, Michael (1995) *Public Access*, New York and London: Routledge.

Burr, Ty (1996) "The Bardcage," *Entertainment*, November 15, 353: 49.

Corliss, Richard (1996) "Suddenly Shakespeare," *Time*, November 4, vol. 148, no. 21, 88–90.

Crewe, Jonathan (1995) "In the Field of Dreams: Transvestism in *Twelfth Night* and *The Crying Game*," *Representations*, 50: 101–23.

Dargie, John (1996) "*Othello*," *L.A. Weekly*, December 27.

Garber, Marjorie (1992) *Vested Interests: Cross-Dressing and Cultural Anxiety*, New York and London: Routledge.

—— (1995) "Some Like It Haute," *World Art*, 1, 30–3.

Gritten, D. (1995) "Shakespeare Is One Happening Dude," *Los Angeles Times*, December 27: 39, 41.

Hodgdon, Barbara (1994) "The Critic, the Poor Player, Prince Hamlet, and the Lady in the Dark," in *Shakespeare Reread: the Text and New Contexts*, ed. Russ McDonald, London and Ithaca: Connell University Press.

Jefferson, Margot (1996) "Welcoming Shakespeare into the Caliban Family," *New York Times*, November 12: C11, C16.

Levine, Lawrence (1988) "Shakespeare in America," in *Highbrow/Lowbrow: The Emergence of Cultural Hierarchy in America*, Cambridge, MA: Harvard University Press.

Maslin, Janet (1996) "Soft, What Light? It's Flash, Romeo," *New York Times*, November 1: C1, C12.

McKellen, Ian (1996) *William Shakespeare's Richard III*, Woodstock, New York: the Overlook Press, 25–6.

Powers, John (1996) "People Are Talking About Movies," *Vogue*, vol. 186, no. 10, October, 210.

Rich, Frank (1996) "A Banished Kingdom," *New York Times*, September 21, 19.

Smith, Lynn (1996) "Language Barrier Can't Keep Apart Lovers of 'Romeo and Juliet,'" *Los Angeles Times*, November 7, F15.

Van Sant, Gus (1993) *Even Cowgirls Get the Blues and My Own Private Idaho*, New York: Faber & Faber.

2

RACE-ING *OTHELLO*, RE-ENGENDERING WHITE-OUT

Barbara Hodgdon

On Friday, 17 June 1994, Shakespeare became a voice-over for a moment of American cultural history. Reporting that a suicidal O. J. Simpson lay in the back of his Ford Bronco holding a gun to his head, CBS television anchor Dan Rather glossed the flickering image of the vehicle, parked before Simpson's Brentwood home, by saying that he was reminded of *Othello*, in which a black man, suspecting his white wife of adultery, kills her and then himself. As though shopping for a good story, Rather had mined the literary archive to imagine an ending which, by courting the obsessive fictions that attach to Othello's color, could mask the culture's racism in Shakespearean suicide and its attendant admission of guilt. What was later dubbed "The Night of the White Bronco" did not of course replicate *Othello's* ending, but in the days immediately following Simpson's arrest, charged with the murder of Nicole Brown Simpson and her friend Ronald Goldman, further evidence (in this instance, as in the play, a media-ted term) connecting these events to the critical, theatrical, and cultural legacy of Shakespeare's play proliferated.

There was, for instance, the uncanny resemblance between Othello's final speech ("speak / Of one that loved not wisely but too well") and Simpson's "suicide note" ("If we had problems it's because I loved her too much").[1] And, as though echoing the famous "dirty still" from Laurence Olivier's 1964 *Othello*, in which Olivier's black make-up has smudged Maggie Smith's white cheek, *Time's* 27 June cover framed a blacked-up police mug shot of Simpson with the headline banner, "An American Tragedy." Even the (patriarchal) state agreed. For after all, Simpson had done it some service, and they knew it. On 23 June, Richard Halverson, Chaplain of the US Senate, evoking II Samuel 1:25 ("How are the mighty fallen"), spoke of how "our Nation has been traumatized by the fall of a great hero," consoled "the unnumbered, who have been disillusioned by the fall of their idol," and prayed "for a special dispensation of grace for this American hero, his loved ones and all who are hurting irreparably by this event" (*Congressional Record*, no. 81). In this narrative, Simpson moves from "great hero" to "American hero" isolated in tragic splendor; never named, Nicole Brown Simpson and Ronald Goldman are simply dismissed as "victims."

Wrapping Simpson's heroic identity in classical ghosts and positioning him as the noble protagonist in a tale of love and betrayal relies on time-honored humanist reading formations that harness the energies of Shakespeare's text to a stable order of meaning which excludes the unruly issues of gender, class, and race. Or seems to. Yet by omission and avoidance, such strategies silently subscribe to the racist discourse which *Time*'s cover image, as well as a range of Internet jokes, represents more overtly. A particularly brutal one asked, "Have you heard about O. J.'s new defense strategy?" and answered, "He's going to say that he was just following his coach's game plan: cut to the left, cut to the right, and run like hell."[2] Although absent from the joke, race matters here: the myth of the black man as an icon of (regulated) performative violence in American (sports) culture, coupled with a prevailing cultural misogyny, makes the joke work – at least for a potential Iago. Situated at the intersection of Simpson's roles as star athlete and defendant, it frames an emergent narrative of O. J. as criminal in terms of an established narrative of O. J. as sports hero – contradictory constructions that not only threaten to turn him, like Othello, into a split subject ("Please think of the real O. J. and not this lost person") but also seek to undo Simpson's efforts to white out his race ("I have worked all my life to get people to look at me like a man first, not a black man" [Simpson letter; see also Cose 1994]).

To make his (de)construction as Othello complete, Simpson's history of wife-battering mobilized other cultural myths, yoking the (white supremacist) fear of miscegenation invoked by his marriage to an archetypal blonde beauty with a stereotype of animalistic black male sexuality – violent, monstrous, even deadly to the (forbidden) white woman. As jury selection proceeded, the 3 January *National Enquirer* printed a "computer-enhanced" photograph of Nicole, purportedly taken by her sister and later seized by authorities, showing injuries she had sustained in a 1989 beating: a blackened eye, a split lip, and the imprint of a hand on her neck. Framed in the American symbolic imaginary between *Time*'s darkened mug shot and the *Enquirer*'s equally doctored photograph, the case went to trial anchored by an iconography through which ideologies of race, gender, power, sexuality, pleasure, and pain became a visible, even tangible body of evidence.

POSTCOLONIAL TERRITORIES: A RE-MEDIATION

This moment in American mass culture frames my viewing of two made-for-television *Othello*s, Janet Suzman's film of her 1987 production at Johannesburg's Market Theatre and Trevor Nunn's film of his 1989 production at Stratford's The Other Place.[3] Aside from Liz White's non-commercially released *Othello*, starring Yaphet Kotto (see Donaldson 1990: 127–44) and Oliver Parker's 1995 film, with Laurence Fishburne, the two are the only filmed representations of the play featuring black actors in the title role – South African John Kani, winner of a 1976 Tony Award for his performance in Athol Fugard's *Sizwe Banzi Is Dead*,

and Jamaican-born American Willard White, an operatic bass-baritone whose performance as Porgy in Nunn's Glyndebourne staging of Gershwin's *Porgy and Bess* brought him wide acclaim. Both involve the return of cultural "parents" to their origins: Suzman, an RSC associate and co-founder of Market Theatre, to her native South Africa despite an international cultural boycott protesting apartheid ("Putting on 'Othello' with John Kani," she remarked, "is infinitely more important than stamping my foot and saying, 'I won't set foot in the country'" [Suzman 1988a: 49]); Nunn, the RSC's former artistic director, to follow a series of glitzy, big-money hits (*Cats, Starlight Express, Les Miserables, Aspects of Love*) with a small-scale *Othello* in Stratford's smallest venue. Both are post-colonial representations in which *mise-en-scène* evokes particular colonialist histories, narratives, and ideologies. Conceiving *Othello* as High Renaissance tragedy, Suzman dresses it in Jacobean silhouettes – a move designed, as she put it, to "focus spectators' minds on the dreadful story" and avoid "imposed anachronisms that might hinder their self-recognition." Asked why she had not updated the setting, she replied, "Where do you suggest, post-revolutionary Pretoria?" (49). Deliberately calling attention to the absence of such a utopian social (or theatrical) space, Suzman appropriates *Othello* as a mirror in which South Africans might confront the racism of their prevailing social order. Nunn's strategy is decidedly less overt. Veiling his project in Shakespearean "authenticity" as an attempt to reproduce, in the intimate Other Place venue, "original" staging conditions similar to those of early modern performances at Court (see Renton 1989), he chooses a milieu reminiscent of the US Civil War or of a nineteenth-century colonial outpost that might be anywhere in Britain's Empire – territories that spawned turn-of-the-century racist-orientalist discourses, among them slavery narratives, which not only mark the turn of the century but also resonate in early modern culture. In Nunn's postcolonial theatre, Empire becomes a displaced sign of the Elizabethan–Jacobean period, a site where contemporary Britons can both discern and misrecognize themselves.

Writing in early 1995, I experience a somewhat similar collapse of history, for Elizabeth I's correspondence with the Privy Council seeking to deport eighty-nine black people and the subsequent warrant issued on 18 July 1596 contrasting blacks ("those kinde of people") with her white subjects ("Christian people")[4] resembles immigration bans and deportation schemes currently under debate in the United States – moves that recall the turn-of-the-century cult of Anglo-Saxon heritage[5] and reinvoke the idea of "purifying" America through proposed legislation aimed at eroding recent initiatives, both within and outside the academy, affirming multiculturalism and racial diversity. At a moment when past traditions of hatred are being appropriated to support such new expediencies, to renegotiate *Othello*'s territory is to situate oneself at the intersection of overlapping, conflicting discourses, to remediate already mediated representations, including the Simpson trial, which haunts my looking. I am interested in how these two *Othellos* circulate metanarratives of race and gender and cultural tropes of assimilation and domestic violence. How, I want to ask, do such discursive

frameworks monitor looking relations? And how do the discourses surrounding these representations work to secure spectators' pleasure and to keep *Othello*, and Othello, in place?

BLACKING UP

Look, a Negro!

(Frantz Fanon 1952)

Most obviously, *Othello* represents a site through which the problem of the black body in the white imaginary becomes visible, gets worked through. Consider, first, a theatrical passing narrative. In his autobiography, Laurence Olivier speaks of transforming himself into Othello, "creating the image which now looked back at me from the mirror":

> Black all over my body, Max Factor 2880, then a lighter brown, then Negro No. 2, a stronger brown. Brown on black to give a rich mahogany. Then the great trick: that glorious half-yard of chiffon with which I polished myself all over until I shone. . . . The lips blueberry, the tight curled wig, the white of the eyes, whiter than ever and the black, black sheen that covered my flesh and bones, glistening in the dressing-room lights. . . . I am, I . . . I am Othello . . . but Olivier is in charge. The actor is in control. The actor breathes into the nostrils of the character and the character comes to life. For this moment in my time, Othello is my character – he's mine. He belongs to no one else; he belongs to me.
>
> (Olivier 1986: 158–59)

Fetishizing his blackened body, Olivier erases distinctions between self and other, claiming the character ("he belongs to me") as though he were colonial property. Although he admits that "throwing away the white man was difficult but fascinating," he imagines that he can "feel black down to [his] soul" and "look out from a black man's world" (153), as though mimicry might efface notions of difference and dissemble the complexity of power relations between black and white bodies into the satisfying wholeness of an ultimate cultural impersonation.

Olivier's Othello confirms an absolute fidelity to white stereotypes of blackness and to the fantasies, cultural as well as theatrical, that such stereotypes engender. Layered onto the body, "blackness" (like femininity) may be constructed – and viewed – as a performance, the theatrical equivalent of what Charles Lamb termed "the beautiful compromise we make in reading."[6] The "real" black body, and the histories it carries, can be elided, displaced into and contained by theatricality, which embraces a long tradition of whites blacking up, primarily, as in minstrelsy, for comic effect.[7] Such impersonation problematizes looking relations precisely because it deflects analysis by aligning racist ideology

26

with theatrical pleasure (see hooks 1993: 293). Most importantly, a made-up Othello ensures that both blackness and whiteness remain separate, unsullied. Putting race matters succinctly, blacking up is whiting out.

Olivier's position of stardom in the Shakespearean theatrical (and cinematic) pantheon not only makes his Othello a structuring absence for both films (though in radically different ways) but operates as a kind of spectatorial counter-memory which any actor of the role, white or black, encounters. Suzman's film recalls him at Othello's first appearance, where (as Olivier had done in 1964) Kani poses against a wall, brushing a red rose across his lips. By quoting Olivier's fetish-African as Kani's ghosted other, the film marks the difference between the "real thing" and the painted-on identity of Othello's (colonial) theatrical history, calling attention to the situatedness of an actor who, like Frantz Fanon's "Negro," experiences first-hand what it means to be black in a pervasively negrophobic society where blackness, in the colonizer's perspective, is simultaneously a point of identity and a problem.[8] Like Othello in Venice, Kani is an outsider in his own land, an alien without citizenship – an irony underlined daily as he travelled from Soweto "through . . . road blocks, *terra incognita* to the rest of the cast" (Suzman 1988a: 49). As Homi Bhabha writes of Fanon's split subject, "Black skin, white masks is not . . . a neat division; it is a doubling, dissembling image of being in at least two places at once which makes it impossible for the devalued . . . to accept the colonizer's invitation to identity" (quoted in Loomba 1987: 54). Or even, in Kani's case, to play Othello. As he himself put it, "There goes the native causing more trouble, and this time he has Shakespeare to do it for him" (quoted in Battersby).

Kani's Othello does not resemble the commanding figure imagined by critical discourse; his generalship, writes Suzman, is "modeled on Alexander, Napoleon, Montgomery, rather than a tank" (Suzman 1988a: 49) and exemplified in theatrical culture by Paul Robeson and James Earl Jones. Keyed to follow his slim, light-skinned body, the camera captures (in long and mid-shots) its full range of movement within the frame, producing the illusion that he controls the space and is free within it. Costumed in a flowing white shirt which accentuates his color, black military trousers, polished black over-the-knee boots, and a magnificent red floor-length cloak, he is an exquisitely elegant Titian-esque figure; a golden circlet, from which hangs a small case, surrounds his neck – a sign of national or tribal identity, of a mysterious otherness (what slavery was he sold into, and how redeemed from it?). But his gestures, as much as his color and attire, distinguish him from the rest: in the Senate scene, for example, broad arm movements open his whole body to the gaze, marking his confidence, his exoticism, and his vulnerability, especially in contrast to Richard Haddon Haines's stolidly built, exhibitionistic Iago, beside whom Kani's presence pales, registering a subdued, even "feminine" passivity. Yet the dynamic between the two never suggests a homoerotic (or even homosocial) bond; instead, Suzman's film rather precisely reveals how such an interpretive strategy masks the implications of race and so evades what Ben Okri calls "the terrors that are at the heart

of the play" (1987: 562). Produced a year after the repeal of the Immorality Act, which criminalized sexual encounters between blacks and whites[9] and subjected the black male gaze to state control, the film condenses these looking relations into Iago's surveillance. Haines's Iago sets out to destroy Othello and Desdemona "with all the relish of a Eugene Terreblanche": a bluff loud-mouth whose vulgar crotch- and nose-grabbing bespeaks his fear of and disgust with sexuality, he cannot touch Othello without afterwards wiping the taint of blackness from his hand. Even five years after Nelson Mandela walked free, Haines's performance highlights apartheid's body politics and invites spectators to resist his blatantly racist inscription of Othello (Suzman 1995).[10]

For black South African viewers, that invitation was enhanced by Kani's star presence, through which Othello's descendants might lay claim to their own histories.[11] And it is through Desdemona (Joanna Weinberg) that Othello's body becomes the object of the gaze for the pleasure – or displeasure – of the dominant (white) spectator. Although Iago may take *linguistic* control over that body, because the film insists that it is *Desdemona's* trajectory of desire rather than Iago's that initiates the narrative (observed by Iago, she first appears as a shadowy figure leaving her father's house), it is primarily her look that keys a white woman spectator into Kani's exoticism and the sexual bond between them. A blonde, dignified Botticelli beauty who is as much wooer as wooed, her gaze not only fetishizes Othello but works to resituate Iago's racist looking relations. Yet if her forthright desire shatters the myth that black men need to force their attention on white women, it also suggests how white women collude in constructing the black man's exotic sexuality. Suzman's theatre production had confronted spectators with memories of a past history still threatening enough to make some white South Africans walk out at the first embrace between Desdemona and Othello, a gentle kiss in the Senate scene after Desdemona has been rejected by her father. In the film, the sexual attraction between the two does not remain just beyond representation until the close, where it becomes aligned with death, but is boldly – and repeatedly – staged. One effect is to reveal how sexual intimacy between black and white bodies drives Iago's fantasies and how private looking relations intrusively invade upon, and problematize, his racist representations.

That is most sharply articulated as Desdemona and Othello meet at Cyprus. When Othello is announced, Desdemona takes Cassio's sword and, standing at the bottom of the stairs as he descends to her, raises it high in salute, prompting his "O, my fair warrior." His line keys music, and the sequence glides into slow motion, alternating between Desdemona's point of view of Othello and his of her, an editing pattern that suggests their shared passion. Both music and slow motion not only function to romanticize their meeting – expressed in a full, sensual embrace – but to separate their seemingly ideal relationship from its perception by others, which is further marked off by a cut to Iago's "O you are well tun'd now, / But I'll set down the pegs that make this music, / As honest as I am." Because this sudden stylistic shift draws attention to their harmony[12]

it is all the more startling when, mid-way through the temptation sequence (and in the so-called whorehouse scene) Othello's "barbaric" sexuality explodes. Pulling Desdemona to him and thrusting his body against hers, he takes her breath away with a rough kiss and pulls down her dress to kiss her breasts, leaving her stunned at a seeming rupture in his identity which destabilizes her own. This moment plays into some spectators' desire to experience Othello's "wildness," to see him dominated by passion, emotionality and unreason – in other words, to find their expectations of a primitive blackness fulfilled. However, it is important to remember that, in South Africa, black and white discourses differ markedly on precisely how such qualities are valued.[13] Although Suzman's film certainly evokes such stereotypes and myths, it appropriates them not as denigrating narratives of cultural othering but, by trivializing and problematizing their racist content, turns them into positive modes of self-definition.

But it is not only through Desdemona that a white spectator has access to Othello's subjectivity, for the film positions Cassio both as his "other" in loving Desdemona and as Desdemona's "twin" in his devotion to and worship of Othello. Highlighting the similarities between these two blond "curled darlings," Suzman stages a moment which, by embodying the possible liaison between them, constructs a screen for Iago's fantasies. After Othello's triumph, Cassio presents Desdemona with a bouquet of daffodils, and she kisses his cheek, but when Othello joins her, he quickly moves away. As the camera isolates Othello and Desdemona, it pans down their joined figures to Desdemona's hand: rapt with Othello, she drops the bouquet, and as Othello leads her off, he directs a low laugh and a salute to the watching Cassio, relegated to wishing himself in Othello's place as he stands guard over their love-making. Crossing to the discarded flowers, he picks them up as though to relish Desdemona's lingering touch; but once Iago emerges from the shadows, offering him an occasion to recuperate his rejected manhood, he drops the bouquet and stumbles off. Having baited his snare, Iago picks up a daffodil, smacks it against the wall, and the flower head falls off.[14] As this treatment of the daffodil suggests, Cassio's love-sickness gets displaced into Iago's destructive jealousy; for Cassio's part, his frank admiration for and loyalty to his commander is intensified when, after a gloating Iago rips off his badge of office, he echoes Othello's own gesture ("My life upon her faith") – a fist brought to the chest in a "Roman" salute. By securely marking these two moments, Suzman's film positions the cashiered Cassio to anticipate the rejected Desdemona, pulling the two into a shared space of loyalty and desire, misread as double betrayal.

Just as Cassio's salute offers to efface the conflict between races, cultures, and histories which *Othello* dramatizes and which constitutes South Africans' lived experience, the film's final scene, where the intersection of race and sex are most fiercely contested, reinstates that conflict only to call it into question. Put simplistically, this scene articulates a demand for "the negro" which Suzman's representation of the negro disrupts. Following the street quarrel (where Bianca

as well as Roderigo is killed), a white scrim descends, and a brief blackout yields to brilliant white light as the camera pans across the bedsheets draping Desdemona's sleeping form, materializing her body as the alabaster monument of Othello's description. Backlit, Othello's magnified figure appears silhouetted on the scrim, making him into the featureless black devil of a colonial fantasy the film imposes only to deconstruct, framing it as a literal projection. Yet once he enters the chamber – nude to the waist, barefoot, and wearing black harem-like trousers – costume codes a return to "native" manners, and his movements parody the primitive animalism so desired by the white imaginary. Turning murder into ritual sacrifice, Kani's Othello *performs* "the other": at once a substitute for the stereotype and its shadow, he simultaneously evokes and deflects the narratives of black males' violence against women that accede to the colonizer's wildest dreams. After the murder – an embrace which Desdemona even seems to welcome – he kneels, yoga-style, on the bed, swaying back and forth in a histrionic lament that pulls him into the space of femininity Catherine Clément marks as characteristic of opera's heroes, who die like heroines: like them, he seems "excluded, marked by some initial strangeness . . . doomed to [his own] undoing" (118). Immobilized by Emilia's revelations about the handkerchief, he is unable to stop Iago from killing her and, as the music which marked his reunion with Desdemona at Cyprus plays under Emilia's reaffirmations of her mistress' chastity and devotion, he watches transfixed as she inches toward the bed to take Desdemona's hand, then reaches out to close her eyes. Once Iago is brought back, however, he returns to the "he that was Othello." Crab-walking toward Iago, he raises his curved weapon up to Iago's crotch and castrates him, not only reversing power relations between black and white bodies but literally enacting an even deeper political and social fear of white disempowerment. Almost as an anticlimax, he moves back to the bed, where he slits his jugular with a tiny knife taken from the golden case round his neck.

Like most filmed *Othello*s, Suzman's turns Desdemona's body into a muse. Unlike most, the shot that records Othello's death pans across the bed to show Emilia's body and then up to Cassio, whose Roman salute to his dead commander connects him once again to the silenced Desdemona. Putting his head in his hands to mask his own gaze keys a dissolve to the film's final shot, of Desdemona and Othello on the bed, entwined together in a last embrace. Although elsewhere the film insists that *Iago*, not the dead Othello and Desdemona, is the "object" that "poisons sight" and must be hid, this shot also calls attention to how, especially for South African viewers, the deed cannot be hid, for as Jyotsna Singh writes, "its image has proliferated through the centuries, making it a site for the production of troubled and contradictory colonial/postcolonial identities" (291). By freeze-framing this shot, Suzman both aestheticizes it and makes its political resonances inescapable, and that is underscored when, as the film's credits roll up, all color fades away, forever fixing *Othello*'s ending in the binary it knows best: black and white. Deeply ambiguous, this still asks viewers to meditate on, even to radically revise, their racist memories.

If Suzman's film deliberately confronts South African spectators, white as well as black, with their own histories, Nunn's seems acutely conscious of catering to a white (British) imaginary, especially in selecting an ambiguously colonial locale where any racist burrs can be attached to a past historical moment. Although Nunn maintains that casting a black actor was essential "for political reasons," he conveniently elides what these might be for late 1980s Britain to wrap his decision in Shakespearean aesthetics – "integrity to the play" – and "sheer theatrical practicality": "a white Othello in black make-up comes off on Desdemona" (quoted in Renton 1989). But if Nunn throws off Olivier's blacking-up, choosing Jamaican-American Willard White evokes another ghost – that of American Paul Robeson, the *only* black actor to play Othello (in 1959) in Stratford. As a (post)colonial subject and a newcomer to Stratford's theatrical culture, White goes Othello one better by occupying two alien categories. Although White's American-ness is acknowledged, even "celebrated," by the Civil War echoes that give him something like an old Kentucky home in Cyprus, his position as an opera star marks him as an outsider both to Shakespeare and to Stratford. As it turned out, that alien identity allowed reviewers to smooth over, even erase, questions of race, turning it into a language game, a playful accident of naming. Stanley Wells, for instance, noted what he called a double irony: that "the black Othello was played by a negro called White," while Bianca – whose name means white – was played by a black actress" (Wells 1990: 194).

In spite of Nunn's claim that race matters in *Othello*, such an awareness need not automatically correspond with politicization. Certainly both his production and the later film offer few ruptures where a spectator, whether black or white, can resist Iago's racist inscription (see Diawara 1993: 211–12). In part, this is a function of casting, which overturns Suzman's physical typing to pit White's statuesque, coal-black Othello – looking every inch the military hero – against Ian McKellen's slight, tightly reined-in Iago, an inscrutable, smiling psychopath with a Führer moustache, dead eyes and officious manners who is consumed by sexual and professional jealousies. When Othello first appears, he bursts open the doors and enters striding, his commanding figure filling the entire frame. Yet from this point forward, the film contains his body ever more closely, producing the illusion that Iago may be in cahoots with both cameraman and editing process – an illusion that carries over into costuming. A Franco-Prussian black uniform and polished knee-high boots encases the black body, turning White's avuncular figure from a (potential) Uncle Tom into a very English Othello whose exotic origins and sexuality are buttoned up and whose assimilation seems (comfortably) complete. Yet even though his still, compelling presence gives him the *look* of a complete Othello, his broadly sketched performance makes him prey to McKellen's precise, transfixing Iago. Indeed, their relationship reproduces the stereotypical opposition between instinctive, emotional, "natural" power attributable to the "native" other and the intelligent, rational judgment of the (civilized) colonizer – and is most clearly worked out in terms of performative bodies.

As Iago, McKellen gives a riveting performance, recorded primarily through close-ups that capture his developing paranoia or through framing that stresses his omnipresent voyeurism – as when, entering Desdemona's bedroom for the first time, he maps it with a furtive glance, fixing its geography as though to give his fantasies a local habitation. Brother, father, valet, mother-hen, his military discipline takes form as obsessive tidiness: straightening papers, adjusting Roderigo's collar, mixing the brew that will make Cassio drunk (and cleaning up after him), saving cigarette stubs in a little silver box, he seems indispensable to the garrison's domestic order. The technical precision of his performance tropes his mastery over the narrative, and because he also controls the material objects that mark the film's densely particularized attention to social detail (Nunn's "neo-Brechtian" trademark), it is he who anatomizes and manipulates its optical economy, as through the eyepiece of a microscope. One effect of this accumulative detail is that, by explaining Iago's actions, it not only exposes his "motiveless malignity" as a critical fiction but also points to how Coleridge's famous phrase serves to wrap both Iago's racism, and that of a critic, in a convenient abstraction (see Taylor 1989). Tellingly, McKellen's Iago touches everyone *except* Othello – shoulder-pats and hair-ruffling for his fellow-soldiers, contemptuous kisses for Emilia, a comforting embrace for Desdemona; through handling the handkerchief – the feminine sign binding Desdemona to Othello's maternal origins – his misogyny taints all the women, including Bianca. Moreover, this absolute control figures his technique in framing Othello, who becomes simply another pawn to maneuver on his screen of desires. Not only does he use whatever evidence he finds at hand, he manufactures it. The most striking instance occurs when, after tucking Cassio into bed following the drinking bout, Iago perches at the edge of Cassio's cot, straightening his kit as he soliloquizes on villainy. Turning in drunken slumber, Cassio throws a leg over Iago's lap: momentarily startled, Iago shies away from Cassio's touch; later, he uses the moment to construct "ocular proof" of Desdemona's infidelity.

Proceeding from a heightened realism full of minute quirks and Brechtian gests, Iago's intellectual control over looking relations also drives the film's sex/gender economy. That he is able to do so depends in part on how the film represents the relationship between White's dignified, massive Othello and Imogen Stubbs's fragile, naive Desdemona (she anticipates going to Cyprus as her first trip abroad), a Scarlett O'Hara-like figure who assumes that everything will be all right tomorrow (Stubbs, quoted in Morgan 1989: 16–18). While the bond between Weinberg's Desdemona and Kani's Othello is clearly erotic, that between Stubbs and White seems like a curiously old-fashioned attraction between an older man and a much younger woman, an arrangement that passes Desdemona from one father figure to another. As though playing house, Stubbs's Desdemona chides and cajoles White like a child; she sits on his lap, twisting him around her finger, and he responds as though she is a prized possession – like the chocolates that are Cassio's tribute to her, a delicious confection.

The moment that marks their relationship occurs, as in Suzman's film, in the quayside scene, where, as before, it distinguishes public from private spheres. In Nunn's film, however, passion remains offstage. As Othello enters, Desdemona starts toward him, but he stops her by extending the flat of his hand to keep her away; lifting her onto a pile of luggage, he circles around her, fetishizing her body, even (literally) positioning her as the cultural capital which has made him an honorary white Venetian; as he finishes speaking his blazon, she throws herself into his arms.[15] Except for this embrace, any expression of physical desire comes from Desdemona; the public view of their relationship exhibits a highly British restraint, deriving both from Nunn's textual fidelity and from casting, but also (perhaps) indicative of anxieties about representing an erotic bond between a black man and a white woman. Whatever the case, because any trace of Othello's sexuality is absent from representation until the close, it remains entrenched in Iago's – and a spectator's – imaginary, where it can be staged, in terms of all the myths associated with the black male's sexual potency, by a spokesman for the white patriarchy who would protect all white women from black men.

That staging becomes most pertinent at the close, where a high-angle shot captures Iago's point of view of Othello's body covering Desdemona's in a last orgasmic embrace, revealing, at last, the image that has haunted his desires. But it is not that image with which the film ends. Instead, the final shot frames Iago, his arms folded across his body as though to maintain his distance from both site and sight. And as the camera dollies in to isolate his face in close-up, it registers, first, his disinterested glance at the dead and then, as he raises his eyes to stare straight at the camera, a dead-eyed gaze that seems to acknowledge, even proclaim, his complicity in the colonial project. All has been done strictly according to the book: spectators meet Iago's eyes only to discover that he is us. Presiding over his private vision of Empire, Iago's look brings to mind a terrifying nostalgia for the good old days when Kipling's "Proper Sort," and the racist ideologies which firmly ensconced that sort at the top of a hierarchy, might flourish. Those who might wish to claim that Nunn's *Othello* – a production with a black actor at its center – is not "about" race may be right, but not in the way they might think. It is about who controls the narrative of racism. Speaking for many who saw Nunn's *Othello* as Iago's – and McKellen's – play, one critic mentions (without citing White's name) "in a subsidiary role, a particularly attractive performance from a black opera singer" (Koenig 1989). But if the film's take on how race matters is most acutely realized through performative bodies, racist ideologies become even more visible in the discourses surrounding it, where, Iago-like, they monitor, interpret, and (at times) punish Othello's performance.

"SAY IT, OTHELLO"

You're your country's lost property
with no office to claim you back.
You're polluting our sounds. You're so rude.
"Get back to your language," they say.

(Adil Jussawalla)

Commenting on these lines from *Missing Person*, Homi Bhabha writes of the difficulty of comprehending "the anxiety provoked by the hybridizing of language, activated in the anguish associated with vacillating *boundaries* – physic, cultural, territorial – of which these verses speak" (1990: 202). Such anxiety, of course, does not belong exclusively to the colonized other, especially when Shakespeare's language is in question. Stanley Wells, for example, writes that "White's speech rhythms were sometimes at odds with the iambic patterns of Shakespeare's verse, resulting in a less than thorough exploration of verbal meaning"; nonetheless, he concedes, "emotional truth overcame technical limitations" to produce a noteworthy performance (Wells 1990: 194). Although faulting an actor's speaking performance gets consistently evoked in critical discourse to register how far he (or she) falls short of an imaginary Shakespearean ideal, that phenomenon has a long history for Othellos, especially when, as with Paul Robeson and James Earl Jones, they happen to be black. In marking White as an inferior Shakespeare speaker while simultaneously praising the emotional truth of his performance, Wells (consciously? unconsciously?) not only expresses a desire to erase any spoken sign of the "other" in the actor's speech but subscribes to an essentialism that aligns emotionality with blackness. If, as John Barton argues, "Shakespeare *is* his text" (168), then disturbing iambic pentameters violates authorial authenticity, threatens to turn Shakespeare "black."

What is at stake in this fear of linguistic miscegenation? More, it would seem, than a white auditor's trouble with blackness "polluting" a language. Words, after all, are Othello's primary expressive instrument, but *whose* expression, exactly, do they represent? Written by a white playwright for a white actor, his language is marked, in the play's linguistic context, by its *difference*: characterized by the large phrase, by repeated metaphysical abstractions (light/dark, heaven/hell), it spans a height and depth of reference embraced by no other speaker in the play (see Calderwood 1987). A role identified by and treasured for its glorious sound – what G. Wilson Knight long ago called "the Othello music" – its canonical performances are often described by critics in musical terms. One hears Olivier singing the lines, building to agonized crescendo on "Othello's occupation's *gone*," or Anthony Hopkins sliding into Welsh accents in the explosive rages: speaking Othello's words generates a "different" language, one which tempts a white British performer to slide from Received Standard Pronunciation into a "native" – or othered – tongue. What is going on here? If speaking Othello's language can mark the *white* performing body with linguistic otherness, what

does it *do* to the black performer? If its rhetorical display mimics an excess which stands in for what Bhabha calls the fading identity of the colonized subject through his inscription in the colonizer's language (1990: 202), then the question for a black actor becomes how to "posit a full and sufficient self in a language in which blackness is a sign of absence" (Gates 1985: 12) – a problem intensified when that language represents a sign of Anglo-European dominance and has high cultural status. Always already perceived as a translation from a "master text," black Othellos' "rude speech" positions them as imperfect slaves who perform disservice to Shakespeare's canonical word.

By casting Kani, whose mother tongue is Xhosa, as Othello, Suzman deliberately challenges the national linguistic stronghold which claims that appropriating Shakespeare's language to the lived experience of the other censors its potential range.[16] Reflecting on the production as it moved into film, Suzman writes: "Not even Paul Robeson, I imagined, could have said 'Rude am I in my speech,' and be entirely believed. In the event, it gave John an innocence, a sense of struggle, that a more Promethean actor, at home in the tongue, couldn't possibly achieve. Better still, it gave him a mystery, an unknowable past, that would attract Desdemona and worry the hell out of most whites" (1988a: 49). Yet however politically astute Suzman may be about energizing Kani's black body, and its "native" identity, so as to trouble white spectators, she herself speaks a curiously conflicted language that, if not entirely accepting the text's (racist) dictates, pulls in terms – "innocence," mystery," "an unknowable past" – common to British colonialist discourse about Africa and especially prominent in Conrad's *Heart of Darkness*. That Suzman is caught up in such discursive formations becomes pertinent in the context of critical frameworks current in South Africa at the time. Martin Orkin writes of how South African academics who do discuss *Othello* rarely touch on its concern with race but instead, by seeking refuge in idealist abstractions about tragedy, "human nature," and interiority, continue, by omission and avoidance, to underwrite the hegemony of the prevailing social order (see Orkin 1987a and b).

Similar strategies surface in two academic reviews of Suzman's production, both written by white women South Africans. Commenting on Suzman's "care and respect for the language" and her "orchestration" of its "poetic music," Elisabeth Lickindorf especially admires Brabantio, Desdemona, and Lodovico for "appropriate" verse-speaking that made their roles intelligible (read, identifiably "white"?) but faults Haines's Iago for "disturb[ing] the auditory composition of the play" and reducing the "diabolical manipulations of the tragedy" to a "shouting match" in which his was the more powerful voice. Although she praises Kani for avoiding the histrionics of Olivier's "highflown and unconvincing hyperbole," Lickindorf finds his Othello most moving in the final act, where he was able to convey "the entire quality of sound that belonged to each verbal cluster and to each facet of anguish" (1987: 69–70). Also remarking on these moments, Hilary Semple speaks a more racially coded language: "dressed in a dark sarong and bootless in his bechamber, [Kani's] movements had

35

grace and were eloquent. . . . At appropriate moments he squatted easily back on his heels in the fashion of Africa . . . keen[ing] his anguish and grief in tones and cadences our ears could recognize as familiar. In such moments he was an exciting and powerful figure, his dilemma and experiences immediate to his audience" (1987: 69). Most "Othello" when dressed in native garb, his body fashioned by African gestures and his speech inflected by a "black" sound familiar to white South African ears, Kani becomes constructed as the reviewer's exotic other, most sharply recognizable once he conforms to the text's closural expectations by killing a white woman and then victimizing himself. In labeling Suzman's production "a metaphor for South Africa," Semple's comments call attention to how perceptions of that staging remain imbricated in the colonial legacy, for as she takes up her part in that metaphor, she speaks to the need to keep a black Othello in his place in order to secure her own pleasure and understanding of "Shakespearean tragedy."

A somewhat similar desire to mark off blackness surfaces in the British critical response to White's Othello. Here, however, racist ideologies masquerade under the guise of an aestheticized "correctness" which measures White's verbal performance against an imaginary audition driven by a mix of Knight-ean and Leavisite reading formations and past theatrical practice. Unlike Kani, White was born into the language Shakespeare speaks, but, by assuming that his "native" language is opera, the review discourse marks the high risks that attach to the outsider attempting to enter the confines of Stratford's Shakespearean precincts. Michael Ratcliffe, for instance, remarks that "the narrative breathing techniques demanded by Shakespeare and Wagner are quite unalike: White's voice resonates where it should colour and remains earthbound where it should rise"; Nicholas de Jongh concurs: "He is an opera singer and it shows . . . : [he] misses out on vulnerability; high notes of desperation and wildness pass him by; he never says farewell to greatness at all."[17] Like de Jongh, Michael Coveney misses Knight's "Othello music": White, he notes, "has lungs but not the slightest indication toward rhetoric . . . [his] velvety rich voice lies many fathoms deep, but neither sings nor intones." Those who, like Charles Osborne, thought White's Othello "a remarkably impressive achievement for a singer with little experience of speaking dialogue, and none of Shakespeare," almost invariably evoked Paul Robeson, a move that permitted identifying White's inability to "immerse [himself] very deeply in the character" as characteristic of the (black) operatic outsider.

Strikingly, most reviewers avoid mentioning White's color. Instead, "opera singer" and "Robeson" became coded terms for the lacks of a performance that "does not take audiences on the kind of dramatic journey undertaken by McKellen's Iago" and that "needs to tap a deeper layer of emotions to match the rest of the company" (Ratcliffe 1989; Nathan 1989). Because such comments also fix White's blackness, it is useful to recall how the desire for a "savage" Othello traced through (white) critics' discourse about Robeson's Othello. Although he faulted Robeson's mastery of Shakespeare's verse, James Agate praised his performance for those moments in which, at play's end, his Othello

"ceased to be human and became a gibbering primeval man." Once the production reached New York, Robeson, his verse-speaking improved, was playing Othello as a man of dignity whose racial honor is betrayed: here, however, Rosamund Gilder noted that his "savagery [was] not believable, the core of violence is lacking" (both quoted in Dyer 1987: 77).

In attempting to fashion a color-blind critical subjectivity, reviewers construct a curiously double discourse which makes the notion of "race," as it circulates in the white imaginary, painfully visible. Watching Othello, it would seem, activates the desire for a stereotypical, mythical blackness out of which the critic may (re)construct his own whiteness. In this regard, Michael Billington's comments were the most telling. With Leavis firmly entrenched in his back pocket, Billington waited in vain throughout White's performance for Othello's time-honored "heroic self-dramatization" to break out; the production, he concludes, "ultimately misses the sound we long for in a tragedy: the agonized cry of a cornered human soul." Titling his review "A tiger tamed," Billington also faults White for not being Salvini, for not demonstrating the famous actor's "tiger-like bestiality" (Billingdon 1989; see also Leavis 1952: 136–59). He does not say that White is not black enough, only that he cannot match the constructed blackness of the white imaginary. In a curious variant of the assimilation narrative, Billington elevates White by comparing him to the great Salvini, but that move arrests White in an historical moment which the critic, who owns the theatrical history, can transcend. Overall, the act of diss-ing White's performance works to "out" a white, predominantly male, racist ideology and to reassert a Shakespearean hegemony that, by aligning blackness with its mythic preconceptions, reminds the critic of his own dominant class status.[18] But if watching a black actor perform Othello awakens anxieties that enable critics to secure their own historical, or Shakespearean, real,[19] what may be most troubling is that, in returning to Stratford for a "farewell" *Othello* which stages the death of a black man and closes the doors on the theatre where he lies, Nunn himself becomes a kind of hero for the white majority. So enclosed, White's Othello can remain shrouded in a theatrical – or televisual – representational domain in which racist ideologies can appear simply as functions of material theatrical culture, never breaching the boundaries separating Shakespearean theatrical politics from those of the social real.

OUTING ABUSE

So far, my account has privileged race almost to the exclusion of gender. Certainly Kani's and White's performances direct particular attention to how race and racializations circulate in these *Othello*s and are re-mediated by the discursive formations surrounding them. But I also have wished to avoid collapsing race and gender into the same marginal space, a move which blurs the distinctions between black masculinity and white femininity separating the histories of black men's enslavement from those of women's sexual oppression

(see Singh 1994: 290–92).[20] As I turn to consider Emilia and Desdemona and to map out domestic violence as an area for further study, the Simpson trial again comes into view. Deputy District Attorney Christopher Darden's opening statement, for instance, represented the defendant as a possessive man caught in a recurring cycle of behaviors – violent abuse leading to apology and to further control over Nicole Brown Simpson, ensuring her economic as well as physical dependence on him. It would be tempting to call this "the Othello prosecution": certainly all signs indicated that Nicole's murder would be represented as the final, inevitable act of a jealous wife-batterer, an abusive – and abused – control freak (the 28 June 1994 *Village Voice* reported Simpson as saying, "If I can't have [Nicole], no one else can"; his "suicide note" claimed that at times he had "felt like a battered husband or boy friend but I loved her"). At least until Mark Fuhrman surfaced as the event's "real" Iago, prosecutors seemed to be framing Simpson *as* Iago; more appropriately, it was as if Othello and Iago had been collapsed into one subject position which revealed, under the smiling public figure of the Hertz commercials, a private face closely resembling Iago's.

In Shakespeare's text, "abuse" is a conflicted term that slips easily from voice to body, from meaning "wrong with words" (Iago's "I'll abuse him to the moor") to "misuse" (Brabantio's "she is abus'd, stol'n from me and corrupted") and "deception" (Emilia's "the Moor's abus'd by some outrageous knave"). Tellingly, Brabantio calls Othello "an abuser of the world"; and Desdemona, remembering her Willow Song's "you'll couch with more men," asks Emilia whether she thinks "in conscience" that "there be women do abuse their husbands / In such gross kind." Characteristically, one might say, Desdemona internalizes the cultural prerogatives which justify misogyny, displacing its "cause" onto women and positioning herself ("Nobody, I myself") in the space of shame allotted to her by men. In both the play and its critical reproductions, abuse is traditionally understood primarily in terms of Iago's "practise" on Othello, his elaboration of a perverse scenario in which racism and misogyny become energized as theatrical pleasure – especially, though arguably, the pleasure of male spectators. But that scenario, which constructs Desdemona as "whore," prompting Othello to strike her in public, to "misuse" her in the so-called whorehouse scene and, finally, to kill her, displaces and represses another narrative of spousal battery, that between Iago and Emilia.

By staging that repressed narrative, Nunn's film reveals how Iago's abuse of Emilia becomes displaced onto and appropriated by Othello, who turns it on Desdemona. Signs of Iago's possessiveness appear first in the Cyprus quayside scene when, as Cassio greets Zoe Wanamaker's Emilia with a kiss on both cheeks, McKellen's Iago quickly moves to re-establish her body as his territory, marking (with a false heartiness and a proffered shot of brandy) his wife as (necessary) domestic property. Later, as he watches Othello and Desdemona kiss, Iago wrenches Emilia's head toward his, staking out his claim with a hard, passionate kiss which belies his thought that the "Moor has done [his] office" – a gesture to which Emilia responds with startled incomprehension. Although

Iago is the film's most obvious voyeur, Emilia is equally omnipresent: in a performance constructed out of loss, mis-used desire, frustration, and constant fear of Iago's displeasure, she watches Othello's adoration of Desdemona and Desdemona's playful confidence in her love with defeated silence. The grounds for that become most apparent when, after retrieving the handkerchief, she muses that she has no such token to "kiss, and talk to," a lack that prompts her to offer it to an Iago who pulls her onto his lap, kisses her, puts a hand up her dress and, through a near-magical sleight of hand, takes both the handkerchief and her pipe, which he puts in his mouth and lights, puffing smoke in her face and laughing as he thrusts her away.[21]

Emilia's own history of verbal, psychological and physical abuse surfaces once she sees Desdemona subjected to similar treatment in the whorehouse scene and recognizes, in Othello, the symptoms of the jealous batterer. But even in the Willow Song scene, where Desdemona guiltily takes Cassio's box of chocolates from her dressing table and the two share a sweet, Emilia can speak only in general terms of "husbands' faults" and women's desires, not of her own experience. As that scene ends, Emilia hesitates before leaving, as if she would say more. The text, which gives her no "good night" in response to Desdemona's, marks her role by silence and Desdemona's with a prayer; the play's ending, of course, overturns this verbal economy to further punish Desdemona for her silence, Emilia for her speech. Domestic violence offers yet another site for exploring the relations between women's speech and silence in *Othello*, one that aligns with recent studies citing women's unwillingness to file charges against spouses who have abused them or to seek their arrest (see, for example, Jones 1994). An even more particular link ties Emilia and Desdemona to Nicole Brown Simpson, whose voice apparently went unheard when, after Simpson had beaten her in 1989, she called police to her home. Tellingly, her statements to relatives and friends about her fears that Simpson would kill her were kept out of "representation" at the trial. Like *Othello*'s women, her "voice" was silenced, cut off – that is, until the end of Marcia Clark's closing statement, when, as though mimicking Shakespeare, Nicole's voice, on the famous 911 tape, filled Judge Ito's courtroom as well as millions of domestic spaces worldwide. Still, neither Nicole's voice nor Clark's strategy influenced proceedings in which the lies of Fuhrman's racist Iago had, as in Shakespeare's play, stopped all ears.

Not unexpectedly, the patterns of abusive behavior toward women which surface in Nunn's *Othello* also went unnoticed by reviewers, who contained and re-mediated such narratives of domestic abuse as "male effects" – either taking them as a given, constructed by "Shakespeare," or as resulting from McKellen's meticulous performance (as in Michael Coveney's "Iago's marriage has gone cold and dead"). One might conclude that abuse represents a symptom apparently so dangerous to the psychic health of the (usually) male critic that it must be consistently repressed. Too fascinating, however, to repress successfully, for what surfaces in its place is a desire for feminine victimization. As Elisabeth Bronfen writes, "Representations as symptoms articulate unconscious knowledge and

desires in a displaced, recorded, and translated manner" (1992: xi). All too willingly, or wilfully, the review discourse constructs Emilia as well as Desdemona in terms of their appearances and "feminine" traits – figured as "some shining Burne-Jones heroine," Desdemona becomes a "young bride with Rapunzel hair"; Emilia is marked as "strong" yet "slow-burning, sickly-sad" (Tinker, Coveney, Osborne, all 1989) – or as potential victims – "[Emilia's] face speak[s] if not volumes then at least a complete Victorian novel" (Coveney); by contrast, Stubbs's Desdemona is "a study of innocence out of its depth" who displays an "empty-headedness [which] makes the last scenes especially moving" as she becomes "a painful, pitiful victim in the clutches of incomprehensible evil" (de Jongh, Osborne, Barratt, all 1989).

This desire for the victim symptomatic of *Othello*'s reviewers aligns with the discourse surrounding the Simpson trial, where the question of how it was that a *black* man's spousal abuse prompted a faddish fascination with domestic violence was displaced into a near-hysterical tabloid discourse that made Nicole Brown Simpson's body, and her sexual conduct, less a site for evaluating her ex-husband's criminal responsibility than for shoring up his masculine mystique. Photographs of Nicole embracing Ronald Goldman or nude in a hot tub with three (white) male "lovers" circulated Iago-like "proofs" of her promiscuity in a series of panic body images; stories of her affair with Simpson's friend Marcus Allen, of her pleas to a minister to "save her from a lesbian hell," and of her drug addiction hinted at behaviors which not only marked her as "unnatural" but seemed designed to demonize her with the signs of her own undoing. With the trial in session, the tabloids extended their surveillance to all the women connected with the case. The 14 February *National Enquirer* featured a double-page spread on Chief Prosecutor Marcia Clark's "topless fling" fifteen years ago with her "hustler hubby"; the *Star* headlined Nicole's sister, Denise, and her "jealous" attraction to O. J. Simpson. Even more troubling was a 28 February *Star* "exposé" entitled "Marcia and Johnnie: Johnnie Cochran puts the smile back on Marcia Clark's face," which printed a series of photos showing Cochran touching Clark (from behind). Clark, the piece claims, was "all business" until, sensing Cochran's touch, she recalled the "correct" relations between a man and a woman: "the thought turns her girlish for a microsecond – and she lowers her eyes," while "ladies' man O. J." looks on in "total glee." Turning the relation between the two trial lawyers into a version of Nicole and O. J., this spread not only "normalizes" the positions of "man" and "woman" but also evokes a familiar scenario – "she's asking for it" – which works to strip Clark of her professional status and to displace responsibility for any "crime" from the male defendant to the female prosecutor.

"If we cannot see things clearly," writes Freud, "we will at least see clearly what the obscurities are" (1926: 125). And if what appears to be at stake in reading the discursive formations surrounding the Simpson case is nothing less than a culture reading itself through a set of heavily coded, highly mediated discourses, the *Othello* connection provides a literary logic not only for containing

blackness within the white imaginary but also, by dreaming the death of "woman," for re-enclosing women's voices and bodies within a male imaginary which sanctions its own destructive desires. At a moment when the law itself has become a theatrical commodity, that dream is more than a transhistorical literary trope. If Lodovico's "Let it be hid" seems symptomatic of a refusal to address domestic violence shared by early modern and late twentieth-century cultures, there is a radical difference between the image of Nicole's battered, bloody body – too sensational to be viewed by eyes other than those in the courtroom – and the serene, alabaster-like Desdemona, safely confined within the boundaries of a discrete, authoritatively Shakespearean tragedy. Or at least one would like to think so.

NOTES

1 Read by his friend Robert Kardashian at a 17 June news conference, Simpson's letter circulated widely in print and television news, in the tabloids and on the Internet.

2 My thanks to Jonathan Shectman for calling my attention to this "joke."

3 Although I refer to both *Othellos* as "films," a more accurate label is "video text," for both use video technology and both were screened on Britain's Channel 4 – Suzman's in January 1989, Nunn's in late spring 1990. Throughout, my descriptions and analyses are based on these video texts, but once I turn to the discourses surrounding them, I rely on reviews of the stage productions. I ask readers to accept this discrepancy for several reasons. For one, both video texts represent records of theatrical performances; for another, the only commentary on the videos falls into the category of "puff" pieces. See, for example, (on Suzman) Lennon; and (on Nunn) Gore-Langton and Conrad.

4 Elizabeth's warrant is quoted in Cowhig 1985: 6.

5 See, for instance, Wister 1895, Casson 1907, and Matthews 1989. My thanks to Richard Abel for calling these texts to my attention and for commenting on drafts of this essay.

6 On femininity as performance, see Butler 1990, esp. 128–41.

7 And in any number of eighteenth- and nineteenth-century burlesques of *Othello*. See Wells, *Nineteenth-century Burlesques.*

8 One of Kani's brothers was sentenced to prison in 1962 for furthering the aims of the outlawed National Congress; another, Xolile, was killed (at the age of twenty-six) during the 1985 riots (see Battersby 1987).

9 For a dramatization of this issue, see Fugard 1986.

10 Terreblanche is the leader of the Afrikaner Resistance Movement (ARM), engaged in terrorism against blacks. Ninety percent of the audience for Suzman's production had never seen the play before; for the first time, Market's black audience "jumped from the usual 10% or 15% for a European classic, to double and treble that number" (Suzman 1988b: 95).

11 Speculating on why black audiences came to see *Othello*, Suzman writes: "they enjoyed it because they had seen nothing like it before in their lives. . . . They enjoyed it because the black guy gets to be in charge of his own death at the end, and because the white guy gets found out" (private communication).

12 The only other cinematic "trick" occurs in the temptation scene, where Kani's look off left frame keys two inset shots, one of Desdemona and Cassio kissing, another of the two parting. Both are moments he (and spectators) have seen before; repeating

them stresses how, once Iago's fantasy has taken hold of Othello, he rereads what he has previously witnessed.

13 Such distinctions were evident in the reception circumstances of Suzman's production. "White couples hissing at blacks to shhhh! Blacks shouting 'look out behind you!' as Iago stabs Emilia. . . . Blacks laughing in the quiet bits because tragedy is an unknown form in Africa. They are not as well-schooled as whites in the manners of the theatre. Thank God. 'You could have heard a pin drop' is the greatest accolade you can pay to a moment of high drama in European theatre. In Africa silence is threatening, as if the lights had fused. . . . The nub of it is, that a black audience is a vociferous thing, and likes to express itself (cf. black church services and sung responses), and a white audience is schooled in polite silence" (Suzman, private communication).

14 In protest of apartheid, Stratford's 1987 Birthday Celebrations Committee decided not to invite representatives from South Africa, a move that met with considerable resistance from the District Council, the Stratford Council and the Birthplace Trust. Brockbank mourns the dissent which transformed "a once inconsequential and delightful festival [once the Grammar School's annual daffodil festival] into a local as well as a national political forum" (1987: 481). Suzman writes that her choice of daffodils did not allude to the Birthday celebrations but was accidental: on any night, the properties manager would snatch up whatever flowers were available from the stalls in the precinct (private communication).

15 This stylization is repeated in the whorehouse scene, where once again a circling camera embodies Othello's point of view as he surveys Desdemona's body, now a scorned object.

16 This may not be the case with "foreign" Shakespeare, where performers working from a translation are perceived as being able to leap over or transcend language barriers (Brown 1993: 21–35). It does, however, pertain to a postcolonial Othello.

17 These and other reviews are collected in scrapbooks at the Shakespeare Centre Library.

18 I am indebted to Mark Fransiscus for the idea of outing racist ideology.

19 For a pertinent discussion of the historical real, see Staiger 1989.

20 Singh offers an important corrective to Newman's deconstructive reading of Othello. See also Loomba 63, n. 4.

21 Suzman's film also stages moments of domestic violence (Iago slaps Emilia on several occasions), but throughout, her emphasis rests more on race than gender.

REFERENCES

Barratt, Helene (1989) "Military Study of Evil," *Coventry Evening Telegraph*, 25 August.

Barton, John (1984) *Playing Shakespeare*, London: Methuen.

Battersby, John D. (1987). "The Drama of Staging 'Othello' in Johannesburg," *New York Times*, 26 October, C16.

Bhabha, Homi K. (1990) "Interrogating Identity: The Postcolonial Prerogative," in *Anatomy of Racism*, ed. David Theo Goldberg, Minneapolis: University of Minnesota Press, 183–209.

Billington, Michael (1989) "A Tiger Tamed," *Guardian*, 26 August.

Brockbank, Philip (1987) "Shakespeare's Stratford and South Africa," *Shakespeare Quarterly*, 38 (Winter): 479–81.

Bronfen, Elisabeth (1992) *Over Her Dead Body: Death, Femininity and The Aesthetic*, New York: Routledge.

Brown, John Russell (1993) "Foreign Shakespeare and English-speaking audiences," *Foreign Shakespeare: Contemporary Performance*, ed. Dennis Kennedy, Cambridge: Cambridge University Press, 21–35.

Butler, Judith (1990) *Gender Trouble: Feminism and the Subversion of Identity*, London: Routledge.

Calderwood, James L. (1987) "Speech and Self in *Othello*," *Shakespeare Quarterly*, 38 (Autumn): 293–303.

Casson, Herbert N. (1907) "The Americans in America," *Munsey's Magazine*, 36 (January): 432–36.

Clément, Catherine (1988) *Opera, or The Undoing of Women*, trans. Betsy Wing, Minneapolis: University of Minnesota.

Congressional Record (1994) vol. 140, no. 81.

Conrad, Peter (1990) "When Less Means Moor," *Observer Magazine*, 24 (April): 24–5.

Cose, Ellis (1994) "Caught between Two Worlds: Why Simpson Couldn't Overcome the Barriers of Race," *Newsweek*, 11 July: 28.

Coveney, Michael (1989) "A Monumental Othello," *Financial Times*, 26 August.

Cowhig, Ruth (1985) "Blacks in English Renaissance Drama and the Role of Shakespeare's *Othello*," in *The Black Presence in English Literature*, ed. David Dabydeen, Manchester: Manchester University Press, 1–25.

de Jongh, Nicholas (1989) "When Less Means Moor," *Guardian*, 7 October.

Diawara, Manthia (1993) "Black Spectatorship: Problems of Identification and Resistance," in *Black American Cinema*, ed. Manthia Diawara, New York: Routledge, 211–20.

Donaldson, Peter S. (1990) "'Haply for I am Black': Liz White's *Othello*," in *Shakespearean Films/Shakespearean Directors*, Boston: Unwin Hyman, 127–44.

Dyer, Richard (1987) *Heavenly Bodies: Film Stars and Society*, London: Macmillan Education.

Freud, Sigmund (1926) *Inhibitions, Symptoms and Anxiety*, Standard Edition XXI, London: Hogarth Press.

Fugard, Athol (1986) *Statements After An Arrest Under the Immorality Act*, New York: Theatre Communications Group.

Gates, Henry Louis (1985) "Writing 'Race' and the Difference It Makes," Editor's Introduction to *Critical Inquiry*, 12 (Autumn): 1–20.

Gore-Langton, Robert (1990) "A Round, Unvarnish'd Tale," *The Listener*, 1 February: 36–7.

hooks, bell (1993) "The Oppositional Gaze: Black Female Spectators," in *Black American Cinema*, ed. Manthia Diawara, New York: Routledge, 288–302.

Jones, Anne (1994) *Next Time She'll Be Dead: Battering and How to Stop It*, Boston: Beacon Press.

Knight, G. Wilson (1949) "The *Othello* Music," in *The Wheel of Fire*, London: Methuen, 97–119.

Koenig, Rhoda (1989) *Punch*, 13 October.

Leavis, F. R. (1952) "Diabolic Intellect and the Noble Hero: Or the Sentimentalist's Othello," in *The Common Pursuit*, London: Chatto & Windus, 393–414.

Lennon, Peter (1989) "Catching His Soul," *The Listener*, 5 January: 38–9.

Lickindorf, Elisabeth (1987) "The Verse Music of Suzman's *Othello*," *Shakespeare in Southern Africa: Journal of the Shakespeare Society of Southern Africa*, 1: 69–71.

Loomba, Ania (1989) "Sexuality and Racial Difference," in *Gender, Race, Renaissance Drama*, Manchester: Manchester University Press, 38–64.

Matthews, Brander (1907) "The American of the Future," *Century Illustrated*, 74 (July): 474–80.

Morgan, Gwyn (1989) "Three Women in Othello," in *Plays and Players* (October): 16–18.

Nathan, David (1989) *Jewish Chronicle*, 6 October.

Newman, Karen (1991) "'And wash the Ethiop white': Femininity and the Monstrous

in *Othello*," in *Fashioning Femininity and English Renaissance Drama*, Chicago: Chicago University Press, 71–94.

Okri, Ben (1987) "Meditations on Othello," *West Africa* (March): 562–63.

Olivier, Laurence (1986) *On Acting*, New York: Simon & Schuster.

Orkin, Martin (1987) "Othello and the 'Plain Face' of Racism," *Shakespeare Quarterly*, 38 (Summer): 166–88.

—— (1987) *Shakespeare Against Apartheid*, Craighall: A. D. Donker.

Osborne (1989) "The Pity of It," *Daily Telegraph*, 26 August.

Ratcliffe, Michael (1989) "Disgust of the Blue-Eyed Monster," *Observer*, 27 August.

Renton, Alex (1989) "Honest Conversation," interview with Trevor Nunn, *Independent*, 17 August.

Semple, Hilary (1987) "*Othello*: An Historic Milestone," *Shakespeare in Southern Africa: Journal of the Shakespeare Society of Southern Africa*, 1: 67–9.

Singh, Jyotsna (1994) "Othello's Identity, Postcolonial Theory, and Contemporary Rewritings of *Othello*," in *Women, "Race," and Writing in the Early Modern Period*, ed. Margo Hendricks and Patricia Parker, London: Routledge, 287–99.

Staiger, Janet (1989) "Securing the Fictional Narrative as a Tale of the Historical Real," *South Atlantic Quarterly*, 88: 393–414.

Suzman, Janet (1988) "Othello Goes to Market," *Punch*, 26 (August): 49.

—— (1988) "*Othello* – A Belated Reply," *Shakespeare in Southern Africa: Journal of the Shakespeare Society of Southern Africa* 2: 90–6.

—— (1995) private communication, 31 January.

Taylor, Paul (1989) *Independent*, 2 October.

Tinker, Jack (1989) "Catching the Soul of the Eternal Outsider," *Daily Mail*, 26 August.

Wells, Stanley (1990) "Shakespeare Production in England in 1989," *Shakespeare Survey*, 43: 183–203, esp. 191–94.

—— ed. (1977–78). *Nineteenth-century Burlesques*, London, Diploma Press, 5 vols.

Wister, Owen (1895) "The Evolution of the Cow-Puncher," *Harper's Monthly*, 91 (September): 602–17.

3

WAR IS MUD

Branagh's Dirty Harry V and the types of political ambiguity

Donald K. Hedrick

COMPLEXITY

It requires little autocritique to unearth the social contradictions of academic left cultural criticism. A relatively unacknowledged one is the aim, on the one hand, to democratize education while, on the other hand, to participate in the process of social stratification through a credentialization separating the future cultural footsoldiers from the academostars.[1]

There are, of course, contradictions and contradictions. A particular one involving these same, future cultural workers may be more acutely felt by them now. Since graduate students presumably publish less, the contradiction is less visible even to a politically self-conscious field like cultural studies, but we see it surface in an occasional voice, such as that of Elayne Tobin in a recent essay about listening to depressing departmental coffee talk about new films. In the present essay I want to talk about Kenneth Branagh's *Henry V* in part responding to the issue she raises from her perspective about current cultural critique. While there is no contractual obligation for any of us to provide our students practical political hope along with critical competency, we must try to be of assistance.

Tobin finds in such talk a continually assumed stance of being "gatekeepers to positive representation," and finds the de-illusioning papers delivered at film and Marxist conferences always to reflect an "exposing" of the same bad faith everywhere, as if we were really to expect Hollywood to represent our agendas. Her disillusionment with de-illusioning boils to a brief parody of instructions for graduate students writing about film: (1) use (preferably big European) critic A to read (preferably popular) film B; (2) expose its bad faith and Hollywood commodification; (3) along the way gesture about how meaning is unfixed; and (4) indicate that more work is to be done. Although careful not to be critically naive, Tobin seems to wish for a more optimistic practice that instead of revealing the always already commodified status of a film might rather "imagine the importance of the film's larger political functions" (Tobin 1995: 72–3). If such an optimistic wish seems merely like a narrative wish for a happy ending, one

might be reminded that unhappy endings can be just as mechanically produced as happy ones. The question is rather one of the routinization and hence blunting of intellectual work. It is also a question of what constitutes the labor of cultural criticism: is it the production of ideas, of arguments, or of theory? And it is a question of those sorts of work versus the "writing of movement" (Lyotard 1989: 187).

The critic I will ultimately turn to in thinking about these questions in the context of reading filmmaker Branagh is, sort of, Lyotard, but with William Empson reading me. What has happened to political criticism by the time of Branagh's *Henry V* might be described as a massive nuancing movement under the influences of poststructuralism, a movement which in terms of Tobin's wishes might constitute a more hopeful direction since we subsequently find in films ideological complexities (subversions, struggles) rather than monolithic exercises of absolute submission and domination. But this move seems only to have made training in critique more rather than less frustrating, if Tobin's views are any evidence.

As Norman Rabkin recounted the "distortions, deletions, and embellishments" of the Olivier *Henry V* film in order to attend both to Shakespeare's text and to a quality of interpretation (285), I want to use Branagh's film to consider political aspects of both the play as well as current "political" criticism, especially regarding the ideology of the image and the idea of complexity. In doing so, I hope to begin to suggest a way to counter an impasse rapidly reproducing that experienced by New Criticism. The latter, it might be said, after losing the historical punch of its moment, ground down into routinized readings invariably ending in tepid gestures commending the "complexity" of the text observed. But whereas New Criticism mastered the text as an ironic complexity of thematic paradox, political criticism has evolved into mastering the text as a neo-ironic and postmodern blank complexity constituting ideological paradox. Thus we read again and again of mixes of subversion and containment, domination and resistance, the utopian and the ideological, and so on.[2]

These inevitable readings begin to lack bite, at least in US academic contexts. Indeed, the old word "irony" might be used as a substitute for the new word "anxiety" used in many of these readings, with no loss of either interpretive or political force. A few tentative shifts may therefore be in order.

MUD

As an entry into the film's "politics," I begin with a striking visual feature within it, one largely unsupported by the text (but what is support?): the general prevalence of *dirt*. A traditional signifier of ambiguity itself, dirt also provides an ideological significance by which one can explore the sources and dynamics of cultural and political energies in this entertaining, powerful, and emotionally savvy film.[3]

Throughout the performance tradition of the play, one finds again and again a variety of means of whitewashing the war and the character of the king, but an innovation in this production is Branagh's accomplishing whitewashing chiefly by means of mud. The presence of dirt in the film – its overwhelming use on the battlefield, on the troops, and on the King himself – is certainly overdetermined. For one thing, it constitutes a traditional theatrical and filmic gesture towards historicity, or at least verisimilitude, often more than in the original playtexts (Saccio 1988: 208). We happen to know that the heavy rains and muddy fields were indeed key factors in the English victory over the armor-laden French. The battle's outcome was thus written primarily in terms of movement rather than strength – a point to which I will return later – particularly considering the huge outnumbering of the British by the French troops. Itself a de-illusioning move, the director's manipulation of mud, like that of King Henry himself, combines the tactile and the tactical. Branagh has observed how incredibly filthy the actual battle was, as if to disillusion any film-derived fantasies about the antisepsis of war. Such a disillusionment might have productive force had it been brought into conjunction, say, with the US media and military imagery of "surgical" strikes and maneuvers in the Gulf War. Such a war demonstrates that even media visuals are increasingly conducted under the sign of the bureaucratic rationalization of war. I will return to the important concept of the theatricalization of war at the end of this essay.

The mud of the film, included not for historical "realism" alone, also serves intertextual and cultural uses. For one thing, the dirt of this visually dark movie is a deliberate counter to the cleaner and brighter visuals of Olivier's film of the play. Accordingly, Branagh's film begins in darkness, with stage lights gradually illuminating the behind the scenes set of modern film production, as if in an avante-garde "exposing" of the film apparatus, ho ho.[4] Branagh both bows to and competes with Olivier's exposure of the Elizabethan theatrical apparatus that opens his production, making Olivier's gesture appear somewhat naive in retrospect, and yet Branagh's gesture of competitive "realism" in no way disturbs the main story. The memory scenes of Hal with Falstaff (drawn from Parts 1 and 2 of Shakespeare's play) are also played more darkly, although not, I believe, to cast as much doubt upon the character of the king as that same memory of the rejection serves in Shakespeare's version.

In addition, mud becomes a sliding signifier whose referent shifts from Agincourt specifically, to early modern combat generally (that's what war was like back then), to war universally and transhistorically (as hell), gathering moral and ideological associations as it goes along. Briefly put, the result of this move is a new form of whitewashing: the film implies that if war has a necessary dark or muddy side, the character of King Henry is thereby exonerated; if the king has his own dark side, on the other hand, the character of war itself is exonerated. We arrive, then, at a knotted ambiguity in which one implied critique or political interrogation is paired up with a different one, a pairing which effectively cancels out both of them. The emphasis on and the use of mud in the film, I believe,

functions more strongly than do the elements of Shakespeare's text themselves to accomplish such a neutralization. It may be – and I will begin to stress the point for theoretical purposes – that the ambivalence of this film is of a different political character than the ambivalence in Shakespeare.

Both films, as it happens, produce certain ambiguous responses, but this should not surprise us, since "ambiguous" Henry V representations are all we have. A brief summary of Henry "sequels" – and all we have of historical representation here are sequels – reminds us of the variety of historically specific ways by which his charisma, along with its interrogation, has been produced, specifically through apparatuses of ambiguity.

Since what is available to us of the original king's character is only a historical representation, it may not be too austerely Foucauldian to begin the count not with the "real" king but with his achieved persona. The first Henry V, then, constituted a figure drawing cultural energies from religion as well as from the burgeoning commerce of the late Middle Ages, thereby mixing piety with ruthlessness to his opponents, and appropriating the King Arthur legends in a typical mode of medieval self-fashioning (Kinsford 1926). The complexity of the image is the direct producer of charisma, in turn producing the primary means of actual political domination. One of the main pieces of evidence for the ruthless side of the persona, of course, has become the subject of continued historical questioning, namely, the king's ordering of the killing of the prisoners of war during the Battle of Agincourt. Whether the actual king did or did not kill the French prisoners, however, was only known to Shakespeare through the second Henry V, the Henry of the Elizabethan predecessors of the play. In the chronicle sources the killing, when present, is not justified as an emotional act of retaliation, as we might expect, but as a calculated move necessary for the far outnumbered English. In one of the sources, moreover, the wholly unironic popular drama *The Famous Victories of Henry V*, there is no killing at all.

As a frequent object of scrutiny among historicist and materialist critics, Shakespeare's version of the king in *Henry V* is typically a site of contestation for the political ideas. That is, whether play, author, or audience are to be critical, approving, or ambivalent about the king, is still under debate. I wish to disturb somewhat the terms of this debate rather than to enter it directly. Of course, the play includes representation of the very issue in the figure of the Welsh captain Fluellen, who complains that the killing of prisoners is expressly against the law of war, and who even finds reason to criticize his sovereign's character through a reference to Henry's having killed the old fat knight's heart. But the complexity in Shakespeare might be assigned a different valence from that of his sources. Here I refer to Shakespeare's drawing from the popular rival to Elizabeth in the figure of the Earl of Essex, notoriously alluded to in the compliment of the Prologue. The fourth Henry of Olivier's famous film drew its monarch's specific charisma, however, from the British nationalism at the end of World War II, in a production that was explicitly dedicated to the British commandos and troops of the airborne divisions. But it drew as well from the charisma of the

director-star, whose substantial reputation in both British and American films was intended to overcome the risk of producing yet another financially questionable Shakespeare film. Here, it would seem that the circumstances of performance do not particularly fuel complexity in the production of a charisma. If there is complexity at all, it is one that takes on a market character and use-value, as British patriotism must be employed for the sake of an American market. A close-reading of the film along these lines might explore the film for faultlines in its marketing and appeal.

Finally, the fifth Henry V of Kenneth Branagh, while repeating some of the gestures of its predecessors, manufactures another charisma more appropriate than ever to the society of spectacle under US and international capitalism. Charisma is a phenomenon that Weber in his study of it recognized to be subject to historically determined variants.[5] Notwithstanding some theoretical resistance to "characterological criticism," in this case another look at the character of King Henry is in order. It is in his character, then, that we may encounter the play's debate about war as refracted through a residual rather than an actively dominant political issue, namely through the sixties anti-war movement in the US and abroad, a time significant in introducing the Clint Eastwood mystique.[6] Although some early reviewers and Shakespeareans took the film to be specifically anti-war, it might be argued that in this area is one of its particular complexities, by which Branagh maintains a stance that both reminds us of that progressive movement (like the memory of Falstaff as represented in the film – also a patronizing recollection of pathetic fun and games), but distances itself from any possible political investment in it.

Neither anti- nor pro-war, therefore, the film studiously maintains what I will preliminarily term a conservative rather than a critical ambivalence, progressive merely in the weakest sense of its openness toward some undecidability, but undecidability here really an alibi for a tactical indecision. What is ambiguous is not produced as a risk, however, as it might have been in the cases interpreted by Annabel Patterson (1989) and Steven Mullaney (1988) for some ambiguities of Renaissance theatrical representation. Although the market component of Shakespeare's version is by no means to be discounted, and heightening attention to the early modern market will no doubt increasingly bear this out for the play (see Agnew 1986; Bruster 1992), the Branagh complexity follows more directly from the consumerist principle that the customer, hawk or dove, is ultimately the rightful sovereign. The customer is always divine, and right. One reason that, despite its determination by the market, the same was not true for Shakespeare's theater is that the monarch, while perhaps somewhat analogous to a consumer by virtue of her patronage, is nevertheless not one. Her sphere is not symmetrical to the niche marketing of box office take, as just another potential ticket.

I do not want to insist overmuch on the specific interpretations here. I rather want to suggest that the different historical contexts, requiring more sustained unpacking in either case, might distinguish both the *kinds* of ambivalence

involved as well as the progressive or reactionary political forces the different versions make available or afford. If this is so, a typology of complexities might be possible.

AMERICAN CLEAN

An unpacking of Branagh's specific ambiguity requires that his king's charisma be understood in another intertextuality, in addition to or apart from Branagh's role as Olivier's epigone. A much darker Henry than Olivier's, then, is constructed by drawing heavily from American gangster and western films,[7] in another reason for all the dirt. Of these films, Clint Eastwood's *ouvre*, especially *Dirty Harry* (1971), stands out as a special impetus for the ambiguities of Branagh. The influence is brought into relief by important new studies of Eastwood: Michael Rogin's recent analysis of the film's importance to American foreign policy, political consensus, and collective US political amnesia; and Paul Smith's study of Eastwood as a "cultural production" perfectly embodying the values and ideology of Hollywood (1993).

The choice of this subtext is closer to the mode of Shakespeare's rather than Olivier's version, in fact, since Essex provided for Shakespeare a quasi-outlaw figure, shortly afterward executed for his attempted overthrow of the queen. For current US political sensibilities as the ground of this charisma, however, we might note the extent of our era's fascination with thugism, everywhere evident in political rhetoric. This has been especially evident in foreign relations: we recall Reagan telling Khadafy that he can "run but he can't hide," or other lethal language not all that anxiously lifted from the gangster and western registers.[8] We increasingly use a bullying rhetoric in handling actual or pretended bullies abroad.

Branagh seems to have developed over time his characterization of Henry, for his film king merely extends what he had earlier portrayed in an RSC version of the play, when the king became a distinctly Eastwood variant – a loner who is holy and just ("a genuinely holy man") but at the same time capable of ruthless enormity. Portrayed unsentimentally in the paradox of his personality, such a character furnishes the ambiguity generally employed as a prop in most wars, for kingship or for leadership. It is a paradox evident in editing: a tear appearing on the king's cheek during the hanging of his former friend Bardolph has mysteriously disappeared when the camera cuts back to the king after the legs finish twitching. Like mud, it is wipeable, but like ideology and screen of the society of spectacle, it is something we don't usually watch wiped. As if speeding up to jump over the slog of contradiction – sorry/not sorry – the camera's movement enforces the ideology of the visual image.

I have used dirt and mud interchangeably up to this point, drawing on the single concept analyzed by Mary Douglas in her important work on cultural taboos, *Purity and Danger* (1966). Douglas famously defines dirt as "matter out

of place," that is, as a category error or violation of boundaries set up for cultural uses, one that thereby produces certain anxieties. But Douglas does not recognize the extent to which the concept itself can become dirtied in the ideological inversions of signification. Indeed, by "whitewashing" dirt, as it were, Branagh has provided the exception to her analysis, as if cleanliness were capable of being defined as itself an unnatural state, disturbing the more normative category of dirt. Nevertheless, the material difference between dirt and mud might still provide a gradation of viscosities, with mud's resulting significance as itself a second-order category error or mediation between dirt and liquid, or morally between dirt and its other – *slime*. To the extent that mud is privileged, slime becomes, as it were, dirty dirt, and the film fulfills this structural slot yet again in a gangster way, providing dirty rats to oppose to any who seem to be clean ones. Of course, Shakespeare provides his own traitor lords whose treasons are uncovered at the beginning of the play, but Branagh allows them not only to be tricked and then executed, but also to be roughed up as well by Henry's men, as they protect him from what momentarily looks like a physical threat just after the conspiracy of Cambridge, Scroop, and Grey is discovered. Watching this pre-emptive violence in a scene evoking the suspense of the mafia dons' meeting, the king clearly expresses his rage and contempt for their sort, but risks moral complicity as a *noir* monarch. When confronted with slime, so it would seem, one's moral rage licenses subordinates to do the dirtier work – an emblem of the US foreign policy from which this register of dirt is drawn.

In battle, too, much of the film's action suggests the movie violence of the gang fight or the western brawl. By this Eastwood device Branagh captures a volatile atmosphere of a potential for instant escalation, the representation of a kind of violence often absent from war films generally, and therefore potentially more progressive in its ambiguity. The Duke of York, for instance, is ignobly dragged down by five or six French soldiers. The killing of the boys at the end of the battle, producing scenes milked for greatest human sentiment, again provides an Eastwood feel of surprise violence. Thus, Henry's rage at the end of the battle, punctuated with the textually displaced line about not being angry in France until that very moment, results in his pulling the French herald down from his horse to start to beat him up. His noble thuggery is restrained only by the interruption of the announcement of the English victory, which appears to bring Henry back to his senses. Losing control is, however, chiefly a charisma-enhancing authentication of possessing the requisite moral force and masculinity paradoxically to control violence. It is an orchestrated spontaneity, of course, not brought into conjunction by Branagh, however, with the available parallel in Henry's controversial speech threatening the town of Harfleur. There he calculatingly disclaims responsibility for the savagery that his angry soldiers, out of his control, will do to Harfleur's greybeards, infants, and virgins should they not surrender to him. An American ambiguity is used to prevent or protect recognition of a deeper ambiguity about ruthlessness, an ambiguity more available in Shakespeare's version.

51

Branagh's overall take on dirt and violence seem typically directed to create and enhance the feel of a huge power continually being held in check, a representation of individual emotions barely under leash during the most unthinkable provocations – the opposite of the military situation of the play insofar as the English in it are the vastly outnumbered underdogs. By transhistorical coincidence, the same atmosphere and poetics of outrage are the result of the convergence of several artistic and political contexts: the scenarios of outrage and escalation stocking the Elizabethan revenge tradition in which Shakespeare got his career going; a decade of Rambo and other US revenge films, producing the classic line adopted by Reagan and others: "Go ahead. Make my day"; US self-representation justifying intervention against Third World "provocation" in the eighties; and British nostalgic identification with and support for this feeling. Raymond Williams's notion of a "structure of feelings" (Williams 1977: ch. 9), which might be useful for predicting and describing the ambivalent feelings of spectators, is somewhat less apt here, since this mixture is one of a dominant US imperialism but a largely residual British imperialism.

In constructing the mixed feelings described earlier, Branagh inevitably relies on the assumption that moral and political mud are primarily to be characterized as emotions rather than as social relations. This helps to explain an odd disjunction in Branagh's plotting: he motivates the killing of the prisoners (the French attack on the luggage and boys) but does not follow through by having Henry kill them, as he does in the text.[9] This nevertheless marks the political unconscious of the film: actual ruthlessness is generally only *in potentia* (as in the Harfleur speech) or in the past (more or less the case with his treatment of Falstaff) – rather than in the present. As such, it is perceiveable more as a paradox of *character* than a contradiction in and marker of political action.

All the unwieldy Shakespearean textual matter that does not wash off is systematically omitted: Henry's use of the former friendships with Falstaff and others to make his reform look better; the substitution of Fluellen to engage in the duel he takes on; the French king's joking comparison of Katherine to the raped French cities (5.2.308);[10] and the locker-room jokes about her sexuality. The latter concludes the scene between Henry and Katherine that Branagh sentimentally reads as an actual falling in love, thus adding to the paradox of tough character, rather than treating the wooing itself as an exercise of power, politics by other means through the ruthlessness of charm. Also omitted is the king's business proposition to "compound a boy" with Katherine (5.2.202), a notion in which Alan Sinfield sees an example of an anxious ideological faultline regarding fear of miscegenation and nation-mixing, yet another example, as it were, of dirt. Here, however, I believe that Branagh is more in line with a neutralizing ambivalence of Shakespeare's, for I see less evidence of the "anxiety" in text or character that Sinfield, in accord with the majority of materialist, feminist, and new historicist approaches, identifies.[11] On the contrary, it seems that Shakespeare reveals how frictionlessly both the military and the emotional can be subsumed within the social intercourse of international trade. It may be

that neither "anxiety" nor any other particular affect need necessarily be linked to the identification of an ambivalence or contradiction. There are complexities and there are complexities.

Branagh's neutralization of the questionable dealings of the king by way of the implied apology for mud is not merely contemporary, for a similar ideological move was made by an Elizabethan lawyer who in 1599 wrote a defense of the prisoner-killing on the grounds that in "the miseries of war are all extremities justified" (Bullough 1962: 365). To counter these evil necessities and to produce a neutralizing ambivalence requires a displacement of all calculating character traits. Thus, it is not surprising that Branagh portrays all the key actions of Henry as being spontaneous: spontaneous tears, spontaneous beatings, and even spontaneous religious feelings. The realm of spontaneity is designed to contrast with the realm of politics, as we see from the church leaders of the play, who are not comical as in Olivier's version but merely cynical, apparently tainted, as are the other non-youthful figures in the film, by their years. Unlike the Shakespearean text, the film represents a true piety blind to class, by linking Henry to his men in a common religious feeling. Before battle, then, we see them all cross themselves humbly and sincerely, later spontaneously raising their voices in the "*Non nobis*" chorus as they trudge through the muddy, corpse-strewn battlefield, the king with a dead boy in his arms.[12] If mud de-idealizes war, it can just as soon be used in a re-idealization. Manliness, we are invited to admit, occasionally allows some tears, as Fluellen is shown to have trouble holding them in at the death of the boys. But the emotional rules for mixing feelings and separating private feelings from the political are again those of the American film tough guy, in this case recalling John Wayne's canny acting instructions that the hero, if audiences are to get choked up in empathy with him, can weep for the death of his horse but never for the death of his wife, or in this case, his boy.

In a minor character of the film, the Duke of Burgundy, Branagh furnishes the key structural negation of mud, through the suspect cleanliness noted earlier. Crucially the least muddy character of the film, Burgundy's appearance provides a visual shock when, after the scenes of the ravages of war, we encounter this pink-cheeked, chubby political minister, like the shock that Shakespeare has Hotspur feel upon encountering a perfumed, foppish lord on his battlefield. Pink, as it is in Kubrick's anti-war film *Full Metal Jacket*, becomes the primary counterhegemonic and queer signifier on the masculine battlefield, though in this case the color is implicitly stigmatized in context, whereas in Kubrick it is continually disruptive or threatening. Of course, Henry's men and Henry himself are cleaned up at this point too, but the point is that this wild bunch is made to look comically uncomfortable, no longer in their proper element as they sit at the negotiating table with the king.[13] The standpoint is again Eastwood, in a stock Western attitude toward politicians and all Easterners, buckaroos among the slick, but the adjustments that must be made with the text are new, revealing more contemporaneousness slipping in despite Branagh's

efforts to evade the topical. Thus, Burgundy is seated between Henry and the French king, staging a literal position of ambivalence, as an emblem of dovish compromise in a non-player from outside the arena. A virtual British Liberal, Burgundy delivers what is transformed into a 1960s anti-war speech, deeply undercut when his remarks about French youth turning to "savages" by war are punctuated by disagreeing looks from Henry's men. Branagh introduces another distinction that further negates the possibility of national autocritique and undermines Burgundy: the French are not parodied, as in Olivier's version, but instead are identified as a military class of youthful heroes who contrast with the elderly politicians of both countries. The new nation is a nation of young, presumably the future transnational market of a New World Shakespeare. What constitutes a nation henceforth is not subject to any disturbing critique, but rather to a comforting vision of an apolitical international youth, Shakespeare having been suitably Bennetonized, as in the 1990s he would be MTVized in *Romeo and Juliet.*

The opposition to a suspect cleanliness is furthered by radically shortening Burgundy's speech on the decay of the garden of France, whereas Olivier assents to his war-weary audience's feelings by means of panoramic vistas of nature that prolong the speech. Movement through the speech, then, if especially fast or slow, signals the ideological work of the director. The love of peace, more calculating and self-interested in Branagh's version were it not for the grim battle scenes, is valued but qualified as less than manly by Olivier, who gives Burgundy an effeminate cast. In neither film, then, is Burgundy as much disturbingly one of the guys as he is in Shakespeare's text, where the wooing scene concludes with Burgundy's difficult-to-recuperate coarse banter about Katherine's sexuality, omitted by both directors. In Branagh's film another telling moment is Henry's retort after the garden speech. While his line, saying that such a poetically envisioned peace "must be bought," lends curtness and insensitivity to his character, Branagh refigures it as merely a "pragmatic" concern, bringing the liberal down to earth, and, as it were, hence beyond dispute. With the lightest of lite ironies, the film shows Henry's men nodding in agreement with this demonstrated common sense. Politics are once again subsumed into charisma.

These examples of the dynamics of Branagh's film could be summed up as an importation of the American mud of Dirty Harry into the British text and film. But what specifically constitutes the importation and the ambiguity as American, since violence and revenge and war are not specifically so? It is here that the specific nature of the ambiguity might be understood in a way that could draw distinctions between ambiguities with more or less political force. Paul Smith describes the political critique of institutions found in Eastwood's *Dirty Harry* to subscribe primarily to an ideology of *vigilantism*, a "social phenomenon indigenous to America, having little prehistory in Britain" (Smith 1993: 92), as many commentators have observed. The ambivalence about this extends to the artistic production itself, as Smith notes that Eastwood himself approved of the politics of Harry, whereas the very director of the film, Don

Siegel, did not (90) – a configuration thus working against coffee talk or criticism that would seek to rate the overall politics of the film. The historical circumstances in which Branagh is operating, then, point in two directions with respect to the ambiguity he is selling to two markets: one with potential political force for an American audience (were it not for the fact that the novelty level of vigilantism would be radically diminished since the sixties and seventies), the other one neutralized and inapplicable for a British audience.

Of course, such neutralizations are themselves a common strategy of US political and media culture, by which true interrogations and critical perspectives are omitted, marginalized, stigmatized, pathologized, or feminized. Thus diluted, any ambiguity resides comfortably, without anxiety, in a society of spectacle where, as Guy Debord has observed, "that which appears is good and that which is good appears" (Debord 1983: sec. I, par. 12).

Here we might make note of class concerns, a sphere marked again in the film by the visuals of dirt. Although Branagh may be argued to display some degree of sympathy given his working-class Belfast background (Donaldson 1991: 68), it is tempered by the sensibility of one who has an interest in seeing his own success as attributable to talent and determination. The world of Bardolph, Pistol and others in Branagh's Shakespeare appear to be dismissed as a group of losers and quitters in the realm of opportunity this Henry enters and even embodies, the realm of the superdirector and king. The type of humor Branagh permits them, moreover, signals that he wants the audience to share Henry's patrician condescension in his nostalgic rejection of his personal past as a renegade youth: the humor (humor being somewhat of a problem for Branagh in the best of circumstances) is characteristically circumscribed – no longer the humor that Shakespeare makes available as parodic and oppositional, like the bravado of Pistol in the text, but instead surprisingly bitter and defeated, as Pistol is in his final address in the film.

The lower-class counterworld is prevented by Branagh from being taken as part of the *present* ambiguity of the king, unlike Shakespeare's version in which Henry's rejection of Falstaff is variously tested, or even interrogated accidentally in the wordplay of Fluellen's Welsh pronunciation comparing the king to "Alexander the Pig" (4.7.13). Moreover, potentially non-genial humor in the text, such as enforced leek-eating, is suppressed. And in the striking scene of Henry disguised among his troops at night, the Branagh version merely maintains a sympathetic reading of Henry, although reenacting the increasingly acrimonious debate with the soldiers who question the justification of the war while not knowing that they are speaking to the king himself. The lower classes serve to explain and justify, not to interrogate, domination. Of course, it might be objected that Shakespeare's version accomplishes the same, but I would suggest that the conditions of its performance would render the class politics less self-cancelling, since what would have probably been much more striking to his audience (as perhaps the first representation of this on the stage) would have been the very staging of the debate and interrogation with the king – regardless

of exactly what was said in the debate or how it turned out. And, even granting their ignorance of his identity, the stage still represents an acrimonious debate between social classes, since the soldiers take him to be a lord. If this is the political force of the representation, it is worth noting that it is one about which the cultural critic can have little to say in addition, perhaps preferring, for professional reasons and publication-driven interpretation, the more textually rich cases where complexity can be unpacked in article-length fashion. At all events, in sorting out the political force of a variety of ambiguities, I hope to avoid the ready tendency to treat Shakespeare as the orginary source of a timeless politics, a tendency that would recreate what has been critiqued as a "testamentary" quality issuing from Shakespeare's era, the right of a will to extend patriarchal power indefinitely (Wilson 1993).

Branagh's attempts at neutralizing and avoiding the political are, of course, just another kind of politics, but they do not succeed on their own terms. In his earlier production of a 1984 RSC *Henry*, moreover, director Adrian Noble explicitly warded off attempts to interpret the play in a specifically British military context, namely the invasion of the Falkland Islands – in order to keep the play from being appropriated jingoistically. His ideal, an almost impermissably political innocence, was to free the interpretation for the actors to do it "as honestly as we possibly could," thus occluding his own identification with king and politician. As Branagh writes, "It was a relief to me that we would not be burdened by the 'Post Falklands' tag that some of the press had already given the production. Our feelings about that conflict would inevitably inform our thoughts on the play but not to the point where the effect was reductive to the work" (Branagh 1988: 98). In other words, we must remain committed to complexity, an allegiance to which we presumbably share with the Master playwright himself. But in contrast to the similarly glorifying Olivier film, Branagh's film achieves its own version of a glorifying charisma in a manner appropriate to capitalism's multinational corporate stage – by suppressing rather than by exploiting (as did Shakespeare and Olivier) topical application, and by appropriating whatever ideology, such as vigilantism, that possesses transnational market value under the sign of Eastwood.

One needs no especially Marxist insight to note the link between Branagh's ambivalently dirty Henry and the thuggish world of corporate capitalism, for the link has been anticipated by the filmmakers themselves. In a promotional video they draw their hype from the character of the king himself, describing how Branagh thinks in a "straightforward, bold, simple, and courageous way." The director's charisma is as spontaneous as Henry's. Even more tellingly and directly, they connect the benign ambivalences of the play with those of the market itself, amusingly noting that "breaking necks is comparatively easy to breaking box office receipts in the international cinema" ("Henry V"). Thus, a Shakespeare film becomes fully equated with the English nation as an underdog competitor.

They might have gone further to note similarities between king and director, since one of the circumstances of the film's production was an actual underdog

experience. In competition with American films for support, Branagh went virtually broke halfway through the production, so that it had to be completed by gaining real financial territory against enormous odds. An investment broker who stepped in for the rescue is also interviewed, and he comments on how difficult it is for a first-time director like Branagh to get money, although he adds that it certainly helps if the film is a *Shakespeare* film. Shakespeare, apparently, is not merely, metaphorically "cultural capital" (Bourdieu 120), but literal capital as well. And it takes no sophisticated anti-canonical theory to recognize that such a value is never absolute but relative to its market, for on the one hand, the sign of Shakespeare helped to fund production presumably among such elite investors, but on the other it was viewed as hindering consumption, the name "Shakespeare" having been entirely omitted from promotional advertisements for the film. Thus disguised, Branagh's film is a little touch of Shakespeare in the night, concealing its class and status to gain advantages over some presumably well-defined but indispensible target market from which it might build allegiance, presumably "gentling their [the audience's] condition."

WAR

I want to expand what I have suggested intermittently in the preceeding discussion of the film, namely, that a needed project for cultural studies generally and Shakespearean political criticism particularly, barely begun here, is to explore and even to typologize the particular structure of feelings, historical and social formations that drive the production of different kinds of complexity at the political level of representation. With a view toward de-routinizing political criticism, typologizing would reveal varying sorts of political forces, whether the ambiguities are those of the author as in the conservative "esoteric" reading model of Leo Strauss (1952), those of resistant "voices" of the play in the liberal model of Annabel Patterson (1989), or those of the historical structures and residues of censorship in the poststructuralist model of Richard Burt (1993). The purpose of these suggestions is not intended, however, to create a nostalgic point of origin in Shakespeare for a progressive politics, an original political intention lost in transmission in a process like that of textual variation for editorial models more discredited now.

I think the case can be made more locally with regard to certain ambiguities. I would suggest, for instance, that in the case of Shakespeare's identification of Henry with Essex, the ambiguity is decidedly unstable. The reason is that the identification, albeit with the monarch, is in a context of threat to the contemporary monarch Elizabeth – the parallels not working out on a one-to-one basis. That ambiguity, while not exactly "progressive," nevertheless maintains more political force than those I have discussed in Branagh's version, which is more risk-free though just as much indebted to its own historical moment and its own form of the market. But there are markets and there are markets. Whether

Shakespeare's play was just as much indebted to market forces as is Branagh's remains to be investigated.

In fact, Branagh's film is more in keeping with the kind of ambivalence previously portrayed by Shakespeareans such as Rossiter and Rabkin. For Rossiter, Shakespeare shows an "essential ambivalence" in his historical vision, transcendently dissatisfied with the black-and-white political moralisms of his time because of his wider view of humanity generally (Rossiter 1961: 51). For Rabkin, the play's ambiguity teaches us about our deepest "hopes and fears" concerning the world of political action, and, more privately and pessimistically, that society will "never" be able to solve the problems we hope that it could (Rabkin 1977: 296). In each case, the human and the private are opposed to the political and the social, and the neutralizations are produced according to this juxtaposition. A political criticism focusing largely on ambivalences, however termed, is in danger of failing to distinguish among contradictions; without any means of doing so one is condemned to repeat in ever more elegant forms the model of Rabkin's analogy: the famous *gestalt* drawing of a duck that, with a slight shift of perspective, turns into a rabbit. In the contemporary version, domination is the duck, resistance the rabbit.

The allusion of the title of this essay to the more formalist and apolitical criticism of William Empson in his *Seven Types of Ambiguity* turns out to be less ironic than I had originally intended. A formalist critique of political criticism might recommend a project to distinguish or even taxonomize varieties of political or ideological ambivalence. It would be a project with political significance as well, however, for it might sometimes be helpful in assigning, as I have occasionally done in this essay, the degree of political force or lack of it to an individual work, although such a determination, fully contextualized, may not turn out to have any one-to-one relationship to the degree that that force is "progressive." What may be sacrificed in the process of distinguishing types is any single, totalizing model for ambivalence, such as Rabkin's spatial view of complementary themes or Greenblatt's narrative view of subversion always followed by containment. Losing their theoretical status, although not necessarily their political value, these models nevertheless retain value not as paradigms but as possible forms of ambivalence, that is, merely as different but important ways that things can and do happen.

Although I can at best only sketch such a project here, it is worth noting that Empson's formal system is itself suggestive. Terry Eagleton begins his introduction to literary theory by separating out Empson as a maverick from the New Critics he often opposed, contrasting their ironies and paradoxes, which suggest fusion and absence of threat to coherence, with Empson's ambiguities, which can never finally be pinned down. His view of ambiguity, according to Eagleton, allies him with later reader-response criticism in finding meaning not just in the work but in the context of social discourse, with every verbal nuance giving room for "alternative reactions to the same piece of language" (Eagleton 1983: 52). The emphasis, then, should be on the production of alternative meaning,

not on self-cancellation of opposing meaning. That an ambiguity or complexity might provide something residual or unmanageable for ideology, moreover, might be implicit in the very form of the taxonomy he employed, since it ranged from the one extreme of fully logical, intended meanings to disordered and illogical ones – full contradiction – at the other extreme (Empson 1930: 48). From the present discussion, one could find a fully resolvable contradiction, for example, in an expectation that any prince must be both pious and ruthless, or an unresolved one in forcing the reader to question, along with the simple Fluellen, whether ruthlessness is something supplementary, the social a flaw of the personal. The possibilities of kinds of ambiguities, as reflected in the preceding discussion, might proliferate: the possibility of ambiguity accompanied or unaccompanied by "anxiety"; the possibility of ambiguity in the play to be resolved by the audience; the possibility of ambiguity resolved for one part of the audience but not for another part; the possibility of authorial confusion or division. How to keep the proliferation from *aporia* would be the task of a responsible, affirmative cultural critique.

One might even claim that a chief assumption of any totalizing model of political complexity is that Shakespeare's representation of King Henry ratifies the basis of our institution of political critique, confirming that our basic work is to refine the critique of those *ideas*. It is always ideas at the heart of the critical activity. The uncovering of necessary complexities may in itself have the effect of turning the procedure into an algorithm of defeat, by which positive ideas are overwhelmed or undermined by the negative ones in the work's production or reception. The question that seems to underlie the work of the ideological critic in such cases, moreover, is whether Shakespeare (Branagh, or whoever) himself qualifies as an ideological critic, with complexity usually brought forth to demonstrate what is in fact methodologically predetermined – that he does not, that the ideas don't work. Again, it's always ideas. I think this structural situation helps account for the frustration that initiated this essay in the role of critic as gatekeeper for representations conveying positive *ideas*, returning us to the despair of the would-be cultural critic.

It may be, therefore, that a scenario of defeat is partly determined by an analogy or rather misanalogy between the job of the critic of ideas and the job of the writer or director. At times in the present essay I have tried to imply an alternative understanding, although it is an understanding difficult even to hint at, much less articulate. The source for this alternative is Lyotard's discussion of cinema, in which he claims that directing, rather than being a reflection of politics (as it is customarily treated in film analysis) constitutes political rule itself, or the art of politics par excellence. We might think particularly of its practices of excluding and including, of framing, and, overall, of "writing movement" (Lyotard 1989: 176). Directing doesn't, as most analysis and even the present essay at times assume, "reveal" politics. It is politics.

If filmwork is more like statecraft than it is like critique, the "complexities" of positive and negative "elements" of the work are less likely to be amenable to

the usual sorts of calculations designed to add up their cumulative significance, casting doubt on some of my own attempts at determining political force by taxonomizing complexity. The possibility of an entirely different, bifurcated reponse of audiences, as in the case of the British vs. American reception of Branagh's imported vigilantism, is one example in which the film's implicit rating as "progressive" or not would be rendered not simply tricky but methodologically incoherent. On the other hand, the "larger political function" of a film, in Tobin's phrase, might not be a function of what is usually regarded as the dominant placement of elements. To take a different Shakespearean example, the controversial submission of Kate at the end of *The Taming of the Shrew*, repeatedly the object of political and ideological investigation, may have much less ultimate force than the preceding representation of her refusal to be the conventional mistress or wife at the beginning. It is the habit, difficult to jettison even if the assumptions of New Criticism are no longer current, of treating the work as a discrete text containing ideas, rather than as a collection of written movements in a complicated and widespread campaign, which privileges the ending of the play, the textual parts of a work played on stage, and so on. In different terms it might be asserted that an aspect of a work might be "structural" in the sense of relational but not "structuralist" in the sense that any textual moment examined will serve as a diagnostic slice of the ideological tissue sample. Ideological critique, especially critique of the image and its power, will have to take account of this.

The quantification of complexity in a work is also rendered problematic when attention is paid only to the work itself. One might consider the example of the liberal anti-racist film *Guess Who's Coming to Dinner*, discussed at a recent seminar on the "Ideology of the Visual Image."[14] Here the discussion proceeded much on the lines of the "selling-out" model of analysis outlined by Tobin, with interpreters reading the famous interracial kiss of the film as qualified or compromised by all of the film's mechanisms of mediation. In such a predictable reading, the film's liberal audience is protected from self-critique and political change by the casting of the acceptable Sidney Poitier as the white woman's fiancé, and the writing of his character as the ideal match, a cultivated professional man, for the daughter of anxious parents Tracy and Hepburn. In the ensuing discussion of the film, however, it became clear that the usual critical approach of de-illusioning the illusion was helpless before the simple fact of this being the first Hollywood interracial kiss, and that the political force of that image of love might have at its historical moment far outweighed any of the recuperative strategies of the rest of the film, so cherished in the cultural critic's analysis, insofar as that analysis must demonstrate some novelty. Political force, in this case, is only understood intertextually, relationally and historically, as may have been the case of the scene with the disgruntled footsoldier Williams in Shakespeare's version of *Henry V*. No balance sheet of textual and discursive counterforces would necessarily neutralize such a strong visual representation at all. To allow for specific complexities in a broad historical and political context

rather than to keep a balance sheet of domination and resistance requires what we hardly have at all and which I only begin to suggest here: a true political theorization of *collective* representation and tradition. Such theorization is all the more needed when the focus is limited, whether by convenience or by residual critical tradition, to a single text or work.

If Lyotard equates cinema direction with political rule itself as the writing of movement, one can add to this equation the writer. If ruling, directing, and playwriting are in fact one, then Henry, Shakespeare, and Branagh, rather than incommensurable categories of an analysis, are engaged in activities which, unlike the work of the cultural critic, share a formal basis in movement. Branagh's novel intuition into this complex is to recognize war itself as the writing of movement, and that its chief ally and enemy is simultaneously mud, no mere signifier. The collectivity of ambiguities, while it must be recognized in order to make the distinctions that avoid the impoverishment of a political critique of film, is at the same time what prevents a single mode of ambiguity from determining political scenarios within or without the work. Speeding up or slowing down to a standstill are in Lyotard's terms cinema at its polar extremes of absolute mobility and absolute immobility. Speeding up or slowing down to a standstill, the camera, too, registers extremes when it runs into ideology. The warworker and filmworker, unlike the cultural critic, are occupationally involved in direct dealing with movement, or movement through dirt, a resistance to theory.

Branagh, moreover, recapitulates the experience of war as work, in the exact terms of Clausewitz' well known nineteenth-century treatise *On War*. Clausewitz saw mud metaphorically as *Friktion*, the quintessence of war, defined as what causes the additional energy and time required for the simplest or most obvious movement, the resistance that requires the greatest excesses of expenditure to accomplish even limited goals. It is what, moreover, makes war "real," rather than the fantasy of the rookie: "Friction is the only concept that more or less corresponds to the factors that distinguish real war from war on paper" (Clausewitz 1976: 119); and in Clausewitz's treatise it is a concept that the scientist of war employs to demythologize it and render it practical. Itself the figure of resistance, it is also what must always create a resistance to an abstraction or theorization of war: "Action in war is like movement in a resistant element" (120). Branagh's specifically filmic insight into mud, his explicit decision to "substitute rain and mud for the grass and sunshine of the earlier film" (Nightingale 1989: H18) thus furnishes more insight into war than either Olivier's or Shakespeare's versions made possible.

Had Branagh been a better theoretician of his own orchestration of ambiguity and of his own identification with warmaking – especially given his opening scene "exposing the apparatus" – he would have acknowledged the crucial "osmosis" that war and film have increasingly had with one another in our century, to the extent that Paul Virilio can even claim that the "theater weapon," like the demonstration message of Hiroshima, has replaced the "theater of

operations" (Virilio 1989: 7), and that perceptual arsenals have replaced actual ones, a "war of pictures and sounds . . . replacing the war of objects" (4). With Reagan's use of *Dirty Harry*, we come full circle to this crucial historical change, not merely as a society of spectacle but as what Nietzsche feared most, a theatocracy.

But if mud for Branagh's film constitutes a lamentably self-stabilizing ambiguity, is there any hopeful residual instability? I think Branagh for a moment recognizes one in a brief historical daydream of movement and mud that might escape his more thoroughgoing neutralization, and go beyond his pseudo-exposure of the film apparatus. In telling remarks on his reading of Shakespeare's play as "more complex . . . *darker* [italics added]" than Olivier's, Branagh's descriptions of the real horrors of the war contains a curious detail: "Irishmen ripping off their clothes and running into the battle naked in the filth. Terrible, unbelievable" (Nightingale 1989: H17–18). Failing to produce this in his visual spectacle, Branagh's intrigue with the image is, however, a little incoherent or incomplete. What, might one ask, were the motives of the muddy Irish? Are they, Branagh's own nation, a nation of mud-loving savages? Or are they performing as warriors, and simultaneously "performing" as savages, a typical resistant move by the dominated as licensed in the carnivalesque? That is, were they playing at savagery, in protective camouflage? One might speculate further about the historical case, but it hints at the loyalty problem played out in Shakespeare's play in the national rivalries of the troops, ultimately to be united in their fight with France. But Branagh's daydream stages a complicated political gesture enabling Irish support for the English, a gesture perhaps interwoven with resistances, an outdoing of English valor and boldness with a jab at "civilization." It sounds as if this is an ambiguity which, had Branagh been able to incorporate it into his production, would have performed a more politically forceful topicality than Dirty Harry ever could. Had it been, the contemporary identifications of the play would have been potentially skewed, with Shakespeare's French as the film's British, Shakespeare's British as the film's Irish.

But the subtext of dirt in the existing film reveals the direction of movement to neutralize opposition, omitting some of the even now potentially useful interrogations within Shakespeare's text. The techniques produce for the American-dominated market familiar structures of feeling from US film genres, not so much exclusively glorifying war as making pro-war or anti-war sentiments available to the highest bidder. And yet it is in the subliminal identification with war-making that Branagh's greatest energies are released, slogging through ideology in its manifestation as mud of the field. Individual agency is glorified in the production of an ambiguous charisma, but serving a depoliticizing point at the same time: the horror of war is acknowledged so as to redeem agency; the dark side of the king is acknowledged so as to redeem war. But if Branagh momentarily thought of himself as outside the writing of movement, outside rule, not needing the charisma of the king in order to promote himself in the international cinema, his Irishness might be allowed to stand as savage critique

of the venture capitalism from which he seeks glory and to which he becomes so indebted as to be an American *addictus*, that is, sold into slavery after irreversible debts.

If Branagh in staging the scene is himself victimized, immobilized and imprisoned in the visual complexity he markets, is our demystification of his complicity, like his demystification of war, any less of an illusion? "Must we then renounce the hope of finishing with the illusion, not only the cinematographic illusion but also the social and political illusions? Are they not really illusions then? Or is believing so the illusion?" (Lyotard 1989: 179–80).

Have I noted the instability of meaning? Can we get to work now?

NOTES

1 I am indebted to personal correspondence with Jeffrey Williams of the *Minnesota Review* for the currency of this term. For a treatment of the contradiction that unites neo-liberals and neo-conservatives, see Michael W. Apple.

2 See Greenblatt (1985), Sinfield (1992), and Jameson (1992). For other sensible claims about the complexity that a comprehensive political criticism requires for characterizing culture, see Howard and Dollimore. But the sensible model again and again works toward impasse, as in Rackin's treatment of the the histories as the impossibility of historiography, their revealed "compromised status as theatrical performances" (Rackin 1990: 72), and *Henry V* as ending the two tetralogies in "a play of unresolved contradictions" (82).

3 For Tobin's desire for a "larger political significance" I might temporarily substitute a desire for a local significance, acknowledging here, in preparation for biting the hand that feeds me, the pedagogical value of Branagh's "compromised" work for introducing my students to Shakespeare. I have seen rural students mouthing every line in advance while watching his *Much Ado*. I approve of this slavishness and think it has unrealized value for a progressive pedagogy, in specific contexts. I argue in a forthcoming essay for a tactic of making more, not less, use of the cultural capital we have.

4 See Donaldson (1991: 62), whose article treats the muddiness of the film as well, although he sees it as representing Branagh's materialism, a claim I would not fully accept. Donaldson also notes the parallel between Henry and Branagh, with the film thus affirming "the values of professional competition and success" (71). See also Fitter (1991) who compares the film unfavorably to the more critical 1984 Adrian Noble RSC stage production that starred Branagh, and who sees the film version as "an establishment cover-up" appealing to mainstream US popopular tastes (260).

5 See Weber (1968), whose opposition of charisma to rational, institutional structures is concerned with historical or epochal changes in their relationship and opposition.

6 Ambivalence needs to be distinguished by what one is ambiguous about, of course, but also at a historically salient level of abstraction. By this I mean that even though Shakespeare presses the dialogue and the action in ways that create a kind of inter-rogation about war, the conditions of the topic were much less strong than in the 1960s when hawks and doves, pro- and anti-movements, constituted war (not just the Vietnam War) as an issue in itself. If one generalizes an ambivalence into one about, say, institutional authority, the sixties, as expressed in *Dirty Harry*, would offer a politically charged arena there. "Institutional authority," as an abstraction, may have less purchase as a topic for Shakespeare's audience, whereas at a different level of abstraction, namely that of the monarchy, there would be a political charge.

A potential for the anti-monarchical (a potential to be historically realized) would thus be an element of representation with much more political force in an ambiguity. The problem with new historicist treatment of "power" and "authority" is not its inaccuracy (for the monarch had both), but that it sometimes provides an illegitimate interpretive power because its level of generalization is higher than warranted by the historical moment.

7 We might also note the tongue-in-cheek opening of Branagh's *Much Ado About Nothing*, in which the arrival of Don Pedro and his men on horseback lovingly spoofs the opening of *The Magnificent Seven*.

8 A subtextual association of dirt for American audiences would be Vietnam, the paradigmatic "dirty" war for hawks and doves alike. The raising of moral consciousness about war would be evident later in hypocritical inversions such as the title of the US invasion of Panama: "Operation Just Cause."

9 The editor of the Oxford *Henry V*, Gary Taylor, in arguing for placing the killing of the prisoners onstage, claims that no Elizabethan would have condemned the obvious military necessity and notes Bullough's citation of R. Crompton's 1599 defense of an action that "had been and would continue to be defended by theoreticians and soldiers" (Taylor 1982: 33). But the fact that it had to be defended, and that "war's miseries" are put forward as a defense, demonstrate that ideology and the historical "belief" of the time are by no means monolithic or seamless.

10 All citations to *Henry V* are from Alfred Harbage's edition of *The Complete Works* (1969). New York: Penguin. The base text for this and most editions of the play is the folio version, which contains much of the dialogue, such as the bawdy joking about Katherine, that "muddies" the war and the character of the king.

11 Sinfield writes, "the text is implicated, necessarily, in the complexities of its culture, and manifests not only the strategies of power but also the anxieties that protrude through them" (Sinfield 1992: 138).

12 This emotional sequence, another element readable as a "realistic" view of the ravages of war and therefore available for an "anti-war" spectator, may also be a gibe at the corrosive cynicism of a fellow-Briton's Vietnam War movie, Stanley Kubrick's *Full Metal Jacket*, whose conclusion portrays the trudging GIs, having just completed an atrocity, singing the Mickey Mouse Club hymn.

13 Donaldson (65) reads this as evidence that the king's reform is marked by his being cleaned up, but I do not believe the reform motif is a crucial part of Branagh's representation of the king, nor that Branagh's demystification of war is as complete or successful as Donaldson believes.

14 Seminar directed by Douglas Kellner and held at the International Association for Philosophy and Literature conference, Duquesne University, Pittsburgh, April 1993.

REFERENCES

Agnew, Jean-Christophe (1986) *Worlds Apart: Market and Theater in Anglo-American Thought 1550–1750*. New York: Cambridge University Press.

Apple, Michael W. (1995) "Cultural Capital and Official Knowledge," in *Higher Education Under Fire: Politics, Economics, and the Crisis of the Humanities*, eds Michael Bérubé and Cary Nelson. New York: Routledge.

Bourdieu, Pierre (1984) *Distinction: A Social Critique of the Judgement of Taste*. Cambridge, MA: Harvard University Press.

Branagh, Kenneth (1988) "Henry V," in *Players of Shakespeare 2: Further Essays on Shakespearean Performance by Players with the Royal Shakespeare Company*, eds Russell Jackson and Robert Smallwood. Cambridge: Cambridge University Press.

Bruster, Doug (1992) *Drama and the Market in the Age of Shakespeare.* Cambridge: Cambridge University Press.

Bullough, Geoffrey, ed. (1962) *Narrative and Dramatic Sources of Shakespeare.* New York: Columbia University Press.

Burt, Richard (1993) *Licensed by Authority: Ben Jonson and the Discourses of Censorship.* Ithaca and London: Cornell University Press.

Clausewitz, Carl von (1976) *On War,* ed. and trans. Michael Howard and Peter Paret. Princeton: Princeton University Press.

Debord, Guy (1983) *Society of the Spectacle.* Detroit: Black & Red.

Dollimore, Jonathan (1985) "Introduction: Shakespeare, Cultural Materialism, and the New Historicism," in *Political Shakespeare: New Essays in Cultural Materialism,* eds Jonathan Dollimore and Alan Sinfield. Ithaca and London: Cornell University Press, 1985.

Donaldson, Peter S. (1991) "Taking on Shakespeare: Kenneth Branagh's *Henry V,*" *Shakespeare Quarterly* 42: 60–71.

Douglas, Mary (1966) *Purity and Danger: An Analysis of Concepts of Pollution and Taboo.* New York: Praeger.

Eagleton, Terry (1983) *Literary Theory: An Introduction.* Minneapolis: University of Minnesota Press.

Empson, William (1930) *Seven Types of Ambiguity.* New York: New Directions, rpt. 1949.

Fitter, Chris (1991) "A Tale of Two Branaghs: *Henry V,* Ideology, and the Mekong Agincourt," in *Shakespeare Left and Right,* ed. Ivo Kamps. New York and London: Routledge.

Greenblatt, Stephen (1985) "Invisible Bullets: Renaissance Authority and Its Subversion, *Henry IV* and *Henry V,*" in *Political Shakespeare: New Essays in Cultural Materialism,* eds Jonathan Dollimore and Alan Sinfield. Ithaca and London: Cornell University Press.

"*Henry V.*" Promotional video viewed at Shakespeare Assoc., Philadelphia, April, 1990. Bibliographic information unavailable.

Howard, Jean (1987) "The New Historicism in Renaissance Studies," in *Renaisssance Historicism,* eds Arthur F. Kinney and Dan S. Collins. Amherst: University of Massachusetts Press.

Jameson, Fredric (1992) *Signatures of the Visible.* New York and London: Routledge.

Kinsford, C. L. (1926) "Henry V," *Encyclopaedia Britannica.* 13th edn. London: Encylopaedia Britannica Co.

Lyotard, Jean-François (1989) "Acinema," in *The Lyotard Reader,* ed. Andrew Benjamin. Oxford: Basil Blackwell.

Mullaney, Steven (1988) "Lying Like Truth: Riddle, Representation, and Treason," in *The Place of the Stage: License, Play, and Power in Renaissance England.* Chicago and London: University of Chicago Press.

Nightingale, Benedict (1989) "Henry V Returns for a Monarch for this Era," *New York Times,* Nov. 5: H17–18.

Patterson, Annabel (1984) *Censorship and Interpretation: The Conditions of Writing and Reading in Early Modern England.* Madison: University of Wisconsin Press.

—— (1989) *Shakespeare and the Popular Voice.* Oxford: Basil Blackwell.

Rabkin, Norman (1977) "Rabbits, Ducks and *Henry V,*" *Shakespeare Quarterly* 28: 279–96.

Rackin, Phyllis (1990) *Stages of History: Shakespeare's English Chronicles.* Ithaca: Cornell University Press.

Rogin, Michael (1990) "'Make My Day!': Spectacle as Amnesia in Imperial Politics," *Representations* 29: 99–123.

Rossiter, A. P. (1961) "Ambivalence – The Dialectic of the Histories," in *Angels With Horns.* New York: Theatre Arts Books.

Saccio, Peter (1988) "The Historicity of the BBC Plays," in *Shakespeare on Television: An Anthology of Essays and Reviews*, eds J. L. Bulman and H. R. Coursen. Hanover and London: University Press of New England.

Shakespeare, William (1969) *The Complete Works*, ed. Alfred Harbage. Baltimore: Penguin Books.

—— *Henry V* (1982), ed. G. Taylor. Oxford: Clarendon Press.

Sinfield, Alan (1992) *Faultlines: Cultural Materialism and the Politics of Dissident Reading*. Berkeley: University of California Press.

Smith, Paul (1993) *Clint Eastwood: A Cultural Production*. Minneapolis: University of Minnesota Press.

Strauss, Leo (1952) *Persecution and the Art of Writing*. Glencoe, Illinois: Free Press.

Taylor, Gary, ed. (1982) *Henry V*. Oxford: Oxford University Press.

Tobin, Elayne (1995) "Coffee Talk," *Mediations* 19: 67–75.

Virilio, Paul (1989) *War and Cinema: The Logistics of Perception*. London and New York: Verso. Rpt. 1992.

Weber, Max (1968). *On Charisma and Institution Building*. Chicago and London: University of Chicago Press.

Williams, Raymond (1977) *Marxism and Literature*. New York and Oxford: Oxford University Press.

Wilson, Richard (1993) *Will Power: Essays on Shakespearean Authority*. Detroit: Wayne State University Press.

4

"TOP OF THE WORLD, MA"

Richard III and cinematic convention

James N. Loehlin

The Shakespeare movies of the new wave that has followed Kenneth Branagh's successful *Henry V* – e.g. Franco Zeffirelli's *Hamlet*, Branagh's *Much Ado About Nothing*, Oliver Parker's *Othello*, Trevor Nunn's *Twelfth Night*, and Richard Loncraine's *Richard III* – have mostly been in what Jack Jorgens has termed the "realist" mode (Jorgens 1977: 7).[1] "Realist" films, in Jorgens's typology, lie between "theatrical" films that simply transfer stage performances to the screen and "filmic" versions that substantially reimagine the play in terms of the aesthetics and resources of the new medium. The Olivier and Orson Welles versions of *Othello* are representative of these two poles; Oliver Parker's new version is a typical "realist" film. Baz Luhrmann's *William Shakespeare's Romeo and Juliet*, with its kinetic visuals and awkwardly naturalistic acting, falls somewhere between the filmic and realist modes. The realist Shakespeare film is characterized by the sort of mid-range naturalistic acting, cinematography and editing that is used in most Hollywood films. The characters are represented as "real people," in plausible make-up and costumes, and the film relates the narrative straightforwardly without calling attention to the medium. Such films are not, of course, realistic, in the sense of imitating anyone's actual experience of the world, but cinematic conventions such as editing and soundtrack music are so universal that they are no longer even perceived by most viewers. The new wave of Shakespeare films, aiming for a share of the mainstream Hollywood audience, adopts Hollywood conventions, to the extent that Parker's *Othello* was marketed in Columbia Pictures print ads as an "erotic thriller" that was "as accessible as *Fatal Attraction.*" Yet while the other new Shakespeare films employ mainstream conventions in a straightforward, unselfconscious way, the Richard Loncraine *Richard III* embraces and exploits those conventions to make a striking and imaginative Shakespeare film that remains every inch a movie.

Ironically, Loncraine's *Richard III*, like the Stuart Burge/Laurence Olivier *Othello*, originated as a stage production. Richard Eyre directed Ian McKellen as *Richard III* at the Royal National Theatre in 1990, and McKellen's desire for a filmed version of the performance led to the collaboration with Loncraine, a director of television advertisements and commercial films with no background in the theatre or Shakespeare (McKellen 1996: 26–7). It is from Richard Eyre's

stage production that the film takes its single most important interpretive choice: resetting the action to 1930s Britain and presenting Richard as a fascist dictator. Yet the film exploits the historical parallel more thoroughly and tellingly than the stage production did, and McKellen's performance, which was stiff and mannered on stage, is subtler and more effective on screen. In the theatre Eyre's production was a grim, humorless history lesson, which drew theatrical excitement chiefly from Richard's ability to perform complicated tasks with his one good hand while rattling off long verse speeches in a clipped parade-ground accent. Loncraine's film, by contrast, is a witty and incisive retelling of the story that capitalizes on cinema's power as popular narrative entertainment. Loncraine exploits to the full the narrative drive of modern mass-market movies, creating an energetic, primarily visual method of story-telling. Scenes and even speeches are broken down and intercut into short, clear sequences whose impact is supported by establishing shots, music and visual paraphrases; the words serve to reinforce or complicate a visual meaning that precedes them. Loncraine's method allows him some of the interpretive flexibility that Dennis Kennedy ascribes to foreign directors working on Shakespeare in translation; the text loses preeminence through its reproduction in a new medium. In the end, Loncraine's film doesn't advance a particularly sophisticated or original reading of *Richard III*; but the sum of its parts is in this case greater than the whole. The inventive insouciance with which the film treats individual characters, scenes and images makes it a consistently engaging riff on Shakespeare's text, which it plays off against a number of other signifying systems.

The text itself is severely cut; there is almost no reference back to the events of the *Henry VI* plays, other than the fact of a civil war in which the York family has triumphed. Queen Margaret, the vengeful spirit of the house of Lancaster, is entirely eliminated, as are many of the large number of supporting characters. Those that remain, however, are in many cases expanded and developed through numerous non-Shakespearean appearances. Queen Elizabeth (Annette Bening), Lady Anne (Kristen Scott Thomas), and the young Princess Elizabeth (Kate Steavenson-Payne) – who doesn't even appear in the text – are all given added prominence and in some cases additional lines. The film's emphasis on visuals over text, together with its 1930s setting, actually allows a greater degree of characterization to various minor figures. Richard's henchmen, for instance, are carefully differentiated: Tim McInnerny's Catesby is a cold-blooded, opportunistic civil servant, Adrian Dunbar's Tyrell a sadistic young NCO, Bill Paterson's Ratcliffe Richard's doggedly loyal batman, who never realizes the full extent of his superior officer's villainy. In spite of their retaining virtually no lines, these three characters are more memorably depicted than in most stage productions.

Loncraine's method of witty visual story-telling is especially evident in the three linked sequences that begin the film. Loncraine gets nearly ten minutes into the film before using a single word of Shakespeare; by the time Richard begins his opening speech, the film has introduced not only the setting and background of the story but all the principal characters and their relationships.

Kenneth Branagh attempted much the same thing in *Much Ado About Nothing*, but his overblown pre-credits sequence of galloping horses and heaving bosoms served mainly to convey a general (and somewhat deceptive) sense of the lusty, busty romp he was presenting the film to be. Loncraine's opening, by contrast, is dense, economical and multi-layered. The first sequence, before the credits, shows the headquarters of Henry VI and Prince Edward during the civil war. Henry is merely shown as old, pious, and weary, but Edward (Christopher Bowen) is given a succinct modern characterization as one of the young Eton-bred officers who perished at the Somme. He is almost a caricature of naive Edwardian Englishness: clean-cut and open-faced, his uniform neatly pressed, he eats his dinner with a photograph of his wife on the table and a loyal dog at his feet. Suddenly a tank crashes through the wall, and the Prince is gunned down by a man in a gas-mask: in a moment the world has changed. A monster out of the wartime drawings of Otto Dix, McKellen's Richard Gloucester executes the old King, then pulls off the mask as the title appears, each glowing red letter accompanied by a gunshot.

The credits sequence that follows shifts to a world of postwar elation. A limousine glides over sunny Westminster Bridge; a shrieking blond princeling scampers away from his indulgent governess; the royal family poses for a formal photograph. The scene then moves to a palace ballroom, where a stylish chanteuse croons a jazz version of Marlowe's "Come Live With Me and Be My Love." The ballroom sequence subtly introduces virtually every character and relationship in the film. The aging, doting King Edward IV dances with his young wife; the audience learns both that he is ill, and that members of the court don't approve of her. A series of brief, across-the-room takes reveals Richard's social and physical unease, his collusion with Buckingham, and his strained, oppressive relationship with his mother, played imperiously by Maggie Smith. Richard's plotting takes effect as Clarence is quietly led away by Brakenbury and his guards; meanwhile Richmond dances with Princess Elizabeth, who will eventually secure his claim to the throne. The Queen's brother Rivers makes a brash entrance to embrace his sister; the prominence given this moment suggests both the Woodvilles' unpopularity at court and the highly significant roles they will have in the film. Above all, the sequence reveals that the film will operate not so much as a series of textual exchanges, but through a pattern of interwoven and overlapping visual codes derived from historical and film iconography.

The film's primary level of meaning comes from its setting in twentieth-century Britain. The story of Richard's rise and fall provides a critical perspective on the current crisis in the monarchy and on the spectre of fascism that has haunted British politics from the blackshirts of the 1930s to the National Front of the 1970s. Richard is iconically linked to Hitler by his haircut and moustache, but his uniform and accent identify him as an upper-class British officer like Sir Oswald Mosely, the charismatic leader of the British Union of Fascists. The film's link between fascism and the ruling class also builds on the figure of King Edward VIII, whose pro-German sympathies, together with his passion for the American

divorcée Wallis Simpson, brought him into conflict with his own government and eventually cost him his throne. These historical resonances give some political impact to the film's central story of a modern England ruled by an aristocratic dictator. Loncraine exploits those resonances through a series of powerful visuals, the most obvious being the scene wherein Richard, through Buckingham's stage-management, is hailed as king by the citizenry. Richard and his henchmen, wearing black uniforms, converse with the Lord Mayor and his retinue in a lobby festooned with red-and-black posters bearing nationalistic slogans from the play: "this noble isle," "glorious summer," "the time to come." Then Richard enters the auditorium and mounts a platform decked with red banners and microphones; the camera backs away at a low angle as Richard raises his right arm to the chanting crowd. The scene essentially duplicates one in Richard Eyre's stage production but on film it gains an added power from its similarity to Leni Rieferstahl's depiction of the Nuremberg rallies in *Triumph of the Will*. The film medium allows Loncraine to create a convincing alternative reality. In the theatre, the 1930s milieu seemed arbitrarily tacked on, presented mainly through costuming; on film, Loncraine establishes an uncanny historicity through a superabundance of visual detail – Bentley limousines, Abdulla

Plate 4.1 Buckingham and Richard watch newsreels of Richard's coronation: Jim Broadbent and Ian McKellen in Richard Loncraine's *Richard III*, 1995

cigarettes, Sten guns, newspapers, railroad cars and recognizable English locations, including several examples of the quasi-fascist architecture of 1930s London. Midway through the film Loncraine succinctly defines his milieu, and wittily acknowledges his medium, when he shows Richard watching black and white newsreels of his own coronation in the royal screening room.

The film complicates and deepens its historical parallel by casting American actors in the roles of Queen Elizabeth and her brother Lord Rivers. No doubt the decision was partly economic: Annette Bening and Robert Downey, Jr are well known and bankable actors, and they figure disproportionately in all the film's publicity. But they also figure prominently in the story Loncraine's film, as opposed to Shakespeare's text, is telling. Queen Elizabeth, the low-born, social-climbing wife of the dying Edward IV, is played by Bening as a Shakespearean Wallis Simpson, gate-crashing the Royal Family with her playboy brother in tow. It's an effective interpretive choice, despite the shortcomings of the actors, and it makes evident the Woodvilles's tenuous position in the court. Bening's Elizabeth develops in complex and interesting directions; in the end, she becomes one of the most important figures in the film, making several non-Shakespearean appearances and taking many lines and speeches from other characters. Evidently Loncraine felt the need for a pole of positive identification to counterbalance Richard, since Richmond only appears late in the play and is scarcely developed. Bening's Elizabeth grows in moral stature through the film, is never seriously tempted by Richard's attempt to woo her daughter, and presides in person over the daughter's marriage to Richmond. Within the film's historical framework, Bening could be read as America growing from an indifference to fascism to come to Britain's rescue in the Second World War. Ironically, Bening's prominence in the film, as imported star-power, simultane-ously suggests the destructive extent to which American mass media came to dominate British culture in the years after the war.

The film's primary level of meaning, then, is a retelling of the Richard III story in the context of modern British fascism, against the background of the 1930s and World War II. However, the film operates at several other levels based on the kinds of cinematic codes it employs. Loncraine exuberantly quotes various popular genres, from the slasher film (Lord Rivers is stabbed from under the bed while having sex with an airline hostess) to the western (Richard's use of a truck-mounted machine gun in the final battle replicates William Holden's last stand in *The Wild Bunch*). *Richard III* can also be read as an inspired conflation of two principal cinematic genres: the British "heritage film" and the American gangster movie. The first of these is the staple of the modern British film industry, much derided in Britain but extremely popular in the United States. A wide-screen variation on the success of *Masterpiece Theatre*, the modern heritage film probably began with *Chariots of Fire* but really hit its stride with the tremendous success of *A Room with a View*, the first of Merchant and Ivory's popular anglophilic adaptations of anglophobic Forster novels. The current spate of Jane Austen films is the most recent outgrowth of the heritage phenomenon.

Heritage films, often adapted from classic literature and filmed in real National Trust properties, are costume dramas of a particularly English sort, wherein the conflicts and sufferings of the beautiful, articulate characters are always mitigated by the reassuring presence of white linen and sunny meadows, leather armchairs and bone china. Most of these films are exquisitely made and acted, and their romantic nostalgia is difficult to resist.[2] *Richard III* is a parody of a heritage costume drama: the idea of "Englishness" is always held up as ironic. In the opening scene with Prince Edward, the loyal dog is shown chewing an ugly piece of raw meat while the Prince tidily cuts up his roast beef. The juxtaposition is suggestive, and the camera lingers on the slavering dog longer than his plot function – sensing the approaching tank – seems to warrant. The glamour of the early scenes of the "glorious summer" of the Yorks is similarly qualified. Interiors are a little too crowded with period detail, so the effect becomes showy and gaudy; the York ladies dine alfresco in their mourning frocks, on a carpet laid out rather absurdly in the middle of a field; the elegantly dressed royal family looks enervated and cadaverous in the bleak seaside sunshine. The parodic effect becomes obvious when the heritage treatment is accorded to some of the ugliest buildings in Britain, from the Brighton Pavilion to St Pancras railway station – which stands in for a royal palace – to the Speeresque Shell-Mex Building, where Richard makes his headquarters. Costumes and locations change constantly and surprisingly, to the accompaniment of Trevor Jones's jazzy score, so that the film provides the visual pleasure of heritage film while making cynical fun of it and the wholesome, hierarchical "English" values it represents.

Richard III also co-opts the heritage tradition by using a number of actors in roles similar to those for which they are well known to international audiences. Nigel Hawthorne exploits the sympathy accorded to his George III as a sweet-natured, trusting Clarence, while Jim Carter, Charles James Fox in *The Madness of King George*, plays another dissolute politician as Hastings. Edward Hardwicke reprises his bluff, honorable Dr Watson as Lord Stanley, played as a sturdy RAF officer, always set off from Richard's black-clad henchmen by his blue aviator's uniform. Kristin Scott Thomas, as a drug-addicted, love-starved Lady Anne, adds to the series of unhappy neglected women she has played in costume dramas ranging from *A Handful of Dust* to *Angels and Insects* to the modern heritage film *Four Weddings and a Funeral*. With the exception of Anne none of these actors has much time to develop a characterization; the film relies on the associations they already carry with them as a kind of cinematic shorthand.

The other set of codes the film uses belongs to a very different genre, the American gangster film. Here, the relation is more complicated, since the gangster genre itself is related to the rise-and-fall archetype partly defined by Shakespeare's *Richard III*. The uncanny similarities between them have been noticed before, most notably by Bertolt Brecht, who anticipated Loncraine by fifty years in linking gangsters, Richard III and Hitler, in *The Resistable Rise of Arturo Ui*. Brecht's play, which charted the rise of a clownish Hitler figure to

the head of Chicago's greengrocery trade, was intended to undermine Hitler's self-mythologizing: in Brecht's words, "*Ui* is a parable play, written with the aim of destroying the dangerous respect commonly felt for great killers" (Manheim and Willett 1977: 458). The Shakespearean allusions in Brecht's play are cuttingly ironic – the clownish Ui is shown studying Shakespearean declamation with a ham actor – and the gangster parallels serve to reduce Hitler to a petty crook. Loncraine's *Richard III* likewise resonates with the gangster genre, but not in a way that reduces Richard's stature. The gangster element of *Richard III* capitalizes on the crude-but-effective psychology of the archetype and the energy of its pop-culture manifestations.

The gangster underworld, with its violence, passion, and feudal conflicts of loyalty, has served several Shakespeare film adaptations, including *The Bad Sleep Well* (Kurosawa's *Hamlet*), the *Macbeth* adaptations *Joe Macbeth* and *Men of Respect*, and several *Romeo and Juliet* spin-offs. Yet Loncraine's *Richard III*, while not given an explicit underworld setting, in many ways follows the classic gangster film even more closely. The American gangster film was defined by a trio of movies from the early thirties. *Scarface, Public Enemy* and *Little Caesar* established the guidelines for hundreds of films in a genre that with variations continues into the present day. Like the Elizabethan tragedies, *Richard III* among them, that focus on an overreaching Machiavellian anti-hero, the gangster film is built on a structure of identification and alienation. In violating the moral and political laws that constrain the viewer, the gangster, like Tamburlaine, the Jew of Malta or Richard III, provides a focus for audience identification and wish-fulfillment. Once the viewer's trangressive desire is vicariously satisfied – when the gangster reaches the "top of the world" – he may be safely rejected, and his fall and destruction assuage the viewer's guilty conscience.

In the classic gangster movie, which Loncraine's film parallels, deliberately or not, with uncanny precision, the anti-hero is an ambitious man who feels unfairly excluded from society (Shadoian 1977: 2–11; Rostow 1978: 27–30). He may be set apart by low or shameful birth, but his marginality often has a physical manifestation as well, such as Paul Muni's disfiguration in *Scarface* or James Cagney's mental illness in *White Heat*. The hero is often haunted by bitterness, shame or some unfulfilled psychological need, usually related to his family. His father is almost always dead, though he may remain a stern presence in the background, but the hero's most important personal relationship is generally with his mother. His rise to power is often motivated by a need to impress her and win her love, yet it invariably somehow alienates her or causes their separation (cf. *Scarface, Public Enemy*, and especially *White Heat*). The hero has difficulties with other women; he often wins, and then neglects, a beautiful wife, who may become his enemy and/or victim (cf. *Scarface* and *White Heat*). The hero's daring and ruthlessness earn him the admiration of the audience and of a small group of followers. In the early part of the story he may work tirelessly to help his family or organization gain dominance over others; he then moves up within the organization through guile and assassination. Certain

scenes and sequences are common to virtually all gangster films: a montage of crimes by which the hero rises; a conference at which the hero reveals his new power to his former colleagues, often making an example of one who challenges him; a scene in which the hero adopts new clothes or mannerisms to go with his new position. The hero is almost always helped in his rise by a close associate or pal, whom he later rubs out for a perceived or actual betrayal. When the hero reaches the top he begins to forfeit audience sympathy; he becomes paranoid, violent and increasingly isolated as outside forces rise against him. He may be haunted by his past deeds; he begins to reveal his weakness. Cornered, he rises to a final heroic moment of defiance before being destroyed.

Shakespeare's play bears some correspondances to this pattern, but Loncraine's film follows it almost exactly. All the elements are there: the troubled relationships with the mother and wife; the bloody elimination of rivals (Clarence, Rivers and the princes); the meeting where the hero reveals himself (making an example of Hastings); the physical transformation as he reaches the top (adopting a black dress uniform and having his portrait made); the betrayal by, and elimination of, the right-hand man (Buckingham); the fear and isolation; the final moment of defiance. The film's 1930s setting lends it many of the trappings of gangsterism – black limousines, jazz, swanky clothes, machine guns – but more importantly Loncraine follows the rhythms of a Hollywood movie rather than an Elizabethan history play. In the stage production the thirties setting seemed artificial, at odds with the dramatic structures of the play. The text of *Richard III* is one of Shakespeare's longest, and it is characterized by large, formally structured scenes and heightened, balanced rhetoric. Loncraine's fast editing, jaunty music and deep textual cuts shape it to the swift rise and fall of the gangster film template, so that the narrative and design seem all of a piece.

McKellen's Richard is invested with many of the psychological qualities of the gangster archetype. In spite of its fascist parallel, Loncraine's film doesn't read Richard's rise in primarily political terms. McKellen's Richard isn't motivated by nationalism, racial ideology or a military-industrial complex, but by a lack of maternal affection. Like Cagney's Cody Jarrett in *White Heat*, McKellen's Richard is obsessed with his mother, and his criminal career is linked to a childhood rejection. Maggie Smith's Duchess of Gloucester hasn't come around to doting on her son in the way Ma Jarrett does – her attitude is closer to that of the rejecting mother in *Scarface* – but she exercises a comparable psychological influence. She is given a disproportionate number of lines in the screen adaptation; indeed she takes over some of the lines, and some of the qualities, of the vengeful old Queen Margaret. In the opening ballroom scene, she applauds Richard only grudgingly, and he notes her disapproval. After the deaths of Clarence and Edward, Richard is present for, and visibly wounded by, his mother's remark that "I for comfort, have but one false glass/ That grieves me when I see my shame in him" (2.2.53–4). Her final, departing curse is made a pivotal scene in the film, and Smith delivers it with ferocity. It gives McKellen his only moment of real vulnerability: as the Duchess departs, Richard stands, frozen

with fear and anguish, while his aides watch him uncertainly, his power undermined for the first time. Her words return in Richard's nightmare, in place of the textual curses of his victims. Throughout the film, whenever his mother mentions his deformities of body or character, Richard shows pain and panic. The implication is clear: she has rejected him for his crooked body, and that rejection has warped his soul. McKellen's notes in the screenplay refer to "the emotional barrenness of Richard's childhood," and his mother's "disappointment and disgust with his physique"; McKellen observes that "perhaps it was from his mother that Richard learned to hate so deeply" (McKellen 1996: 144, 236). This psychological reading of the character is a little simplistic, and perhaps politically naive, but it reinforces the film's connections to the gangster genre and makes the bitter anguish of McKellen's Richard vivid and intelligible.

McKellen's performance is far more successful on film than it was on stage, in part because the proximity of the camera breaks through the surface armor of his icy characterization. As in the stage production, McKellen eschews the traditional majesty and charisma associated with Olivier, who flaunted sexual magnetism and athletic vigor in spite of his limp and hump. Though McKellen gives asides and soliloquies directly to the camera, as Olivier did, he rarely ingratiates himself; he is no charming Vice-figure but a haggard, sleepless killer. Yet while McKellen's stage performance was rigid, unvaried, and not integrated with the rest of the production, in the film his work comes across as more nuanced and complex. The camera catches his relationships to the other characters in subtle details: the amused affection with which he offers chocolates to Tyrell, the glinting malice with which he flatters Hastings just before condemning him; the mute contempt with which he rejects the sexual offers of the miserable Lady Anne. McKellen's performance remains highly self-contained, but it resonates with other elements of the film's production style in tantalizing, sometimes enigmatic ways, and it remains continually involving.

The final moments of the film provide a good instance of its complex allusiveness and effective use of the medium. The Battle of Bosworth takes place in the environs of the Battersea Power Station, an abandoned industrial monstrosity on the south bank of the Thames. Pursued by Richmond, Richard climbs to the top of a giant structure of metal girders, from which he falls into the flames below. The sequence literalizes Richard's rise and fall, like any number of film climaxes where the anti-hero climbs upward in a last desperate attempt, only to fall back defeated. Yet this ending also specifically recalls the "top of the world" finale of one of the classic gangster pictures, *White Heat*. In that film James Cagney, pursued by the police to the top of a gasworks, shoots into the tanks and destroys himself in a fiery explosion after proclaiming, "Made it, Ma, top of the world!" In *Richard III*, McKellen, atop the Battersea Power Station, holds out his hand to Richmond and the audience and invites us to accompany him, "If not to heaven, then hand in hand to hell." As he topples grinning into the flames, the soundtrack plays Al Jolson singing "I'm sitting on top of the world."

75

Plate 4.2 "Top of the world, Ma": James Cagney in *White Heat*, directed by Raoul Walsh, 1949

This ending works on a number of levels, suggesting with equal pertinence the heroic, self-defining suicide of the greatest of movie gangsters and the fall into the hell-mouth of the medieval devils who are Richard's theatrical ancestors. Further, Richmond's final smirk to the camera calls into question the apparently simple relation of good and evil in the film's fascist parable: will the cycle of tyranny merely begin again, according to Jan Kott's cynical reading of Shakespearean history? The jaunty music on the soundtrack further ironizes the ending, as well as cementing the link to the gangster genre. The specific use of Jolson alludes to a defining moment in film history, the introduction of sound in *The Jazz Singer*: the first time words and images were used together to create the layered texture of modern film that *Richard III* exploits so effectively. The above observations unpack some of the moment's range of meanings, but they by no means exhaust it.[3] Roland Barthes, in an essay in *Image/Music/Text*, locates three levels of meaning in a moment from Eisenstein's *Ivan the Terrible*: a narrative level, the message; a symbolic level, what Barthes calls the "obvious" meaning; and a third level, what he calls the "obtuse" meaning. The obvious meaning uses familiar, established codes, while the obtuse meaning is "a signifier without a signified" that exists outside the level of articulated language and rational

analysis; it can be apprehended but not described (Barthes 1977: 54). As Barthes puts it, "the obtuse meaning appears to extend outside culture, knowledge, information . . . it belongs to the family of pun, buffoonery, useless expenditure." Barthes associates this meaning specifically with films and their plenitude of signification: "It is at the level of the third meaning, and at that level alone, that the 'filmic' finally emerges. The filmic is that in the film which cannot be described, the representation which cannot be represented" (64). The ending of Loncraine's film seems to me to go beyond its "realist" mode into this realm of layered and elusive meanings. It is readable both in terms of the surface narrative of a Shakespearean dictator's rise and fall, and in terms of the signifying network of cinematic codes and conventions to which the film repeatedly alludes. Yet the image of McKellen's laughing face receding into the flames has a disturbing comic strangeness that can't be fully accounted for at either level; he seems to be mockingly aware of meanings just beyond the viewer's grasp, just over the shoulder of the obvious meaning, in Barthes's phrase. The multivalent power of signification evident in such moments gives film its potential as a medium for myriad-minded Shakespeare, a potential that Loncraine's *Richard III* effectively realizes.

Plate 4.3 "I'm sitting on top of the world": Ian McKellen in *Richard III*, directed by Richard Loncraine, 1995

NOTES

1 The recent proliferation of mechanically and electronically reproduced Shakespeare has provided examples of all three of Jorgens's modes. The Trevor Nunn and Janet Suzman versions of *Othello*, both based on stage performances adapted for television, remain in the theatrical mode, whereas both Derek Jarman's *The Tempest* and Peter Greenaway's *Prospero's Books* can be described as filmic. But the majority of the commercial Shakespeare films released since *Henry V* remain realist productions grounded squarely in the conventions of naturalistic cinema.

2 In an illuminating essay in *Sight and Sound* magazine, Claire Monk discusses the ambivalent relationship to the heritage genre of another recent British film, Christopher Hampton's *Carrington*:

> *Carrington* treats its audience to the visual, literary and performative period pleasures associated with that critically despised but highly exportable British product, the heritage film, while pointedly seeking to distance itself, through various strategies, from the supposed conservatism these films were so often condemned for in the 80s and early 90s, particularly their innate escapism, and their promotion of a conservative, bourgeois, pastoral, "English" national identity.
>
> (Monk 1995: 33)

In my view *Carrington* mostly fails in this endeavor, at times revealing a self-righteous hypocrisy equivalent to that of many of its Bloomsbury subjects, while *Richard III* is more successful.

3 McKellen comments on the aptness of Loncraine's use of Jolson in the screenplay:

> When [Richard Loncraine] invited me to see the first rough-cut of *Richard III* at the studios of Interact in west London a month after shooting, I relished the double irony of the Al Jolson song which he had overlaid on the final frame of his film. Richmond and Richard simultaneously feel, in the moment their fates collide, that they are sitting on top of the world.

McKellen's remarks suggest that the song was not part of the initial conception of the scene, and that McKellen at least may have been unaware of the Cagney parallel (McKellen 1996: 286).

REFERENCES

Barthes, R. (1977) "The Third Meaning: Research Notes on Some Eisenstein Stills." In *Image/Music/Text*, ed. and trans. S. Heath. New York: Hill & Wang.

Hammond, A. (1981) *The Arden Shakespeare: King Richard III*. London: Methuen.

Jorgens, J. (1977) *Shakespeare on Film*. Bloomington: University of Indiana Press.

Kennedy, Dennis (1993) *Foreign Shakespeare: Contemporary Performance*. Cambridge: Cambridge University Press.

Kott, J. (1967) *Shakespeare Our Contemporary*. Trans. B. Taborski. London: Methuen.

McKellen, I. (1996) *William Shakespeare's Richard III: A Screenplay*. Woodstock, New York: Overlook Press.

Manheim, R., and J. Willett, eds (1977) *Bertolt Brecht: Plays, Poetry and Prose*, vol. 6. New York: Vintage.

Monk, C. (1995) "Sexuality and the Heritage," *Sight and Sound* 5, 10 October.

Paré, L. K., and S. Bayly, producers (1995) *Richard III*. Directed by Richard Loncraine. Mayfair Entertainment International, in association with United Artists Pictures.

Rostow, E. (1978) *Born to Lose*: *The Gangster Film in America*. New York: Oxford University Press.

Shadoian, J. (1977) *Dreams and Dead Ends*: *The American Gangster/Crime Film*. Cambridge, MA: MIT Press.

POPULARIZING SHAKESPEARE
The artistry of Franco Zeffirelli
Robert Hapgood

"I have always been a popularizer," Franco Zeffirelli declares in the self-portrait that concludes his *Autobiography* (Zeffirelli 1986: 341). He is speaking of his work in staging and filming opera, but his words apply equally well to his Shakespeare films: *The Taming of the Shrew* (1966), *Romeo and Juliet* (1968), and *Hamlet* (1990). As he once explained to an interviewer: "I have always felt sure I could break the myth that Shakespeare on stage and screen is only an exercise for the intellectual. I want his plays to be enjoyed by ordinary people" (Lucas 1967: 94). Comparison will show that in all three of his Shakespeare films his efforts in this direction have much in common. The differences among them will also reward analysis and help to explain why of the three – all of them estimable in their own ways – *Romeo and Juliet* is the most successful, artistically as well as commercially.

Two reasons make Zeffirelli's success as a popularizer especially worth examination now. Costs of filmmaking have risen so high that if full-budget Shakespeare films are to be made at all they must have a wide appeal that only Olivier, Zeffirelli, and Kenneth Branagh have so far achieved. Furthermore, it is beginning to look as though Zeffirelli's approach will prove to be more durable than Olivier's. Olivier's most popular films, *Henry V* (1944) and *Hamlet* (1947), have dated badly; now about fifty years old, they have for some time been virtually intolerable – even laughable – to my college students; while Zeffirelli's nearly thirty-year-old *Taming of the Shrew* and *Romeo and Juliet* seem almost as accessible as ever and indeed still have the power to make audiences laugh and weep. Of Branagh, and his work as a popularizer of Shakespeare, more will be said at the end.

As Zeffirelli's career as a filmmaker attests, a popularizer and a popular artist are not necessarily the same. At best, his recent forays into films with a directly popular appeal have had mixed results.[1] It was as a popularizer that Zeffirelli made his name in films, and it is as such that his greatest successes have come. In a sense Shakespeare himself was not only a popular artist but also a popularizer. For a largely illiterate audience he transferred from page to stage and from narrative to drama some of the central writings of his time, such as the historical chronicles of Plutarch and Holinshed. Like Zeffirelli, Shakespeare's gifts were not

those of an originator *ab ovum*: almost all of his plays are reworkings of sources. Of course, despite wholesale cutting, Zeffirelli makes much more use of Shakespeare's language than Shakespeare did of his own sources; his art is that of an adaptor or free interpreter whereas Shakespeare transmuted inherited materials into distinct creations. As Zeffirelli has been quick to acknowledge: "Direction is not pure creation. You take somebody else's conception and have to respect it. Your work is going to pass, their work is remaining" (Zeffirelli 1963: 439). Unlike Shakespeare, Zeffirelli has focused on acknowledged masterpieces for his filmed popularizations – Verdi's operas *La Traviata* (1983) and *Otello* (1986) and the Bible (in his 1977 television miniseries, *Jesus of Nazareth*) as well as Shakespeare. Moreover, all the classics Zeffirelli has chosen have previously had a much broader range of appeal than they do today. His ability to reactivate this appeal is basic to his success. Strictly speaking, he is a *re*-popularizer.[2]

From a recently published question-and-answer session on filming Shakespeare that Zeffirelli gave shortly after the success of his *Romeo and Juliet*, one may piece together an impromptu *apologia* for his practice as a popularizer, before and since. At its heart is his address to the general public:

> With the cinema, you have to make up your mind whether you do a film for a small number of people who know it all – and it's not very exciting to work for them – or really to make some sacrifices and compromises but bring culture to a mass audience.
>
> (Zeffirelli 1990: 244)

From the fact that during his student days Shakespeare's plays reached him in Italian, Zeffirelli draws confidence that they apply "to every human being on earth, no matter what cultural background" (241). By the same token he, even though Italian, can serve as their intermediary to others: "If we really believe in the great values, we communicate one way or another, despite the difference in language, civilization, background, and age" (242). Essentialist and universalist as can be, Zeffirelli here sums up in a sentence the extravagantly all-inclusive faith of a popularizer.

As a go-between, Zeffirelli is wary of "parting company with the audience and asking them to contribute the kind of attention which comes through the brain" (Zeffirelli 1990: 244). Instead he has sought to provide "something they could really identify with" (244), "to make the audience be there with their guts and heart" (262). And their imaginations: he seeks "to make the fantasy of the audience come to life and run together with the actors" (254). The search for this kind of compelling rapport drives all his work: "to make the thing really happen for the audience of today – to make the audience understand that the classics are living flesh" (252).

At the same time Zeffirelli seeks also to be faithful to Shakespeare's work and to hold tenaciously true to what he sees as its core (Zeffirelli 1990: 242). In *Romeo and Juliet* this core idea was Zeffirelli's decision to take literally Shakespeare's indication that Juliet was about fourteen and that, in that time of

boy actresses, "he wanted a young kid to play the part" (257). From that every-thing else followed: "In every scene I said, 'Don't forget she is fourteen. She's fourteen, and that holds the structure of the play together.'" Given that fidelity to what he sees as Shakespeare's central intention, Zeffirelli is unrepentantly prepared for the sake of audience rapport to make necessary "sacrifices and compromises" where non-essentials are concerned. The apothecary had to go because the episode raises questions in the audience's mind that impede the wave of emotion that makes Romeo's suicide acceptable. The killing of Paris was shot but finally cut because if Romeo "was a murderer – 'ugly boy, ugly boy!' It wouldn't have worked" (244–45). At times, as with his inventive handling of Mercutio's sword-fight with Tybalt and death, he is prepared to grant himself some poetic license: "it is not quite what Shakespeare meant, but I think he would have liked it" (251).

In Zeffirelli's view, alterations may also be justified because of the centuries that stand between Shakespeare and ourselves. It is the popularizer's responsi-bility to bridge this gap to the classics and imagine that the author had been able "to write that play today for us" (Zeffirelli 1990: 257). So Romeo and Juliet's love-making in the film was appropriately more physical than Shakespeare's circumstances permitted.

A movie-maker who seeks a popular audience must also mediate boldly between the original theatrical medium and film: "cinema creates a different chemistry with the audience, a different taste, and the attention of the audience moves so fast . . . fantasy gallops in the audience in movies (Zeffirelli 1990: 261) . . . your mind flashes-flashes-flashes" (263). Hence Zeffirelli felt justified in cutting the parts of the original that slowed this rapidity – the pestilence in Mantua, the clowns, the friar's speech at the end (260): "sometimes it is better to do without certain things than jeopardize rapport" (262).

In his relation to his film audience Zeffirelli differs fundamentally from Olivier. When Olivier made his films, he of course stood with Gielgud at the center and pinnacle of high-culture Shakespeare. Zeffirelli was not without high-culture credentials himself: he had worked as a designer for Visconti, directed at La Scala and Covent Garden, brought a hit Italian Hamlet to London, and directed Romeo and Juliet at the Old Vic. Yet where Olivier in his Shakespeare films was in the position of sharing a family heirloom with outsiders, Zeffirelli – as an outsider – was in a more inviting role, escorting the uninitiated on the same journey of discovery he himself had made as a youth.

Some of Zeffirelli's success at the box office has come from frankly commercial calculations, although their crassness has typically been redeemed by a touch of imagination. His first feature film, Taming of the Shrew, was conceived as a remake of the Douglas Fairbanks/Mary Pickford version (Zeffirelli 1986: 200). With Elizabeth Taylor and Richard Burton for Taming of the Shrew, as with Mel Gibson and Glenn Close for Hamlet, he chose hugely popular stars. Of course, it is a fact of Hollywood life that bankable stars are virtually essen-tial to funding feature films. Indeed, Taylor and Burton themselves put up most

of the money for *Taming of the Shrew*. Yet Zeffirelli's casting has also consistently had an element of discovery and risk about it. Neither Taylor nor Gibson were thought of as Shakespearians, and until they proved otherwise serious doubts were expressed about their ability to perform their roles. Such risks could also prove an opportunity. "Cinema is a day-by-day discovery, and fresh is best," he has observed (Zeffirelli 1990: 250). For example, he found it more satisfying to direct Taylor than Burton because certain of his acting patterns were stale (Zeffirelli regrets that he did not dare to challenge them) whereas with Taylor: "she was fresh like me. She was new [to Shakespearian acting] and very insecure, and so we worked on a lot of new ideas, and she burst out in a much more unexpected way than her husband" (250). In *Romeo and Juliet* he pushed this element of discovery to an extreme, choosing then unknowns for the leading roles – only to find that at first no major company would finance it (267).

What finally made Zeffirelli's *Romeo and Juliet* possible was another way of attracting financial backing for a film project: that it promised to draw young audiences. Consistently, he has sought to be timely and especially to address the young. For the opening carnival in *Taming of the Shrew* he had hired young extras. In his approach to *Romeo and Juliet*, as we have seen, his characteristic accent on youth was of the essence. For his Old Vic production of the play he chose unusually young principals and cast. While rehearsing the play he is said to have frequented *West Side Story*, then playing in London. Certainly his film draws on similar youth-culture, generation-gap appeals. As he recounts in his *Autobiography*, the fact that a Hollywood producer's teenage son was moved by what he saw of the film in progress was crucial in the producer's decision to fund its completion (Zeffirelli 1986: 228–29). In its first year, Paramount's one and a half million dollar investment returned forty-eight million dollars at the box office (240).[3]

In choosing Mel Gibson Zeffirelli hoped to have found "the Hamlet for the nineties." "We must bring the young kids to see Shakespeare," he told one interviewer, "I began to look at youngish actors, and I landed on this extraordinary Gibson" (Stivers 1991: 52). He explained to another that Gibson has "an image the kids can identify with . . . that old-fashioned movie-star magic" (Darrach 1991: 38). Zeffirelli has never tired of recounting the moment of decision when he saw a parallel between Hamlet's abortive meditation on suicide in the "to be or not to be" soliloquy and the scene in *Lethal Weapon* when Gibson as Martin Riggs cannot bring himself to pull the trigger that would end his life. Did Zeffirelli succeed in finding a Hamlet for the nineties? Certainly the film speaks to my current students more powerfully than any other film version of the play. Barbara Hodgdon, however, has some astute reservations, finding that the film "never quite intersects with late twentieth-century history" (Hodgdon 1994: 290). And it has not had anything like the box office success of his *Romeo and Juliet*. The *New York Times* summary was judicious: "Mel Gibson may not be a Hamlet for the ages, but he is a serious and compelling Hamlet for today"

(James 1990: C21). "*A* Hamlet . . . for today," then, if not quite "*the* Hamlet for the nineties" that Zeffirelli sought.

Aspiration toward timeliness, although it helps to attract paying customers, need not lead to a cheapening of the original. Zeffirelli has not, for example, succumbed to the too-easy updating that can come with modern dress; all of his Shakespeare films have had period mountings. "You can't take the Fifth Symphony and play it as jazz," he has observed (Zeffirelli 1963: 439). There was much more to the power of his *Romeo and Juliet* than an appeal to the latest teenage fad. In my own experience the film, overnight, made the play teachable to college students, who had hitherto rejected it as celebrating the high school puppy love they were trying to put behind them. What they found in the film is illustrated by the testimony of Michael Cole and Helen Keyssar, who have looked back as adult teachers on their student experiences of the play and the film. Both were put off by the play when they read it; both were caught up by the film's immediacy. Cole "was captured first by the fight among the boys" (Cole and Keyssar 1985: 58), and as the precise "tragic possibilities of all-consuming passion" came home to him, he "wanted to reach out and say, No! Stop! Don't do it." Keyssar also wanted to say "Stop," but – carried away by "their fervor of reckless abandon" – she "also wanted neither of them to stop because to stop was to arrest their passion as well as mine." The film's "unabashed eroticism" was thus one of its attractions for her, but with it came a tragic "sense of irretrievable loss": "the film made me feel what death was all about: It was about absence, and I recognized that absence because the human beings on the screen had been made so present to me " (59).

Zeffirelli's concern with youth and contemporaneity goes deeper than a desire for dollars. What he writes about renovating his house applies equally well to his adaptation of classics: "my real pleasure is to make whatever I have added look as if it has always been there . . . this notion of belonging both to the past and the future pleases me so much. When I succeed, I feel I have defeated time . . . " (Zeffirelli 1986: 345). Through his ongoing work in cinema, he has said with a sigh, "I want to keep young for my work for the future" (Zeffirelli 1990: 244). In turn his work has appealed to the young because it is itself young at heart.

Zeffirelli's Shakespeare films have a highly distinctive style, well suited to fulfilling his goals as a popularizer. Many of his ways with Shakespeare parallel Shakespeare's own ways with his sources. Both artists are bold in their appro-priation of their originals and seem uninhibited in fulfilling the demands made by their mediums. Just as Shakespeare takes whatever liberties are required to convert narrative into drama, even altering historical materials, so Zeffirelli does the same in converting drama to film. What he says of opera may be applied to his total acceptance of film:

> Don't pretend to the audience that it is seeing a musical comedy; don't disguise opera or apologize for it or try to make it something it's not. Opera is complete in itself.

> (Merkling 1962: 15)

The whole-heartedness of Zeffirelli's embrace of the film medium adds zest to his work and is a key difference from Olivier. Try as he would to be cinematic in his directing and acting, Olivier often fell between the two stools of theatre and film. With all due respect for the greatness of his stage acting and the historical importance of his groundbreaking contributions to the filming of Shakespeare, one must acknowledge that as a film director his blocking now seems static and stage-bound. Even as an actor, Olivier in his film portrayals of Henry V and Hamlet often seems wooden and underacted – perhaps he was trying too hard not to overact in a stagey way. And his attempts to employ "movie magic" today often seem embarrassingly superficial.

Nowhere is the contrast between the Zeffirelli and Olivier approaches more evident than in their attitude toward Shakespeare's dialogue. Both are obliged to cut a great deal of it, but Zeffirelli takes many more liberties than does Olivier in the way of transpositions and interpolations. Olivier relies more on the poetry and seems more conflicted about reworking it. Regarding as a benefit what might be thought a defect, Zeffirelli takes the fact that English is for him a second language as license to start with the story, which communicates in any language, and to keep his emphasis there: "you have to tell the story from scratch ... using a language that makes clear and accessible every single word of William Shakespeare [included in the film script]" (HBO Special 1990). Poetry may be welcomed as "an additional beauty" (Zeffirelli 1990: 241) – witness Burton's alluring evocation of "ruffs and cuffs and farthingales and things" – but clarity comes first.[4]

Zeffirelli revels in the audience-involving visual opportunities that motion pictures afford. The wonderful richness of Shakespeare's words, their Renaissance copiousness and plenitude, has its cinematic parallel in the profusion of Zeffirelli's images. Although the fertility of his invention seems effortless, it is also based on hard work, inspired by the "passionate attention to detail" he learned as a stage designer for his mentor Visconti:

> Everything was always researched to a point far beyond the needs of the actual scene. You immersed yourself in the period, the place, its culture, so that even though the audience might not take in every detail they would be absolutely convinced of its essential "rightness".
>
> (Zeffirelli 1986: 85–6)

A Florentine, Zeffirelli was already thoroughly at home in Renaissance Italy. A master-stroke of his *Taming of the Shrew* and *Romeo and Juliet* was to capitalize on his birth-right and take literally the Italian-ness of their Shakespearean settings in Padua and Verona. Both are very much "Made in Italy," being shot there and with largely Italian designers and technicians. Since the two films came first and close together, I will consider them as a pair before coming to *Hamlet*.

Zeffirelli's Padua and Verona are attractive places for an audience to visit and engagingly full of life. Both are densely populated and noisy, inhabited by

animated, voluble, volatile people. Padua seems more crowded (it was shot in studios in Rome), Verona more spacious (it was shot mostly on locations). Clothing in Padua is riotously colorful; in Verona its colors are more restrained, governed by the Capulet and Montague liveries (at their ball the red-clad Capulets serve rose wine in rose-colored goblets; the roses in their garden are pink). In both places the pace of life is very rapid. As befits a farce, this is especially true in Padua; in Verona a lot happens fast but in a more modulated way – as when the leisurely, half-playful tempo of the duel between Mercutio and Tybalt gives way to the fury of the hand-to-hand struggle between Romeo and Tybalt.

The audience response Zeffirelli seeks in the two films is broadly based and fluid, covering a wide spectrum between detachment and engagement. He has remarked on the "air of unreality" he imparted to his Padua (Zeffirelli 1986: 214), along with many naturalistic touches; in his Verona the balance is tipped: it also has story-book qualities, but there he places more emphasis on a realistic atmosphere, including hand-held camera work. Both films are very pleasing to the eye. At times the painterly look of his shots invites his viewers to be onlookers, sitting back and enjoying the beauty of the film as it unfolds. Much more often they are encouraged to sit forward and be caught up in the action.

The immediacy of both films is heightened by intense sensory appeals, not only to seeing and hearing but, vicariously, to all the other senses. In the wool-loft scene, the super-softness of the piles of fleece in which Kate at first luxuriates suggests one kind of tactile sensation; her penchant for bashing men over the head with a lute, planks, and a warming pan suggests the opposite extreme. Nor are our inner noses neglected, as when Petruchio's smelly feet remain unwashed in "the silver basin full of rose-water" (*Taming of the Shrew*, 1.1.53–4) which fastidious Hortensio has provided. Zeffirelli loves such contrasts, and in *Taming of the Shrew* elaborates them to the point of sensory overload. In *Romeo and Juliet* the contrasts are fewer but larger and more telling, as between the cool greenery in Capulet's garden and the hot and dusty plaza where the duels are fought.

As befits a love tragedy, the eroticism of *Romeo and Juliet* is much more direct than that of *Taming of the Shrew*. Once they have fallen in love at first sight, Kate and Petruchio share few tender looks or touches. Romeo and Juliet hug and kiss, even in the balcony scene, and are shown partly nude after their wedding night; but their sensual ardor is best conveyed by Olivia Hussey's non-verbal portrayal of Juliet's sexual awakening – from gasps and giggles of joy to post-coital relaxation.

Above all is the kinetic appeal of these two films, intensified in well-chosen places by explosions of violence. They are very much "movies," and Zeffirelli makes the most of the charge of vitality that they can give his viewers. Not only are his principals active and energetic (no one stands still to deliver a speech) and their stories dynamically told, but on the sidelines numerous little stories are sketched, suggesting the flow of ongoing community life. Not for nothing did Zeffirelli as a director of opera learn to individualize his La Scala choruses

(Zeffirelli 1986: 126). This is especially true of *Taming of the Shrew*. For one example among dozens, through reaction shots at the wedding, we can follow Bianca's anxiety that the marriage will not happen (with its impact on her own marriage prospects) and her joy when it does occur. Even the props are given stories, as when Michael Hordern's Baptista – hunched over with paternal cupidity – is amusingly careful to retrieve the family silver Petruchio has been fondling. In *Romeo and Juliet* Capulet's ball is similarly treated. The first meeting of the lovers takes place amid round-dances so dizzying that even the camera is caught up in the whirl (Cirillo 1969/70: 87). On the sidelines, a domestic triangle is sketched between Tybalt and Lord and Lady Capulet. But elsewhere in this film Zeffirelli gives most attention to working out fewer stories at greater length and depth.

Taken together these various elements in Zeffirelli's filmmaking comprise a composite art of story-telling, by which he claims and rewards the attention of his viewers while ensuring that, without too much effort, they will be alerted to everything they should know. Again, his methods are instructively overt in *Taming of the Shrew*, where indeed the neophyte film director seems intent on displaying everything he can do at once. So he is busy cross-cutting between the wooings of Kate and Bianca, exaggerating (hilariously but to scale) the slap-stick part of Kate's first wit-combat with Petruchio, ramifying the chase motif, under-lining the dialogue by repeating key phrases, visually undercutting Petruchio's line "I will not sleep till I see her" (1.2.102) by having him immediately drop off to sleep, musically mocking his bombastic speeches by a march on the soundtrack. Such textured interworking of parts extends to all aspects of the film.

Romeo and Juliet is no less integrated, but in it the director's hand is less obtrusive. As before he allows his inventiveness several virtuoso displays – the opening brawl, the ball, the duels – all of them handled in his characteristically supercharged, richly textured style. These come in the first part of the film. As in *Taming of the Shrew*, Zeffirelli then changes emotional gears in mid-course, as he delineates the problems that confront the two marriages. But in *Romeo and Juliet* this change is reflected much more graphically, in the subdued style of the interiors (Jorgens 1979: 89). And for the most part Zeffirelli seems to let the story tell itself, pausing in places to admire the beauty of the lovers' faces and bodies, but in a compelling away entering into the story's own pace, rhythm, and points of climax, which he emphasizes by lavish use of background music.

The style of *Romeo and Juliet* is thus much more mature than that of *Taming of the Shrew*. Yet looking back over the features the two films share, one can see that they all help to enhance the intense rapport that Zeffirelli seeks with a popular audience.

After a farce and an early tragedy, *Hamlet* presented much more of a challenge to Zeffirelli's skills as a popularizer. In telling its long and complex story, he takes his usual approach. He focuses sharply on the core of family tragedy; politics

scarcely figure, Fortinbras is gone without a trace, as is the opening appearance of the Ghost. The pace is rapid (this is an "action film"). Of Hamlet's soliloquies, only "to be or not to be" emerges entire; "how all occasions" is cut entirely and the others are severely reduced. The characterization of the Prince accords with this approach. Virile, dynamic, violent, wild, Gibson's Hamlet is not a more than usually thoughtful man. Zeffirelli in fact goes to elaborate pains to provide external occasions for his reflections, even in soliloquy. This Hamlet, as Gibson says, is "a man of action" (Darrach 1991: 42).

To readers conscious of what is omitted from the original, the film may seem choppy. But if we take the film-script on its own terms we can see that Zeffirelli finds a number of ways to enhance its flow for moviegoers who may not know the play. He frequently divides Shakespeare's scenes into shorter segments. So the second scene opens as in the original with Claudius's statement from the throne about his marriage, but what follows is broken into a series of fast-moving, private exchanges. Unlike Shakespeare's hero, who must make intuitive leaps in order to understand the forces against him, Zeffirelli's Hamlet, thanks to extensive eavesdropping, is never taken by surprise. We are always therefore carried forward by the clear logic of what he does.

Many of Zeffirelli's alterations of the original are resourceful. Simply by having Polonius observe Hamlet's silent visit to Ophelia sewing, he is able to move directly to the scene where Polonius expounds to the king and queen the causes of Hamlet's lunacy. He efficiently accomplishes some exposition by substituting King Hamlet's funeral for the Ghost's first appearance. But this time the commercial compromise Zeffirelli made to obtain funding (holding the running time to two and a quarter hours) cramped everyone's style, especially his own. This is most evident in his handling of Hamlet's aborted voyage to England, where the story-telling is almost as jerky as in a silent film: first comes a short shot of Hamlet's boat at sea; then – between Ophelia's mad-scenes – a short sequence in which the Prince exchanges the fatal packets and Rosencrantz and Guildenstern are summarily beheaded; finally, Hamlet is back in Elsinore, with no indication of how he got there. How much more adroitly Zeffirelli abbreviates the delayed delivery of Friar Laurence's message to banished Romeo! He simply shows the messenger riding his donkey on the road to Mantua and being overtaken by Romeo's servant on horseback; he then points the irony by having the two of them unknowingly pass the messenger on their way back to Verona.

In general Zeffirelli's inventiveness in *Hamlet* is not as robust as before. Elements derive from previous Shakespearean films. During the credits, the subjects who wait, silent and still, outside King Hamlet's funeral recall the still more frozen figures who await the outcome of the opening scene of Peter Brook's film of *King Lear*. At the end Gibson's antic duelling-style echoes that of Nicol Williamson's still more eccentric Hamlet. His debts to Olivier's *Hamlet* film are numerous. In addition to the mother/son incest, they include having the interview between Ophelia and Laertes follow immediately after the "solid flesh" soliloquy, having Hamlet on a level above Polonius for the "words, words,

words" exchange, having "to be or not to be" follow rather than precede the nunnery scene, having Gertrude turn away from Claudius after the closet scene, having Laertes and Claudius do their plotting after rather than before Ophelia's funeral. As it happens, each of these borrowings works effectively in its new context, but their number suggests that the springs of Zeffirelli's invention were not flowing as freely as before: "fresh is best."

A more serious shortcoming is that Zeffirelli's approach to the mounting of *Hamlet* cut him off from many of the ready appeals which had helped to make his Italian Shakespeare films so popular.[5] One cannot move from his Padua and Verona to his Elsinore without a feeling of sensory deprivation. Although some idea of the daily life of Elsinore is suggested, there is nothing like the involving abundance of surrounding life to be found in the earlier films. The open spaces in the castle seem huge and virtually deserted. Nor is there the same kind of color and beauty as before. Except for the queen's costumes, clothing is drab and the stone walls are mostly bluish gray. Background music is sparingly used, primarily pedal tones for the Ghost; more frequently, the soundtrack records the neighs of horses, cries of gulls, howling winds and other atmospheric sounds.

Obviously, Zeffirelli was trying for something different from his earlier work, an austere vision suited to the particular world of Shakespeare's play and designed to concentrate our attention on his strong cast of English and American actors. It would be harsh to dismiss it, as does *Sight and Sound* as "set-text cinema Shakespeare at its most inexpressive" (Romney 1991: 49). It must be conceded, though, that Zeffirelli does here deny himself the extended, free-form cinematic fantasias that distinguished his previous Shakespeare films, and that he is simply not as much at home in Elsinore as he was in Padua or Verona.

Whatever the stylistic shortcomings of his Shakespeare films, Zeffirelli never loses sight in them of the human drama at the heart of the originals. This is the most important source of his success as a popularizer. "Squeeze Shakespeare's characters to the utmost," he told an interviewer, "and you still find poetry." His focus therefore is on "this poetry of the human relationships . . . " (Kitchin 1960: 217). As he stated elsewhere:

> The aim in my profession is to create beauty and to make dreams come true. I am fed up, however, with the label "creator of beauty." Beauty is just the frame. Inside it must be the picture. I don't think people cried and suffered with my *Romeo and Juliet* just because the costumes and sets were beautiful. They cried because I really grasped the essence of this love story, the reality and the vitality of the characters.
>
> (Zeffirelli 1984: 34)

As discussed, Zeffirelli sees as crucial the ability of a popular audience to iden-tify with his protagonists. All three films feature attractive and high-spirited individuals – one in *Hamlet*, pairs in the other two – who win our admiration by the resource and resilience they show in asserting themselves in surroundings

which in one way or another would stifle their lives. Even Kate and Petruchio, as much as they fight with one another, are allied as free spirits in a conventional world. She defies the patriarchy, he flauntingly exploits it. All of the leading characters are frustrated in the expression of love, whether because of external circumstances or, in the case of Kate and Petruchio, of their own insistence on dominance. With Hamlet, Zeffirelli has explained:

> The problem of the boy is quite simply – whom to love? He did not really love his father; that was a secondary character in his life. Ophelia? No, there is no love-story possible there, he is always uncertain, ambiguous – *because his heart is not come out of mother's womb! Because there is no safer place in all the earth!*
>
> (Zeffirelli 1991: 94, Zeffirelli's emphasis)

Accordingly, Gibson at one point in the film kneels before his mother and for a moment presses his head to her womb.

The resulting conflicts can be explosive – as with Kate's violent tantrums and Romeo's rage after Mercutio's death; Hamlet, Gibson explains, is "a mine-field of contradictions . . . you never know when he's goin' to explode . . . the man is a livin' bomb" (Darrach 1991: 42). Yet Zeffirelli's most moving moments depict suffering and loneliness – when Kate, locked in a room, peers through its transom while her fate is decided; when Mercutio looks longingly back at Romeo as their friends hurry him away or when Juliet is white-faced in her disillusionment with her parents and nurse; when Hamlet roams the parapets looking down from great distances at the plots against him, or when mad Ophelia hurries about, alone in her own world. It is through Zeffirelli's sure and sensitive revelation of their vulnerabilities that they win our sympathies.

As Zeffirelli has disclosed details about his life, the autobiographical parallels to this patterning have become evident. His illegitimacy, with an absent father who at first would not acknowledge him; his successive mother-figures (his nurse, his dying mother, his aunt), each change involving a withdrawal of love (Zeffirelli 1986: 9); his homosexuality; his adventurous ability to win his way through war, poverty, and artistic hostilities – all help to explain the submerged personal resonance that adds depth to the emotional power of these films (Donaldson 1990; Watson 1992). His kinship in spirit with Kate, Juliet, and Mercutio gives his audience unusual access to their inner lives and thus strengthens our identification with them.

With Hamlet, one need not look far for personal connections with Zeffirelli's formulation of his tragedy: "at the heart is this boy's anguishing problem, about who he is, and what he's supposed to do in life" (Zeffirelli 1991: 94). Yet the deep tie Zeffirelli sees between Hamlet and his mother does not quite fall into place. Certainly the incestuous implications derive authentically from his own life: he has revealed how when he was five years old he regularly slept in a narrow single bed with his mother, who "would cling to me as if trying to draw warmth and health from the being she had made" (Zeffirelli 1986: 7). Some years before

Zeffirelli made the *Hamlet* film, he described Hamlet as "a boy taken just in the moment when his affections would move away from his mother, but he dies too soon" (Zeffirelli 1963, 440); and some of this formulation seems to persist in the film. Significantly, Zeffirelli has habitually referred to Gibson in interviews as a "boy." Glenn Close's Gertrude is unusually girlish and Helena Bonham Carter plays Ophelia as a fourteen-year-old. But Gibson's Hamlet simply does not look like a boy nor does Close's Gertrude look old enough to be his mother. That is why, although the closet scene is the most powerful one in the film, it doesn't sit well with the rest. In this case Zeffirelli's private compulsions are not fully in tune with the main action.

In their poetry of human relationships the three films pose progressively greater challenges. In *Taming of the Shrew* there is only the one principal relationship, between Kate and Petruchio, which Zeffirelli does much to clarify. Between the moment Kate decides to follow her husband rather than return to her father and her final speech of devotion (which Taylor delivers without irony (Zeffirelli 1986: 216), her tug of war with her husband for dominance moves through a series of distinct phases (I count eight), often heralded by her wicked little smile. In this progression, she more and more takes the lead in defining the terms of their marriage, most of all at the very end, when Petruchio, while boasting of his triumphs, turns his back on her only to find that she has run off once more.

Again in *Romeo and Juliet*, the prime relationship is of course that between the lovers. Zeffirelli chose not to emphasize the difference Shakespeare brings out between Romeo's dreaminess and Juliet's practicality, yet he does differentiate between them in his own way. In the emotion tone of their love, hers is hot, his is cool. In her hates, too, Juliet has a kind of fierce intensity that Romeo shows only when revenging Mercutio's death. Each of them also has important secondary relationships, Juliet with her nurse and parents, Romeo with Mercutio and Friar Laurence. It is especially on the latter that Zeffirelli puts his own touch. He is less sympathetic to Friar Laurence than is Shakespeare (Zeffirelli 1990: 264–65), having him run off altogether at the end, repeating "I dare no longer stay." To Mercutio he gives a manic reading of the "Queen Mab" speech, a forehead-to-forehead intimacy with Romeo, and the twist that his friends mistake his death throes for clowning. Tybalt, too, is given more than Shakespearean depth, especially his dismay at seeing the blood on his sword after unintentionally stabbing Mercutio.

Thanks to *Romeo and Juliet*'s richer characterization, Zeffirelli was thus able to give fuller expression than in *Taming of the Shrew* to his powers of rendering human relationships. In *Hamlet*, however, Shakespeare's reach too much exceeded Zeffirelli's grasp. The play presents a web of human relationships within and between the two families. Zeffirelli's acclaimed stage *Hamlet* in Italian left no doubt that conceptually he was fully able to handle such intricacies; when this production came to London it was praised for treating all of the principals as developing characters (Young 1964), and the same is true of the film, where the

gifted actors do a remarkable job of supplying nuance for their abbreviated roles. They make the most of the few key moments they are allowed – Paul Scofield's Ghost yearningly reaches out to his son (who does not respond in kind), Alan Bates's Claudius struggles to keep his composure but finally loses it completely at "Give me some light!", Glenn Close's Gertrude, poisoned herself, realizes with horror the murderousness of the king. Such moments suggest what they might have done if given more scope. Claudius especially suffers from the omission of his functions as a ruler and the reduction of his attempt at prayer to a series of heartfelt groans. Zeffirelli has himself expressed regret that he did not include more humor: "Mel has an ironic humour that matches Hamlet's" (Robinson 1991: 19). Two hours and a quarter was simply not enough.

It is in *Romeo and Juliet* that Zeffirelli's artistry as a popularizer is at its best. In every way the film represents a happy conjunction of play, medium, style, cast, audience, and cultural moment.

Kenneth Branagh is often compared with Olivier, and as an actor his delivery of his lines does show a comparable sensitivity to Shakespeare's language, whether grand or subtle. Yet where popularizing Shakespeare on film is concerned he is – as screenwriter and director of *Henry V* (1989) and *Much Ado About Nothing* (1993) – as much in the tradition of Zeffirelli. His shooting *Much Ado about Nothing* in Italy with a mixed cast of American and British performers certainly recalls Zeffirelli's practices, and the parallels, whether conscious or not, go further. Always careful to label his scripts as "adaptations" of the original, Branagh is almost as free as Zeffirelli in cutting and interpolating to suit his filming needs. Both clearly love film and delight in the opportunities it offers, occasionally permitting themselves fantasias that extrapolate on Shakespearean moments – as when Mercutio clowns in his fountain or Benedict capers in his. Yet their work is still recognizably based on Shakespeare: as with Zeffirelli much of the appeal of Branagh's films comes from his ability to revitalize qualities that originally made the plays popular. Except for *Hamlet*, both have sidestepped the most challenging of Shakespeare's works (for the most part they are probably best left to stage productions and art-films); instead they have chosen relatively early ones, plays whose dialogue could be cut without great loss and whose characterization was tolerant of the simplifications endemic to popular culture. Branagh is as bold as Zeffirelli in seeking rapport with the audience and makes the same kind of extensive use of mood-music. Audiences find their films of Shakespearean comedies genuinely funny; like the first meeting of Kate and Petruchio, the eavesdropping scene of *Much Ado about Nothing* evokes spontaneous laughter, a rare distinction. Neither is shy about laying claim to compelling reasons for audience identification with their leading characters: even more than Zeffirelli, Branagh's films have been about young people; he is himself young. And no less than Zeffirelli he plays on our sympathies by enhancing the vulnerability of his leading characters – his Henry V sheds more tears in the exercise of his royal office than does Shakespeare's and his Beatrice, like Zeffirelli's Kate, is warmer and softer than in the original.

In all these ways, whether from instinct or observation, Branagh seems already to have learned and applied the lessons in popularization that have emerged from this analysis of Zeffirelli's Shakespeare films. As I write he is about to release his four-and-a-half-hour version of *Hamlet*. There is thus every reason to hope that Branagh will continue to carry on where Zeffirelli has left off.

NOTES

1 Zeffirelli was pleased with *The Champ* (1979) and it made a great deal of money, but critics found it too sentimental. Along with the critics, he was displeased with *Endless Love* (1981), although it, too, was highly profitable. *Brother Sun, Sister Moon* (1973) was an all-around disaster, and *The Young Toscanini* (1988) remains incomplete, "a $22 million, nine-month nightmare" (Stivers 1991: 56).

2 Lawrence Levine has recalled a time in early nineteenth-century America when Shakespearean drama was both popular and elite, "attended both by large numbers of people who derived great pleasure from it and experienced it in the context of their normal everyday culture, *and* by smaller socially and economically elite groups who derived both pleasure and social confirmation from it" (Levine 1988: 86). He analyzes the sacralizing processes which in the latter part of the century *de*popularized Shakespeare along with opera, classical music, and fine art. Although he briefly recognizes certain twentieth-century tendencies to break down the hierarchies that had thus come to separate high-brow culture from low, he does not discuss the *re*-popularizing potential of Shakespearean films.

3 What is timely in a youth-oriented market may soon, however, prove fatally out of touch. Zeffirelli attributes the failure of *Brother Sun, Sister Moon*, with its flower-child St Francis, to the change in attitudes reflected in the final years of Vietnam protests and flag-burnings: "Just as *Romeo and Juliet* had struck the right note at a time when young people were creating a cultural revolution, so *Brother Sun* went totally against the grain of the new cynicism" (Zeffirelli 1986: 265).

4 There is a revealingly apologetic note about Olivier's description of his film as "An essay on *Hamlet*," complete with its portentous topic-sentence: "This is the tragedy of a man who could not make up his mind." What a difference from the irreverent but ebullient credit in Zeffirelli's *Taming of the Shrew*: "Screenplay by Paul Dehn, Suso Cecchi D'Amico, and Franco Zeffirelli, with acknowledgements to William Shakespeare, without whom they would have been at a loss for words"! In a study that in many ways complements mine, Ace Pilkington details some of the screenwriters' verbal liberties (Pilkington 1994: 167–68).

5 Although the play has often been set in the milieu of a Renaissance court, Zeffirelli preferred an earlier period. In his search for locations for his Elsinore castle, he originally intended to "contrast the brutality of the surroundings with the flowering of the first Renaissance man in the character of Hamlet himself" (*Scotsman* 1989). In the event, though, the tie with the Renaissance which had proved so fertile in Zeffirelli's earlier films was lost altogether and Gibson's Hamlet became "a rugged young Viking in a coarse woolen tunic and leggings, his hair chopped short and his beard untended" (Darrach 1991: 42).

REFERENCES

Cirillo, Albert (1969/70) "The Art of Franco Zeffirelli and Shakespeare's *Romeo and Juliet*," *TriQuarterly* 16: 69–92.

Cole, Michael and Helen Keyssar (1985) "The Concept of Literacy in Print and Film,"

in *Literacy, Language, and Learning*, eds David R. Olson, Nancy Torrance and Anela Hildyard. Cambridge: Cambridge University Press: 51–72.

Darrach, Brad (1991) "Mad Max Plays Hamlet," *Life* 14: 38–43.

Donaldson, Peter (1990) *Shakespearean Films/Shakespearean Directors*. Boston: Unwin Hyman.

HBO Special (1990) "Classic Mel Gibson: The Making of *Hamlet*."

Hodgdon, Barbara (1994) "The Critic, the Poor Player, Prince Hamlet, and the Lady in the Dark," in *Shakespeare Reread*, ed. Russ McDonald. Ithaca: Cornell University Press: 259–93.

James, Caryn (1990) "Playing Mad Max to a Prince Possessed," *New York Times* 19 December: C15, 21.

Jorgens, Jack (1979) *Shakespeare on Film*. Bloomington: Indiana University Press.

Kitchin, Laurence (1960) *Mid-Century Drama*. London: Faber & Faber.

Levine, Lawrence (1988) *Highbrow/Lowbrow: The Emergence of Cultural Hierarchy in America*. Cambridge, MA: Harvard University Press.

Lucas, Walter (1967) *Christian Science Monitor* 15 July: 94.

Merkling, F. (1962) "Firebrand of Florence," *Opera News* 15 December: 15–16.

Pilkington, Ace G. (1994) "Zeffinelli's Shakespeare," in *Shakespeare and the Moving Image*, eds Anthony Davies and Stanley Wells. Cambridge: Cambridge University Press: 163–79.

Robinson, David (1991) "Hamlet, Prince of Hollywood," *The [London] Times Saturday Review* 13 April: 19.

Romney, Jonathan (1991) "*Hamlet*," *Sight and Sound* (May): 48–9.

Scotsman (1989), 12 September.

Stivers, Cyndi (1991) "Hamlet Re-Visited," *Premiere* (Feb.): 51–6.

Watson, William Van (1992) "Shakespeare, Zeffirelli, and the Homosexual Gaze," *Literature/Film Quarterly* 20: 308–25.

Young, B. A. (1984) "*Amleto* Again," *Financial Times* (London) 25 September.

Zeffirelli, Franco (1963) "Staging Shakespeare," in *Directors on Directing*, eds Toby Cole and Helen Chinoy. New York: Bobbs-Merrill: 437–40.

—— (1984) "Beauty Is Just the Frame," *Architectural Digest* 41.

—— (1986) *The Autobiography of Franco Zeffirelli*. New York: Weidenfeld & Nicolson.

—— (1990) "Filming Shakespeare," in *Staging Shakespeare: Seminars on Production Problems*, ed. Glenn Loney. New York: Garland: 239–70.

—— (1991) "Franco Goes to Elsinore," *Independent on Sunday* (London) 14 April.

6

SHAKESPEARE WALLAH AND COLONIAL SPECULARITY

Valerie Wayne

Shakespeare Wallah is about the reception of Shakespeare's plays in India after the end of the British Raj. Written, directed, and produced by Merchant Ivory Productions, the company that later made such films as *A Room with a View*, *Howard's End*, and *Remains of the Day*, the movie was released in 1965.[1] It tells the story of a British acting troop called the Buckingham Players that has fallen on hard times because they can no longer count on devoted audiences to attend their performances. The political changes in India as a result of independence, combined with the rising popularity of India's own cinema, have prompted a largely negative reaction to Shakespeare's plays among those who had previously received them with great enthusiasm. From a hybrid position of former British and newly independent subjects, the Indian audiences respond not only with approval but with mimicry and resistance; they also completely disrupt one performance. *Shakespeare Wallah* presents the bard's texts as sites of considerable cultural conflict in this post-colonial context.

Ania Loomba observed in 1989 that "more students probably read *Othello* at the University of Delhi every year than in all British universities combined. A large proportion of them are women." She estimates that 20,000 students may study Shakespeare's texts annually at that university alone. The pedagogy associated with this instruction is not encouraging. Loomba explains that the "English literary text" is studied in India "as an amalgam of universal value, morality, truth, and rationality" (Loomba 1989: 10). Jyotsna Singh agrees that the text of English literature "remains a hallowed entity" (Singh 1989: 457) in post-colonial India and relates contemporary approaches to Macaulay's support for education as an ideological means of subduing Indians in the nineteenth century: "in introducing English literature to elite Indians [then] – or in allowing them access to Calcutta theatres – the colonial rulers were not being egalitarian, but rather, were engaged in a 'hegemonic activity,' by which, in Gramsci's terms, the consent of the governed is secured through intellectual and moral manipulation rather than through military force" (449).[2] Viewed in this context, Merchant Ivory's film problematizes the place of the privileged Shakespearean

text in post-colonial India. The filmmakers even misrepresented the audience reception of performances staged by a real troop of Shakespeare players on which the movie is based.

Geoffrey Kendal was an actor-manager of a British theatre company called "Shakespeareana" that toured India in the 1940s and 50s. With his wife, Laura Liddell, their two daughters, and Indian members of the company including the actor Utpal Dutt, he performed Shakespeare's plays in schools and colleges with an average attendance of 300 to 500 per show. In his biography, Kendal describes the first play that his company presented during its 1953 tour: *Macbeth* at the Fort Convent. Having arrived with hand-carts of theatrical equipment, built a rostrum out of benches, borrowed a gramophone and put up curtains, members of the company

> retired to a kindergarten classroom to make up, cramming our knees under tiny desks and watched by crowds of children in the doorway. At the appointed time, the Witches and the Thanes emerged from the classroom to play their parts, and once again we were among the most rewarding audiences in the world; rows of intelligent Indian schoolgirls gazed at the drama with startled absorption, drinking in every word and gesture.
>
> (Kendal 1986: 107)

The compliance of this audience is disturbing. The young Indian girls at Kendal's schools "absorbed" the play, drinking in its language and gesture. I suspect Macaulay would have been pleased, and it is little wonder that Kendal was pleased as well, having found "the most rewarding audiences in the world."

What Kendal was less pleased with was the representation of his experiences as an actor-manager of the British touring company in the film, which was based on a screenplay by James Ivory and Ruth Prawer Jhabvala after they had read Kendal's diary of his company's 1947 tour. "Wallah" in Hindustani means "a small-time operator or anyone closely identified *with* something" (Ivory 1973: 89), so Kendal is the Shakespeare wallah of the title: he is the Shakespeare-man, the one who brings Shakespeare to India, who is so associated with the juxta-position of England and India that his title becomes half English, half Hindustani. The movie not only tells the story of a British acting troop based roughly on Shakespeareana; Geoffrey Kendal, his wife, his daughters, and Utpal Dutt also star in the film. But the movie's account is fictionalized and, in some respects, politicized. Ivory saw that the diary "contained a view of the transfer of power from the British to the Indian authorities as seen in small local events." He and Jhabvala reshaped those events into a story that would be "a metaphor for the end of the British Raj" (87). To do that, they changed the audience response to Shakespeare's plays.

Kendal's diary was written during 1947, the year that India became independent from Britain. The film was made eighteen years later in India. James Ivory, who also directed it, acknowledges that its making "was sometimes

distasteful for the older Kendals, especially in the beginning. It was too close to their own experience for comfort, yet far enough away to seem to them at times a kind of lie. The premise of the film appeared to be the negation of everything they had worked for for so long" (88). Ishmail Merchant, the film's producer, who was born and educated in Bombay, explained to me in an interview that at the time of its filming "we found a declining situation in India of English, of everything that was learned and understood about England." He adds that the number of people in India today who speak English has dwindled to about ten percent of the populace. So if Shakespeare is still taught today in Indian universities in ways that often sustain the imposition of British customs and values onto Indian society, this film creates a variety of responses by Indians to that cultural imperialism, including resistance and disruption of the Shakespearean text. It explores the cultural friction occasioned by performances of Shakespeare's plays in that time and place.

One of the audiences to the performances of the plays in the film is only too enthusiastic about them. An Indian maharaja establishes himself in a dinner-table conversation as one who knows his Shakespeare well enough to recall long quotations from the plays, and he uses the Shakespearean text to lament his own loss of wealth and power. The play that he asks the company to perform is *Antony and Cleopatra*, and the scenes we see from the production describe the dotage and death of Antony as soldier and lover. The maharaja is an audience of one for this production, although others in his large household are permitted to look on, and he identifies intensely with the decline of the great general. The setting of the production in an elaborate Indian courtyard reinforces an Orientalist view of the exoticism of India, which is adapted here to stage the exoticism of Cleopatra's East. At the end of the scene the maharaja gives money to Buckingham as the manager, flowers to the actresses, and general appreciation to all. His evening of Shakespeare has permitted him a personal catharsis for the loss of his own influence since the end of the British Raj, but his present wealth appears in contrast to the members of the Buckingham players, British and Indian alike, who are short on cash and down on their luck since there are fewer and fewer audiences like this one.

Shakespeare Wallah projects its own male audience of one throughout the film in a very different character, that of Sanju, who is played by the famous Indian film star, Sashi Kapoor. Sanju is an Indian playboy, a product of the new India, who appears in the movie as a spectator of and companion to women. In the course of the film he is asked to choose between two women who represent different media and cultures. He has long had an affair with an Indian film star named Manjula, who is gorgeous, enormously popular, self-indulgent, and brilliantly acted by Madhur Jaffrey. He is also entranced by the young daughter of the Buckingham players, named Lizzie, who is played by Felicity Kendal, daughter to Geoffrey Kendal and Laura Liddell. Sanju's attraction to Lizzie seems inseparable from his attraction to the culture of Shakespeare and the world of the theatre.

As specular objects, both of these women are associated with their respective arts of film and theatre, and their respective cultures, India and Britain. Sanju moves uneasily from one to the other, becoming increasingly attracted to Lizzie and progressively alienating Manjula. Although this story might be viewed as a traditional love triangle in which the women function as competing objects of desire, their objectified status and conflicting origins also permit them to be seen as the two faces of Indian culture, both of which are present in this post-colonial context. Homi Bhabha has described colonial specularity as "doubly inscribed . . . it is always the split screen of the self and its doubling, the hybrid" (Bhabha 1986: 175). Something like this hybridization occurs in the scene in which Manjula quite forcefully subjects Lizzie to tea, only to assert her own, prior claims on Sanju. When the man whom they both desire discovers them together in conversation, he is presented with the doubles of his desire, very different in simplicity and experience, submission and assertion, and yet both integral parts of his present culture.

Although the film asks him to choose one of these women, he seems unable to do so, perhaps because he is himself hybrid in being neither Indian nor British but some uneasy amalgam of both. The story of his attraction to Manjula and Lizzie reflects his desire for elements of a colonial past just as Indians are reaching for the freedoms of an independent future. Even Manjula, whose popularity as a film star depends upon the rise of the new India, serves Lizzie a formal English tea, using the occasion to manipulate the observance into a kind of ritualized subjugation of the English woman. Rather than ignoring English customs, Manjula appropriates them against their source. Her "display of hybridity," to quote Homi Bhabha again, her specific "'replication' – terrorizes authority with the *ruse* of recognition, its mimicry, its mockery" (176). Those strategies also evoke the mimicry that Irigaray characterizes as the "'path' . . . historically assigned to the feminine." Both accounts of mimicry are associated with attempts by non-unitary subjects "to recover the place of [their] exploitation by discourse" (Irigaray 1985: 76).

The movie's most sustained presentation of hybridity occurs during a performance of the murder of Desdemona in *Othello*. By this point in the film Sanju has grown closer to the English Lizzie, who takes the role of Desdemona, and Manjula agrees to attend a performance of the play. Although Sanju is present for the entire show, Manjula does not arrive until the murder scene: she stages her arrival as a disruption of the English production. Since she is far more able to attract an audience than the English actors of Shakespeare are at this point in Indian history, her entrance shifts the gaze of the audience from the performance of *Othello* by Lizzie and her father onto herself. The film dramatizes hybridity both on stage and in the box at the theatre, for black Othello is murdering white Desdemona while the Indian film star is challenging her lover's desire for the British actress by, quite literally, killing the scene.

The scene that Manjula disrupts shows jealousy on stage and in the balcony: as Othello is murdering Desdemona for what he supposes is her infidelity,

Manjula is killing the English production as revenge against the lover who has slighted her. Ethnicity as well as gender occasion jealousy in both cases. Othello's fear, as encouraged by Iago, is that Desdemona might desert him for one "Of her own clime, complexion, and degree" (3.3.232), and Manjula, who has a lover alike to her in culture and race, knows he is developing a relationship with the former colonizer. Both Othello and Manjula fear that their loved ones will turn coward and make the more conservative, white, and Western choice.

In both scenes, then, the non-Western other rises up against his or her oppressor in an act of what might be called resistance. But the lines of oppressor and oppressed, colonizer and colonized, are not so easily drawn as this remark suggests. While Othello is a Moor, he is also a man, and he murders a subordinate wife in Desdemona as well as a European. While Manjula is in the position of power in this scene, she is also an Indian woman attempting unsuccessfully to seduce her lover to return to her. And while Sanju is a man attracted to a British actress and her cultural past, he is also an Indian sensitive to the alien character of the theatre and of British values. All four characters have alliances with non-hegemonic identities, which is what makes their interaction in the film so multi-layered.

Bhabha says that "colonial specularity, doubly inscribed, does not produce a mirror where the self apprehends itself" (175). When Desdemona looks at Othello, she sees a husband who is both a Moor and a Venetian general, and at the end of the play Othello will kill himself as a means of killing the Turk, or Moor, in himself. When Manjula looks at Sanju, she sees one of her own culture who is drawn to a woman speaking the English of Shakespeare and his own colonial past. Even Othello and Sanju cannot associate each woman simplistically with a specific culture, for Manjula's wealth, like the maharaja's, gives her access to many of the Western luxuries that her own countrymen and women lack, and Desdemona has disclaimed her allegiance to the patriarchs of Venice in order to subject herself in marriage to the Moor. So all four characters are plural, non-unitary subjects who speak from conflicting subject positions. Further, Manjula's activity of disavowing British influence is maintained through some of the same strategies as the colonial mission, which Bhabha describes as "structured around the ambivalence of splitting, denial, repetition – strategies of defence that mobilize culture as an open-textured, warlike strategy whose aim 'is rather a continued agony than a total disappearance of the pre-existing culture'. . . . Hybridity intervenes in the exercise of authority not merely to indicate the impossibility of its identity but to represent the unpredictability of its presence" (175–76). Manjula's presence in this scene turns the unpredictability of the colonial culture onto itself, mimicking its power with the energy of the new India. As she does so, she sees herself, her culture, her lover not as "a mirror where the self apprehends itself," which would presume a unified subjectivity, but as "the split screen of the self and its doubling, the hybrid" (175).

There are, then, multi-layered hybridities as the two Indians sit in the theatre watching the two British actors. Yet the hybridity of the actor who plays Othello

is far less stable than any other, for he inverts the colonial position of black skin/white mask by painting a black mask over his white skin to present the part of the Moor. When Manjula disrupts this scene, Buckingham "loses it": he steps out of his role as Moor and reprimands the Indian audience for their inattention. For the Shakespeare-man, the role of non-Western is so alien that it does not prevent the re-assertion of his colonial authority when he believes his production of the British text is at stake. His hybridity, in other words, is only a part that he plays, and it is much more capable of collapse than the Indians'. Later in the movie he regrets his authoritarian reprimand, recalling that David Garrick once apologized for a similar act of chastising his audience at the next day's performance. Buckingham recognizes that in the new India he no longer has the authority of the colonizer and must rely on theatrical power and ideology to hold his audience. So the plural subject positions associated with theatrical representations are more unstable than the hybrid identities that Sanju and Manjula inhabit, which are not roles easily doffed at the end of a performance. Nor is the replication exercised by Manjula a mere matter of role-playing, for the text that she recognizes, mimics, and mocks is British culture. She is not free to determine that text, only to react against it. Perhaps that is one reason why colonial specularity assumes such importance in this film. Members of the Indian audiences can discover, create, and project their own subject positions through their reactions to the Shakespearean text, although they can also create texts of their own like the scripts for Manjula's films.

Sanju's split loyalties collide in the film's climax when his involvement with Lizzie prompts him to consider her as his own woman and beloved. Then the skills that Lizzie has as an actress threaten them both because she is seen to violate Indian norms for the conduct of women through her self-display. When Lizzie takes the part of Juliet, her role as a subject and object of desire elicits whistles and cat-calls from the Indian audience, because she is soliciting and responding to Romeo's affection in a public place. Those jeers are a disruption of the Shakespearean text by Indians who assert their own cultural norms for women's behavior over against the aesthetic conventions of British drama. Sanju then reacts not as a connoisseur and consumer of English culture, but as an Indian man whose woman is being publically shamed and ridiculed. The result is a conflict among Indians that completely disrupts the Shakespearean production, for a fight ensues that stops the show and eventually concludes the relationship between Sanju and Lizzie because Lizzie says she is willing to give up her acting career only for Sanju – "You only have to ask" (Ivory 1973: 151) – and he does not ask. At the end of the movie Lizzie is on board ship on her way to England, a place where she has never been although it is supposedly her home country. Her parents remain in India, where the acting troop is depleted by her departure and the death of another member. Given Lizzie's youth and her desire to act, one senses she is taking the most vital performances of Shakespeare's plays back with her to England because they no longer have a privileged place in India.

Lubna Chaudhry and Saba Khattak have argued that *Shakespeare Wallah* conveys Lizzie's departure and the demise of the British company with an "underlying nostalgia for the colonial period" that "makes the political stance represented in the film problematic" (Chaudhry and Khattak 1994: 21). They claim it shows that "with the demise of colonialism, things are falling apart, and the innocent bearers of high culture are the sufferers" (22).[3] I do not wish my analysis of the specular positions of audiences to imply that I find the film unambiguously supportive of Indian nationalism or entirely progressive in other respects. I agree with Chaudhry and Khattak that the filmmakers' "political attitudes" can be described as "ambivalent" (21–2) to their material, which may be appropriate to the conditions of hybridity that they explore. However, the only chaos depicted in the film is that associated with the productions of Shakespeare's plays, so it is not independence alone that occasions disorder, but independence combined with the continued performances of those hegemonic cultural instruments. While the film asks us to sympathize with the British players enough to care about their story, I do not see them as "romanticized" (22) and "heroic" (23); I see them as unable to change and slightly ridiculous. For me their recollection of the colonial era is presented as gently satiric, with the result that the viewer need not participate in the Buckinghams' nostalgia. Their investment in the past is instead part of the problem. Rather than unambiguously supporting either Indian nationalism or the purveyors of British culture in India after independence, the movie presents in my view a conflicted, post-colonial moment when the cultures are beginning to pull themselves apart. Shakespeare's texts provide the site of that rupture. Problematizing their cultural role in this way does seem to me to contribute to a critique of those texts as hegemonic devices, although the film avoids addressing larger issues about relations between Britain and India after independence.

The Indian audiences in *Shakespeare Wallah* range from the approval of a nostalgic maharaja and some well-behaved school children to the resistance of Manjula and the fighting throngs that disrupt the performance of *Romeo and Juliet*. This last audience is also in conflict with itself as Indians take up varying positions and receive assorted blows occasioned by the Shakespearean text. The film does not offer any easy resolution to this cultural friction, but the adaptation of the plays in a post-colonial context is, I think, a far better form of education than the study of those texts as icons of universal truth and value. *Shakespeare Wallah* presents its viewers, Eastern and Western alike, with a range of responses to the texts of the bard, including opportunities to mimic, resist, or reject them. These are options we might well keep in mind at a time when Shakespeare, the movie (and I do mean the movie, not the book) is once again a hit at the box office.[4]

NOTES

1 Further information on the early work of Merchant Ivory Productions is available in John Pym (1983) *The Wandering Company: Twenty-One Years of Merchant Ivory Films*. London: British Film Institute and New York: Museum of Modern Art.

2 For further discussion of this issue, see Gauri Viswanathan (1989) and Rajeswari Sunder Rajan (1992).

3 This essay on *Shakespeare Wallah* was first presented at a 1991 conference called "Translations/Transformations: Gender and Culture in Film and Literature, East and West," held at the University of Hawaii at Manoa and the East–West Center. A year later Chaudhry and Khattak presented their paper at a 1992 conference called "Gender and Culture in Literature and Film, East and West: Issues of Perception and Interpretation," which was sponsored by the same institutions and Chulalongkorn University and held in Chiang Mai, Thailand. Since the idea for their paper "was partly triggered by" my talk (Chaudhry and Khattak 1994: 25, n. 1), I am responding in this paragraph to their implied critique.

4 I am grateful to Joseph Hurley, Richard Tillotson, and Merchant Ivory Productions for providing books and information on the film which were of help in preparing this essay. My thanks as well to Shelley Nishimura for conveying to me the responses that members of her sophomore literature class had to the film when they viewed it at the University of Hawaii at Manoa in Fall 1996.

REFERENCES

Bhabha, Homi K. (1986) "Signs Taken for Wonders: Questions of Ambivalence and Authority under a Tree Outside Delhi, May 1817," in *"Race," Writing, and Difference*, ed. Henry Louis Gates, Jr. Chicago: University of Chicago Press.

Chaudhry, Lubna and Saba Khattak (1994) "Images of White Women and Indian Nationalism: Ambivalent Representations in *Shakespeare Wallah* and *Junoon*," in *Gender and Culture in Literature and Film East and West: Issues of Perception and Interpretation*, eds Nitaya Masavisut, George Simson, and Larry E. Smith. Literary Studies East and West, vol. 9, 19–25. Hawaii: University of Hawaii Press.

Irigaray, Luce (1985) "The Power of Discourse and the Subordination of the Feminine," in *This Sex Which Is Not One*, trans. Catherine Porter. Ithaca: Cornell University Press.

Ivory, James (1973) *Savages, Shakespeare Wallah: Two Films by James Ivory*. New York: Grove Press.

Kendal, Geoffrey, with Clare Colvin (1986) *The Shakespeare Wallah*. London: Sidgwick & Jackson.

Loomba, Ania (1989) *Gender, Race, Renaissance Drama*. Manchester: Manchester University Press.

Merchant, Ishmail (1991) telephone interview, 22 August.

Rajan, Rajeswari Sunder, ed. (1992) *The Lie of the Land: English Literary Studies in India*. Delhi: Oxford University Press.

Shakespeare, William (1984) *Othello*, ed. Norman Sanders. Cambridge: Cambridge University Press.

Singh, Jyotsna (1989) "Different Shakespeares: The Bard in Colonial/Postcolonial India," *Theatre Journal* 41: 445–58.

Viswanathan, Gauri (1989) *Masks of Conquest: Literary Study and British Rule in India*. New York: Columbia University Press.

7

POETRY IN MOTION
Animating Shakespeare

Laurie E. Osborne

Early in the nineteenth century, Mary Lamb and her brother published their "Tales from Shakespeare," rendering his plays in narrative form as "easy reading for very young children." The introduction offers the tales "for young ladies, too . . . because boys being generally permitted the use of their fathers' libraries at a much earlier age than girls are . . . frequently have the best scenes of Shakespeare by heart, before their sisters are permitted to look into this manly book" (Lamb 1975: viii). As both the introduction and the tales themselves prove, the production of Shakespeare for young children not only exposes how a culture imagines the education of its young people but also how reworking Shakespeare for children justifies a revealing degree of abbreviation, naturally only in preparation for the "real thing." The reconstruction of the plays in brief narrative form reveals as much about the growing importance of narrative as it does about the position and use of Shakespearean texts in early nineteenth-century England.

In the late twentieth century, *Shakespeare: The Animated Tales*, the recently released joint production originating in Wales, England, and the Soviet Union, alludes to the earlier tales quite deliberately in its title. Like the Lambs' narratives, the *Animated Tales* are centrally important not just because of how they present Shakespeare to a new generation of readers and potential audience members, but also because they train that audience in the influential new medium for conveying the plays. The *Animated Tales* underscore the mechanics of film, particularly as it brings Shakespeare's poetry into illusory motion. In fact they prepare their audience to understand the plays cinematically rather than theatrically or literarily. Thus these cartoons simultaneously introduce viewers to supposedly timeless canonical works and predispose them to understand those works and their significance through the lens of contemporary video culture, in which the most prominent visual mechanism is the film cut.

All Shakespearean films cut and rearrange materials from the plays – often to the dismay of eagle-eyed scholars – but the *Animated Tales*, like the Lambs' Tales before them, readily justify that curtailment on the basis of audience. Because of the immaturity of the youthful potential Shakespeare fan and the presumably limited attention span of the cartoon generation, the series first produced versions of *Macbeth, Romeo and Juliet, A Midsummer Night's Dream, Twelfth*

Night, *The Tempest* and *Hamlet* cut to run only a scant half hour each. To achieve such brief productions, the directors have reworked Shakespearean texts in ways as extreme as any of Mary Lamb's alterations. Yet because they are on film, a contested medium at the juncture of popular culture and high art, the explanations of the *Animated Tales'* editing derive equally from their proposed audience of ten to fifteen-year-olds and from their status as independent works of art, thus appealing to adult audiences as well. This double justification launches several competing perspectives on their treatment of Shakespeare's "sacred" texts.

Certainly there is a great deal to notice about the way the plays have been cut and rearranged. There is even more to explore if we go beyond the disparity between the *Animated Tales* and the Folio or quarto versions to examine the considerable differences between the films and the texts published as companions to the cartoons. To give one example of many, the *Animated Twelfth Night* is the most severely cut and rearranged of the productions, with its entire final scene reduced to a simple meeting between Olivia who is dancing with Sebastian and the Duke and Viola/Cesario who have just ridden up on elongated horses. None of Antonio's, Sir Andrew's, or even Olivia's complaints against Cesario even occur; Malvolio never returns to challenge Olivia with the letter. Instead the *Animated Tale* presents a simple but affecting meeting between the twins, Olivia, and Orsino, and miraculously clothes Viola in her woman's weeds once Orsino requests it. However, the Random House text of the *Animated Twelfth Night* does include a more substantial version of the final scene, although that text, too, cuts the Folio scene by quite a bit. The coincident publication of cartoon and text – as well as their disparate content – marks the significantly multiple ways in which the twentieth century conceives and recreates Shakespeare's texts.

These divergences also offer an unexpected echo of Lamb's introduction, which presents their tales as a first introduction and suggests that knowledgeable brothers gradually offer other parts of the plays to their less well-read sisters. Now the divide is not so clearly gender-based, but the implicit strategy is the same: a short taste of Shakespeare in the animated film and a somewhat longer version in the form of text (accompanied by cartoon drawings to indicate the action) will offer gradual exposure to Shakespeare's works. These strategies seem deliberately geared for British fourteen-year-olds, who now face mandatory written exams on Shakespeare's plays (Thomas 1992: 37). Truly, as some journalists have suggested, the texts seem aimed more at the adolescent facing a multiple choice test, while the animated films garner more complex responses (Buss 1992: 33).

Typically, the early journalistic coverage of the *Tales* was pretty evenly divided between analyses/criticisms of the necessary cutting of Shakespeare's texts and descriptions of the unique features of the series' production, including both animation techniques and the unusual alliance between Wales television and the Soviet animation studio, Soyuzmultfilm. In fact, the multinational origins and audiences of these productions often overwhelm considerations about supposed purity of Shakespeare's texts as well as the barely concealed cultural and financial

goals of this series. Even Britain's Prince Charles has praised the productions in revealing terms: "I welcome this pioneering project which will bring Shakespeare's great wisdom, insight and all-encompassing view of mankind to many millions from all parts of the globe, who have never been in his company before" (Waite 1992: C16). This not-so-veiled cultural imperialism runs alongside musings about the series' financial potential: "As a result of pre-sales alone, tens of millions of people are guaranteed to see it, and Shakespeare is set for his best year since the *First Folio*[sic] was published in 1623" ("Macbeth: Moscow-Style" 1992: 29). Such interests in the widespread cultural impact of these films – and the attendant monetary rewards – are generally balanced out and downplayed by discussions of actual physical production.

The Welsh–Soviet partnership and the relative poverty and difficulty of the Soviet animators' working conditions justify the financial gains while analyses of the varied strategies of animation in the series stress the importance of combined European skills (i.e. Soviet artistic animation rather than the commercial American version). Of course, the Welsh producers sought out Soviet animators not just because they would cost less than Hollywood practitioners, but because they were actively seeking a style and flavor of animation which would *not* smack of Saturday morning cartoons or the relentlessly commercial, thoroughly controlled Disney animating machine. As Christopher Grace, series producer, put it, "'I became aware that one could not challenge Disney on its own patch. The Americans want things like Ninja Turtles [not a Disney production], so I thought – stuff that, let's do something specifically European. Disney had conditioned a mass audience to expect sentimentality; big gooey-eyed creatures with long lashes, and winsome, simpering female characters. This style went with enormous flair and verve and comic panache and timing; but a lot of it was kitsch'" (as quoted in Lambert 1992: 17). The *Animated Tales*, then, were to be art, not kitsch. Even though founded in contrast to Disney's heavily commercialized popular appeal, the *Tales*' own extensive marketing collapses this opposition between commercial and artistic, popular and elite. In fact, because of commercial success, the production of a second series, *Julius Caesar, Richard III, A Winter's Tale, The Taming of the Shrew, As You Like It*, and *Othello*, followed quickly after the first series which I discuss here.

The tension between popularization and artistic goals produces inevitably conflicted assessments of the substantial cutting of the texts required by such brief versions. Almost every commentary on the series offers Leon Garfield's comments about the task he undertook in abbreviating the plays; several repeat his analogy for his work on the scripts as "painting the ceiling of the Sistine Chapel on a postage stamp" (Waite 1992: C16). He even produced his own brief essay in *Books for Keeps* on the subject (Garfield 1992: 36). Alongside Garfield's minor apologies for the narrative voice-overs which move the action forward at a cartoon-clip, he insists that he has kept as much of Shakespeare's dialogue as possible for a thirty-minute adaptation. Attending to abbreviation results in repeated suggestions that, despite their overt appeal to an adolescent audience

and self-evident educational purpose (the texts have an accompanying Study Guide offered free to teachers), these productions are also independent works of art, suitable for adult audiences. Stanley Wells, the series Literary Advisor and well-known editor of the *Complete Oxford Shakespeare*, suggests "that these films are not just educational aids that will introduce children to Shakespeare painlessly, but independent works of art which, like many of the operas, ballets, and paintings based on Shakespeare, transmute their raw material into something rich and strange in its own right" (Wells 1992: 6). Although Wells neglects to include other Shakespearean films as examples of the independent creativity which justifies these productions, nevertheless, the connections between the *Animated Tales* and Shakespeare on film are one of the most striking aspects of the series.

Clearly, *Shakespeare: The Animated Tales* offers fertile territory both for cultural materialists intrigued by its political, financial, and multinational strategies for promoting Shakespeare and for Shakespearean textual purists most involved with the ways Shakespeare is endlessly revised for changing audiences.[1] However, I am most interested in the juncture between the strategies of filming and the editing of the plays which animation so tellingly reveals. The mechanics of the animation process underscore the connections between textual editing and the construction/editing of Shakespearean films. Equally importantly, the medium's effects on its various audiences bring to the forefront film techniques which operate less visibly in the "realistic cinema" of other Shakespearean films. As these cartoons introduce children to Shakespeare's plays, they also establish the conventions and strategies of film as the condition of the plays' current value and interest.

Obvious support for the significant connection between the *Animated Tales* and Shakespearean feature-length productions appears in the visual echoes which these productions offer of earlier films. The most distinctive aspects of color and design in *A Midsummer Night's Dream* have interesting connections to Peter Hall's 1970 film production. Both productions have fairies of unusual and changing hues, Oberon and his companions blending into the forest background for invisibility, and the occasional shot of only feet in the frame. Although Mercutio's lines in the *Animated Romeo and Juliet* are a fraction of those he has in the Zeffirelli version, his face and distinctive blond hair could be a caricature of John McEnerny's angular, chiseled features. Lady Macbeth and particularly Macbeth often resemble Jeanette Nolan and Orson Welles in feature and gesture, even while the clays masks, mutating bones and insistent presentation of drumming recall some of Welles's more distinctive alterations to the play. The *Animated Twelfth Night* offers an obviously piratical Antonio, Olivia amidst a sea of heavily veiled ladies in waiting and an opening sequence of the ship splitting which repeat images from the 1956 Soviet *Twelfth Night, Dvenadsataia 'noch*. This film is not so well known in the West but likely more familiar to the Russian-born animators who created these tales. Claudius of the *Animated Hamlet* could have been drawn directly from Olivier's Claudius just as the

constructed camera movements echo Olivier's unusual tracking shots which trace the battlements, follow a dizzying climb up the stairs, and concentrate shadow and isolation about the young prince of Denmark. I am not suggesting that the Soviet animators deliberately allude to these other Shakespearean films, though in some cases the images are so close that the similarity seems designed rather than accidental. Whether deliberate or happenstance, these connections serve to associate the cartoons more closely with Shakespearean films than with narrative children's versions or with Saturday morning cartoon programming aimed solely at children. These traces of earlier film productions often give the *Animated Tales* a familiar feel, but more importantly underscore the potential realized in animation to reflect upon the ways all Shakespearean films recreate his poetry in motion.

At the heart of these connections lies the fact that animation as a film technique enacts the basis of all film – the use of successive still images which create an illusion of motion. This effect is possible because of persistence of vision, that is, the ability of our retina to retain an image as long as a tenth of a second, and its conceptual equivalent, the so-called phi phenomenon, which allows us to perceive connections and relationships between such images.[2] Moreover, animation creates its movements self-consciously and fluidly because of the animator's control over the drawings or figures which form the basis of motion. Russian film theorist Yu. Lotman suggests that, while film presents a "moving photograph" which functions as a direct sign of reality, the semiotics of animation "operates with signs of signs; images of images are what moves on the screen in front of the spectator" (Lotman 1981: 37). British and American film theorists pursue this logic in slightly different ways, sometimes arguing that what is most crucially at stake in animation is the way in which the still image can be used to create apparent motion, the ways in which the knowledge that the visual image is static conflicts with the perception of successive images transforming that stasis into motion.[3] Animation creates a kind of magic for the spectator wherein what we know to be immobile becomes mobile before our eyes.

In the arguments I wish to offer about the first series of *Shakespeare: The Animated Tales*, the differing strategies of animation used for the initial six productions enable greater or lesser degrees of distance for the spectator. Because our awareness of the images' static quality varies, we can see more readily in the *Animated Tale* than in other Shakespearean films how cutting, rearranging and layering the Shakespearean playtext are embodied within the strategies of film editing. I see the individual frame of the animated Shakespeare tale as fundamentally analogous to the individual lines of the playtexts – as the abbreviated tale must splice together lines and speeches from the play to create an ongoing movement of narrative which represents a version of Shakespeare's play, so the animator must set image by image to create the movement of the characters and objects which enact that play. The comparison I am suggesting here is supported by the series producers' ready acknowledgment that the animators revised the

texts as they were drawing them (Buss 1992: 33). As a result, the three different techniques of animation used in both the first and second series – cel animation, puppetry, and an innovative Russian method involving painting on glass – all offer fascinating and different reflections on the changes which the cartoons enact in the dramatic text. Each establishes a slightly different perspective on the relationship between text and film, between the static image and the illusion of movement which film creates.

Three of the *Animated Tales* are produced using cel animation, a technique familiar from a host of Disney films. This method uses images created on layers of transparent acetate so that parts of the background can remain unchanged as images move in front of them. To create the illusion of depth of field, cel animators sometimes use a device called a multiplane camera, which places the layers of acetate at varying distances from the lens. *A Midsummer Night's Dream*, *Romeo and Juliet*, and *Macbeth* are all presented through this technique. While Russian cel animation is distant kin to the Western version, the styles of drawing are wholly distinctive, as are the effects created for the audience. Although some argue for the unique efficacy of animation in engaging its audience, accepting the animated image involves degrees of awareness, affected by the quality of the image, the perceived jerkiness or smoothness of the movement, and the extremity of the transformations in the images. Through these varying features, we discover that the material production of animated film also negotiates the changes to the Shakespearean text.

In *A Midsummer Night's Dream*, for example, the most noticeable textual change is the sheer dominance of the narrative voice-over in the cartoon. Of all the productions, *Dream* keeps the least of Shakespeare's dialogue and constructs the most extensive narrative overlay. The rewriting of the play as narrative is especially obvious in the opening, where Menna Trussler, the narrator, explains almost everything: the situation of the lovers, the disposition of the homespun actors, and the nature of the mysterious wood. Of the first several scenes, the cartoon keeps one line, Lysander's "So quick bright things come to confusion"(1.1.149).[4] The flow of near-continuous narration and the omniscience evinced by our unseen guide anticipate the transformations of the animation which represent the fluid world of the forest.

In fact, the voice-over narrative moves from representing actions as they happen in the plot to invoking the fairy world in ways which elide elements of the text which are omitted. In the opening, the voice may omit Theseus's role in conquering his bride as well as his participation in the coercion of Hermia, but otherwise it offers us events as they appear animated before our eyes: Egeus promising Hermia to Demetrius, Helena betraying Hermia's and Lysander's intended flight and all four of the lovers fleeing to the forest. Initially, at least, the narration seems to promise an accurate condensation of the plot which will match up with the images on the screen directly. However, once the lovers reach the forest, the narrative voice begins to rework speeches which exist in the play. The narrative substitutions for both Titania's eloquent invocation of the discord

in nature and Oberon's own description of the magic flower coincide with images which make ample use of the possibilities in cel animation but rather less use of Shakespeare's text. The suns which emerge from the mouths of fantastical animals and turn into snowflakes represent a radical abbreviation of troubles caused in nature by the fairies' disagreement. However, this image seems in fact to come from Oberon rather than Titania since it apparently emerges from his head as his leafy hair turns out to the its backdrop.

The description of the flower offers only its magical properties, which the animators represent first as a sequence of stop-action growth much like stop-action photography used to display the entire cycle of a plant in a minute. The petals grow and then suffuse with purple, alternate petals fatten and pinken into hearts, and then those petals actually grow red hearts in their centers. Just as the flower seems about to overgrow the screen, its petals break from the stem, shedding droplets which strike the sleeping butterfly below. In an active demonstration of the flower's potency which echoes its symbolic imagery as a love-flower, the hapless, anointed butterfly awakens only to spy and love a singularly unattractive armored bug. Like the narration, the animation – which lasts all of twenty-six seconds – represents the flower's effects but leaves out its source since the fair maid of the west disappears from both the imagery and the language.

Initially, given that persistent narrative voice, the plot of the comedy seems to remain almost intact. In fact, however, much of the framing action falls by the wayside: the details of Theseus's impatience and the conquering of his bride Hippolyta, his own harsh injunctions to Hermia, and almost all of the lovers' decision-making and posturing. The tale moves quickly into the forest world where the fairies and rude mechanicals dominate and where the play itself signals a space of transformation and magic. In the forest, animation and editing begin to coincide through mechanisms of transformation which culminate with Bottom's hat descending over his face and transmuting into a head with long ears, gradually turning from the gray of his hat to the brown of his asshead.

Most notably, the animators render the Fairy King, Puck and even the Queen invisible by making their human-like bodies vanish and leaving only the feathers and natural items of apparel which blend into the background. That strategy best exemplifies the editing process applied to Shakespeare's text, wherein the narrative voice "paints" the background action and events while brief excerpts from fully fleshed speeches mark the outlines of a largely invisible play. As the feather/leaves of Oberon's hair and ornamentation trace his presence although his body is gone and the animation registers the movement of that invisible body by the shifting of his surrogate "features," so the *Animated Tale* threads together elements of Shakespeare's comedy and creates the outline of the whole largely through the motion of its chosen features against its narrated background.

For the *Animated Dream*, the manipulations of animation, not of magic and theatricality, overwhelm the humans in the forest. The self-consciousness of

the animating replaces the framing of the wedding entertainment, leaving the performance of Pyramus and Thisbe as the briefest of afterthoughts. In this concentration on the magic of the forest, the *Animated Tale* echoes other films of *Dream* where "film magic" overwhelms the comedy's theatrical elements. One need only recall the lengthy, spectacular effects of the fairy world in Reinhardt's 1940 *Dream* or the deliberate jumpcutting of Hall's; both films use cinematic magic which almost subsumes the mortal theatricality in the non-fairy plots. However, the *Animated Tale* so explicitly overtakes and upstages the images of theater that it cuts almost all of the rustics' planning and worrying about their production. Animation becomes the producer of magical illusions which can replace the text.

By contrast the drawing and movement of the *Animated Romeo and Juliet* offer a stylized, even artificial version of cel animation which one commentator likens to "a prettily imagined, colorfully illustrated Renaissance folktale. The characters are more like types than individuals" (Andreae 1993: 14). In *Romeo and Juliet*, more than in either *Dream* or *Macbeth*, the necessarily flattened perspectives of cel animation are brought into the foreground in the drawing, especially in the chiseled and largely immobile features of the characters. Their expressions vary only minimally – Juliet actually brings a mask up to her face to transform her placid expression into tears upon hearing that Romeo is a Montague. The relative immobility of their facial features reflects and enacts the limitations on their emotional depth. Equally the compression of the already swiftly running action of the tragedy makes the potentially troubling double suicide of the youthful lovers seem more than precipitous. In such circumstances, the persistent image of the striking clock, which recurs on seven separate occasions, seems an almost superfluous reminder that the action we watch is proceeding too rapidly for the characters' spoken emotions to justify fully their passionate actions.

For example, Mercutio barely speaks and never engages the audience or Romeo with even a truncated version of his Queen Mab speech, so that the narrator's assertion that he is Romeo's best friend and his strikingly similar haircut (though blond rather than brown) are all that tie him closely to Romeo. As a result, when he dies, the cartoon figure's pain is literally neither so wide as a church door nor so deep as a well; it is not enough and won't serve to motivate the sudden duel which follows between Romeo and Tybalt. Juliet has no opportunity to vilify Romeo or mourn Tybalt nor does she turn to defend Romeo from the Nurse; as a result, her passion and her character seem shallow and unthinking. Because these levels of their responses are cut, Romeo's and Juliet's feelings are as flattened as the images of them which the *Animated Tale* presents. The result is a very pretty cartoon whose lack of perspectival depth underscores the erasure of differing aspects of the characters in its editing. The flattening of perspective also comes to reflect the repressiveness of the cartoon's handling of the potentially volatile double suicide. The cutting of the playtext, though obviously necessary for such a brief production, also works to limit audience

engagement with the youthful protagonists as they rush headlong to join each other in death.

In the middle of the *Animated Tale*, however, there is a decisive shift to more feature film-like techniques: superimposed images, the animated equivalent of soft focus, and intercut shots of movement. The tale also moves into more voice-over narration, in this case more effectively than in *Dream* because actual dialogues or monologues are used. This late shift in animation reinforces and exceeds the one early voice-over during the balcony scene where Juliet speaks while we see the moon which neither of the lovers actually mentions. On the night of their union, not only are images superimposed as the lovers appear entwined in an overlay of the outside of Juliet's balconied window, but "ghost images" of the lovers take over from the undressed figures embracing. These appear clothed, pale, and shot through by Cupid's arrow. Finally, the lovers disappear entirely as their debate about the lark and nightingale occurs only in voice-over as day lightens the same exterior shot. These filming strategies achieve a depth to the young love which it lacks until this point, ironically during the moments of the film which caused the animators and their associates the most trouble artistically.

Conflicts arose between Western marketers and the Soviet animators over the representations of sexuality in the play, so much so that the revisions delayed production: "In *Romeo and Juliet*, director Efim Gamburg had trouble animating the love scenes. . . . 'The BBC had special demands,' says Gamburg. 'Not too explicit, but not too abstract.' . . . Animators joked (roughly translated) that Romeo and Juliet could have had children in the time Gamburg took to make the film" ("Macbeth: Moscow-Style" 1992: 30). Much of the overt debate in the production obviously stemmed from the proposed images of Romeo's and Juliet's sexual union, even though that sequence paradoxically is most likely to engage the viewer's sympathy in the lovers' plight. Removing their stylized clothing while keeping the brief and poignant argument about the lark and the nightingale achieve for them a degree of emotion which they only seem to caricature in the rest of the film.

The opening scenes emphasize the lack of perspective in the drawings even as the textual editing removes layers from the characterization. Then, the *Animated Romeo and Juliet* brings in film techniques from live action films to enact the even more radical cutting of the end of the playtext. The later movements of the tale also use voice-over, but more to telegraph missing parts of the playtext. Friar Laurence's plan to rescue Juliet from marrying Paris becomes the voice-over narration which accompanies the images of her taking the potion, her death and the mourning of her family, and her funeral. This swiftly changing scene, shot with white fog at the edge as if in soft focus, effectively replaces several scenes of dialogue with animated action in an acceleration of the plot which hurtles the lovers toward their final encounter. The textual editing coincides revealingly with the combination of flattened perspectives and voice-over techniques. As a result, the effects of one-dimensional acetate images and the potential power of

dislocating voice from animation during the voice-over underscore the way the text has been reworked.

The drawings of Macbeth resemble more closely the heavily shadowed cartoons of muscled heroes in comic books than the uniformly placid features of Romeo and Juliet or of Disney's heroes and villains. Changes in the shadows marking Macbeth's face keep his expression in near-constant motion. This strategy is essential for maintaining the illusion of movement during the long scenes focusing on him as he speaks the various speeches which must necessarily remain part of the *Animated Tale*.

The witches and Lady Macbeth, by contrast, undergo radical transformations of body and face which reflect and enact their lines, giving motion and re-inforcement to the witches' predictions and Lady Macbeth's self-transformation. The witches' bodies fluidly change shape, and Lady Macbeth "unsexes" herself by splitting the bodice of her dress and allowing the emergence of a horse and a toothed beast from her body. During the murder of Duncan, Lady Macbeth's body moves with the shadows of blue marking her femaleness and signaling her movements so vividly that the numerous cuts to her role are hardly apparent. In the sleepwalking scene, Lady Macbeth appears alone and unwatched by maid or doctor; she relives the night of Duncan's murder with her eyes open, but neither her actions nor her madness impinges on Macbeth at all, even though he does give some of his famous lines upon her death.

The reworking of Macbeth's role is largely represented through images of fragmentation which characterize the tale as a whole, creating a visual coherence in the cartoon which belies the disintegration which both the tale and its editing of the play seem to record. Nowhere are the connections between animation and editorial strategies more explicit than during Macbeth's decision to murder Macduff's family. After his speech, the image of his head literally fragments into seven separate pieces – as the kingly mask offered at the beginning fragments and Lady Macbeth's body splits in two when she calls upon the ministers of darkness to unsex her. Whereas the pieces of Lady Macbeth's fragmented self transform into beasts before our eyes, the seven pieces of Macbeth's head gradu-ally become the five murderers who move upward on the screen until three black shadows apparently destroy Lady Macduff and child. The actual scene of Lady Macduff's murder is cut, replaced by a stained glass image of a mother and two children assaulted by three shadowed murderers. The fragmentation establishes Macbeth's sole guilt in the act, while the successive loss of the fragments from seven jigsaw shadows down to three shadowy murderers marks the losses to the text which is so fissured.

The recurrence of these images which fragment and become reconstituted as other parts of the plot and action underscores the ways in which the play *Macbeth* has been fragmented and then reconstituted, almost impressionistically, linking the disparate fragments: pieces of Macbeth's speeches are detached and moved around in the play, as Lady Macbeth's "unsex me" speech has itself been split and moved. In some cases, the cutting and reconstitution paradoxically

creates a kind of unity. For example, all of Lady Macbeth's speeches from the sleepwalking scene have been spliced together as a continuous soliloquy, removing the nurse, doctor, and all of Macbeth's knowledge about her distress all at one blow. The animation magic which creates connections here works to smooth over the patchwork linkage of elements of *Macbeth*; however, ultimately, the use of animation to fragment and reassemble images reflects the ways parts of the text have become lost fragments while others are reassembled to insure that all the "good lines" remain.

Whereas the tales using cel animation employ transformation, stylized drawing, and imagistic fragmentation in their renderings of the shortened texts, the puppetry of *Twelfth Night* and *The Tempest* offers significantly different relationships between the material production of the film and the reworking of the texts. The puppets and physical sets used for *The Tempest* and *Twelfth Night* provide a depth and sense of perspective much more difficult to achieve in cel animation. The trade-off, however, lies in the audience's increased awareness that puppets are inanimate and must be moved by hand to create the illusion of motion. As Lotman puts it, "The transposition of puppets onto the screen means an essential displacement in their nature [from] . . . the puppet theatre, where the 'puppetness' is the neutral background. . . . In cinema the puppet replaces the live actor and thus its 'puppetness' comes to the fore" (Lotman 1981: 38). The *Animated Twelfth Night* actually foregrounds its own use of puppets as opposed to illustrations by showing Orsino worshipping a picture of Olivia which then fades into a shot of the Olivia-puppet herself.

Indeed, awareness of 'puppetness' is quite evident in the responses to these two cartoons. One commentator praises the *Animated Twelfth Night* in telling terms: "the exquisitely crafted and articulated little puppets, shifted frame by frame in answer to scrupulous observation of human movement, give the action rare enchantment and wit" (Andreae 1993: 14). The evident craftsmanship as well as the scale of the figures make the audience quite conscious of "scrupulous" movement enacted by others, not by the figures themselves. In fact, the details of that movement preoccupy those who write about the series: their jointed skeletons designed for minute movements, the replaceable heads which offer different facial expressions and the eyeballs which can be moved with a pin ("Animation: A Visual Symphony" 1992: E14). The size of the puppets proves equally fascinating for everyone from Robin Buss, who visited puppeteer Marcia Muat, creator of the *Animated Twelfth Night*, to Stanley Wells, who marvels that "subtly different figures were used for the 'identical' twins, Viola and Sebastian" (Wells 1992: 6). The paradox of such puppetry is that, by setting these plays at one remove, it augments both the audience's awareness of manipulation and their admiration for resulting illusion.

The most obvious way that this method of filming reflects the textual editing lies in the change in scale: the human actors are replaced by nine-inch puppets. Scaling the performers down to a seventh the size (or less) is roughly comparable to cutting a three-hour play down to half an hour. However, the use of the

puppets reflects the manipulation of the text in more important ways. Their physical presence not only heightens the consciousness of the still images fashioned into motion, but also produces a depth of field for the animation which is reflected in the layered editing which the *Animated Twelfth Night* offers. In distinct contrast to the multiplane filming on cel animation which achieves only minimal effects of depth, the puppet stage permits foreground and background action.

Like the puppets themselves, segments of *Twelfth Night's* text are moved around freely and often shortened drastically. However the most important revision involves both movement and interleaving of various scenes; Act 2, scenes 1 and 2 and Act 3, scene 3 are all intermingled in layers on the screen as Viola paces back and forth in her soliloquy, while Antonio and Sebastian appear together for the first and only time in a conversation which combines both their meetings in the Folio. In effect, the cutting and mingling of an array of scenes from the Folio text overlap visually on the screen. This mingling exploits changing depth of focus to show Viola and Sebastian together, yet separate, and recalls other equally rearranged film productions like the Dexter/Plowright *Twelfth Night* which juxtaposes Plowright in both roles through a soft focus shift from Viola's lament for her sister to Sebastian, declaiming "My name is Sebastian" (2.1.16).

The complexity of choreographing the movements of multiple puppets also dictates some of the revisions and streamlining of the text. For example, as I have already noted, some of the most extreme cuts appear in *Twelfth Night's* final scene. The director, Marcia Muat, chose to avoid the multiple confrontations of the Act 5 in favor of moving only four puppets around the stage. Rather than emphasizing the twinning through the series of claims on Viola, the *Animated Twelfth Night* relies on the nearly identical puppets of Viola and Sebastian, whose twirling embrace includes the film's audience among those who cannot, briefly, tell the two apart. As a result the cartoon achieves effects with puppets which elude the films of the play unless they resort to doubling the roles of the twins.

Puppetry has explicit, even thematic connections to *The Tempest*, as one journalist's description demonstrates: "9 in. figures stand on stage sets 5 ft. square and are moved by a director, who becomes a Prospero in his own right" ("Macbeth: Moscow-Style" 1992: 30). The production itself invokes more familiar versions of puppetry, as Ariel flies about on wires, alternately embracing Prospero's neck and descending as the terrifying Harpy whose eyes shed lightning on three men of sin. Even more intriguing, Prospero's magical manipulations of the people on the island draw his influence startlingly close to that of the puppeteers. The information at the start of Act 1, scene 2 is given over to the narrator, so that Prospero's initial interaction with his daughter becomes nothing more than assuring her no harm was done and hastily sending her off to sleep. The *Animated Tempest* keeps only one line (boldfaced) of three that register Prospero's power to impose sleep: "Here cease more questions./ **Thou art inclin'd**

to sleep; 'tis a good dullness,/And give it way. I know thou canst not choose" (1.2.184–86). What the play presents as a gradual falling asleep, the film limits to a single statement. Not only are all of Miranda's questions about her mother and situation omitted from the scene, but also, at Prospero's peremptory "Thou art inclin'd to sleep," her eyes close and she is laid out in total stillness on a rock. The effect here is to draw attention to her as a puppet no longer in motion once Prospero lays her to rest.

He imposes a similarly resonant stillness on Ferdinand later in the same scene. When the prince responds to Prospero's threat of manacles with "I will resist" (1.2.466), Prospero renders him immobile with a gesture of his staff and a flash of bluish light. As with Miranda, Ferdinand's stillness and rigidity recalls the fact that he is a puppet just at the moment when Prospero proves that he has "more pow'r" than Ferdinand. These two magical gestures from Act 1, scene 2 establish Prospero as the puppeteer by bringing the puppet nature of his daughter and the Prince of Naples explicitly into the foreground.

Further deliberate emphasis on puppetness occurs in the figure of a female Ariel who literally flies on wires. However, while most obviously tied to Prospero's puppet-strings, this figure also undergoes a dramatic cel-animation-style transformation into the Harpy and appears to fade in and out of visibility as if translucent. Despite these indications that she transcends mere puppetry, this Ariel requests no freedom, exercises no influence, and claims no pity from Prospero for his captives. She only assures him briefly that they are "Just as you left them, all prisoners . . . They cannot budge till your release" (5.1.9,11). Prospero then spontaneously forgives them himself. Thus the one figure who exceeds the puppeteering powers of Prospero has her lines cut so that she is even more under his control than those he overtly stops and starts.

Such strategies of investing Prospero with the powers associated with the medium of production are surely familiar to those who have seen Peter Greenaway's *Prospero's Books*. As with *A Midsummer Night's Dream*, the *Animated Tempest* recreates the magic in the play by resorting to the illusions and manipulations of the mechanisms of animation. Most strikingly, the wholly subservient Ariel of this production combines the techniques of cel animation with the self-conscious representation of puppetry in order to create a Prospero whose powers apparently extend beyond the reach of sheer manipulation of figures.

The final and possibly most distancing technique employed in the *Animated Tales* is the unusual version of animation used for *Hamlet*. *The Guardian* offers the fullest description of this technique:

> The production of *Hamlet* was a remarkable achievement as it uses one of the most difficult animation techniques of all – painting on glass. This creates a final result with all the attractive textures of a moving oil painting . . . the animators paint directly on to sheets of glass which are suspended beneath the camera. They use a thick ink that dries slowly. After a frame is exposed to the film, tiny changes are made to the painting by scraping

away some ink and adding a little more as necessary. It is a painstaking process . . . with painting on glass, all of the work takes place under the camera with the surface of the same sheet of glass gradually transformed from the first frame of a scene to the last.

The difficulty of this technique means that it would be completely impractical to produce 24 paintings for every second of *Hamlet*. Instead, several frames at a time are shot of each painting, dissolving into several frames of the next. This approach also helps to give a more fluid look to the movements.

("Animation: A Visual Symphony" 1992: E14)

The light shone through the glass allows the film to register the images and their subtle changes. As Stanley Wells describes it, "elaborate paintings made on glass are slowly altered, detail by detail, till they exist no more" (Wells 1992: 6). The slow revision of a fragile painting on glass until the entire image is erased not only produces a painting-like quality to the work but also reflects a meticulous care in both presentation and erasure altogether suitable for a frequently revised work like *Hamlet*.

I address *Hamlet* last not so much because I necessarily share the general opinion that this cartoon is the masterwork of the series (it was the only one to receive an Emmy), but because its technique most thoroughly alerts viewers to the manipulation and changes in the images they watch. One critic notes that the medium is remarkable, "with the moving figure slightly adjusted by repaint-ing and the background filled in appropriately," but nonetheless acknowledges, "the movements do not have the same fluidity of motion as cel animation; they rarely let you forget you are watching something drawn or painted" (Andreae 1993: 14). This heightened awareness of the constructedness of the *Animated Hamlet* echoes the editing of the text by implicit acknowledgment of erasure, movement, and insertion.

The fact that *Hamlet* must be cut in performance is well known; the degree of cutting necessary to reduce a four-hour play to a half-hour cartoon is extra-ordinary. It goes well beyond the quarto-like limiting of the Fortinbras plot or the complete omission of Rosencrantz and Guildenstern. Moreover, the cutting of *Hamlet* is reflected in an animation technique which resembles a series of slight jump-cuts in its presentation of successive images. Such visible film jumps in movement often echo excisions from the play.

To give one notable example, the *Animated Hamlet* combines Ophelia's confession to her father at the close of Act 2, scene 1 with Polonius's self-important disclosure to Claudius and Gertrude that Hamlet is mad for love in the middle of Act 2, scene 2. The scene opens with a long tracking shot of Ophelia running, in the semi-fluid, semi-jump-cut style of this technique, from screen right to left throughout the cross-sectioned view of the castle. Her appearance follows the narrator's announcement after Hamlet's meeting with the ghost that he "resolved to hide his terrible knowledge under a cloak of madness"

and effectively usurps the frequently cut interchange between Polonius and Reynaldo about how best to spy on Laertes. When she reaches her father, shown in a long shot as seated at the right side of a table, she begins her lament, "My lord, as I was sewing in my closet" (2.1.74). As in Olivier's *Hamlet*, the animated production shows Hamlet visiting her as she describes the scene. When the film cuts back to Ophelia, she is on her knees, responding to her father's question about whether Hamlet is mad for her love, "My lord, I do not know,/ But truly I do fear it"(2.1.82–3). Thus far, her exchange with Polonius has seemed an intimate conversation, filmed in the animated equivalent of the two-shot.

However, at this point in their conversation, Polonius says, "This is the very ecstasy of love" and turns to his right at the table (screen left). Only then does he address Claudius and Gertrude who have apparently been sitting at the table with him throughout the entire sequence. Careful examination of the earlier long shot of Polonius reveals that the royal pair are there, though very far to the left and not illuminated as Polonius is. In this truly remarkable cut on action, as Polonius merely turns to begin his explanation to the King and Queen, the *Animated Hamlet* cuts all of Rosencrantz's and Guildenstern's roles, the ambassadors from Norway (that is, the Fortinbras plot), and Gertrude's suggestions that the source of Hamlet's behavior "is no other but the main,/ His father's death and our o'er hasty marriage"(2.2.56–7). These cuts embody the principal strategies which the film as a whole uses: the secondary "plots" of Rosencrantz and Guildenstern and Fortinbras are limited or excised throughout the production as are the complications of both Gertrude's and Ophelia's responses.

This shift in scene effectively uses the spatial requirements imposed by painting on a single pane of glass to efface in one scene almost all the major elements which the *Animated Tale* excises from the text. Just as important, the cut on action here is deliberately disconcerting, as what is encoded cinematically as an intimate conversation, made more personal by the images from Ophelia's memory, abruptly becomes a public revelation to the King and Queen about Hamlet's madness. Even an audience unaware of the significant cuts masked by Polonius's immediate gesture to Claudius and Gertrude will notice how unexpectedly the King and Queen appear in the frame. This mechanism under-scores the omission and misdirection even while establishing a spatial continuity of action which also allows the removal of almost all the bombast in Polonius's revelation. In this sequence, with less matter, we receive more art.

Not only are segments of the movement, like sections of the text, visibly "jumped over," but the viewer is always aware that each image is a revision of the previous one. Each moment of *Hamlet*, like the set pieces so often removed or strung together by other authors like Tom Stoppard, stands alone as a picture – mysterious, shadowy, and prey to loss and remembrance. Just as important each image is eradicated by the next one that fills the glass. As in the case of the sequence I have just described, the erasure occurs both on the pane of glass and in the text, evoking through the animation strategy the striking changeability which has always characterized both texts and performances of *Hamlet*.

It is no accident that the *Animated Hamlet*, with its painting-like images and self-conscious interplay of stasis and motion, is considered the most "artistic" production of the series thus far. This cartoon links the "high-art" form of oil painting to an animation technique which is both labor-intensive and visually reflective of how animation creates motion from immobility. This film in particular displays the fixed, apparently static canonical text being brought to life, but only through radical rewriting and the movement created by film.

The different techniques applied to these six plays test the limits of creating animated motion at the same time that they reveal the pressures on those who produce and cut Shakespeare's plays for performance. As even these brief analyses show, the audience of *Shakespeare: The Animated Tales* experiences an ever-shifting awareness of how the animators manipulate the still images which produce (when shown in rapid succession) the illusion of motion. The performative sequence becomes a more visceral and obvious feature in animation because of its method of production, but performative sequences and the reworking of Shakespeare's texts to produce plausible movements of character and plot development underlie all Shakespearean films and indeed all Shakespearean performances on stage as well. Such cutting and revision have always historically refashioned Shakespeare's plays, but are not always thrown into such sharp relief by the representation of the still images used to create illusory motion.

For *Shakespeare: The Animated Tales*, the paradoxical union between stillness and movement underwrites the ongoing debates about how Shakespeare's ostensibly inviolate texts are being rewritten and re-established as classics. The contradictions in audience and purpose which both producers and critics have revealed are equally significant results of this medium. For adults and for children, multicultural high art and popularizing educational device, the *Tales* enact an array of tensions about how Shakespeare's plays can and should be culturally positioned. As these categories collide and critique each other, the *Animated Tales* also unobtrusively teach both children and adults that the static Shakespearean text can be animated cinematically, that film, at the juncture of high art and popular culture, can make Shakespeare's plays live again.

NOTES

1 Attacks on the cartoons' cutting of Shakespeare apparently can come from all directions, as Geoff Brown notes in "Bard Suffers Slings and Arrows" (*Sunday Telegraph* Nov. 1, 1992: 12). Both Nick Seaton, member of the revealingly titled "Campaign for Real Education," and Terence Hawkes, well-known analyst of Shakespeare as a cultural icon, roundly criticize these films for their abbreviations.
2 Susan Rubin, *Animation: The Art and the Industry*, 1. The general information about cel animation and other animated techniques which underlies my arguments here comes from Rubin's work.
3 For a sampling of recent theoretical work on animation, please see Edward S. Small and Eugene Levinson, "Toward a Theory of Animation" in *The Velvet Lighttrap: Review of Literature* 24 (Fall 1989): 67–74, and a useful recent collection, *The Illusion of Life: Essays in Animation*, ed. Alan Cholodenko.

4 All references to the Shakespearean text will offer parenthetical notes to Act, scene
 and line numbers in *The Riverside Shakespeare*, ed. G. Blakemore Evans. If I am
 offering the cartoon text, I will footnote the appropriate accompanying text.

REFERENCES

Andreae, Christopher (1993) "'Animated tales' of Shakespeare," *Christian Science Monitor* Jan. 6: 14.

"Animation: A Visual Symphony" (1992) *The Guardian* Nov. 23, *Guardian Education*: E14.

Brown, Geoff (1992) "Bard Suffers Slings and Arrows," *Sunday Telegraph* Nov. 1: 12.

Buss, Robin (1992) "A Palpable Hit," *The Independent* Nov. 8, *The Sunday Review*: 33.

Cholodenko, Alan (ed.) (1991) *The Illusion of Life: Essays in Animation*. Sydney: Power Publications.

Dvenadsataia 'noch (1956) Y. Fried (dir.), Lenfilms.

Garfield, Leon (1992) "Shakespeare: The Animated Tales," *Books for Keeps* Nov.: 36.

Hamlet (1948) Laurence Olivier (dir.), Two Cities Film, 1948.

Hamlet: Shakespeare: The Animated Tales (1992) Natalia Orlova (dir.), Shakespeare Animated Films Limited, Christmas Films, and Soyuzmultifilm.

Lamb, Charles and Mary (1975) *Lamb's Tales from Shakespeare, A Facsimile of the 1909 Edition*. New York: Weathervane Books.

Lambert, Angela (1992) "Move Over, Goofy, It's Time for the Bard," *The Independent* Nov. 4: 17.

Lotman, Yu (1981) "On the Language of Animated Cartoons," in V. V. Ivanov, Yu. M. Lotman, and A. K. Zholkovsky (eds) *Film Theory and General Semiotics*: Somerton, Oxford: Russian Poetics in Translation, V. 8.

"Macbeth Moscow-Style" (1992) *Radio Times* Nov. 7: 29–30.

Macbeth: Shakespeare: The Animated Tale (1992) Nikolai Serebirakov (dir.), Christmas Films and Soyuzmultifilm.

A Midsummer Night's Dream (1935) Max Reinhardt (dir.), MGM/UA.

A Midsummer Night's Dream (1968) Peter Hall (dir.), Water Bearer Films.

A Midsummer Night's Dream: Shakespeare: The Animated Tales (1992) Robert Saakianz (dir.), Shakespeare Animated Films Limited, Christmas Films, and Soyuzmultifilm.

Romeo and Juliet (1968) Franco Zeffirelli (dir.), Paramount.

Romeo and Juliet: Shakespeare: The Animated Tales (1992) Efim Gambourg (dir.), Shakespeare Animated Films Limited, Christmas Films, and Soyuzmultifilm.

Rubin, Susan (1984) *Animation: The Art and the Industry*. Englewood Cliffs, NJ: Prentice-Hall.

Shakespeare, William (1974) *The Riverside Shakespeare*, G. Blakemore Evans (ed.). Boston: Houghton Mifflin Company.

—— (1987) *The Complete Oxford Shakespeare*, Stanley Wells and Gary Taylor (ed.). Oxford: Oxford University Press.

Small, Edward S. and Eugene Levinson (1989) "Toward a Theory of Animation," *The Velvet Lighttrap: Review of Literature* 24: 67–74.

The Tempest: Shakespeare: The Animated Tales (1992) Stanislav Sokolov (dir.), Christmas Films, and Soyuzmultifilm.

Thomas, Peter (1992) "Shakespeare: The Animated Tales," *Books for Keeps* November 1992: 36.

Twelfth Night: Shakespeare: The Animated Tales (1992) Marcia Muat (dir.), Shakespeare Animated Films Limited, Christmas Films, and Soyuzmultifilm.

Waite, Teresa (1992) "'Tempest' and Others the Size of a Teapot," *New York Times* Nov. 9 (v. 142): C16.

Wells, Stanley (1992) "Shakespeare's Been Framed," *Daily Telegraph* : *Telegraph TV and Radio* June 11: 6.

8

WHEN PETER MET ORSON
The 1953 CBS King Lear

Tony Howard

Grainy grey images, transmissions from a primaeval era less than fifty years ago. Videotape ages more brutally than film, but more hauntingly. . . . King Lear is carried out of the mill; as Mad Tom leaves with him, men and women converge on childless Gloucester. He is hemmed in by the dark grinding wheels. Goneril and Regan torment him and the camera slowly moves in, manoeuvring, ensuring the viewer will watch in close-up as Cornwall digs his thumb into the socket of Gloucester's eye. The camera does not look away. . . . Lear and Cordelia are reconciled; suddenly the enemy forces led by their general, Oswald, enter and cut the dialogue short. Father and daughter are seized without a battle. . . . In a dark corner of a New York t.v. studio King Lear drags a cloak across the floor; his dead daughter lies on it. He re-enters the empty stateroom where he divided the kingdom and he dies slumped in his throne. His last words are "Never, never, never, never, never." Only Kent and Albany are left alive . . .

"A perversion . . . " (Wadsworth 1954)

"Unforgivably bad . . . " (Griffin 1955)

"This performance went into history as a stern lesson in what not to do with Shakespeare on television" (Rosenberg 1954)[1]

In 1953 American academics were outraged by the *King Lear* broadcast live by CBS TV in its Sunday evening arts slot, *Omnibus*. *Omnibus* was prestigious – even in London the *New Statesman* praised its "serious, intelligent" programming[2] – and *King Lear*, presented by the Ford Foundation's TV-Radio Workshop, was budgeted generously at $150,000 and was broadcast, unusually, without commercial breaks. Advertised as the play's very first television production, it attracted enormous interest because of the collaboration at its centre: the director was Peter Brook, then the rising star of British theatre, and Lear was Orson Welles making his first appearance in America since film industry hostility drove him to work in Europe in 1948. By now Brook was twenty-eight, Welles thirty-eight, two ex-*enfant terribles* exploring Shakespeare's vision of old age.

King Lear was seen by 15 million people and won a high approval rating, but

like Olivier's film *Hamlet* it became a focus for scholarly panic, the fear that adapting Shakespeare for the mass media – worse, the mass *audience* – meant the violation of perfect texts. Brook cut *Lear* radically to fit *Omnibus*'s ninety-minute time-slot, and in fact it only ran seventy-three minutes because CBS bookended the play with adverts, an introduction by Alistair Cooke and a closing interview with the breathless and excited director. The issue was not cutting as such – George Schaefer's *Hamlet* (1952) only ran half an hour longer – but Peter Brook's virtual reinvention of the play.

Edmund and Edgar went. Mad Tom remained but was played by Micheál MacLiammóir (Welles's screen Iago) as the bedlam beggar he seems to be, and Edmund's role as Goneril and Regan's lover was taken over by Oswald, who ascended dazzlingly from Steward to General and embodied Brook's tendency – bitterly evident later from *The Marat-Sade* to *The Ik* – to present social change as by definition catastrophic. His reptilian new Oswald had none of Edmund's charm or cunning, no private motivation, and no soliloquies. And with no Edgar to overthrow him he was nearly triumphant.

"Literary amputation is a dangerous thing – with Shakespeare it usually leads to murder", complained Frank Wadsworth, who thought the mad scenes became "meaningless" and the new Oswald was "unconvincing" – how could princesses fight over "such a lackey"? (Wadsworth 1954: 261) But what was really provocative was the fact that neither Brook nor Welles was apologetic. When Olivier dropped Rosencrantz and Guildenstern he nervously called his film a mere "essay in *Hamlet*" and published the full text with his cuts marked for inspection; but Brook said seventy-three minutes was quite enough to tell *Lear*'s "story" – "intact" – and Welles used the same terms: "The play has been cut for television – a lot of the subplot – but the central story is still there. That's all people remember anyhow. If we did a full-length version, that would be too long for television. I've seen two-hour dramas on the BBC and they get tiresome."[3] In fact time was not the only factor behind the revisions: Brook *always* downgraded the Edgar–Edmund plot. In his 1962 RSC production both parts were strangely undercast; his 1970 film hacked them to a minimum, filling narrative gaps with caption cards; and he never made Edgar's victory heroic. In the 1953 *Lear*, Brook's interpretation, Welles's barnstorming presence, and the compromises forced by a commercial medium all shaped the final product.

The press responded differently from the professors. Though some reviewers thought the cuts made the second half incomprehensible, they found the event *reassuring* proof of the corporate enlightenment of sponsors and networks. The *New York Times* (19 October 1953) praised the Ford Foundation for keeping commercials out of the play itself, for "true t.v. experimentation", and for luring Welles back from Europe: it was his performance that attracted the popular and trade press's attention because he was an exiled Lear returning to his kingdom. Jack Gould praised his "true excitement, restraint and feeling", the *Herald Tribune* said he made Lear human, *Cue* called him "magnificent", and one critic proclaimed "Orson Welles burst into television (after several years of watchful

waiting) and knocked everything for a loop. The performance he gave of King
Lear established a new high for the medium in terms of power, heart and sheer
artistry." As a cultural event the credits were carefully balanced. Welles gave
publicity interviews beforehand – though the *New York Times* headline-writer
("Orson Welles, Making His Video Debut, is Both Helpful and Co-operative",
18 October 1953) was more welcoming than their reporter, who claimed he
wandered about bored when he was not in a scene ("He appears not to walk but
to shuffle with an air of relaxed pomposity") and puffed cigar smoke in Goneril's
face when he was – but it was Brook who went on-camera afterwards to
sum up.[4]

The production survives in the New York Museum of Broadcasting but
surprisingly little attention has been paid to it, even though Brook and Welles
were such crucial figures and though *Lear* subsequently loomed large in their
careers. Both staged it (Welles: New York 1956; Brook: Stratford 1962 with Paul
Scofield) and both filmed or tried to film it: Welles spent the last months of his
life straining to raise money for his own version. Ironically that project collapsed
along with promised funding from the French government, who had supported
Brook's experimental work since 1971. The CBS version preserves the moment
when the power balance between Shakespearean stars and directors shifted and
makes us ask whose *Lear* it was, Welles's, Brook's or Ford's?

In 1947 the producer Sydney Bernstein, later the head of Granada TV,
suggested Welles film *King Lear* in Britain. Welles became fascinated by the idea
of a low-budget Shakespeare film – a "charcoal sketch" in place of Olivier's
embalmed stateliness – which he would rehearse quickly, stage, and then shoot.
By trying to recapture the pace and spontaneity of his 1930s Mercury Theater
productions rather than creating classics for the archive, he hoped to bypass
Hollywood politics, exploit cinematic language, and reach a mass audience. The
details evolved erratically. When the Edinburgh Festival invited him to stage
a Shakespeare, Welles substituted *Othello* for *Lear*, planning to rehearse in
America and film in colour in the UK for £740,000. He took the revised project
to a different producer, Alexander Korda, who rejected his budget as unrealisti-
cally low. What finally emerged was Welles's notorious *Macbeth* (released 1948),
first staged in Utah then filmed for the B-picture studio Republic Pictures on
papier-mâché sets in twenty-one days.

As the last great actor-manager Welles needed to play Othello and Lear; as a
pioneer of new technology he had to rework them for different media. He began
to film *Othello* in 1948. *Lear* however joined *Julius Caesar, The Merchant of Venice*
and the Falstaff plays in the handful of Shakespeares which Welles tried again
and again to direct. All were meant to be cross-cultural, *international* projects
involving British, European and American actors, theatres in London, Dublin or
New York, and backers as varied as King Farouk, Italian and American t.v., and
of course Welles himself, recycling his income from acting and voice-overs.
During his bewildering travels Welles met Brook – whom he already regarded as
the best living Shakespeare director – when both were working on *Salome*

projects, and they fitfully discussed collaborations. Coincidentally, *Omnibus* invited Brook to create a major t.v. Shakespeare production just as Welles suggested he should direct him as Lear (Higham 1985: 281).

The budget was $150,000, which included generous fees for most of the cast ("I couldn't resist this job because of the dough they're paying": Arnold Moss [Albany]), $5,000 for Brook and a Byzantine deal for Welles, who was trying to extract himself from tax disputes and was paid in cash, cheques, lavish expenses, and cigars. Both Brook and Welles involved close colleagues including MacLiammóir, the composer Virgil Thomson (from Welles's *Voodoo Macbeth*), Natasha Parry (Brook's wife) as Cordelia, and the Russian designer George Wakhevitch who worked on many Brook productions, including his *Lear* film. Alan Badel, the Fool, had played the part triumphantly at Stratford in 1951 with Gielgud but most of the cast were American, led by Beatrice Straight (Goneril), Elizabeth Proctor in Arthur Miller's new play *The Crucible*. *King Lear* was transmitted live on 18 October 1953.

It began with Virgil Thomson's drumbeats and snarling brass over a close-up of a primitive map of Britain. Then Welles, offscreen, spoke the first words – "Give me the map there!" – and it was ripped apart. Just as in Brook's 1970 film, where the camera pans across a sea of mysterious, expectant faces until Lear breaks the silence with one preemptory word – "KNOW!" – Brook cut the exposition and established Lear's world with his disembodied voice and a harsh image of Rule. In 1953 Brook opted for urgency, in 1970 for numbed suspense (this crystallized the difference between the two versions), but both openings focus uncompromisingly on the rituals of personal power and discard social contexts: revealingly the map was held the wrong way up, with Ireland at the bottom.

Welles's Lear begins as a figure from a fairy-tale, wearing a black robe, a vast white collar and a pointed crown. He is triply monumental: immobile, huge, and with a face as stylized as an Easter Island statue – eyebrows like brushes, padded cheeks, a foxlike sculpted nose. "We have divided in three our king-dom": his words are measured and resonant but unexpected pauses suggest an old man's difficulties with concentration, even – despite the rumbling vocal power – insecurity. Welles is one beat ahead of the director here, for as Brook pans from Lear to Cornwall to Albany and to the sisters, the steady camera movement suggests unquestioned control.

The daughters sit in a row on a platform, eyes modestly downcast, hands folded on their laps. Everyone but the ancient King wears Elizabethan dress with stiff imprisoning ruffs for the women, who resemble a naive Tudor family portrait – each is backed by a blank panel as though painted on canvas. Cordelia wears a light dress, her sisters' are dark, and this good/bad coding extends to Albany and Cornwall. All three sisters are chilly and speak with a strangulated Kensington accent which seems a comment on upbringing and class. Like staid Goody Proctor at her McCarthyite trial, Beatrice Straight's Goneril does not know what to say. She makes a nervously high and rhetorical declaration of love.

Margaret Phillips's Regan is more sly, more knowing: she speaks caressingly and *chooses* her "loving" imagery. This is the key to both performances. When Goneril speaks, Brook cuts to a medium-shot of Cordelia (he restricts close-ups to what he sees as a few key moments) but she doesn't confide in the viewer: her aside is pre-recorded and echoes from a loudspeaker somewhere in the studio, creating an odd effect of privacy-plus-proclamation. She half-mouths the words she cannot say.

The whole scene has an air of icy rigidity which is visually embodied in the formal groupings and flat compositions. This is theatrical, but Brook also uses depth of focus in a powerfully stylized way. Time and again he plays variations on one image: the sisters' faces are in the foreground and their father is pushed back into the rear distance, a tiny figure whose loss of political and emotional power is blatant. This becomes Brook's basic visual strategy for their scenes of conflict as Lear, Regan and Goneril fight to possess the small screen. Like his RSC film, this *Lear* is a study of space – but in 1953 claustrophobia is the key, the royal family are caged rats. Even when Cordelia tries to communicate with her father there is no eye-contact; her profile fills one half of the screen with the confused old man dwarfed in the other. The characters' almost universal refusal to look at each other – France is more a foster-father than a lover – creates a sense of isolation which will become an overt philosophical statement in Brook's later versions. The scene ends on the faces of Goneril and Regan. Brook cuts their dialogue to a minimum but Regan's languid smile tells everything: they have already usurped the screen.

Brook's methodical story-board compositions and Welles's "grotesque" make-up (*New Yorker*) were both attempts to handle a medium in its infancy.

The make-up was bizarre even by Welles's standards (as an actor he seemed afraid of showing his face naked) and this was partly explained by distrust: "The technical excellence of the images in that Punch and Judy set, television", he said, "is about as bad as a picture of a Chinese play, in which someone brings on a chair and tells you it is a mountain" (Welles 1954). He was intrigued because somehow "the public is sufficiently held by that" but was horrified by the quality of reception in New York: "Good God, is that what *Lear* is going to look like?" His gross tragic mask was an attempt to make a strong facial image register on the tiniest screen. Yet the stylization was interpretive too: in his 1956 stage production Welles's Lear looked still more extraordinary and non-human; balding, hollow-eyed and hawk-like, "an Old Testament prophet caught in some medieval story – patriarchal in size and demeanour", a legendary "figure of fury" out of his time (*New York Times* 22 January 1956). The roughness and rapid turnover of live t.v. suited Welles's view of Lear as a monomaniacal Jonsonian humour, rather than a "genius" like Falstaff or Hamlet.[5]

One of Welles's motives in playing Lear was to investigate television, which he defined as an *Elizabethan* form because it was discovering its own possibilities: "Television is an actor's medium", he said, "It is going to reduce the director to something like his position in the theater", but he believed all directors should

learn from its "lightness and ease": "Television is an exciting thing because it is in the hands of the first generation." Cinema, however, had been taken over by non-innovators – "and they are ashamed of the first generation" (Welles 1954: 122).

Welles was right. 1953 was the start of the "golden age" of American t.v. drama, the year of Paddy Chayevsky's "documentary of the human heart", *Marty*. Soon William Salter would observe that television played a much greater part in US national life than in the UK and "draws on an altogether greater proportion of the talent available". By 1956 there would be as many as ten live plays a week: "From such an awful abundance", said Gore Vidal, "a dramatic renaissance *must* come." (*New Statesman*, 18 August 1956). Though it was Welles's first t.v. project, Brook had more experience. He wrote (in 1949) and directed (a few months before *Lear*) a popular short play for the BBC, *Box for One*, an existential thriller which experimented with the relationship between dramatic space and the *literal* space of the t.v. set, "the box in the corner": a man on the run sweats in a phone box, frantically trying to reach anyone prepared to save him from the gang hunting him down. Brook borrowed from *Huis Clos* and Cocteau's *The Human Voice* to create an intense effect of lonely confinement. In *Lear* he tried to marry this with characteristic moments of theatrical spectacle and with groupings recalling courtly and religious Renaissance paintings; but, most important of all, t.v. suggested a unique domestic answer to Brook's search for physical ways of re-animating Shakespeare's plays: "They were conceived in a world of shifting values, of violent belief and violent disbelief, of individualism, ambition, enterprise, imperialism: they were set on a platform stage in the heart of the audience, *and their power lay in their closeness*" (Brook 1948: 139).

Could the technology enhance art? Brook tried to match Shakespeare's formality to the aesthetics and limitations of black-and-white low-definition broadcasting: Lear's scenes with his daughters became an attempt at 3-D t.v. In 1953, the year Hollywood launched Cinemascope to fight off television, Hitchcock was adapting *Dial "M" for Murder* to fit the stereoscopic process and Mickey Spillaine's *I the Jury* was on release ("Violence in 3.D."). The t.v. industry needed to prove its own visual potential and Brook's depth-of-field compositions might have been commissioned to show off, say, Philco's new HF-200 with "Deep Dimension Picture" advertised in that very day's *Sunday Times*. But Brook (unlike Welles) always knew how to satisfy commercial or conservative managements while pursuing his own astonishingly consistent experiments. The horrific close-up blinding of Gloucester works subversively. When the CBS *Lear* was mooted the West was still fighting in Korea, so Brook suddenly intruded appalling violence into countless comfortable living-rooms, demanding a response. Fifteen years later this would be the final image of his Vietnam film *Tell Me Lies*.

"Renaissance" was the word in 1953. The CBS *Lear* was the only time Brook ever costumed a Shakespearean tragedy in Elizabethan dress, and doing so a few months after the Coronation had a unique significance. He was toying with

the late-imperialist myth that this marked the beginning of a second great Elizabethan Age, Britain's new Renaissance. *Lear* testified to the renewed prestige of British culture. During the week of the broadcast – compered by Alistair Cooke, the Special Relationship personified – Winston Churchill won the Nobel Prize for Literature for *The History of the English-Speaking Peoples* and the US press lauded the award, the book, and Britain's "growing voice in world affairs" under the Conservatives. With a young Queen crowned, Churchill reinstated and the levelling Labour Government forgotten, Britain was back where it belonged.

Elizabeth II's Coronation was the most massive television event in history so far. Half a million Britons bought or rented sets and RAF jets flew kinescope recordings to the US networks to make it "the English-speaking peoples'" symbol of heritage re-sanctified. In January 1954 NBC broadcast Maurice Evans's *Richard II*, weirdly featuring Churchill's daughter Sarah as the Queen; it included Coronation footage in colour.[6] Brook's formal management of the opening of *Lear* reruns the royal ceremonies more minimalistically and, unlike Elizabeth Windsor, Cordelia cannot perpetuate dead rituals, cannot recite her oaths. That summer Nigel Kneale's BBC science fiction serial *The Quatermass Experiment* pinpointed Britain's postwar anxieties by taking viewers back to Westminster Abbey only to see it invaded by a monstrous alien virus, the deformed remains of a crew of heroic British pilots. Though in a different style, Peter Brook's first *King Lear* also evoked genteel complacency only to shatter it.

Lear's world changes: the second scene, in Goneril's castle, involves fluid camera-work, ensemble acting, and the violent uproar of Lear's knights as they barrack his daughter and beat up innocent servants. Brook does not make them vengefully smash the place on Lear's orders as they would in his RSC productions – they are the rowdy embodiment of male aggression rather than the arm of his tyranny. Welles's Lear is far more detached and (his word) "amiable" than Scofield's, already distressed by his tragic error in exiling Cordelia. Though this gains him sympathy it reduces the scale of his later enlightenment; however, there are two fascinating innovations which Brook's sixties *Lear*s dropped. First, Oswald becomes a largely silent agent of conscious evil whose smug profile dominates the screen. He paces the castle in slow motion. He is sleek, dark, balding and sensuously lipped and like Lear he tends never to look directly at anyone. His mind is on his private agenda. Apart from Alan Badel's brilliantly shrill, permanently terrified Fool, he and Cornwall are much the youngest male characters. They are both saturnine and efficient intruders in a world of bewigged and bearded posing Old Vic courtiers. They look almost identical. They are cool and vicious. They are the future.

Secondly, Brook and Welles show Lear trapped in repeated behavioural cycles. At Goneril's castle he becomes Holbein's Henry VIII in virile but gross old age, all furs and broad shoulders, trying to defy history by bellowing his way through his daughters' reigns. Like Welles's friend Churchill, he is an ailing giant; he holds a riding whip in one hand and a walking stick in the other. He only

registers Goneril's hostility (it seems justified but hectoring and panicky) very slowly, and then – exactly as he did with Cordelia – he explodes, decides on abrupt and absolute rejection ("Saddle my horses! I'll not trouble thee"), and once again turns his rage against an honest bystander, this time Albany. Movement becomes manic: Lear hustles to and fro nervously, has to be on the move, has to escape the situation he created. To loud chords and drumbeats his men mill about him and he turns back to drown his bewilderment in more curses. This time he blasts Goneril with a sexual hatred that seems to come from nowhere. In frozen profile she shows no reaction then, her father's child, herself scapegoats and shrieks at the Fool. Lear's family becomes a psychological hall of mirrors.

The CBS *Lear* is a unique record of Brook's early mastery of dramatic scoring and choreography, but it lacks intellectual clarity. Goneril is neither the clear victim of his later productions nor the traditional villainess. Albany's condemnation of her in this scene is undeserved and Brook seems unsure about her, so he resolves the problem melodramatically: suddenly she kisses her steward in a long extreme close-up. Though Brook rejects the fairy-tale evil sisters, ultimately he does explain the later horrors by demonizing Goneril and Regan – through their sexuality.

Because Gloster is downgraded, Lear's ultimate rejection appears to take place at *Regan's* castle, and its architecture becomes a model of her and her husband's consciousness. A portcullis rises. Iron gates and cages cast shadows everywhere. The diagonal chain of a drawbridge slices the image in two. Kent is shackled inside a cage and as they confine him we look out at Cornwall and Regan through the bars: the whole t.v. screen becomes a cage. This *mise en scène*, which echoes Iago's torture in the Welles *Othello*, shows with its baroque shadows and maze of iron how much Brook's early visual style owed to Welles. It first traps, then expels Lear into a pitch-black world where he no longer has any identity. Brook makes him run through still more desperate and repetitive actions. First he tries to strangle Cornwall, then Oswald, then he swoops crazily at his daughters as if trying to curse and kill them both at once. And once more their movements cram him into shrinking spaces, reducing him to the King of Lilliput.

Brook has said of the storm, "If you try to stage it realistically, you have to go the full Reinhardt way", and he did so televisually here with a battery of experimental effects, from ludicrous model shots (lightning hits a toy tree) to real rain and a hallucinatory glimpse of long white grass against a black sky. The production is only interested in the descent into madness, not Lear's social enlightenment (Brook cuts the "naked wretches" prayer) or the growing compassion for the dispossessed: Welles ignores the Fool, who crawls and seizes his master's flapping cloak, crying for attention as Lear shouts up into hammering rain. But all this is really only a prelude . . .

Brook runs the hovel scene, the mad trial and the blinding of Gloucester together and locates them all inside a ruined windmill whose wild, spinning arms

provide the sound of Lear's consciousness: "My wits begin to turn." The camera follows the Fool in as he explores the mill and clambers inside the many levels of its machinery. It is a Piranese torture chamber of wheels and cogs but also the Fool's playground. He adapts to it instantly and though Mad Tom terrifies him they soon become playmates riding imaginary horses together. The mentally damaged Fool finds comfort and whoops as he joins in the fantasies.[7]

Mad Tom is extraordinarily powerful precisely because he has no existence and no role outside this place. The mill is "the dark tower" of his imagination, nightmarishly fused with King Lear's own. Micheál MacLiammóir embodies male madness. He finds a frenzied Celtic beauty in Tom's disordered phrases and – aided by Brook's cuts – makes him a man driven wild not by injustice or poverty but by libido. In place of the Edgar/Edmund relationship Brook builds a parallel between Tom's Dionysiac memories of lust for his mistress inside the mill and Oswald's cold, professional affairs outside. Brook and Welles emphasize the sexuality in Lear's madness too both here and in the Dover beach scene where, surrounded by hanging nets and crowned with seaweed, Lear berates women's sexuality ("beneath is all the fiend's") with slow, lip-smacking satisfaction straight to camera. Brook preserves, stresses and clarifies far more of the erotic language than most 1950s theatre directors dared. Rembrandtesque lighting shines on the characters from below, deforming their faces, and Tom's dark bearded features fill the screen as he confesses to "the deed of darkness" and the "contrivings of lust". Lear and the Fool join him – three ages of man – hammering out a frantic, gleeful sexual litany damning women in their absence. This is the *Marat-Sade* in embryo.

Violence is closing in. The moment Lear's party leave, Cornwall's forces enter and converge on Gloucester (Brook uses exactly the same effect to truncate Lear and Cordelia's reconciliation). Since Gloucester is only another innocent bystander in this version, the blinding becomes a completely unmotivated atrocity. Inside the churning mill, there is a sense of accelerating universal madness. Gloucester's torture becomes a sickening reprise of the aggression and persecution central to virtually every preceding scene and – though probably baffling for viewers new to *Lear* – is the climax of the whole production's stress on the brutal arbitrariness of events. Brook's RSC film symbolically blacks out the screen when Gloucester is blinded, but the television version makes the act startlingly explicit and obscene, even for a modern viewer. The mood is orgiastic, then post-coital, as Cornwall is stabbed and half-collapses, holding himself up by clinging to a chain. Crucially, Brook puts Goneril in this scene and has Albany hover disgustedly outside.

The mill sequence was a direct assault on academic purism, on the belief that television must be bland (particularly on Sunday) and on the myth of Shakespearean gentility. But it also invited two warring readings.

From one angle the scene is about fascism, with Cornwall in black leather embodying state violence. But it also shows *the daughters* nightmarishly venting their cruelty on a proxy father. What kind of evil was the CBS *Lear* about? The

scene reprises the butchering of Cinna the Poet in Welles's anti-Nazi *Julius Caesar* (1937) where the innocent bystander was a Jew murdered by a crowd whipped into hysteria by Antony's Nuremberg Rally. After the war, Welles's plans to film a modern-dress *Caesar* and *The Merchant of Venice* showed his preoccupation with resurgent fascism and anti-Semitism (he abandoned a 1950s *Merchant* because of a spate of attacks on synagogues); Albany, condemning Goneril's crime but doing nothing, becomes another Brutus, Welles's archetype of the impotent liberal. And the blinding of Gloucester had a specific political meaning for Welles. In 1946 he used his radio programme to demand justice for Isaac Woodward, a black veteran who was beaten and blinded by South Carolina police. He played unmercifully on the horror of the act (which was said to have involved gouging out Woodward's eyes with a truncheon) and when the Mayor of Aiken insisted his force was not involved Welles replied on-air, "You should have addressed your demand for a retraction to Sergeant Woodward. But it would have to be sent in Braille, Mister Mayor, for Isaac Woodward has no eyes" (Higham 1985: 234). Though ABC threatened to stop his programme, Welles continued his campaign and addressed 20,000 people at a Lewisholm Stadium benefit rally. He broadcast scenes from *King Lear* a few days later.

But Brook's career imposes a quite different perspective. Though he later directed two plays on the Holocaust (*The Representative* and *The Investigation*) he always dismissed polemical theatre and he made blindness an essentially *spiritual* symbol. Brook called *King Lear* a study of "sight and blindness – what sight amounts to, what blindness means", of "sclerosis opposing the flow of existence, cataracts that dissolve, rigid attitudes that yield, while at the same time obsessions form and positions harden" – "a vast, complex, coherent poem designed to study the power and the emptiness of nothing – the positive and negative aspects latent in the zero". In fact the quasi-Buddhist detachment of some of Brook's work is totally absent from the CBS *Lear* (Gloucester's sight-in-blindness is cut) and it actually foreshadows his *Titus Andronicus* (1955). Gloucester's random mutilation, like the cruelty in *Lord of the Flies* and *The Ik*, becomes atavistic proof of human savagery when the mechanics of control – however flawed – are ripped away. The scene catches the odd fact that though both Welles and Brook made themselves semi-stateless artists, Welles remained a New Deal Democrat (Roosevelt had wanted him in the Senate) whereas Brook's anti-ideological position even drove him to break the cultural boycott against the Shah of Iran. Brook originally planned to give *Titus Andronicus* an all-black cast like Welles's 1936 *Voodoo Macbeth*. The jury will always be out on that production – how far was it a breakthrough for black actors and the arts in Harlem, how far a piece of patronizing exoticism? – but in 1955 the idea of explaining *Titus*'s horrors by casting Afro-Caribbeans was very strange.

Collaboration at a high level explores contradictions instead of suppressing them. *Lear* does finally resolve the ideological mismatch of director and star but again does so by making the source of violence the sexuality of Goneril and Regan.

Brook follows the blinding with three studies of venomous or sanctioned female energy. First Goneril slaps Albany in the face. Then Brook cuts to Regan's hand stroking Cornwall's dead cheek; as she rises she fixes her gaze on Oswald and seduces him over the corpse. She is fixated on her sister's body and the thought that Oswald has already found "the forfended way": another languorous kiss (Oswald is totally passive). Then we see Cordelia and *her* husband as they land at Dover. France has no lines, so he too seems ineffectual and kisses her chastely on the brow. A crucifix-like shipmast behind her head sanctifies Cordelia's return about her father's business.

For both auteurs at that time, sex in Shakespeare was a dark region. Brook had recently explored male heterosexual neurosis with John Gielgud as Angelo and Leontes, and in the sixties and seventies he would memorably reassess Goneril with Irene Worth, Cleopatra with Glenda Jackson, and all the women in *A Midsummer Night's Dream*. But his first Shakespearean success after the CBS *Lear* would be to stage the rape of Lavinia and Tamora's punishment-by-cannibalism "acceptably", and for CBS he invented an erotic melodramatic climax worthy of *Titus* or Otway's *Venice Preserv'd* (which he also directed in 1953). When the daughters murder each other over Oswald, he stabs himself in triumphant ecstasy: there is nothing left for him to achieve. We know too that Welles's Shakespeare films were oddly uncomfortable with women's sexuality. Though he added bedroom scenes to *Othello* and *Macbeth* and blamed Iago's envy on impotence, his legendary inability to cast Lady Macbeth and Desdemona adequately – and he rejected Charlton Heston's invitation to direct *Antony and Cleopatra* for the same reason – is important. He played God the Father by literally creating Desdemona himself in the cutting room, fusing footage of Lea Padovani, Suzanne Cloutier, several stand-ins and the voice of Gudrun Ure. Othello's tragedy is of course his inability to match flesh-and-blood Desdemona to *his* dream. The uncompleted Shakespeare projects to which Welles most often returned minimized women's strength; it was necessarily marginal in *Julius Caesar* and he excluded it completely from *The Merchant of Venice* by cutting Portia. Bizarrely, on the night of the live *King Lear* broadcast, Welles forgot the text in the reunion scene and told Cordelia she had no cause to hate him.

All these productions enacted postwar sexual anxieties which fifties society masked with the fetish of marital bliss. The day *Lear* was broadcast the *New York Times* featured twenty-six pages of wedding and engagement notices, packed with photographs of Society brides looking like Cordelia and Elizabeth Windsor, but through the welter of ads for fashions, cosmetics, bedlinen and consumer durables snaked paranoid stories like the tale of "Sergeant Donald Lee of the British Army, who fought off eleven months of Red brainwashing in a Korean prison camp, [and] came home this week to find his young wife had turned Communist." Goneril and Regan too, King Lear discovered, had "turned".

At the end Lear staggers through the studio darkness back to the set for scene 1, dragging his dead daughter on a meaningless circular journey. Welles's

Shakespeare films too are closed circles, beginning and ending with images – the witches, Othello's funeral, Falstaff's passing – of the protagonists' annihilation. Yet Welles's pessimism was romantic. Though the destruction of Othello, Desdemona and Falstaff – even the grotesque degeneration of his Macbeth – entails the death of human values, his films affirm that those values have existed even if their historical moment – a golden age or one hour of content – is lost. In contrast Brook's RSC *Lear*s were remorseless. He seemed driven by the conviction that Western values would implode into nothingness and became fascinated by the problem of preventing catharsis – his Stratford production closed brutally with Edgar dragging out the brother he had killed, the filmscript at one stage closed on Edgar's dazed face contemplating an unknowable future, and the release print uses a slow-motion flashback of Lear himself falling forward in death, an image for contemplation.

Yet the CBS version finally veered away from its own nihilism. Brook cut most of the lines that imply hope and gave the last words to ineffectual Albany. However, they were pre-recorded like Cordelia's first aside, so "Speak what we feel, not what we ought to say" became a ringing public exhortation on the tannoy. This is surprising – Welles obviously despised the well-bred conformists who always inherit the world in his Shakespeare films, and Brook's *Lear* film leaves the planet in ashes – but the moralizing treatment of Albany's speech reflected network policy. A week earlier a CBS producer, Felix Jackson, condemned "pessimistic t.v. drama": "There is too much insanity and neuroticism on television. . . . People in plays are always killing themselves or one another. Things aren't that bad, at least not hopeless. Television drama has slipped into a trend of being too morbid, although the emphasis should be on a less gloomy outlook. Complete gloom just isn't true." And "a drama of tragedy", Jackson added, "should carry a positive statement at the finish". Asked why he had just opened CBS's late-night Monday drama series "Studio" with *1984*, Jackson gave a Cold War answer: "We prefaced the show by saying that this could happen to you if you don't guard your freedom" (*New York Times*, 17 October 1953).

Welles went on to incorporate many elements of the t.v. production and adaptation in his 1956 stage *King Lear*.[8] Brook, however, seems never to have discussed it again in public and his later versions rejected its heavy visual detail, its spectacular storm, the use of music, and the Tudor setting: "I know that ninety per cent of our audiences know that sandwiched between Henry VI and someone else there didn't happen to be a King Lear" (Brook 1989: 87).[9]

It was a transitional work, partly a Wellesian left-Democrat text from the 1930s yet also mapping out Brook's growing concern with extreme irrational states. It was their one collaboration, but both would try to direct Shakespeare for commercial television again, with unhappy results. In 1969 CBS withdrew funding for Welles' condensed *Merchant of Venice* during filming in Yugoslavia and in 1956 the end of Brook's *Hamlet* for the new British commercial franchise ATV was faded out to make room for a jingle for Kia-ora orange juice. This provoked a bitter debate about the direction British culture was taking, so while

the Labour MP Tom Driberg granted it was a sign of grace that commercial television broadcast Brook's *Hamlet* at all, he protested that Shakespeare was being treated "as if it were simply merchandise from the same counter as a light variety show".[10] Twenty years later Brook saw Welles speak on French television and was struck deeply by his words: "We all betray Shakespeare". The CBS *Lear* showed how revealing acts of betrayal can be.

NOTES

1 *King Lear* was produced by Fred Rickey and co-directed for television by Peter Brook and Andrew McCollough. For a more recent comment see H. F. Coursen, "The Peter Brook/Orson Welles *King Lear*". See also Kenneth Rothwell, "Representing *King Lear* on Screen", in Davies and Wells (1994): 211–34.

2 *New Statesman*, 18 August 1956.

3 *New York Times*, 18 October 1953. The blurb for the International Film Forum video release of the recording takes the same line forty years later: "British Theater director Peter Brook wisely focuses on Lear's relationship with his daughters, presenting all of the play's essential elements, while eliminating a number of the subplots that have made its staging so cumbersome."

4 See also Glenda Leeming, 1985: 390. *Variety* called it "the most definitive Shakespearean work in terms of any show-biz media".

5 Welles speaking in *Monitor*, BBC TV, 1963. He argued that Mercutio, Falstaff and Hamlet were figures of genius whom it was impossible to perform adequately, and that after *Hamlet* Shakespeare simplified his technique.

6 Evans's collaboration with George Schaefer and the sponsors Hallmark Cards made him deeply influential in the 1950s. When Rank withdrew finance for Olivier's *Macbeth*, Schaefer and Evans did it instead. Welles said he was not a bad actor: "Worse, he was poor" (Orson Welles and Peter Bogdanovich 1993: 36).

7 The baroque mill recalls the bathhouse murder in Welles's *Othello* and the sepulchral corridors of his *Macbeth*. Here too are the grotesque prison and the giant clock-mechanism Wakhevitch designed for Brook's *Beggar's Opera* and *Boris Godunov* – the latter echoes the clocktower where Welles's Nazi war criminal is bloodily killed in *The Stranger*.

8 As in the t.v. version, there was no interval in Welles's New York Civic Center production. He again ran the storm scenes together (like the Edmund–Goneril–Regan and Edgar–Gloucester sequences) and used a heavy pictorial castle set. Though he restored Edmund (John Colicos was highly praised) Welles still cut Oswald's Shakespearean death scene and once again the enemy army truncated Lear and Cordelia's reconciliation. It, too, was planned for an Anglo-American cast but US Equity prevented this. Welles kept to the hectic spirit of live t.v.: it was a brief run (two weeks) and when he broke one ankle and sprained the other he played Lear on crutches.

9 Brook's RSC *Lear*s discarded detailed costumes and complex architecture (he designed his own set at Stratford, then dropped it) and he explained, "*Lear* is so complex a work that if you give the slightest bit of added complexity to it, you are completely smothered. The basic principle has to be economy" (Brook 1989: 206). In 1956 Welles used a score by Marc Blitzstein, but Brook decided after working with Virgil Thomson, "I don't think there is any place for music in *Lear* at all".

10 *New Statesman*, 10 March 1956. This was a version of Brook's Phoenix Theatre *Hamlet* with Scofield, reblocked for television with many close-ups, heavy cuts and a narration. Brook said he was "swooping down on some of the highlights".

REFERENCES

Brook, Peter (1948) "Style in Shakespearean Production", John Lehman (ed.) *Orpheus I*. London: 139–46.

Brook, Peter (1989) *The Shifting Point: Forty Years of Theatrical Exploration*. London.

Coursen, H. F. (1991) "The Peter Brook/Orson Welles *King Lear*", Shakespeare on Film Newsletter XV, 3 (April).

Davies, Anthony and Wells, Stanley (1994) *Shakespeare and the Moving Image: The Plays on Film and Television*. Cambridge: Cambridge University Press.

Griffin, Alice (1955) "Shakespeare Through the Camera's Eye 1953–54", *Shakespeare Quarterly* VI: 65–6.

Higham, Charles (1985) *Orson Welles: The Rise and Fall of an American Genius*. New York and London: St Martin's Press.

Leeming, Glenda (1985) *Orson Welles*. London.

Rosenberg, Marvin (1954) "Shakespeare on TV: An Optimistic Survey", *Quarterly Journal of Film, Radio and Television* IX, 2 (Winter): 166–74.

Wadsworth, Frank W. (1954) "Sound and Fury: *King Lear* on Television", *Quarterly Journal of Film, Radio and Television* VIII, 3 (Spring): 254–68.

Welles, Orson (1954) "The Third Audience", *Sight and Sound*, January/March: 120–22.

Welles, Orson and Peter Bogdanovich (1993) *This Is Orson Welles*. London.

9

IN SEARCH OF NOTHING
Mapping *King Lear*[1]
Kenneth S. Rothwell

Nothing will come of nothing. Speak again
(1.1.90)

Nothing almost seems miracles
(2.2.165)

In William Shakespeare's *King Lear*, the old king begins his spiritual odyssey with a "map" (1.1.37),[2] and ends it with a "looking-glass" (5.3.262). The way in which these two non-verbal elements frame the narrative suggests they are more than casual but have some kind of metaphorical significance.

At the beginning of the play, to illustrate his "darker purpose" (an ill-advised scheme for dividing the kingdom among his daughters), King Lear calls for a visual aid: "Give me the map there" (1.1.37). In the imperative mood, the terse words challenge an actor to wring them dry of meaning through the "para-linguistics" of pitch, loudness, tempo, timbre, etc.[3] How exactly should they be uttered? Which word should be stressed? Unstressed? "Give?" "Me?" "Map?" The 1623 Folio text capitalizes "map" while the 1608 Quarto lower cases it. Does this slight alteration imply not so much indifference in the printing house as an authorial revision that latently privileges "map" over the other four words? (Urkowitz 1980: *passim*). As the possibilities multiply, the actor runs the risk of becoming like the obsessed student of Stanislavsky who found forty-four different ways to say "Good evening" (Elam 1980: 82).

Actors playing King Lear have recorded on film and tape widely different strategies for uttering this single line. There've been a bombastic Orson Welles, inscrutable Paul Scofield, powerful Michael Gambon, cherubic Laurence Olivier, testy Yuri Yarvet, irascible Michael Hordern, and introspective Burgess Meredith. The brusque king who bellows and snarls at underlings has not yet been exposed "to feel what wretches feel" (3.4.34). If the actor emulates Michael Hordern, he stresses "there," which makes the reading especially harsh and

135

querulous, a growl to a churl. "There" carrying the sense of "hop to it" resembles the testy voice of, say, "Let me not stay a jot for dinner, go get it ready" (1.4.8). Formal speech act analysis might argue that the king's command includes both an order issued and a resulting action taken – the producing of the map. The word, "there," then stirs interest in proxemics. It becomes a stage direction embedded in dialogue, a common enough practice in Shakespearean dramaturgy. The director must locate the map somewhere and find an actor to carry out the king's command.

The actor's quandary then mutates into the semiotician's quarry. In Prague School theatrical theory any object on stage, such as a map or mirror, may take on a "symbolic or signifying role" and act as "scenic metonymy" (Elam 1980: 8,28), something Shakespeare fully intuited for neither any sources nor the earlier play, *Leir*, include the map. In a theater, Lear's map would commonly be called a "stage prop"; on screen, an "expressive object." The difference between the two may be more than casual since a "stage property" is an inanimate object with a "dislocated function" (Teague 1991: 17), while an "expressive object" is directly inscribed in the film narrative (*diegesis*) through the ascendant camera (Pudovkin 1929: 143). Luke McKernan's insight that "a play is a text which may be performed on a stage, but a film is both text and performance" helps to clarify this subtle distinction (McKernan 1994: 22). The phenomenon of converting inanimate objects into animate life was already apparent in the 1895 Lumière brothers' "Arrival of a Train at the Station," when the train itself took on alarming vitality. The pioneering Russian cinéaste, V. I. Pudovkin, stressed the "enormous importance in film" of an inanimate "expressive object," such as a map, in relation to an actor. He explained that

> An object is already an expressive thing in itself, in so far as the spectator always associates it with a number of images. A revolver is a silent threat, a flying racing-car is a pledge of rescue or of help arriving in time. The performance of an actor linked with an object and built upon it will always be one of the most powerful methods of filmic construction. It is, as it were, a filmic monologue without words.
>
> (Pudovkin 1929: 143)

In movies the power of the cigarette as an expressive object has been unmatched by any other physical object known to humankind except perhaps the handgun. Hollywood superstars like Bette Davis and Humphrey Bogart puffed on cigarettes so adeptly that they became role models for an entire generation of potential cancer patients. The mystique that grew up around cigarettes even inspired Jean-Luc Godard to construct the cult of *Belmondisme* out of the world-class smoking talents of Jean-Paul Belmondo in the 1960 *Breathless*. Cigarettes are obviously not major players in Shakespeare movies, but another fine example of an expressive object occurs with Emil Jannings's frenzied chewing on a handkerchief in the 1922 Buchowetzki *Othello* that carries ostensive acting to its outermost limits. From a psychoanalytical view, the

handkerchief, to use Karen Newman's term (Newman 1991: 91), becomes a "a snowballing signifier" with protean implications.[4]

The term "map" carries heavy symbolic freight with its extraordinary capacity for "iconicity," as a semiologist would put it (Elam 1980: 22). Maps, say geographers, are "mediators between an inner mental world and an outer physical world . . . fundamental tools helping the human mind make sense of its universe at various scales." So instinctive is this charting impulse to the human experience that mapping preceded "both written language and systems involving number" (Harley 1987: 1). The "mapmaking" metaphor permeates many discourses, as, for example, a *New York Review of Books* advertisement: "In this book, the author begins the process of *mapping out*, contextualizing, and critically appraising [Jean] Baudrillard's trajectory" (1989, 36: 20, italics mine).[5]

Adrian Noble's RSC *King Lear* at the Barbican in 1994 spectacularly integrated the map into the overall design of the production. Even before the performance began, the audience was confronted with a program whose cover flaunted a *faux* Elizabethan map of Great Britain, over which had been superimposed the words *King Lear*. On stage, Noble had carpeted the floor wall to wall with a paper map of Britain. In the background a huge globe placed the king's lands in the context of the entire universe, while a gaggle of Lear's courtiers signified the third component of the tryptich of family, nation and universe. When Lear says "Give me the map," he points to the floor and the courtiers titter, which echoed a similar business in Nicholas Hytner's 1990 RSC production starring John Wood. As the king gives Scotland to Goneril, Wales to Regan and reserves the "third more opulent" morsel of England for Cordelia, the Fool obligingly defines the boundaries by painting a red line on the floor. The map remains as flooring until in Gloucester's castle the king irascibly rips it up, which symbolizes the disintegration of both king and kingdom. Having utterly failed as a map for the king's unmappable journey, the offending document receives short shrift at the hands of the Fool, who further rips and tears away at it until it lies in tatters. The disposal of the map exposes the blood red stage flooring beneath it, an ominous portent of things to come. As so often happens, the trappings of state conceal underlying turmoil and violence.

In the pioneering silent movies when directors squeezed a whole play onto one reel, the result was likely to be a collage of scenes familiar to the mass nickelodeon audiences, such as the love test in *King Lear*. The map in the 1909 Vitagraph *King Lear*, which in the print that I saw at the NFTVA has German-language titles despite its Brooklyn origins, suggests an outline of Great Britain. Superimposed titles on the screen identify the three sisters, while at the king's feet the Fool mugs constantly. Lear, possibly played by William V. Ranous, uses a pointer to mark out sections of the map. Departing from typical Vitagraph methods, the movie relies entirely on studio backdrops to the exclusion of outdoor settings.[6] Lear's ordeal on the moor takes place against a painted Stonehenge backdrop. In a curious technique, the rain-storm was suggested by white dots from scratches on the film itself, which, as Luke McKernan has

noted, gave the movie "a certain wild vigour that harks back to nineteenth-century melodramatic conventions" (McKernan 1994: 84).

Gerolamo Lo Savio's 1910 *Film d'Arte Italiana, Re Lear*, which has English titles, restates the play's love-test episode in the grandiose cultural codes of Italian opera. (Silent movies were truly multi-national in that title cards in the language of a host country could easily be spliced into the film, which explains the unlikely combination of an American *King Lear* with German titles and an Italian movie with English titles.) The first intertitle ambiguously reads: "King Lear makes the division of his kingdom between Goneril and Regan to the detriment of Cordelia his third daughter whose unexaggerated profession of love for him arouses his displeasure." While the two plump young women playing Goneril and Regan mime their devotion, the Fool assists the king by unrolling a parchment map, in a mockery of its inadequacy as a guide to the kingdom's perilous terrain. The Fool grins sardonically as the cynical daughters flatter their father, who, it should be noted, can't be flattered enough. Cordelia stands aside, aloof. When she spreads her arms wide and raises her head, she clearly mimes "Nothing!" The Fool acts out derisive laughter. The king drops the map to the sitting Fool who then triumphantly rolls it up. The Fool as the Keeper of the Map mirrors the king's foolishness in thinking the map's certainties a buffer against uncertainties.

Years later, Peter Brook's 1953 televised production starring Orson Welles and better-known 1971 movie with Paul Scofield showed still other ways for handling the map. A stage curtain with a map of Britain inscribed on it provides the establishing shot for Brook's televised 53-minute drama, which was a Ford Foundation attempt to keep middlebrow culture alive on increasingly commercialized channels. Broadcasting in North America also suffered from the repressive McCarthy-ite atmosphere when politically suspect actors were regularly black-listed. Not surprisingly, then, even a Shakespeare production was susceptible to current orthodoxy. If there are any transgressive tendencies in the Brook television version, they're covert. Thanks to the stage curtain device, with horns and trumpets blaring, drums rolling, the map is already "there," ready for its role. Off camera, a stentorian voice thunders "Give me the map there" (though without particular stress on any single word). Orson Welles as King Lear then slashes his way through the paper map and occupies the throne. As the king, Welles often seemed to be more Orson Welles than King Lear but the pressures on actors in live television drama with the risk of forgetting lines in front of millions were truly frightening. Even in tatters, the map remains on screen as an expressive object, interacting with the king as a "filmic monologue" to suggest his impetuousness. Seated, Welles holds the maimed document on his lap, while he wallows in Goneril and Regan's hypocritical speeches. He tears off sections and tosses them to his daughters, as if they were household pets being fed table scraps rather than princesses of the realm.

The sizeable remnant of the map awaiting Cordelia's flattery then becomes a hapless scapegoat for the king's rage over her stubbornness. At "mar your

fortune" the king fidgets with the map fragment, and at "so young" he crumples it. Holding the wrinkled remnants, he excoriates the stubborn Cordelia: "Let it be so: thy truth then be thy dow'r." As coda for Cordelia's disempowerment, Welles throws the shredded map to Albany and Cornwall, and growls: "Cornwall and Albany,/ With my two daughters' dow'rs digest the third" (1.1.128).

The 1971 Brook movie disprivileges the map in favor of two other icons – the king's curious throne and the orbs of ceremony. A shadowy, inscrutable figure, Paul Scofield's powerfully reserved king contrasts with the blustering monarch portrayed by Welles. After the famous opening take panning over the knights' faces (which may be a quotation from the trial scenes in Fritz Lang's 1931 *M* starring Peter Lorre), Scofield speaks from deep within a throne that's as big and round as a boiler. This seat of majesty also conveys a sense of raw potency, of phallocentricity. Yet that potency is undercut by the hoarse, whispery voice making a pun on "Know" and "No," which emerges from its hollowed/ hallowed recesses.

The orb, a sphere surmounted by a cross symbolizing royal power and justice, smugly held aloft as the daughters attest (or ovulate) their loyalty, also threatens to upstage the map. The orb suggests both masculinity and femininity (testicularity and ovularity), which joined assure a healthy state, disjoined a diseased body. "Pelican" daughters violate their femininity, and "milk-liver'd" men their masculinity. This transgressiveness, however, fits the mood of the emerging sexual revolution at the end of the sixties decade. Any white male, king or not, was automatically guilty of venal patriarchy. The Godardian film techniques employed by Brook became the aesthetic corollary to these ideologies.

As Goneril ends her appeal, the king finally reveals a fuzzy, blurry map, so shabby it looks as if it'd been stored in a fruit cellar. Cords functioning as primitive dividers radiate from a small stake at its center, indicating boundaries, as Lear himself says, comprised of natural barriers such as "shadowy forests . . . with champains rich'd,/With plenteous rivers and wide-skirted meads" (1.1.64). In an analytical close-up, scribes scrawl Lear's decrees on parchment.

A smirking Regan ritually elevates the ceremonial orb, while Cornwall in close-up unfurls the blurry chart that hints of his imminent empowerment. Cordelia remains isolated, alone, in long shot, awaiting her turn to utter the fatal three words, "Nothing, my lord." The cinematic rhetoric of shot/reverse shot visually punctuates the dialectical cross purposes of powerful king and powerless daughter. Cordelia banished, the king fades back into the inscrutable recesses of his covered throne. The forceful, masculinized, daughters having now won control of the orbs of power, abandon the father to the hollow throne. As I've already hinted, prevailing gender politics may've encouraged the rehabilitation of Goneril and Regan who seem not quite more sinned against than sinners but at least sinners in a context of patriarchal abuse.

The map returns to prominence in Michael Elliott's 1983 Granada Television production, starring Laurence Olivier, where it's blown up to the size of a living-room rug. The map's domestication might've been reassuring to the middle-brow

television audience that this commercial production targeted. Intimacy between actor and object vanishes, but other opportunities surface. The establishing shot of Stonehenge's rocky shafts echoes the 1909 Vitagraph silent movie. The hoarse bleating of primitive horns proclaims the king's arrival, who enters leaning on a Cordelia whom he dotes on. Olivier's king, unlike Welles's blusterer or Scofield's manipulator, comes across as genial, "generally having a grand time" as Alexander Leggat aptly says (Leggat 1991: 128). Michael Elliott's filming in color rather than in the charcoal tones of Brook's movie complements the king's mood by softening the *mise-en-scène*. As uttered by Olivier, the operative line, "Give me the map there," emerges with stresses evenly distributed, almost lyrically. Three serving louts unroll the monstrous map, which is a formidable projection of the king's ego. Goneril, "the eldest-born," speaking first, falls prostrate on the map, as if it were an altar, as prelude to her oily preamble: "Sir, I love you more than words can [wield] the matter,/Dearer than eyesight, space, and liberty" (1.1.52ff.). When the king is incensed by Cordelia's stubborn, "Nothing my lord," he hurls his crown on the map, where in its mindless rolling about it ignores the kingdom's boundaries. Map, crown and king embody the essence of Pudovkin's "filmic monologue without words."

Even though Grigori Kozintsev's film of *King Lear* emerged from a Marxist and Peter Brook's from a capitalist community, in each case artistic decisions superseded any ideological fervor. Not that there aren't differences, but with Kozintsev, for example, they grow as much out of probing the generally wretched condition of humankind as with making any overt ideological statement. The movie opens with an enigmatic establishing shot, or maybe the correct term would be "dis-establishing shot," since the audience isn't quite aware of what's going on. As Brook's opening take features Lear's 100 knights, Kozintsev's shows dozens of wretchedly shod feet painfully climbing a steep, bare hill, resembling a stony moonscape. Brook's vision highlights the empowered; Kozintsev's, the disempowered. The lowly feet challenge the hegemony of the arrogant head.

Fire replaces stone.[7] A scribe intones his royal decree, while Lear warms his hands over the fire. The map itself, a largish sheet of parchment, remains on a table in the foreground. As the two wicked sisters flatter their father, reaction shots of Cordelia show her as looking angelic, pathetic and anxious – all at once. Less revisionist than Brook's movie, Kozintsev's King Lear follows orthodoxy by thoroughly demonizing Goneril and Regan and beatifying Cordelia.

After Cordelia obstinately refuses to imitate her sisters' cynical tactics, Yarvet exhibits a dazzling flair for ostensive acting as he vents his spleen on the map. He snatches it up, rends it, twists it this way and that way, moves it back and forth, shakes it and rattles it so fiercely that it rumbles like distant thunder. He tosses it away, a spoiled and shriveled symbol of his lost hopes. Crying out "Call France. Who stirs? / Call Burgundy" (1.1.126), he aims yet another kick at it. The map as an agent of orientation ironically counterpoints his own disorientation. Kent clings to the map, as if to rescue the king from his inevitable *hamartia*, but

he's rewarded by having the king spit in his face. So again the loss of the map accompanies the king's growing dis-orientation.

Jonathan Miller's low budget 1982 BBC television version offers a tiny map in contrast with the oversized monster in the Elliott/Olivier televised drama. Miller's modest chart compensates for its shrunken size, however, by remaining at the center of the *mise-en-scène* all the way to the close of the second scene when Edgar retreats from his father's misplaced wrath. The map, however, loses metaphorical significance and moves toward "scenic metonymy" (Elam 1980: 28). That is to say, the map functions more as an attribute of the art of government than as a major symbol for spiritual despair. Even so, in the sparsely appointed *mise-en-scène*, the unostentatious but ubiquitous map stays in the frame from the beginning of Act 1 all the way to the close of the second scene when Edgar retreats from his father's misplaced wrath. At first it's a scroll under Kent's (Colin Blakeley) arm during the heavy badinage with Gloucester about Edmund. When the king (Michael Hordern) enters, Kent drops the map to his side, discreetly retreats, but then unobtrusively, like an audio-visual assistant, puts it on the king's table.

The old king advances, touches the map, seems hardly to glance at it, and then, surprisingly, turns his back and walks away. Some portent of disaster has chilled the king's enthusiasm, as well it might. The map sullenly lies *there*, a flattened shroud, ready to assist in a fatal division, that word "division" having been spoken in the play's fourth line by Gloucester: "It did always seem so to us; but now in the *division* of the kingdom, it appears not which of the dukes he values most" (1.1.2–5). The map then comes in and out of the frame synchronously with the king's alternating acts of empowerment and disempowerment.

An abrupt shift in camera angle brings the map back into the center with an over-the-shoulder shot of Cordelia. Goneril looms over it to the right, her hand stroking it; Regan stands to the left, protectively. The possessive attitude of the two evil sisters hints that to them the map's become a quasi-legal document validating their claims to power.

Then in two-shot, the king devastatingly inquires of Cordelia: " . . . what can you say to draw / A third more opulent than your sisters'? Speak" (1.1.85–6). A wretched Cordelia glances back over her shoulder toward the map that has become the locus of her torment, the proximity of the map giving a special edge to Lear's use of "draw," as if Cordelia were being challenged literally to "draw" out on the map her real estate claim. Cordelia will not "draw" any more than she will speak.

Later, the Fool (Frank Middlemass) hovers near the map as Cordelia bids farewell to her sisters. The trope of the Fool with the map, as in the early Vitagraph *King Lear*, restates the idea of reason in madness, the map aiding the king in folly and the Fool in reason. When Edmund says, "Let me, if not by birth, have lands by wit" (1.2.183) viewers expect the map to be ushered off with some kind of portentous flourish but that never happens. Instead in an anti-climactic coda, it fades from view.

Jean-Luc Godard's transgressive 1987 "twisted fairy-tale" of a *King Lear* nearly loses the map but in postmodernist terms absence often becomes more significant than presence. The spectator is taken on a journey (maybe "three journeys" – as one alienating intertitle suggests) beyond the limits of any map. Godard's movie is metacinematically about the impossibility of making movies, of finding visual equivalents for any verbal structures, of indeed mapping the unmappable. It is, as the iterative title cards keep saying, about "No-thing." Unlike the expressionistic flaunting of the map in Noble's RSC stage production, Godard's recontextualization forces the spectator to create his/her own map. In a flipflop, the stage version privileges the icon and the cinematic disprivileges it. Even so, on the soundtrack, Burgess Meredith can be heard calling out, "Give me the map." But sound and image are disassociated. There's no map in the hotel dining room in which Meredith and Molly Ringwald are seated. For that matter, what map could ever adequately chart the way through the visual turmoil of this extraordinary anti-movie? Godard has since the 1967 *Two or Three Things I Know about Her* (Guzzetti 1981:*passim*) notoriously spurned filmic conventions that promote viewer passivity. In a mindless consumerist society, seamless narrative becomes a seductive instrument of oppression, a kind of white devil. As has been said by the philosopher, Gilles Deleuze, Godard's films raise "questions which silence answers" (MacCabe 1980:111). Instead the viewer is not only to look but *see* ("See better, Lear" [1.1.187] as Kent says) and then construct a personal narratology out of Godard's uninflected images.[8]

This Godardian refusal to make life easy for audiences has cost him dearly at the box office and in lowered prestige with mainstream film critics (cf. Canby, McGrady, Nokes). The apocalyptic syntax of his kaleidescopic movies qualifies them for display in a gallery with other baffling but dazzling postmodernist works of art. It's a truism, though, that artful segmentations of Shakespeare's plays can sometimes work more powerfully than mediocre full-scale performances. Closure remains an illusion.

In Godard's disruptive universe of non-linear discontinuities, interruptions, deferrals, subversions, and self-referentiality a sense of exact place is irrelevant. His 1966 *Made in USA*, for example, is notoriously not made in the USA and makes use of the "American shot" only to parody and "imprison the film within its own reference" (Kriedl 1980: 162). What's supposed to be Atlantic City is apparently Paris. Analogously Godard's *King Lear* at least twice (repetition is another Godardian tactic) uses a shot of the neon sign lit up at night for the Hotel Beau-Rivage in Nyon, Switzerland. The Swiss setting is subverted, though, by Burgess Meredith (Don Learo) quizzically asking "What country is that over there?" or again, Peter Sellars (William Shakespeare, Jr, the Fifth) plaintively inquiring "Where are we? What city is this?" while a Godardian voice on the soundtrack replies "Los Angeles."

The uninflected episodes in Godard's *King Lear* put its meaning largely in the eye of the beholder. The search for a map is superseded by the need to make a map, a map with clues but no clear orientation. The Godardian vision of a

universe that is both lost and recuperable in time is the thread that holds this movie and all his others together. The systole and diastole of his work become despair and hope. A glimpse of Easter flowers negates the former and the success of the exploiters of humanity the latter. And yet with Godard, in a kind of Derridean sense all meaning seems endlessly deferred.

Several characters expand on these themes. Molly Ringwald (Cordelia) introduces temporal as well as spatial indeterminancy when she abruptly turns into Joan of Arc, Defender of France against barbaric American Culture. Don Learo's choric refrain, "Who is it that can tell me who I am?" reinforces this sense of timelessness and placelessness. The only certainty we have is that the movie begins "after Chernobyl" when the world must be reinvented. Molly Ringwald makes a wonderfully expressive Cordelia, with a face in close-up that captures the ineffable mystery of this most enigmatic of Shakespearean women. It's a pouty, teenage, passively rebellious face ("so young, and so untender" [1.1.106]) but a face that also maps out her inarticulate loneliness. When she as Cordelia dressed in white stands alone on the hotel room balcony while her father reads letters from her sisters, "Gloria" and "Regina," she embodies the recurring Godardian image of women entrapped by language and custom. Only her disjunctive voice on the soundtrack reciting Sonnet 47 ("Betwixt mine eye and heart a league is took") gives a clue to her own inner thoughts and feelings. She is simultaneously the object of spectatorial gaze and of her own gaze.

Peter Sellars as William Shakespeare, Jr, the Fifth, plays an editor in search of the unrecoverable Shakespeare text. A likeable but rather vague young man, he's been hired by Cannon Films (the original backers of Godard's film). In Denmark he encounters the "To be or not to be" soliloquy but here in the dining room of the Hotel Beau-Rivage, he struggles to reconstruct the lost words of his ancestor. Gradually, for example, he discovers the title for "As You Like It" after discarding "As You Wish It." Then throughout the film he records in his notebook passages from *King Lear* that are then transferred over to Don Learo himself, who even becomes dependent finally upon young William for his lines. After Chernobyl art has been lost and must be reinvented. The search for the lost Shakespeare text then becomes metonymy, another icon in Godard's arsenal of signs, for the incapacity of the artist to construct any art. Hence the viewers/auditors must make their own art out of the materials handed to them by the failed artist.

In a spasm of self-referentiality, Godard plays himself playfully in a ridiculous getup with dreadlocks and dogtags streaming from his head. As Professor Pluggy, he fakes some kind of a speech defect, talking out of the corner of his mouth in a maddeningly inaudible way, probably again to show the inadequacy of language for expressing ideas. He not only fills the bill of the inevitable philosopher who plays a cameo role in almost every Godard movie but also resembles Lear's Fool. Godard has been quoted as saying that "cinema plays with itself." True to that vision, he "spectates" the sight of his own film's impossibility for closure even as his audience is watching it. At the end of the movie a

character called Alien (Woody Allen actually) is shown at a Movieola still desperately and ineptly trying to splice together the flawed movie with needle and thread.

Another cluster among the film's rich accretion of signs reflects Godard's fascination with American gangsters, which extends all the way back to his commercially successful 1960 *A bout de souffle* (*Breathless*). In the opening scene, the Great Writer (Norman Mailer as himself) declares that "the Mafia's the only way to do *King Lear*." His daughter anxiously asks "Why are you so interested in the Mafia?" Later we find out why. Burgess Meredith, by now Don Learo, reads from Albert Fried's *The Rise and Fall of the Jewish Gangster* about how Bugsy Siegel's casino ultimately "Las Vegasized" the entire nation (Fried 1980: 280). Fried's acid portraits of such stalwart American folk heroes as Lepke Buchalter, Lefty Louie, Dopey Benny, Al Capone, Bugsy Siegel, Meyer Lansky, Dutch Schulz, and their nemesis, Thomas E. Dewey, problematize the moral vectors of American society. Is the gangster simply your friendly local capitalist who's carried unbridled competition to excess? Was Eagle Scout Governor Thomas Dewey just as cynical and ruthless as the wretched thugs that he dispatched so competently to Sing Sing's electric chair? We hear Don Learo quoting a sancti-monious Meyer Lansky in a passage lifted verbatim from Fried's book: "When you lose your money you lose nothing; when you lose your character you lose everything" (Fried 1980: ix). Fried's vision of America as predatory jungle comes perilously close to echoing Lear's own despair:

> What, art mad? A man may see how this world goes with no eyes. Look with thine ears; see how yond justice rails upon yond simple thief. Hark in thine ear: change places, and handy-dandy, which is the justice, which is the thief?
>
> (4.6.150ff.)

There's no map, no guideline, for human behavior in an ethically vacant universe. The question directed at Professor Pluggy, "Just what are you aiming at, Professor?," sums up the audience's feelings. Instead of answers they are treated to the silence of alienating, Brechtian title cards with the words "Nothing," "Power and Virtue," "An Approach to Lear," "Fear and Loathing"; recurring images of a Raphael angel who may have been "shot in the back" (a Godardian preoccupation in many of his films, especially at the end of *Breathless*); illustrated lectures by Godard on the history of filmmaking; tributes to great filmmakers such as Orson Welles; the harsh cries of gulls; the deliber-ate scrambling and counterpointing of voices; a copy of Virginia Woolf's *The Waves* washed up on the beach (another Godardian signature device in which the covers of books are incorporated into the narrative); then a galloping white horse on screen from the unforgettable last paragraph of Woolf's novel; Godard as the reclusive Professor desperately striving for closure in untangling his hope-lessly tangled film; and a beatified Cordelia in white robes lying a sacrifice on a large boulder – all these discontinuities on soundtrack and image suggest an

emptiness, a nothingness, too profound to capture in any human language, visual or verbal.

Contrary to what's often been said, Godard's alienating images – aggressive quick cuts, rapid editing, discontinuities, fractured images – do not so much undermine the words as frame them. Even the dissonance of the squawking sea gulls empowers Shakespeare's language all the more. Burgess Meredith's voice becomes sacerdotal with "She's gone forever! / I know when one is dead . . . She's dead as earth. Lend me a looking glass . . . " (5.3.260ff.). At the end of the play the "looking glass" replaces the map as expressive object, only by now the imperial "give me" has softened into the chastened king's "lend me." The transition from map to mirror represents the shift from anticipation to participation, from a bright future to a dark present, in which Lear will see better but too late. Of course, as with the map, the looking-glass never appears in Godard's film.

"Give me the Map there" in its blunt monosyllabic way energizes and maps out the play's trajectory – "Give me" as typology for Lear's and his daughter's selfishness; "the Map" as metonymy for his misguided errors; and "there" as a portent of even darker purposes ahead. Fully decoded, "Give me the Map there," is humanity's cry for salvation at the edge of the abyss, beyond the map's borders, in the imaginary realm of Gog and Magog, which, if nothing can be about something, is pretty much what *King Lear*'s about.

NOTES

1 A version of this chapter was read at the 1995 Ohio Shakespeare Conference at Ohio University in Athens, Ohio.
2 All citations to Shakespeare's text are from G. B. Evans, *et al.*, eds (1974) *The Riverside Shakespeare*, Boston: Houghton Mifflin.
3 See Keir Elam, *Semiotics*: 78. Elam's useful terminology for a "poetics of the theatre" is employed throughout this chapter especially because it applies as well to the semiotics of cinema.
4 Newman summarizes a Freudian reading in which the handkerchief becomes "the fetishist's substitution for the mother's missing phallus" (91), which is an extraordinarily limp phallus. She also cites Lynda Boose's argument that the "handkerchief represents the lover's consummated marriage and wedding sheets stained with blood" (166, n. 52).
5 Shakespeare's uses of mapmaking and geography in general have most recently been studied by John Gillies in *Shakespeare and the Geography of Distance*, 1994. Lloyd A. Brown's *The Study of Maps*, 1977, offers an excellent introduction to the history of mapmaking.
6 The Vitagraph company produced about a dozen one-reel, ten- or fifteen-minute Shakespeare movies in the first decade of this century. For a full account, see Robert Hamilton Ball's *Shakespeare on Silent Film*; and most recently, William Uricchio and Roberta E. Pearson, *Reframing Culture: The Case of the Vitagraph Quality Films*.
7 Kozintsev in his chronicle, *The Space of Tragedy*, describes how the stone in a Japanese garden influenced his making of the film.
8 As Peter Donaldson has done in *Shakespearean Films/Shakespearean Directors* (189–225), which views the movie as more of a "dissemination" than representation of *King Lear*. Donaldson interprets the movie in Derridean and psychoanalytical

terms in which fatherhood becomes "a metaphor for the relation between authors and texts, artists and disciples" (190). See also David Impastato's "Godard's *Lear . . .* Why Is It So Bad?"

REFERENCES

Ball, Robert Hamilton (1968) *Shakespeare on Silent Film: A Strange Eventful History*, London: Allen and Unwin.

Brown, L. A. (1977) *The Story of Maps*, New York: Dover.

Canby, Vincent (1988) "Film: Godard in His Mafia *King Lear*," *The New York Times*, 22 Jan.: C6.

Donaldson, Peter (1990) *Shakespearean Films/Shakespearean Directors*, Boston and London: Unwin.

Elam, Keir (1980) *The Semiotics of Theatre and Drama*, London and New York: Methuen.

Evans, G.B., Herschel Baker and Harry Levin eds (1974) *The Riverside Shakespeare*, Boston: Houghton Mifflin.

Fried, Albert (1980) *The Rise and Fall of the Jewish Gangster in America*, New York: Holt, Rinehart & Winston.

Gillies, John (1994) *Shakespeare and the Geography of Distance*, Cambridge: Cambridge University Press.

Guzzetti, Alfred (1981) *Two or Three Things I Know about Her. Analysis of a Film by Godard*, Cambridge, MA: Harvard University Press.

Harley, J.B. and David Woodward, eds (1987–) *Cartography in Prehistoric, Ancient and Medieval Europe*, vol. 1 of *The History of Cartography*, Chicago: University of Chicago Press.

Impastato, David (1994) "Godard's *Lear . . .* Why Is It So Bad?", *Shakespeare Bulletin* 12.3 (Summer): 38–41.

Kozintsev, Grigori (1977) *The Space of Tragedy*, trans. Mary Mackintosh, Berkeley: University of of California Press.

Kreidl, John (1980) *Jean-Luc Godard*, Boston: Twayne Publishers.

Leggat, Alexander (1991) *King Lear. Shakespeare in Performance*, Manchester and New York: University of Manchester Press.

MaCabe, Colin (1980) *Godard: Images, Sounds, Politics*, Bloomington: Indiana University Press.

McGrady, Mike (1988) "Review," *Newsday* 22 Jan.: Weekend 5.

McKernan, Luke and Olwen Terris, eds (1994) *Walking Shadows: Shakespeare in the National Film and Television Archives*, London: British Film Institute.

Newman, Karen (1991) *Fashioning Femininity and English Renaissance Drama*, Chicago: University of Chicago Press.

Nokes, David (1988) "Review." *TLS* 29 Jan.: 112.

Pudovkin, V.I. (1929) *Film Technique and Film Acting*, trans. and ed. Ivor Montagu, rpt. 1968 Hackensack, NJ: Wehman Brothers.

Teague, Frances (1991) *Shakespeare's Speaking Properties*, Lewisburg: Bucknell University Press, London and Cranbury, NJ: Associated University Presses.

Uricchio, William and Roberta E. Pearson (1993) *Reframing Culture: The Case of the Vitagraph Quality Films*, Princeton: Princeton University Press.

Urkowitz, Steven (1980) *Shakespeare's Revision of* King Lear, Princeton: Princeton University Press.

STAGE PERFORMANCES OF *KING LEAR* CITED

Dir. Adrian Noble (1982) with Michael Gambon, Royal Shakespeare Co., Stratford-upon-Avon, England.

Dir. Nicholas Hytner (1990) with John Wood, Royal Shakespeare Co., Stratford-upon-Avon, England.

Dir. Adrian Noble (1994) with Christopher Robbie [for Robert Stephens], Royal Shakespeare Co., The Barbican Theatre, London.

SCREEN PERFORMANCES OF *KING LEAR* CITED

Dir. William V. Ranous [?] (1909) USA, Vitagraph, with William Ranous, Silent, B&W, 10 mins, German titles.

[*Re Lear*] Dir. Gerolamo Lo Savio (1910) Italy. *Film d'Arte Italiana*, with Ermete Novelli, Silent, B&W, 11 mins, English titles.

Dir. Peter Brook (1953) USA, Omnibus TV-Radio Workshop of the Ford Foundation, with Orson Welles, Sound, B&W, TV, 53 mins.

Dir. Grigori Kozintsev (1970) USSR, Lenfilm, with Yuri Yarvet, Sound, B&W, 140 mins.

Dir. Peter Brook (1971) GB/Denmark, Athena/Laterna Films, with Paul Scofield, Sound, B&W, 137 mins.

Dir. Jonathan Miller (1982) GB, BBC/Time-Life, with Michael Hordern, Sound, Col., 180 mins.

Dir. Michael Elliott (1983), GB, Granada Television, with Lord Laurence Olivier, Sound, Col., 158 mins.

Dir. Jean-Luc Godard (1987) France, Cannon Films, with Burgess Meredith, Sound, Col., 91 mins.

10

A SHREW FOR THE TIMES

Diana E. Henderson

Of all Shakespeare's comedies, *The Taming of the Shrew* most overtly reinforces the social hierarchies of its day. Lacking the gendered inversion of power and the poetic complexity of Shakespeare's romantic comedies, this early play might seem less likely to capture the imagination of modern audiences and producers; we might expect it, like its farcical companion *The Comedy of Errors*, to be filmed infrequently and almost obligatorily as part of canonical projects such as the BBC-TV Shakespeare series. Quite the converse is true. More than eighteen screen versions of the play have been produced in Europe and North America, putting *Shrew* in a select league with the "big four" tragedies, and outpacing those comedies scholars usually dub more "mature."[1] What accounts for this frequent reproduction of an anachronistic plot premised on the sale of women?[2]

Part of the answer lies in a venerable tradition of adaptation. Discussing David Garrick's *Catharine and Petruchio*, Michael Dobson points out that seemingly minor changes in the text "mute . . . the outright feudal masculinism of *The Taming of the Shrew* in favour of guardedly egalitarian, and specifically private, contemporary versions of sympathy and domestic virtue" (Dobson 1992: 190). Garrick's version provides the source for a performance tradition that tames not only the "shrew" but also the text. Here "Dr. Petruchio" consciously assumes his boorishness as part of a therapy program for a disturbed Katherina. This Petruchio is a far cry from Shakespeare's blusterer, knocking his servant Grumio soundly as he comes to wive it wealthily ("if wealthily then happily") in Padua. Such attempts to obliterate gender struggle ultimately collapse the leading couple into a single entity, "Kate-and-Petruchio," replicating the play's narrative movement and its ideology. Viewing the story in a euphemized and relatively untroubled way from Petruchio's perspective remains the norm in almost all modern video versions – though not, intriguingly, in the two feature films starring Hollywood's most famous couples of their respective generations, Mary Pickford and Douglas Fairbanks Sr, and Elizabeth Taylor and Richard Burton. The film's differences derive not only from the unusual box office power of their leading ladies but also from their directors' cinematic choices.

These choices strive to create a female subject position for Katherine, adding gestures, glances, and private speech to the script's most notorious silences. The

148

erasure of the Christopher Sly induction from filmed versions of *Shrew* removes the play's most common theatrical "excuse" for its gender politics (i.e., it's all a prank, or a drunkard's wish fulfillment). In the very necessity of using the camera's eye to produce a second perspective on the story, modern filmmakers both reveal the potential of their medium to provide an alternative "frame" to the script's use of Sly and call attention to the text's troubled relationship to Katherina as shrew-heroine. Their choices also highlight the continuing difficulties involved in imagining a woman as the dramatic subject as well as object of narrative desire, and especially the interrelated muteness and mystery associated with woman-as-knower. Yet while the use of the camera to gesture at female subjectivity deserves special attention, ultimately each foray is displaced by a more conventional "solution" in representing femininity.

Both modern theater and film have removed the ironic potential of a cross-dressed boy playing Katherine. Thus they make all the more central their basic reliance on modern culture's enshrining of the heterosexual love plot and the presumed link between love and marriage. The familiarity and tug of this domestic fantasy helps explain *Shrew's* obsessive return to the screen – particularly during the decades of "backlash" when advances in women's political participation outside the home have prompted a response from those who perceive a threat. The timing of the *Shrews* reinforces this cultural connection. In addition to five silent shorts between 1908 and 1913, "spin-offs" such as *Taming Mrs. Shrew* attest to the popularity of the story during the heyday of suffragism.[3] Soon after suffrage came another silent (1923), and finally United Artists' *The Taming of the Shrew* of 1929, the only movie in which Pickford and Fairbanks co-starred. It claims pride of place as the very first of all Shakespeare "talkies."

Having been supplanted by more sophisticated remarriage narratives and screwball comedies during the Depression Era, *Shrew* returned as an ur-text for two musicals in the 1940s.[4] Soon after, the next set of "faithful" *Shrews* (as well as the filmed version of *Kiss Me, Kate*) coincided with the enforced return to domesticity of the women who had provided World War II's "swing shift"; Rosie the Riveter was supplanted by Kate the Happy Housewife, as sponsored on television by Westinghouse and Hallmark. All these 1950s productions adopt Petruchio's perspective; on television he is a "frame speaker" who gets the first or last word, while in *Kiss Me, Kate* his character doubles as the narrator for the titular musical-within-a musical. The new homeviewing technology gave *Shrew* new resonance, as it not only promoted female consumerism but quite literally kept women in their homes. And despite its stylistic innovations and dazzling tempo, Zeffirelli's feature film for the swinging sixties retained this emphasis on domesticity – though the motivation and effect of its domestic desires may be interpreted in a radically different way. Indeed, because of an unusual alliance between the director's and Katherina's perspective vis-à-vis the narrative, the unexpected subtext of this farcical film reveals female silencing and isolation, the issues that *Shrew* ballads of Shakespeare's era were quite blatant in

promoting but which stage and film versions of the modern era have anxiously tried to suppress.

The third wave of *Shrews* appeared not in the cinema but back on the t.v. screen, during the decade following the emergence of "women's liberation." Between 1976 and 1986, five *Shrews* (including one parodic rewriting) appeared on North American television – setting a frequency record for productions during the era of sound recording. The most telling cinematic innovation in several of these is a post-"sexual revolution" directness in emphasizing the erotic appeal of Petruchio's body as a motivation for Kate's conversion. The centrality of sex appeal is particularly powerful in two versions based on theatrical performances, both broadcast on PBS: the 1976 video of the American Conservatory Theater (ACT) production, and Joseph Papp's 1981 video repackaging of scenes from the New York Shakespeare Festival's Central Park production. By contrast, Jonathan Miller's putatively historicist and undeniably sober *Shrew*, made for the BBC Time-Life Series, was the perfect production to usher in the neo-conservative 1980s.[5] Miller set his production in opposition to what he perceived as "American" "feminist" versions less true to Shakespeare's text; he identified this foreign enemy with Papp (Miller 1986). Ironically, the stars of Papp's own video, *Kiss Me, Petruchio*, appear to share Miller's sexual politics: in interspersed backstage moments creating another version of a "frame" story, Meryl Streep and Raúl Juliá deny that the play's gender representation constitutes a problem.[6] Indeed, by replicating Juliá's stage energy and sexual appeal through its angled close-ups and fast-paced intercuts, *Kiss Me, Petruchio* seduces. For very different reasons, so does the send-up of *Shrew* on the US network television series *Moonlighting* (1986), which seems wildly progressive in simply advocating marriage as a "fifty-fifty" agreement. A sign of the times, indeed.

The clustering of filmed *Shrews* correlates with those decades when feminism has induced conservative responses and when the media are actively encouraging women to find their pleasures in the home; moreover, *Shrew* occurs at moments of new viewing technologies and is promptly reproduced in the new media before most if not all other Shakespeare plays. The agents of culture seem anxious to make sure *The Taming of the Shrew* is preserved, even as our science progresses: from moving pictures, to the first Shakespeare talkie, to early television drama, to Zeffirelli's first popularized "younger generation" Shakespeare film, to the world of network t.v. spoofs and home videos.[7]

In choosing to erase the Sly frame and use actresses for the female roles, the filmmakers increase the inset story's claims to social reality, already abetted by the transfer to a normatively realist medium. As Barbara Hodgdon has effectively argued, film's tendency to reify the voyeuristic and consumerist logic of the play's presentation of sexuality also reinforces the tendency to view Kate as a spectacle, bound by an economy in which her pleasure derives from placating "her" man; the female spectator who identifies with Kate, not wishing to deprive herself of what is represented as the means to heterosexual pleasure, thus participates in her double-bind. Patriarchal inscription becomes inevitable and

self-consuming for woman, with intended subversion revealed as always already inscribed as a subversion in the dominant discourse.

While finding this analysis compelling and descriptive of the narrative logic of most filmed *Shrews*, I resist viewing patriarchal reinscription as a formal necessity, as this discounts some striking film moments as well as the agency (and responsibility) of the filmmakers. My aim is not to deny that all the *Shrews* we currently have are works of ideological containment, but rather to suggest that despite their ultimate closing down of possibilities, their use of the camera and voice do temporarily work otherwise, and could be employed and extended in ways that might lead away from a co-opted and conservative gender politics. By looking closely at such moments of filmic adaptation and perspective play, my aim is not to argue about the prior existence of female subjectivity in Shakespeare's text nor to ignore the relative meagreness of those moments that catch my eye as causes for celebration within a bleak cultural canvas; rather, it is to affirm the significance and resonance of local artistic choices within our ideological frame, and hence the need to acknowledge their particular cultural agency and consequences.

To this end, I focus briefly on four films and four television shows that epitomize their generations' dominant patterns in representing *Shrew*, all are works that were constructed for screen viewing through editing and/or script-ing, rather than being video recordings of theatrical performances. In *Kiss Me, Petruchio*, the actual scenes from *Shrew* are filmed theater, but the intercutting of backstage interviews and commentary by audience members constructs a new narrative logic specifically for the camera. By combining a chronological discussion with emphasis on the use of the camera to create a second "authorial" perspective, I hope to illuminate both the attempts to expand the representation of Kate as subject, and the particular cultural "solutions" and frustrations tied to the eras of their production. Viewing these *Shrews* historically, we can better understand their duplicitous, shrewd cultural work.

EARLY SHREWS

The silent short films and early talkies establish the basic filmic patterns and modifications to *Shrew* that have been reproduced throughout the twentieth century. D. W. Griffith's direction of Biograph's brief 1908 *Shrew*, the first extant moving picture version, gains it a place in film history; Robert Ball regards it as one of Griffith's "fumbling experiments to express himself artistically in a new form" (Ball 1968: 62). Paving the way for several patterns in *Shrew* representa-tion, Griffith's Petruchio laughs at Katherine's physical assaults and brings his whip to the wedding; in keeping with the "improvement" of Petruchio on film, there is no final wager on Kate's behavior but rather an offering of flowers. As interesting as the film is Biograph's promotional material, which begins with a moralizing message clearly applied only to Katherine: "If we could see ourselves as others see us what models we would become" (cited in Ball 1968: 63). This

language foreshadows Jonathan Miller's 1980s statement that Petruchio gives Kate "an image of herself" (Miller 1986: 122) and Meryl Streep's matching explanation of Kate's visual education. In each case, woman uses her eyes not to view (and hence potentially criticize and judge) others, but rather to see an objectification of her inadequate self. Through this "proper" viewing of herself through the culture's eyes, Katherina is indeed transformed into a model of femininity.

The first *Shrew* produced in the era of women's suffrage, Edwin J. Collins's twenty-minute British & Colonial production of 1923, accounts for Katherine's transformation in terms superficially more amenable to independently minded women. One of the many narrative title cards explains: "By noon the next day, though famished and weary for want of food and rest, the Shrew deep in her heart admired the man whose temper is stronger than her own."[8] Here is the "two of a kind" logic that some critics later apply to Zeffirelli's film, arguing that this wild couple stands in opposition to the tame, mercantile society of Padua; here too begins the representation of Katherine as the desiring subject erotically drawn to an alpha male, a pattern dominating the late twentieth-century *Shrews*. Petruchio's strength is signified by the invulnerability of his body to her fists and fury, gendering the female as the one who is subject to physical suffering. When she hits him to punctuate her warning to "beware my [wasp] sting," she hurts only herself: enacting a classic comic trope, he laughs while she nurses her own hand. Again deleting the final wager, the film ends with Kate firmly transplanted to her new home and cured of her "vile" temper, laughing and kissing Petruchio as she sits in his lap.[9]

United Artists' feature film of 1929 shares this final image of the happy couple, but the backstage context informing Sam Taylor's movie is more complicated. Whereas the other silent *Shrews* prefigure the norms that predominate in the sound era, this version reveals the struggles and momentary counterimages that encourage us to look closely. Made at the moment of transition from silents to talkies when many theaters were not yet equipped for sound, the movie was released in both formats; this knowledge helps explain the extreme gesturing and slow pace of the early scenes, and adds to one's appreciation of Douglas Fairbanks Sr's spirited entry and almost throwaway delivery. It does not, however, explain his bungling of famous lines ("I come to wive in Padua – wealthily"). For that, we must turn to Mary Pickford's autobiography:

> the strange new Douglas acting opposite me was being another Petruchio in real life . . . I would be waiting on the set for him till nearly noon. . . . When Douglas finally showed up, he wouldn't know his lines. They had to be chalked on enormous blackboards, and I had to move my head so he could read them. . . . With dozens of eyes focused on us every minute of the day I couldn't afford to let my real feelings be seen.
>
> (Pickford 1955: 311–12)

Pickford was hardly an impartial observer: during *Shrew* her marriage to Fairbanks was disintegrating. But even if read skeptically, her tale of the traumas

of playing Kate (and play[Kat]ing Fairbanks, to invoke Hodgdon's pun) resonates in later actresses' accounts, most notably those of Fiona Shaw.[10] While director Sam Taylor's writing credit created an uproar at the time, more enduringly troublesome is the acting advice he had relayed to Pickford, against her own better judgment: "We don't want any of this heavy stage drama; we want the old Pickford tricks." The result, Pickford notes, was that "Instead of being a forceful tiger-cat, I was a spitting little kitten."[11] The "set was tense with unspoken thoughts" as her suggestions were overridden: "The making of that film was my finish. My confidence was completely shattered, and I was never again at ease before the camera or microphone." Internalizing *Shrew*'s dynamics, Pickford gave up her unpopular attempts to become something other than America's Sweetheart, soon abandoning her career as an actress for behind-the-scenes employment.

Despite her Shirley Temple timbre and pout, Pickford nevertheless was given equal time on screen, with added speeches and close-ups creating a sense of her ongoing agency, albeit in solitude or silence. The film's more equivalent representation of Kate and Petruchio includes giving them duelling whips, duelling soliloquies, and duelling eavesdropping scenes. Echoing Garrick's script, Katherine gets the last lines of the "wooing scene" as a soliloquy (a form she lacks in Shakespeare), using Petruchio's animal-taming metaphors to refer equally to herself and her rider/falcon:

> Look to your seat, Petruchio, or I'll throw you.
> Katherine shall tame this haggard or if she fails,
> I'll tie up her tongue and pare down her nails.

Though the scene begins with a phallic parody in which Katherine visually assesses their respective whip-length and retreats upon discovering that Petruchio's is longer, both this and the previous scene broadcast an ironic send-up of the usual Fairbanks hero. Gremio and Hortensio exchange sidelong winks and glances behind Petruchio's back when he delivers his braggadochio catalogue of experience ("Have I not heard lions roar?"), and he breaks down in near-hysteria at the prospect of a "woman's tongue." In a remarkable dissolve, we continue to hear Fairbanks' laughing reiteration of "a woman's tongue" as the scene shifts to the unhappy face of Baptista, being chastised by Katherina in her first speech of the film (earlier, we only *saw* her, and briefly). Thus the director's edit serves to mock Petruchio even as it confirms the narrative's logic that he plays a necessary role in taming Katherina's dangerous tongue.

Both through this visual choice and textual modifications, the following scene accentuates the fear of uncontrolled female speech, whose power is in some part confirmed as Katherina exits with a curse (borrowed from Gremio's part) which silences her father: "you may go to the devil's dam." She later uses her tongue as well as body parodically when waiting before the wedding, imitating Petruchio/Fairbanks' sweeping arm gestures, swagger, and incessant "ha ha" as she describes his behavior. Both speech and visuals collude in deconstructing

Petruchio's dominance, reaching a climax when the man who began by leaping over walls ends up reeling in pain from her blow to his head (with a jointstool), murmuring "Have I not heard lions' roar?" in woozy bafflement. While the film alters the story to undo Petruchio's harsh agency in effecting a change, Katherina's speech must nevertheless be tamed, a sign of her tender feminine heart when she discovers her husband's vulnerability.

Uniquely among screen *Shrews*, Katherine's final assertion of voice does not require the disappearance or rejection of Bianca: Pickford's famous final wink after her abbreviated last speech, the film model for later winks at the audience, is here clearly aimed at her *sister*, and is acknowledged as such: behind the patriarchal ventriloquizing remains a conspiracy of "unspoken thoughts," a female subculture whose bond is unbroken. Though her words have become tame, Katherine remains the one who sees more than her husband, creating a silent connection between her perspective and the filmmaker's own. In concert with the shift from an invulnerable to a wounded Petruchio, these adaptations – while hardly presenting a challenge to the social world of Padua – preserve a "separate sphere" for woman as agent. Kate thus sustains her own gaze and the illusion of self-creation from a subaltern position, becoming the sneaky servant rather than the Stepford wife of patriarchy. And in what seems on screen to be their "merry war," Pickford and Fairbanks together provide a prototype for the great Hollywood comedies to come, in which equally important co-stars mix screwball antics with subtler repartée than this transitional film affords.

A SHREW IN THE HOME

The camera's eye works quite differently in US television's first *Shrew*, the Westinghouse Studio One production broadcast June 5, 1950. Whereas the Pickfair film represents an ironic visual contest between the sexes, this *Shrew* suggests a gap between the viewer's expectations about a "classic" and what the new technology will reveal. The hour-long video begins with a visual joke premised on our sense of historical distance from the past, a distance the immediacy of live, modern-dress performance will then work to deny. Beyond a stone arch labelled "Padua," we survey a painted backdrop with a monumental column dominating an ancient townscape; then the camera tracks back to reveal the modern world of sidewalk cafés as Petruchio (Charlton Heston dressed in trenchcoat, hat, and sunglasses) enters on a bicycle and reiterates "Padua." Shorn of all that might distance this story from an American viewer (including the master/servant relations and class stratification that complicate the text's power relations), this version relentlessly reiterates conventional postwar ideas of gender difference. Even the radios Betty Furness hawks during a commercial break are gendered.[12] Having downed a beer in one gulp, pleased-with-himself Petruchio laughingly pronounces his modernized version of Grumio's couplet: "Katharine the curst!/Of all titles for a woman, this one's the worst"; slapping her ass and chuckling to himself throughout the play, he appears entirely satisfied to embody

those attitudes that two decades later would be called male chauvinism. The transformation of Lisa Kirk's Katherine, meanwhile, is played out through frequent costume changes. As if to replicate the recent displacement of the silver screen's strong women by "softer" sweethearts, Kirk begins in a riding outfit clearly evocative of Katherine Hepburn's trousered look (she beats blonde Bianca, who wears an off-the-shoulder dress, with the riding crop), but with her courtship and marriage this Kate changes to the "proper" dresses that accentuate her hourglass figure.

The new medium of television also accentuates a cartoonish vision of Katherine; Kirk's Broadway background ill prepared her to convey gesture subtly on screen, and she mugs in silent close-up while Petruchio talks in the middle distance. She is done a further disservice by director Paul Nickell's decision to give her a voice-over "soliloquy" of lamentation in Act 4 (the speech usually addressed to Grumio) while she silently gestures her hunger straight at the camera: in both cases, she appears less angry than mad. Nickell's treatment of Kirk could not be more remote from the use of voice-over for soliloquies in Olivier's films of himself as Henry V and Hamlet, in which the actor's pensive face becomes an occasion for aesthetic adulation. By contrast, this vocal/visual experiment in the new technology serves, like the production as a whole, to legitimate the domestication of women. Unlike Petruchio, who gets to speak directly to the camera in his soliloquies outlining his plan, Katherine is shown silently mouthing comments at the end of the "wooing scene" and then close-mouthed at this moment of putative self-expression; but she does get to speak directly to the camera in the final speech, as she reminds all those happy home-makers about their duties to their husbands. Meanwhile, a grinning Petruchio casually eats grapes. The hour concludes with Kate's sustained wink to the camera while engaged in her third stolid kiss with Petruchio. She is thus allowed to address the t.v. audience as a unified speaking subject only when she has learned to manipulate the system and stand by her man.

Stylistically at the opposite end of the spectrum, the other US television *Shrew* of the 1950s nevertheless shares with the Westinghouse version an air of confidence and nonchalance in regard to its subject matter. Moreover, for all its visual wit and parody, the 1956 Hallmark Hall of Fame production starring Lilli Palmer and Maurice Evans concludes similarly to the 1950 "realistic" version.[13] The divide-and-conquer logic implicit in most productions, wherein Bianca must be revealed as the "real" shrew when Katherine is tamed, is accentuated by transferring the widow's lines to the younger sister (see Miller 1986, 122). In this regard, both the 1950s television *Shrews* seem to have taken a step backward in time from Pickford's finale. And as in the 1950 production, Palmer's Katherine shifts her gaze from Bianca to the camera during her final speech when pronouncing that "women are so simple"; deploying the new intimacy of the television screen to make herself a guest in our home, she smiles as she calls us "unable worms." The play had opened with an oblique use of lines from the Sly Induction, when Grumio invited the audience to watch these "antic players," addressing the t.v.

camera as he said "Come, madam wife." Now all the madam wives of middle America discover the purpose of their spectatorship as Katherine goes down on her knees, earning a final kiss from her husband and lord. Despite Maurice Evans's friendly reappearance after the curtain calls (in order to advertise subsequent programs), the feminine mystique of the play's conclusion has not been ironized by this "romp."

A SHREW ALONE

Ten years later, Elizabeth Taylor similarly performed *Shrew's* final speech without irony – and indeed without any lead-in request from her Petruchio, for she launches into her chastisement immediately upon re-entering the banquet hall (having dragged along the other women on her own initiative as well). The result was to naturalize Katherine's assertions as her own spontaneous feelings, flamed by her indignation at unruly wives and empathy for her husband's unexpressed desires. In this, art imitated life. For Taylor herself chose to perform the scene "straight" to the surprise of both director Franco Zeffirelli and co-star Richard Burton, and her husband was touched:

> The usual trick is for the actress to wink at the audience . . . Amazingly, Liz did nothing of the kind; she played it straight . . . and she meant it.
>
> Full of that Welsh passion, Richard was deeply moved. I saw him wipe away a tear. "All right, my girl, I wish you'd put that into practice."
>
> She looked him straight in the eye. "Of course, I can't say it in words like that, but my heart is there."
>
> (Zeffirelli 1986: 216)

Complete with Taylor's stated inability to own the powers of language, this incident epitomizes the paradoxical nature of Zeffirelli's film, in which Katherina is presented far more empathetically and with greater agency than in most video versions, yet employs that agency to naturalize a traditional sex-gender system all the more doggedly.

With similar irony, there is a surprising undercurrent of melancholy and nostalgia for home within this fast-paced lark of a film designed to appeal to the sixties younger generation. Those raised on MTV may find the contemporary reviews of this *Shrew* bemusing, for their worries about the disorientation caused by busy sets and camerawork seems almost quaint given the subsequent speed-up of our visual culture. Moreover, this concern with pace tends to displace detailed analysis of why the film makes unusual choices, such as presenting a predominantly boorish Petruchio and an often tearful Katherina, whose isolation is accentuated by sentimental music and lingering close-up shots. Some have regarded the movie solely as a vehicle for the co-producing star couple, but in this paradoxical tempo one finds marks of the director's own sensibility, representing through the images of *Shrew* the same emotions that his autobiography

articulates regarding his fractured and romanticized childhood. His tendency to empathize with the social outcast becomes the occasion for cross-gender identification with Kate, as the camera repeatedly adopts her perspective and adds private moments in which we see her thinking.

An illegitimate child, Zeffirelli felt both beloved and abandoned. He was raised sequentially by a peasant wetnurse, his professional but socially ostracized mother (who died when he was six), and his unmarried aunt. His father, who occasionally visited his mother, at which time the "family" all shared a bed, remained in other ways distant from the little boy; his father's wife memorably hounded the child as a "bastardino" and haunted his dreams (her harassment becomes his autobiography's framestory). What Peter Donaldson notes in regard to Zeffirelli's other films also applies to his *Shrew*, providing a subtext for his empathetic representation of Katherina's perspective: "Mourning for his mother's death and absence, grief for his own exclusion from the parental relationship . . . and the effort to find a place in a fragmented family leave their mark on Zeffirelli's work in film" (Donaldson 1990: 147).

Zeffirelli's sensibilities are split and seemingly contradictory, befitting the topsy-turvyness of life in the sixties. His favorite movie of the year was the Beatles' *Help!* and he got its buffoon-villain Victor Spinetti to play Hortensio, as well as hiring disaffected Roman *capelloni* ("long-haired ones") for the university scenes. At the same time, Zeffirelli insisted that the Italian premiere of his film be the English-language version, to please any of the old English ladies still surviving in Florence who had shared in his own youthful discovery of filmed Shakespeare through Olivier's *Henry V* – a film he credits with having liberated him from paternal authority by giving him the confidence to choose an artistic career.[14] In a version of subjectivity akin to that which the film grants Katherine, he became free to follow the master(s) of his own choosing. As director of *Shrew*, he creates a fantastic version of "home" as screen image, displacing his own illegitimacy, his absent/present father, and the Florentine scandal that precipitated his mother's death, and replacing them with a cultural inheritance from the Bard, Italian *cinéma-verité*, and the visual splendors of the Italian Renaissance. Zeffirelli concludes the account of his childhood by remarking "I still have difficulty in trusting love when it is offered. This is something that has marked my entire life" (Zeffirelli 1986: 9). Within his representation, the farcical frenzy slows only when his camera lingers on those who are emotionally isolated, unsure, or far from home. The movie embodies the appeal of "traditional values" for those self-creators who were only partially transformed by the sixties sexual "revolution."

The plaintiveness of the moments when one sees Katherine's isolation and sense of betrayal and the balancing tenderness of attention to gestures of gentleness provide an unexpected counterpoint to this *Shrew*'s energetic opening. Such moments also sentimentalize the story more thoroughly than does Taylor's particular (though consistent) choice in the banquet scene. Throughout the film, the pauses are pregnant, and sympathy goes to the outcast: Katherina hurt and crying in defeat after the protracted wooing chase, as she realizes she has been

betrothed against her will; locked in a darkened room while the men chortle in the public hall; looking anxiously to her father for support as she faces unfamiliar applause before her wedding; unintentionally witnessing the backroom trans-action selling her (the transfer of the massive dowry her father has paid Petruchio); Katherine and Petruchio awkwardly preparing for bed; Katherina alone again, sobbing in the unfamiliar, wrecked bed in Petruchio's home; and then, in a key shift as she takes control of domestic space, a newly sympathetic Petruchio looking at his wife's working alliances with his re-clothed servants; melancholy Katherina sitting amidst the wreckage of her promised clothes; Petruchio uncomfortably focusing on his drink at the banquet and waiting to see if Katherina will come at his bidding; and Petruchio surprised to find her gone after he finally achieves his long-desired kiss. All these extratextual moments create another layer of storytelling, allowing Katherina as much subjective presence as Petruchio.

The dynamics of power change radically at the moment when Katherina discovers her means to control: housekeeping. While it is easy enough for the critic to point out the patronizing gender assumptions informing this means of attaining "power" (and Zeffirelli's political pronouncements affirm his conser-vatism on some gender issues), it is also important to recognize the seductiveness of his representation, rooted in another aspect of Zeffirelli's social vision: his sense of allegiance to and nostalgia for peasant life. Not only does Katherina remake herself as the force of culture and domestic beauty in opposition to Petruchio's ruffian masculinity, but she does so through an alliance with servants. She trans-forms the dusty barrenness of Petruchio's bachelor home into a lively arcadian villa, in which lady and grooms share featherdusters and wear similar homemade clothes. (Tellingly, the scene of Grumio's tormenting Kate with the prospect of beef and/or mustard is omitted.)

Here too Katherine's newly chosen way of life – not exactly "slumming" but finding solace in a working vacation from her privileged social position – matches a powerful memory from Zeffirelli's youth. He had spent summers in Borselli with his wetnurse's family, in a world later lost through the parallel changes of his growing up (and the death of his individual caretaker) and the culture's development (the displacement of the age-old peasant economy). Ironically, it was only in that "simple peasant town" that Zeffirelli "had a sense of permanence" (Zeffirelli 1986: 10–11). The director's affection for this world in which the children picked out dead ticks from the wool and all the clothes were homemade overdetermines the more obvious messages produced by similar actions on film (Petruchio's boorishness in proudly displaying his dog's ticks at Hortensio's table; Katherina's "capture" in the woolbin; her rustic home decorating); it also deepens the film's nostalgic desire to embrace a past in which class as well as gender are mystified. After comically recording the skepticism of laborers who hear Lucentio's outburst of academic desire upon entering Padua, the rest of the movie presents the people as a jolly chorus to the public scenes – an energetic film correlate to a theater audience's response, but also one that

recreates feudalism as the good old days. It counters critical attempts to read Kate and Petruchio as carnivalesque opponents to a rigidly monolithic society: this jolly, frolicking Padua is not represented in a way so amenable to Bakhtinian schematization.

Conversely, the ironies and wit of Zeffirelli's *Shrew* defy oversimple interpretation of this as a conservative film. In addition to its unusual crediting of Katherina with interiority akin to the director's own, it is also a work of pop art in postmodern style. For the film, as Holderness observes, is a minefield of parody. The fact that it is the giant prostitute who breaks into tears at the domestic fervor of Katherine's grand finale makes her action equally available for sentimental or ironic interpretation.[15] Moreover, the stress on Baptista's "selling" of his daughters provides a countertheme to the romanticized home. This is especially true in the film's midsection, where Zeffirelli delivers a 1–2–3 punch showing Katherine isolated and silenced at her own wedding festivities. First Katherine, humiliated by Petruchio's loud, late arrival, tries to yell "I will not" at the altar in response to her wedding vows – but Petruchio literally stops her mouth in an uneroticized kiss before the last word, at which point the entire congregation loudly celebrates. Then in a second shot Katherine is shown half buried by the congratulatory crowd, desperately yelling "no" and "father" despite the crowd's indifference to her will. We then appear to shift mood with Katherine as she graciously thanks guests at the reception while a musical consort plays; this, however, is merely the prelude to her witnessing, beyond a doorframe, the handshake and transfer of dowry funds from her father to her husband, an action confirming her isolation. She stands silently gazing from outside the space of a more orderly transaction than took place at church. This sequence of isolating moments, which highlights the culture's traffic in women, works in concert with an undercurrent of violence and the shifting use of the camera's perspective to create a more complicated film than has been fully credited.[16]

WHO'S ZOOMIN' WHO?

Zeffirelli's perspective play, in and out of Kate's vantage point, makes obvious the shaping potential – and ironic openendedness – allowed by artful use of that other movie "subject," the camera. Such play is especially appropriate for representing the subjectivity of a character who, though called a shrew, seldom gets a word in edgewise. Fiona Shaw observes, "Along comes a man to tame the noisy one. And for almost five acts we never hear her speak"; but Paola Dionosetti rightly adds that although Petruchio gets the lines, "Kate has eyes everywhere" (Rutter 1989: 1). The more socially progressive versions work to equalize the battle of wills by showing Katherine in thought, or by constructing visual matches. In Zeffirelli's film, the balance shifts in keeping with his visual priorities as well as emotional sympathies.

While critics swoon over her eyes and bustline, the camerawork not only accentuates Taylor's feminine beauty but mimics her positionality: showing her

first as a single watchful eye above the street action; viewing her viewing; pausing to watch her pausing to think; concluding scenes when she concludes her sequence of emotions and decision-making. Indeed, it is Bianca's usurpation of Katherine's viewing position at the window that initiates Kate's attack on her sister, prompting the mock-horror sequence that actually unites the camera's perspective with Kate's own gaze. This affinity between the camera and Kate holds true after the wooing sequence, when the camera returns to join Katherina in her darkened room looking out rather than moving on with the men in the hall; gone is the scene of bartering over Bianca, leaving Katherine's solitary smile to close the narrative's first section. Similarly, in the wedding scenes her looks counterbalance Petruchio's blustering comedy and she again has a solo moment to end the sequence, when she pauses on donkeyback at Padua's gate recognizing that neither direction holds much promise. She is seen last in the travel scene (in which Kate actively schemes to intercept the other riders, rather than merely suffering as in Grumio's textual account), and she gets both the nuptial bed and the last image on her wedding night – all the more remarkable since Petruchio's soliloquy is virtually cut.

By presenting Petruchio as a material creature at the start (a choice often criticized despite its textual defensibility and cinematic usefulness), Zeffirelli allows these camera shots to establish Kate as the movie's silent thinker. This subjectivity remains even after her gain in power causes a shift of empathy embracing Petruchio (now quieter, smarter, and sadder than before she started cleaning house). Because we have already seen Katherina plotting, acting unexpectedly, and only afterwards understood her motives, her final "straight" delivery of her major speech benefits from that sense of anticipation: when Petruchio turns to find her gone, he experiences the surprise that we, filmically, have been trained to expect. Yet we do end up looking at the world from Petruchio's rather than Katherine's vantage. The ironies in this conclusion are legion: the actress's unexpected choice of sincerity is overriden by the director who thereby sustains his own vision by crediting the character with more artfulness than the actress professes. As such, this version shares with so many other productions a power struggle not only between the protagonists but also between director and actress. What remains indisputable is the complexity of cameraplay in the Zeffirelli film, and its crucial effect upon the representation of Katherine.

BACK TO THE FUTURE

The five television variations on the theme of *Shrew* appearing in North America between 1976 and 1986 demonstrate the range of stylistic interpretation the play continues to afford; they also reveal how meagerly the previous decade's political upheavals informed those productions deemed worthy to broadcast. Despite radical theatrical reinterpretations such as those of Charles Marowitz and Di Trevis, the hallmark of these t.v. productions (with the obvious exception of the last, a network spoof) is textual fidelity. The most notable shift has been

an explicitly sexual one. In trying to make a recalcitrant text appeal to both sexes, the productions and camerawork for both the ACT and Papp videos celebrate the male body as erotic object; that body is well represented by the charismatic, slyly self-parodic figures of Marc Singer and Raúl Juliá.

For the "me generation," sexual passion (leading automatically to true love) provides the quick-fix to explain away the societal dynamics of power in Katherine's "taming" – or so Meryl Streep's backstage commentary seems to imply in the video aptly entitled *Kiss Me, Petruchio*.[17] Raúl Juliá's Petruchio plays the sexual Svengali, his perspective credited as fully reasonable and his body the prize worth any price; as Juliá himself asserts (in comments that shift between the third and first person), Petruchio "is very self-confident . . . [and] feels he can make the best husband in the world, and he *can*, too . . . I'm here to make money . . . and any father [with the money for a dowry], he's getting a good bargain." The video seems to confront the potentially offensive aspects of the play right away, with Petruchio performing his post-wedding assertion of owner-ship ("she is my goods, my chattel . . . ") – the only speech recorded twice, in and out of context. What we are soon told, however, is that we should not have been identifying with the audience members who boo – or if we do, our protest has already been as domesticated as Katherine herself (Streep: "They boo because they don't *see* it"; Juliá: "I love it when they boo and hiss Petruchio, because that means Petruchio is making them feel something."). Throughout, offstage cuts deflect potential criticisms of the production, as do camera pans of the audience (we are shown women laughing at the end of the "wooing" scene as Petruchio sits on Katherine announcing she will become as "conformable as other household Kates"). Because the actors are commenting during a perfor-mance, they understandably adopt the perspective they have created for their characters. In Juliá's case this adds an unintended layer of comedy; however, Streep's replication of Katherine's "conversion" – seeing the world through the eyes of patriarchy – is more disturbing, particularly because she does not show comparable imagination in understanding Katherine's former "shrewish" identity. Onstage, she performs a cartoon catalogue of "masculine," anti-social behavior (stomping on flowers, "pumping up" for a fight); although she always appears smart and funny, none of these actions is presented with the nuanced psychological realism she accords to the reformed Katherine. The video accen-tuates this by allowing her voice-overs to explain the latter part of the play, whereas Juliá's comments dominate during the first half. In a voice-over during the tailor scene, as Kate sits with the torn gown in hand, Streep asserts "Really what matters is that they have an incredible passion and love; it's not something that Katherine admits to right away but it does provide the source of her change." Then, as Katherine silently gives the dress to Petruchio, Streep makes the leap to his perspective (thereby legitimating what she never directly confronts, the inequity of behavioral reformation and her infantilization in this putatively mutual scene of passion and love): "What Petruchio does is say I'm going to take responsibility for you, and I'm going to try to change you *for your*

better, make you as great as you can be." Both actors presume throughout that Petruchio does not need to be (could not be?) improved.

The focus solely on the leads and the constant need for the actors to justify the narrative testify to the play's intractability; Streep's exasperated attempts ultimately underscore the interpretive work necessary to make sense of Kate's fate, and leave one agreeing instead with Ann Thompson's sense that "we can no longer treat *The Shrew* as a straightforward comedy but must redefine it as a problem play in Ernest Schanzer's sense: . . . 'so that uncertain and divided responses to it in the minds of the audience are possible or even probable'" (Thompson 1979: 41). Perhaps the video's most appealing choice is to allow audience members to voice the tensions that the actors try so hard to erase. In the viewers' responses a gender gap appears. None of the men interviewed expresses discomfort, whereas the women divide: most express reservations, though one (speaking in concert with her male partner) fully enjoys this "fabulous love story."

A jolly conclusion recapitulates the performance's emphasis on Petruchio as sexual prize, as if to defuse the social hierarchy: Kate begins to drag him off to bed during the final lines, and then he concedes to exit in her direction during curtain call. While a woman in the audience gets the last word (noting that "It's a fantasy that is dangerous for men" and that she feels "very ambiguous"), the last image is Streep patting Julia's ass as they exit – as if this role-reversal of Heston's fifties' slaps constituted a restoration of equality.

WHEN A WOOER GOES A WOOING . . .

Comparison between this production's and Zeffirelli's rendering of the climactic scene of *Shrew*'s first two acts, the initial encounter between Katherine and Petruchio (2.1.178–269), reinforces the crucial role of the camera in establishing empathy and shaping the script's significance.[18] To achieve the dowry that has motivated his suit, Petruchio must obtain "the special thing . . . That is, her love" which her father regards as "all in all" (2.1.124–25). Nevertheless, as in the parallel "wooing scene" in *Henry V*, it is not clear that Katherine's consent is actually required: Petruchio's reply "Why, that is nothing" (2.1.126) not only indicates his confidence that he will make her yield but also how little evidence it takes for the men of Padua to decide she has been won. Both in the play and in criticism, Katherine's own last words of the act, her refusal to marry ("I'll see thee hanged on Sunday first!"; 2.1.288), are overriden and supplanted by Petruchio's brazen assertion – directly contrary to what he knows of her "private" behavior, and consistent with his decision to invert the truth verbally to get his way – that "tis incredible to believe/ How much she loves me" (2.1.295–96). Indeed, to make *Shrew* into a romantic comedy, one needs to make Petruchio a truth-teller in spite of himself or else motivate an even more "incredible" reversal later (having Katherine fall for him when he deprives her of all forms of ownership). Neither subtext is psychologically implausible in a

world of contorted desires and socially endorsed abjection, but to say so removes the lightheartedness associated with farce and may make a viewer uneasy. Once the complexity of real-life psyches intrudes, slapstick can look distressingly like domestic violence, and the problem of Kate's consent is not evaded but compounded.

In the Papp production, the eroticized male body which provides an explanation for Kate's desire is thus invoked most insistently in the initial encounter. The scene allows Juliá to dominate playfully and seductively without seeming overtly violent. Thus Petruchio tickles, carries, and encloses Katherine, but only she actually slaps, hits, and spits; nevertheless, she is the one who is left breathless and lying on the floor, while he retains his poise and humor. When Kate strikes Petruchio to "try" whether he is a gentleman (the scene's only scripted violence), he does not flinch. When she spits in his face in response to his request to "kiss me, Kate," he pauses and then delightedly licks his lips to ingest her spittle. Although Streep makes the most of her wittier lines, she is clearly confronted with a superior force here, whose apparent invulnerability to abuse or opposition is only a step less absolute than Fairbanks's laughter as he is whipped. The tide of inevitability that Petruchio had predicted is thus for the most part fulfilled in these performances through the men's delighted embodiment, and Kate's resistance seems both doomed and counterintuitive. These are the sexual dynamics captured by the camera most frequently in twentieth-century *Shrews*.

By contrast, the extended farcical chase in Zeffirelli's movie defuses the scene's focus, transforming Petruchio's relentless verbal enclosure of Katherine into an unpredictable game in which neither words nor rooms can effectively enclose energy: both their bodies hurtle precariously through space, walls, and ceilings. Petruchio does show his persistence, using his head to raise the trap door upon which Kate heavily sits (thus giving a visual punch to the bawdry of his "tongue in [her] tail" retort). But the camera's giddy tracking from room to courtyard to barn to roof and back down through roof to woolbin conveys the film's ongoing message that Kate may eventually be trapped but not easily tamed. The end of the scene brings a shadow of violence, but in doing so acknowledges a change of mood as well: when Petruchio pins down Katherine in the woolbin, the stick in her hand (with which she has been pounding his head) is forced across her throat, while the camera angling down upon her head and heaving breast comes close to Petruchio's perspective of dominance. This eroticized shot puts Katherine in the position of countless female victims in movie thrillers, cowering with a knife at the throat. Zeffirelli earlier used a conventional horror movie sequence in open parody, with Kate in the unseen killer/monster position of the camera closing in upon Bianca as the screaming victim. Thus the shift in Katherine's placement underscores her succumbing to the superior force of Petruchio and the coincidence of that position with eroticized femininity. She will later reclaim equanimity through her greater intelligence and her adoption of a matron's role, but here – and in her subsequent collapse on the floor in tears – she is first revealed as vulnerable in body and spirit. Even as Petruchio looks

on tenderly and helps her to her feet, this "wooing" concludes by uneasily signalling his power and her abjection, not her consent. Here again Zeffirelli's practice implies the possibility of a more extensive use of the camera to suggest another perspective on Shakespeare's story.

CODA: ALL'S WELL . . . ?

The silliest of the 1980s *Shrews* constantly parodies Zeffirelli's film, and goes further in modifying Shakespeare's text to create a space for modern love. Replacing the Sly frame with a homework-resisting schoolboy who wants to watch television, the *Moonlighting Shrew* begins with some self-reflexive comedy about the most widespread modern addiction and its target audience. And by placing the series' stars in Shakespeare's plot (sort of), we get a market-pleasing three-for-the-price-of-one dose of character deconstruction: when Cybill Shepherd plays Maddie Hayes plays Kate, and Bruce Willis plays David Addison plays Petruchio, who can say what's "really" going on? One joke involves Willis/Addison/Petruchio presenting his parchment list of dowry demands, which includes a winnebago, rights to direct, and other t.v. contract items; having earlier quoted other Shakespeare lines ("wrong play"), he now realizes "wrong scroll." As much a send-up of contemporary media as of Shakespeare, the show nevertheless displays a commonsense consciousness of the textual tensions scholars spend so much energy explaining away, and uses its over-determined characters to comment on how times do change (as in Willis's comic aside after his pre-wooing soliloquy, which devolves into the Steinian mantra "the man is the man is the man . . . ": "if you're a man, you gotta love the sixteenth century"). Willis's rock-n-roll wedding number, "Good Lovin'," invokes the familiar medical trope but converts Dr. Petruchio into the patient ("I said doctor, Mr. M.D., /can you tell me what's ailin' me? . . . he said all I really need is good lovin'"). Of course, singing "I got the fever, you got the cure" to a Katherina bound and gagged at the altar takes "commentary" over the top. The looney-tunery of his post-wedding courtship (at which point Shakespeare's plot is entirely rewritten to replace coercion with mutual respect) reanimates a classic cartoon sequence: upon Petruchio's third gift offering at a hostile Katherine's door, her hand shoves a stick of dynamite into his suit-of-armor's visor; he "looks" at us, walks off camera, and then the picture jiggles with the unseen explosion. Inverting the sun and moon speech to allow Katherine her own eyesight, the show carries further Shakespeare's comic logic, allowing hierarchies (artistic as well as gendered) to evaporate without pain. Unlike the Papp video so titled, when Kate here says "Kiss me, Petruchio" and sweeps him into her arms, role reversal gives the story a new lease on life, without victims. And for those who wish to find a Petruchio motivated by true love rather than money, this version makes his culminating gesture the renunciation of the dowry (which here is involved with the wager). An unabashed American wish-fulfillment of painless change resulting in equality for all, this sunny moonlit

Shrew announces it is now the best of times, when the messages a schoolboy learns from his "Atomic Shakespeare" resemble those in "Free to Be . . . You and Me."

As Graham Holderness concludes, if historical analysis "fails to engage with contemporary sexual politics, then the play will continue to speak . . . for the same repressive and authoritarian ideology" (Holderness 1989: 117). In Zeffirelli's emphasis on the visual, he suggests that artful camerawork and conceptual adaptation could yet produce a textually grounded but truly modern *Shrew*: a fully filmic version that would address rather than replicate the gender hierarchy that continues to haunt most screen versions. Until that time, viewers may take solace in the farcical throwaways of the *Moonlighting* grapple:

PETRUCHIO: Where there's a will –
KATHERINA: There's a won't.

Perhaps it will take a new millennium to produce a more experimental filmic rendering of this resistant tale. For the present, by studying the subtler differences and historical reflections of the many twentieth-century *The Taming of the Shrew*s, we may learn more – if not about a golden world, at least about this brazen one.

NOTES

1 This number excludes spin-offs.
2 While aware of the shiftiness of meaning in comedy and of the ways people ironize or evade some of the text's less pleasant implications, the work of Boose, Newman, and Marcus has demonstrated, and companion plays such as Fletcher's *The Woman's Prize* confirm, that the text responds to the particular gender issues of its time.
3 A link with contemporary gender issues occurs in the spin-off *The Taming of the Shrewd* (Knickerbocker 1912), in which a suffragist who has neglected her housework is "tamed" by her husband's arousal of jealousy when he escorts another woman to one of her political meetings (Ball 1968: 149).
4 See Hirschhorn (1981: 236) on *Casanova in Burlesque* (1944). The famous musical was *Kiss Me, Kate*, debuting on Broadway in 1948 and made into a film in 1953.
5 Radical only in its departures from theatrical tradition, this BBC-TV museum piece unabashedly celebrates the order achieved through female submission – and makes John Cleese seem not very funny as part of that project. The show was broadcast on the BBC in June 1980, soon after Thatcher's election; in the US on January 26, 1981, at the beginning of Reagan's presidency.
6 Although the stage director was Wilford Leech, I refer to this as the Papp *Shrew* because the video foregrounds Papp's proprietary control.
7 In a related "first," in 1964 *Kiss Me Kate* was the first US musical to be adapted for British television (Rothwell and Melzer 1990: 275).
8 Cited from the Folger Shakespeare Library Archive's 35 mm print. Another title card tells us that this Petruchio follows in the tradition of Garrick's "masked" educator: "In order to tame the Shrew, Petruchio determines to be more unreasonable than her in all things."
9 Visually, this *Shrew* epitomizes the style Collick characterizes as quintessentially and conservatively British, replicating the Victorian stage spectacle in its elaborate

costumes, proscenium-like sets, and statically full-front camera work. Collick (1989: 33–57) interprets it as symptomatic of a desire to define an English, as distinct from a US, style and tradition; see also Rothwell and Melzer 1990: 270–71.

10 Shaw remarks upon her parallelism with Kate as an actress alone among men in rehearsal, a gendered isolation which men don't [often] experience: "the sense of the terribly clouded confusion that overwhelms you when you are the only woman around. That was Kate's position, and it was mine: she in that mad marriage, me in rehearsal. Men, together, sometimes speak a funny language" (Rutter 1989: xvii).

11 Pickford 1955: 311. The 1966 version removes "with additional dialogue by Sam Taylor," replacing it with "Adaptation and Direction by Sam Taylor." Although the cutting of lines and variation from "pure" Shakespeare aroused criticism in 1929, the development of film theory and practice would confirm the necessity of true screen adaptation – including line cuts as well as the discovery of visual equivalencies and distinctively filmic motifs.

12 These radios are rhetorically and physically differentiated: the young man wants the "swell-looking job in the dark green cabinet" with the "powerful" reach; whereas the ivory compact is a "big favorite with the girls because it's light as a feather." Having been given the properly sexed radio, the couple dances away together.

13 Extending a pattern introduced by the 1929 film's opening with a Punch and Judy puppet show, this production uses *commedia dell'arte* techniques; the constant movement of acrobats, dancers, and clown-nosed servants combines with active camerawork to create an energetically three-dimensional look within the bare studio "setting."

14 See Zeffirelli 1986: 224 and Holderness 1989: 55–6 on *Help!*, and Donaldson 1990: 148–49 on the role of Olivier's film.

15 On the use of metafilmic parodies, see Holderness 1989: 64–7.

16 None of this undermines the farce or enjoyment that the film affords.

17 The stage directors' motivations for emphasizing the male body lie outside the scope of this essay. My aim is to outline the filmic effects of such choices, and how (even if informed by alternative sexualities and unconventional desires) when combined with a traditional narrative they reflect the dominant ideology of their times – in this case, making a patriarchal text more palatable to a predominantly heterosexual public affected by the "sexual revolution."

18 Line citations for *The Taming of the Shrew* refer to the Cambridge edition edited by Thompson in 1979.

REFERENCES

Ball, Robert Hamilton (1968) *Shakespeare on Silent Film*. New York: Theatre Arts Books.

Boose, Lynda E. (1991) "Scolding Brides and Bridling Scolds: Taming the Woman's Unruly Member." *Shakespeare Quarterly* 42.2: 179–213.

Bulman, J. C. and H. R. Coursen (eds) (1988) *Shakespeare on Television*. Hanover, NH: University Press of New England.

Collick, John (1989) *Shakespeare, Cinema and Society*. Manchester: Manchester University Press.

Coursen, Herbert (1990) *Shakespearean Performance as Interpretation*. Wilmington: University of Delaware Press.

Dash, Irene (1981) Review of the BBC *The Taming of the Shrew*. *Shakespeare on Film Newsletter* 5.2: 7 ff.

Dobson, Michael (1992) *The Making of the National Poet: Shakespeare, Adaptation and Authorship, 1660–1769*. Oxford: Clarendon Press.

Donaldson, Peter S. (1990) *Shakespearean Films/Shakespearean Directors*. Boston: Unwin Hyman.

Eckert, Charles W. (ed.) (1972) *Focus on Shakespearean Films*. Englewood Cliffs, NJ: Prentice-Hall.

Fineman, Joel (1985) "The Turning of the Shrew." *Shakespeare and the Question of Theory*, eds Patricia Parker and Geoffrey Hartman. New York: Methuen: 138–59.

Freedman, Barbara (1991) *Staging the Gaze: Postmodernism, Psychoanalysis and Shakespearean Comedy*. Ithaca: Cornell University Press.

Garrick, David (1981) "Catharine and Petruchio." *The Plays of David Garrick: Vol. 3*. Carbondale: Southern Illinois University Press.

Haring-Smith, Tori (1985) *From Farce to Metadrama: A Stage History of "The Taming of the Shrew," 1594–1983*. Westport, CN: Greenwood Press.

Hirschhorn, Clive (1981) *Hollywood Musical*. New York: Crown.

Hodgdon, Barbara (1992) "Katherina Bound: or, Play(K)ating the Strictures of Everyday Life." *PMLA* 107.3: 538–53.

Holderness, Graham (1989) *Shakespeare in Performance: The Taming of the Shrew*. Manchester and New York: Manchester University Press.

Jones, Edward T. (1977) "ACT's *Taming of the Shrew*: A Consciousness-Raising Farce." *Shakespeare on Film Newsletter* (2.1): 4–5.

Jorgens, Jack J. (1979) *Shakespeare on Film*. Bloomington: Indiana University Press.

Kahn, Coppélia (1975) "*The Taming of the Shrew*: Shakespeare's Mirror of Marriage," *Modern Language Studies* 5: 88–102.

Kliman, Bernice (1988) "Maurice Evans' Shakespeare Productions." In Bulman and Coursen, 91–101.

Manvell, Roger (1971) *Shakespeare and the Film*. New York: Praeger Publishers.

Marcus, Leah (1992) "The Shakespearean Editor as Shrew-Tamer." *ELR* 22.2: 177–200.

McMillin, Scott (1988) "The Moon in the Morning and the Sun at Night: Perversity and the BBC Shakespeare." In Bulman and Coursen, 76–81.

Miller, Jonathan (1986) *Subsequent Performances*. New York: Viking.

Morris, Peter (1972) *Shakespeare on Film*. Ottawa: Canadian Film Institute.

Newman, Karen (1991) *Fashioning Femininity and English Renaissance Drama*. Chicago: University of Chicago Press.

Oruch, Jack (1987) "Shakespeare for the Millions: 'Kiss Me, Petruchio.'" *Shakespeare on Film Newsletter* 11.2: 7ff.

Pendleton, Thomas A. (1987) "Garrick and the Pickford–Fairbanks *Shrew*." *Shakespeare on Film Newsletter* 12.1: 11.

Pickford, Mary (1955) *Sunshine and Shadow*. Garden City, New York: Doubleday & Co.

Rothwell, Kenneth and Annabelle Melzer (1990) *Shakespeare on Screen: An International Filmography and Videography*. New York: Neal-Schuman Publishers.

Rutter, Carol (1989) *Clamorous Voices: Shakespeare's Women Today*, ed. Faith Evans. New York: Routledge.

Thompson, Ann (ed.) (1979) *The Taming of the Shrew*. Cambridge: Cambridge University Press.

Van Watson, William (1992) "Shakespeare, Zeffirelli, and the Homosexual Gaze." *Literature/Film Quarterly* 20.4: 308–25.

Wells, Stanley (1982) "Television Shakespeare." *Shakespeare Quarterly* 33: 261–77.

Willis, Susan (1991) *The BBC Shakespeare Plays: Making the Televised Canon*. Chapel Hill: University of North Carolina Press.

Zeffirelli, Franco (1986) *Zeffirelli*. New York: Weidenfeld & Nicolson.

FILMS AND VIDEOS DISCUSSED

"Kiss Me, Kate" (1953) Dir. George Sidney. With Kathryn Grayson, Howard Keel.

"Kiss Me, Petruchio" (1982) Joseph Papp, producer. Video dir. Christopher Dixon [Stage production, dir. Wilford Leach, 1978]. With Raúl Juliá, Meryl Streep.

"Moonlighting" (1986) Dir. Will McKenzie. Written by Jeff Reno and Ron Osborn. With Cybill Shepherd, Bruce Willis.

"The Taming of the Shrew" (1908) Dir. D. W. Griffith. With Florence Lawrence.

—— (1923) Dir. Edwin J. Collins. Scenario Eliot Stannard. With Mdlle. Dacia, Lauderdale Maitland. Folger Shakespeare Library Archive.

—— (1929) Dir. and adapted by Sam Taylor. With Douglas Fairbanks, Sr, Mary Pickford.

—— (1950) Westinghouse Studio One Theater. Dir. Paul Nickell. With Charleton Heston, Lisa Kirk.

—— (1956) NBC Hallmark Hall of Fame. Produced and directed by George Schaefer. With Maurice Evans, Lilli Palmer.

—— (1967) Dir. Franco Zeffirelli. With Richard Burton, Elizabeth Taylor.

—— (1976) PBS "Great Performances." ACT. [Stage dir. William Ball.] With Fredi Olster, Marc Singer.

—— (1980) BBC/Time-Life TV. Produced and directed by Jonathan Miller. With Sarah Badel, John Cleese.

11

SHAKESPEARE IN THE AGE OF POST-MECHANICAL REPRODUCTION
Sexual and electronic magic in
Prospero's Books

Peter S. Donaldson

Prospero's Books offers a striking interpretation of *The Tempest*, similar to recent feminist and psychoanalytic accounts, in which Prospero attempts to to control female sexuality and "appropriate" the birth-giving powers of the maternal body. Greenaway gives such a reading of *The Tempest* a technological inflection. By associating Prospero's "magic" with the ability of the new medium of digital cinema to create enhanced illusions of life, Greenaway recasts central questions of the play in contemporary terms. And by associating his own electronic medium with earlier wonder-working technologies – the voice of the magus, the printed pages of the Renaissance book – the film suggests that we are still living in the era of Renaissance magic, perhaps at a time toward the end of that era when, to quote Donna Haraway, "our machines are disturbingly lively, and we ourselves frighteningly inert" (Haraway 1985: 68).

ARTIFICIAL LIFE AND DIGITAL CINEMA

In Peter Greenaway's version of *The Tempest*, Prospero is not not just the "master manipulator of people and events, but their prime originator" (Greenaway 1991: 9) With the possible exception of Miranda, Caliban and Ariel, Prospero actually *creates* the world of the island, including its plants and animals, its buildings, the spirits who inhabit it, and the shipwrecked characters from the mainland who are cast up by the tempest. This creation takes place in two ways, both involving *books*. The first combines the roles of dramatist and magus. Prospero conjures with words he himself has written, the words of *The Tempest*:

> On his island of exile, Prospero plans a drama to right the wrongs done to him. He invents characters to flesh out his imaginary fantasy to steer his enemies into his power, writes their dialogue and having written it, he

169

speaks the lines aloud, shaping the characters so powerfully through the words that they are conjured before us (9).

The working of Prospero's magic are presented in the film in several ways: spirits hold up a mirror in which Prospero beholds the scenes his pen evokes or screen overlays show Prospero's cell and his writing utensils as well as the world he is calling into being. At times, when the levels of illusion and reality, or present narration and memory proliferate, there are three and four images on the screen at once, one nested in another, each permitting a partial view of the screen beneath. Often the foreground screen shows, in huge close-up, Prospero's hand and quill incribing parchment in a beautiful italic hand. Lest we think that the temporal primacy of *writing* makes this a programmatically deconstructive *Tempest*, it may be useful to note that the text that Prospero is writing remains authorized not only by its Shakespearean origin but by the continued presence of its fictional author as well. The handwritten words we see on the screen are, essentially, transcriptions of an authorial intention and serve to reactivate that intention as oral discourse.[1] That is not to say that the "book" Prospero is writing is not important. The material inscription of Prospero's *verbum mirificum* is central to the design of the film, for the reinscription of *The Tempest* by its main character makes Shakespeare's play one of twenty-four wonder-working books – "Prospero's books" which are the technical glory of the film.

These books, like the text Prospero is writing, are used by Prospero to create the world we see in the film. But Prospero hasn't written them. In the fiction of the film, they are the books, the "volumes that I priz'd above my dukedom," which Gonzalo gave to Prospero to take into exile. As described in the script, they provide an epitome of Old World knowledge and technique, with a cabalistic or hermetic flavor. There are books on navigation, education, farming, colonial administration, herbals, bestiaries, mythologies, etc. (11–12). These are not ordinary books, not even ordinary books of Renaissance magic like the Athanasius Kircher texts from which Greenaway drew his inspiration, for when opened, the books come alive with movement and animation. In the *Book of Water* there are "rippling waves and slanting storms. Rivers and cataracts flow and bubble" (17); the *Book of Mirrors* has pages that are "covered in a film of mercury that will roll off the page unless treated cautiously"; the *Primer of Small Stars'* pages "twinkle with travelling planets"; the pages of the *Anatomy of Birth* "move and throb and bleed"(20). Many of the special effects described in the filmscript are realized in the film, some even more impressively than in the script, as when small live animals – salamanders, toads and insects come to life and walk off the pages of the *Bestiary*. The script describes Prospero as *using* these books to create the physical and human environment of the island:

Prospero walks among books that blow and rustle in the contrary winds. There are a great many of them . . . for Prospero's initial twenty four books have begotten thousands more . . . Covering the whole screen at one point is one very large book – maybe four metres by seven . . . – *The Book of*

Mythologies. This is the "example book," the template for Prospero's imaginings to people the island. With this book – a primer and textbook of his humanist education – Prospero populates the island (57).

For Greenaway, the technologies used to create this book on screen are analogs of Prospero's generative magic. The magic voice, the manuscript text of *The Tempest*, the printed books of Renaissance hermetism and technique, and the wonderworking "arts" of late twentieth-century digital cinema form a continuum that links our age to Shakespeare's.

Greenaway describes his own image-processing system in loving detail (28–33), and speculates that Prospero himself would have approved of its use in the "manufacture of magical volumes" because he

> would no doubt call upon the most contemporary state-of-the-art techniques that the legacy of the Gutenberg revolution could offer. The newest Gutenberg technology – and to talk of a comparable revolution may not be to exaggerate – is the digital, electronic Graphic Paintbox. (28)

Digital image technology is present in the film by analogy: the multiple "windows" summoned and dismissed by Prospero's "art" evoke the scene of digital composition; the quill pen with which Prospero writes has acquired the functionalities of the electronic stylus; the repeated shots of Gielgud's writing fingers may allude to the medium of composition through the ambiguity of the word "digital," which can refer to works of the hand or the effects of computation.[2] Subtler references – should we call them metacomputational or metadigital? – help to explain the extraordinarily restrictive, stilted blocking and dancing style of *Prospero's Books*. It is an attempt to make live performers on film look as much like computer animations as possible. Prospero is a double for Greenaway, the digital cinema artist, as much as for Shakespeare the playwright.

Like the Elizabethan stage, the contemporary arts of digital image-making and computer enhanced animation trouble the margin between representation and originary creation, between licit and illicit forms of artistic endeavor, between "white" or natural magic (which is only technology, however marvelous its successes) and something beyond ordinary technique, no longer called necromancy, which, like forbidden or questionable forms of Renaissance magic, aims at rivalling or supplanting the natural world and its modes of reproducing itself.

The discourse in which the new medium of digital cinema is described by its practitioners speaks of artifical worlds, and, at its most explicit, of artificial life. In a sense, these writers are extending claims for artistic creation that derive, ultimately, from Renaissance artistic and poetic theory. Sidney can say, for example, that the poet, disdaining the limits of the laws of nature "doth grow, in effect into another nature, in making things either better than Nature bringeth forth, or, quite anew, forms such as never were in Nature" (Sidney 1965: 100). In the *Apology for Poetry* it is not in mirroring Nature, but in

171

rivalling and surpassing Nature's power to "bring forth" forms that highest claims of art consist. The inventors of photography were to make analogous claims:

> The Daguerrotype is not merely an instrument which serves to draw nature; on the contrary, it is a chemical and physical process which gives her the power to reproduce herself.
>
> (Daguerre, as cited in Gernsheim and Gernsheim 1968: 81)

Greenaway's claims for digital creation echo claims to a creativity that replaces or betters natural creation which have been revived at the advent of every substantial advance in representational technology since the Renaissance. Giving nature the power to reproduce "herself," Daguerre's potent metaphor for photo-chemistry, is a Greenaway *motif* in *Prospero's Books*. The next section of this essay deals at length with the film's images of birth and reproduction, but there is one passage in the filmscript that is particularly resonant in relation to Daguerre – it is the moment when Prospero's hand reaches into the frame in which the *Anatomy of Birth* is displayed to caress the animated engraving of the body of his wife at the moment of giving birth (70);[3] later, Prospero will act literally as a midwife at the birth of Caliban (88).

It is surprising how closely theorists of the new media used to create the bestiaries of *Prospero's Books*, from which "live" toads and other small creatures arise, follow the pattern of Prospero's creations as Greenaway imagines them. Roger Malina, for example, places digital image-making in the context of other computer-based efforts to create artificial life. Some of these "life forms" are no more than robots or enhanced animated images:

> Workers in artificial life such as Randall Beer have been developing artificial insects, such as miniature robots capable of maneuvering around computer circuit boards to carry out circuit repairs. Artist Vernon Reed has been for some years creating cybernetic jewelry that can be viewed as a precursor to cybernetic art insects.
>
> (Malina 1990: 36).

But, as Malina recognizes, the cybernetic art insect – a phrase that neatly describes a number of the creatures that Prospero's books produce[4] – may not represent the closest approach to artificial life that the computer can claim. Microrobots are impressive, but digital art can claim to be like life in more profound ways. One of these ways is its simulation of personhood. Because computer software can be designed to be responsive, adjustive to the user, it is less a passive tool like a paintbrush, however sensitive, and more like a collabo-rator, whose suggestions, redrafts and sketches introduce a second consciousness into the artistic process. A further claim (which merits equal scepticism) is that computer art is generative in ways that rival human reproduction.

A diffferent kind of reproduction is made possible by software – this is what I will call post-mechanical reproduction (although a more descriptive term such as

"generative reproduction" is needed). The goal of post-mechanical reproduction is to make copies that are as different as possible from each other, but constrained by a set of initial rules. The prototypical type of post-mechanical reproduction is of course sexual and biological reproduction (Malina 1990: 37; see also Verostko 1987). Most interestingly in regard to Greenaway's reworking of *The Tempest*, Malina regards "compassion" as both the limit and the challenge of digital generativity. Acknowledging that male dominance has affected the development of the computer, pushing development toward war games and toward mind–body dualism, Malina ends his paper by calling for a redirection of computer art toward "a technology of compassion."[5] "A technology of compassion" is an ambiguous phrase in contemporary discourse. It might once have meant only that technology would be directed by compassion, or used for ends determined by compassion. As used by proponents of artificial intelligence and others, it can mean that the technology itself might be compassionate, that computer programs might be written that would emulate human compassion. To quote Donna Haraway again, more fully:

> Late twentieth-century machines have made thoroughly ambiguous the difference between natural and artificial, mind and body, self-developing and externally designed, and many other distinctions that would apply to organisms and machines. Our machines are disturbingly lively, and we ourselves frighteningly inert.
>
> (Haraway 1989: 68).

Such a statement differs from older humanist protests against mechanization (for example F. R. Leavis's objections to C. P. Snow, or Joseph Weizenbaum's critique of artificial intelligence [Weizenbaum 1976]). Haraway, like Greenaway, finds the margin between the human and the machine troubling, but also glamorous and exciting, even liberating, as her title implies.

The idea that "compassion" marks a limit or a challenge to attempts at creating simulations of life is a crucial one in Greenaway's reading of *The Tempest*.[6] The structure of *Prospero's Books* depends upon this idea. Prospero can conjure people into existence, but his magical creation is incomplete:

> the characters walk and gesture, act and react, but still they do not speak. Their life-giving words are not their own, they continue to be the mouthpiece of Prospero, the master dramatist. . . . Then there is a twist, a rearrangement of events, a reversal. When his enemies are totally in his power, Prospero is admonished by Ariel for the ferocity of the revengeful humiliation he forces on them, and he repudiates his plans and turns again to forgiveness. The characters that his passion for revenge had created now speak for the first time with their own voices, brought to a full life by his act of compassion (9).

The concluding sequences of *Prospero's Books* hover, as this passage does, and as the theorists of digital art and artificial intelligence do, between regarding

"compassion" as a human quality that cannot be artificially produced, and regarding it as the final achievement or necessary condition in the creation of artificial life.

Greenaway stages the end of *The Tempest* as a renunciation of the magician's tools of trade, including, in this version, the quill pen and the magic animated volumes. The pen is broken, all the volumes are snapped shut with dust flying and cast into the waters of Prospero's immense Roman bath. The tools of cinematic illusion, too, are renounced, for, according to Greenaway, at the end

> Prospero/Shakespeare breaks the theatrical filmic illusion by appealing directly to his audience . . . and all his audiences . . . and his last audience in his last play . . . as he takes leave of the island, the theatre and possibly his life. (164)

Much of this section of the film is impressive, even moving in its multi-layered attempt to "humanize" both Prospero and the other characters, who now speak for the first time. But the film's pace (always almost slow motion), its rigid blocking, oppressively rectilinear composition, bizarrely heavy costumes and extremely low-key style of dialogue even in the scenes in which the other characters *do* speak undermine the turn toward acknowledging the autonomy and independent life of others. This effect is so pronounced as to suggest that Greenaway intends (as in all his films) to undercut whatever Romantic or humanist impulses he sets in motion.

Ariel, Miranda and Caliban are not wholly engendered by magic as are the tiny creatures that hop from the pages of the magic books, but they are creatures "new created" by Prospero's potent art, and in accordance with the film's central premise do not fully exist until they speak in their own voices. Yet, despite the script's apparent commitment to bringing them to a "full life," the film itself does not or cannot present their voicing as a convincing mark of independence and autonomy. The sequence in which Ariel first speaks is compelling. With the conspirators under Prospero's power, the youngest of the Ariels,[7] a golden haired cherub, looks over Prospero's shoulder to read what he is writing, and reads aloud the end of the passage in which Prospero exults over his enemies, now "all confin'd together." At this point, Ariel takes the quill from Prospero and writes, followed in turn by each of his elder siblings or clones. It is they who write the script for Prospero's conversion to mercy. When they have finished writing, Prospero takes the book back, we see a halting, childish hand instead of Prospero's confident italic, and he reads the lines in which Ariel admonishes him to allow his "affections" to "become tender." At the end of the passage ("the rarer action is/In virtue than in vengeance; they being penitent,/The sole drift of my purpose doth extend/ Not a frown further") Prospero breaks his quill in two, Ariel's hands are seen to snap the book shut, and then follows a series of shots in which all of the twenty-four books are snapped shut in a definitive turn away, it would seem, from the scripted toward the interactive, driven by this powerful moment of recognition of self and other. But what follows does not allow the

other characters more than the perfunctory autonomy conferred by the fact that they speak.

The conspirators are confined by a bright blue charmed circle; their movements are restrained and even puppet-like; Miranda and Ferdinand are no exceptions. In the final moments of the film, Prospero's face is presented in freeze-frame, and the camera tracks back from it, while Ariel runs toward the retreating camera and then leaps, in slow motion, toward us and over it, in what Greenaway, on the evidence of the filmscript, intended as a moment of final liberation in which the image of Prospero would be reduced, as it were, to the manufactured, filmed image it really is, allowing space for others. However, it is possible to read this moment very differently, as Prospero's continuing direction of the action, even in the absence of his moving form and voice; as the authorial sponsorship of a licensed enfranchisement over which Prospero and the canonical text of *The Tempest* retain authority. Instead of seeing Prospero as very small and immobile, we can see him as the originator of the film in an enhanced, permanent way. As the voice-over, which is the most dominant and dominating of all vocal positionings in cinema (Silverman 1988), Prospero has been the central cinematic figure until this point, and has been used exclusively by Gielgud and by the narrator who describes the books, so now the image of Prospero remains fixed at the vanishing point, the implied origin of all that we see on the screen. Because this is so, Ariel's slow-motion run toward the retreating camera, and his leap up and apparently over it out of the image and into audience space does not convey the feeling of independence from Prospero that the script implies for this moment. Rather, Prospero seems to suffuse the space; he has become one with the point of origin of the image, the point of convergence of a perspectival space that emanates from his unchanging simulacrum.

This effect whereby Prospero, far from renouncing his powers, is installed as a permanent, authorizing presence, is reinforced by the conclusion Greenaway gives to the tropes that center on textuality and its relation to authorial intention. All of the wonder-working books are closed and thrown, one by one, into the water, to the accompaniment of fireworks, explosions, burning acid and other displays of destruction and dispersal. But Caliban saves two of them – the plays of Shakespeare and a slim volume – the book Prospero has been writing – which will be bound into it as its first section. As Ferdinand and Miranda are joined together just before the final shots of the film, the text of the First Folio *Tempest* (*not* the manuscript Prospero has been writing) unscrolls as an overlay on the screen, in large gilt letters. The manuscript that is no longer seen, like Prospero's still image, mystifies origins, makes them inaccessible even as they continue to influence the future. Though this is a work in which books come apart, are dispersed, are seen to be written, *Prospero's Books* ends in a series of powerful images that remystify the book as the inscription of an originating discourse that is both artistic and magical.

"AN UNDERGOING STOMACH": MALE BIRTH AND MIDWIVERY IN *PROSPERO'S BOOKS*

Several recent critics have argued that Prospero's magic in *The Tempest* may be understood as an attempt to control a dangerous and threatening female sexuality, and to replace it with a kind of sanitized, non-physical generativity that is gendered male. I place *Prospero's Books* in the context of such interpretations, and suggest that Greenaway technological version of Prospero's "life-giving" magic can illuminate some aspects of the current discourse relating the human world to the new electronic technologies. *Prospero's Books* is part of an extensive discursive shift that includes aspects of cyberpunk, "technoporn," extreme versions of artificial intelligence and virtual reality theory, and other attempts to reconfigure desire and sexuality in terms of human/machine interaction. Greenaway's work – *Prospero's Books* as well as his other films – may be regarded as a soft-core, high-culture manifestation of what Constance Penley and Andrew Ross call "technoculture" (Penley and Ross 1991). *Prospero's Books* portrays Prospero's magic powers as an "appropriation" of maternal power, and in doing so may suggest a psychoanalytic framework for understanding the "technophilia" of the present cultural moment, and its preoccupation with "disturbingly lively" machines.

Kay Stockholder, in a brilliant paper entitled "Sexual Magic and Magical Sex" (1989), has argued that the magic in *The Tempest* is "both generated by and based on revulsion from and fear of women's sexuality." The strict sexual morality Prospero enforces, the demonization of sexuality in his accounts of Sycorax and Caliban, and much else in the play suggest that magical control is necessary to protect his hopes for a generative, spiritual and redemptive love relationship for Miranda from his own fear that sexuality is inherently cruel and corrupt. But in Stockholder's reading, Prospero's magic does not merely control, but derives from and usurps female potencies – the "bad" magic of Sycorax as well as the nurturant and compassionate aspects of Shakespeare's "good" female characters. Power thus "passes from female to male figures"; Prospero appropriates female qualities "while keeping female figures subject to male authority by defining compassion as an aspect of his magic." His magic, then, both controls female sexuality and competes with it, replacing "feminine" nurture and care-giving with modes of concern, compassion and forgiveness that are fused with his willful and magical (I would add, "technical") control.

Janet Adelman is even more direct in claiming that *The Tempest* enacts a usurpation of specifically maternal powers:

> Prospero's reappropriation of control at the beginning of *The Tempest* is nearly diagrammatic: even before the play has begun the maternal body has been defined as dangerous and banished in the form of Sycorax ... Prospero's use of Medea's words to describe his own magic suggests the extent to which his reappropriated control is based firmly on her banishment.
>
> (Adelman 1992: 237)

Adelman is most persuasive, here and throughout her book, in discovering submerged metaphors of birth, and in analysing the strategies by which fears associated with birth from the mother are defused and redirected. For her, Ariel's release from the "cloven pine" is a kind of birth, as is the voyage from Milan:

> Miranda's passage to the island is similarly mediated by a birth-act, the fantasized pregnancy – he "groan'd" under his "burthen"; her smiles "raised in [him]/An undergoing stomach to bear up/Against what should ensue" (1.2.156–58) – that imagistically remakes her wholly her father's daughter.
>
> (Adelman 1992: 237)

"Thus able to control the maternal body," Adelman continues, "Prospero seems able to reshape the world in the image of his own mind." Adelman, however, places somewhat greater credence than Stockholder in Prospero's turn toward compassion and self-recognition at the end. For her, the cost of Prospero's magical control is isolation from others which he begins to overcome when Ariel prompts him to the recognition that it is "less than human to refuse the vulnerabilities of human feeling."

Such an account of *The Tempest* would, if technologically inflected, be close to the reading proposed by *Prospero's Books*, implicitly in the film itself and explicitly in the filmscript. For Greenaway, Prospero's magic is associated with sexuality – with a kind of regressive yet efficacious autoeroticism that creates, indeed, gives birth to things and to people. Like the Prosperos of Adelman and Stockholder, Greenaway's protagonist is self-enclosed despite his attempts at magical generativity, is beset by images of bloody, violent and excremental birth, and, toward the conclusion attempts – but only attempts – to break out of the solipsism his magical control imposes by recognizing others and allowing them voice, and through "compassion," which here, as in Stockholder and in the discourses on computer-created life,[8] may be read as yet one more appropriation, or reappropriation, of the feminine.

The film begins with what Greenaway likes to call a "bravura, virtuoso" sequence that links writing and magic as works of the hand. Perhaps the most exciting part of Gielgud's performance in *Books* comes here, at the start, when he responds to his own writing as a cue for his speech. Having imagined, and *thought* the word "Boatswain!" as a line for a character in the play he is writing about his imagined revenge and restoration, Prospero sees his own written mark as if for the first time and recites it with surprise, in a kind of auditory mirroring, the freshly inscribed page serving as script. Though he has just written it himself, Gielgud responds to the word (which we also see written on an immense image, overlaid upon the scene of its writing) as if responding to the writing of another, with approval and delight. That there is an element of regression in such delight is conveyed in many ways – Prospero speaks the line in a Roman bath, waist-deep in water; the storm he is imagining begins as a single drop of water, seen in immense close-up splashing into his own outstretched palm. The image suggests a connection between writing and masturbation in a paradigmatic way, recalling

Derrida's playful critique of Rousseau's fear of the dangerous "supplementarity" of writing and of autoeroticism. A connection between magic and psychological regression is also suggested: Ariel's supernatural, seemingly inexhaustible urine stream, splashing into the bath as he swings on a trapeze above the surface of the water, is overlayed upon a scene of storm upon the high seas – and when a toy boat Prospero sets to drift in the bath is drenched by the stream, the ship carrying Prospero's enemies founders. Later, in a flashback to Prospero's life as Duke of Milan, we discover that the toy ship is one of Miranda's childhood toys. As the storm scene develops, spirits hold up an immense ornate mirror before Prospero, and he watches the scene he has conjured as if in a mirror. Prospero's pen, his voice, the toy boat, and the preternatural waterings of Ariel all seem necessary to create the magic storm – Greenaway wants us to see it as the product of an erotically tinged infantile fantasy.

But the project – Prospero's project – of making his imaginary dramatic creation "real" entails breaking free of the constraints of infantile wish fulfillments, both erotic and agressive, with which the "magic" begins. The moment at which the characters become real, and "speak in their own voices" is the point at which Prospero accepts rebuke and shows compassion. Yet it is possible to understand compassion not as a rejection of magical thinking, but, as Stockholder suggests, as a magical appropriation of the "feminine".

If we follow the logic of the filmscript, nearly all of the many inhabitants of the island are literally Prospero's creations, conjured into being with the help of his magic. Even the shipwrecked Italians are, in Greenaway's account, "creatures that his passion for revenge has created."[9] Miranda is born from her mother, who appears in the film, and is named, like Shakespeare's daughter, Susannah. Yet her appearance does not wholly answer contemporary questions, such as those of Stephen Orgel, about her absence, for she never speaks, even through Prospero, and her childbirth scene is made to seem, in a remarkable sequence, to proceed from the pages of a book, Vesalius's "lost *Anatomy of Birth*." As this book is first described, we see Miranda's birth-scene, intercut with the pages of the wonder-working anatomy, in which animated dissections are presented, as well as a childbirth scene that may be an alternate presentation of Miranda's birth itself. As Prospero recounts this scene to the sleeping Miranda on the island, Susannah, naked to the waist, appears at the side of Miranda's bed while she is sleeping, and silently pulls down the skin of her abdomen as if she were a living anatomy lesson, revealing a blood-saturated mass of internal organs, including a uterus swollen with her pregnancy. The absent mother – actually the dead mother, for she appears not only in the *Anatomy of Birth*, but also in the *Book of the Dead*, as the last entry in a register of deaths that extends from Adam to Susannah, "Prospero's wife" – returns when summoned by Prospero's thoughts. This apparition at the bedside not only makes birth terrifying, but also links the image of the *unconscious* Miranda to other scenes of blood just shown: the story of Miranda's birth is intercut with the massacre in which Prospero lost his political power, a scene of twitching bodies, pikes penetrating every bodily

opening, and a blood-and-corpse filled bathtub. The shots of the Vesalius *Anatomy* alternate with these shots, and connect the blood of birth to that of massacre and dissection.

The illustration of the *Anatomy of Birth* which is presented at greatest length shows a large operating theater, on which a woman in childbirth is placed at right angles to the screen, her head to the rear of the image, a cloth draped between her legs. The shot, both in its careful perspectival arrangement and in its blocking of what, in the logic of the composition should be the si(gh)te of greatest interest, recalls Dürer's famous engraving of the perpective artist at work, with the body of his female model aligned along the axis of his sight line, a cloth between her legs.[10] Other Greenaway films are similarly preoccupied with connections between linear perspective and female sexuality. In *A Zed and Two Noughts*, the obsessive object of attention is the "foreshortened" body of Mrs Bewick, the legless, pregnant lover of the twin zoologists who are the film's protagonists. Often seen through the round circle of the iron bed rail, at the center of the image along the axis of sight, the bedclothes that cover Mrs Bewick's reproductive organs indicate the film's thematic center. The perspectival vanishing point and the point of origin of human life coincide.

In *Prospero's Books*, the horrors of childbed seem to procede from the biological facts of birth, and from a terror that inheres in female anatomy. Yet, if one attends to the deployment and the blocking off of the gaze of the spectator, as well as to the fact that the blood we actually see is a product of either political fratricide or anatomical *dissection*, a scientific analog of the inquiring, objectifying aspects of the male gaze, it is possible to understand the horror that attends these scenes as a projection of Prospero's violent fantasies.

As in many other parts of the film, the script is not only more explicit (more "graphic" as the slang expression has it), but also more interactive. The loss of the texture of interaction between the twenty-four wonder books and the rest of the world of the film constitutes the most significant difference between script and book. Technical limitations may have determined this shift – but it may also represent a pulling back from the script's bolder approach to the themes of *The Tempest*. So, for example, the magic books *do* come alive in the film, but the living creatures that emerge from their pages do not, as the script leads us to expect, *leave the frame* but remain confined to the tight close-ups in which the books are presented. We do not see Prospero using the books to fill his world with artificial life. In the birth scenes, too, the *Anatomy of Birth* is more sequestered in the film, intercut with, but not sharing a continuous space with the narrative of the massacre or the narrative of Miranda's early life. In the script, Prospero opens the *Anatomy* as he recites the history of Antonio's rebellion to the sleeping Miranda. The open pages of the book enact the story of Miranda's birth and then, as the book is replaced by a mirror brought into the room, the story of Susannah's death:

> As he turns the pages . . . Prospero's fingers appear to become covered in blood . . . the organs of the body become three dimensional – small

reproductions of the liver, the spleen, the heart, the intestine . . . then red ink floods the page . . . then black ink. There is the sound of babies crying . . . and then exultant singing . . . as Prospero and we contemplate a handsome and awesome drawing of a woman giving birth . . . we surmise that the woman is – was – Prospero's wife. The diagram's discrete figures and dotted lines are animated. Prospero's fingers enter the frame and caress his wife's body.

A woman materialises behind Prospero – leaning lightly on the back of his chair – she is alternately a Titianesque nude and then the Vesalius figure – flayed – her blood vessels and nerve endings and internal organs displayed and marked with black figures and numbers as in the book . . . she leans lightly over and kisses Prospero on the cheek. The kiss leaves a blood-red mark on his withered cheek (70).

A mirror is then brought into the room by Prospero's spirits, and he sees Susannah's corpse laid out for her funeral. In the film, as noted previously, Susannah does appear in Miranda's room and silently opens her abdomen as if she were a living anatomical picture. But the interactive elements of the script – the hand reaching into the book and the blood staining kiss are absent from the film. Again, the world of the "books" remains separate from the rest of the setting, and, in this case, that separation intimates a psychic defense against the disturbing associations connected with the birth of Miranda and the body of her mother.

Prospero's Books embodies the general reading prosposed by Stockholder and Adelman. Birth is presented as so disturbing that Prospero's efforts to recast the facts of birth in masculine, magical terms seem a relief. Insistent patterns of birth imagery also move both Caliban and Ariel into the sphere of Prospero's quasi-maternal ambitions. Caliban's actual birth from the body of an immensely swollen, lewdly hairless Sycorax is closely juxtaposed to two symbolic "births." Ariel's release from the cloven pine is presented in a way that recalls Stockholder's reading of the passage as a fantasy of retentive birth, and Caliban descends, at Prospero's command "Come forth!" from a foul sewer-pipe or cloaca into a pit of filth.[11] In each case, Prospero's magic is presented as giving the characters a second, or supplementary birth by male command.[12] There is a sense that Prospero is compelled, perhaps by his hatred for the natural course of birth *inter faeces et urinam*, to engineer magical, highly controlled, morally "purified" substitutions for motherhood.

If Prospero attempts to replace maternal birth, both by literally creating many of the characters through his magic and by reinscribing others as his "creatures," he also attempts, in both the play and the film, to control Miranda's sexuality, in an effort, as Stockholder suggests (11–12), to control his own. In *Prospero's Books*, the rigorous control over the relationship between Ferdinand and Miranda is intensified and extreme, and underscored by Prospero's ventriloquial control over their words. The film's pervasive and idiosyncratic recourse to nudity is also, paradoxically, a defense against sex. The troops of naked dancers

and extras function as a kind of *a fortiori* argument against the possibility of incestuous feelings. For example, when Prospero first approaches Miranda's bed, he is accompanied by an attractive naked female "spirit." Prospero ignores her, and in fact never is seen to glance at any of the naked denizens of his island, male or female, even for an instant. That does not imply that he is without sexuality, but that he controls it. Indeed, by creating hordes of naked attendants, he multiplies occasions to manifest his control.

If the autonomy of the other characters was to have been one mark of the success of Prospero's project of creation and reformation of self and other, the spontaneous sexual relationship between Ferdinand and Miranda was to have been another. The filmscript's treatment of the erotic union of the couple, would, if it had been realized in the film, have made an impressive central scene. Recognizing both the scripted and the spontaneous character of "love at first sight" Greenaway had the Ariels, like Raphaelesque *putti*, mediate the scene through texts, checking at each moment of the infatuation to see what was written in the *Book of Love*, before whispering the appropriate lines to Ferdinand and Miranda (lines spoken of course by Prospero). At one point Ariel even acts as couturier, gathering Miranda's diaphanous gown behind her to display her body more clearly, as if fitting Botticelli's Aphrodite for a wedding dress (103–6; see also 123). None of this appears in the far less witty and more stilted "love scene" in the film, and, unbalanced by such major recourse to an eroticism that was to have been both mythic and literally "textual," the supposed attraction between the couple seems merely formal, rote, and overcontrolled.[12]

The betrothal masque is likewise overcontrolled. The movements of the dancers – male and female, nude and semi-nude – parody sexual passion. At times the dancers mechanically jerk their long hair, pulling it out to the side in a burlesque of hair-flying or wind-swept ardor; at other times they mime the gestures of piercing their breasts with arrows, clockwork victims of Cupid, cloned postmodern descendants of Bernini's St Theresa. They are "real" performers, but in the fiction of the film, they have been literally created by Prospero, and do his bidding, reacting with somewhat abrupt and robotic obedience to his will. Like Prospero's ventriloquism, the jerky and unconvincing eroticism of the film is partly diagnostic, meant, perhaps, as a criticism of a self-loving, overcontrolling, unself-knowing character whom Greenaway understand to be a "moralising scold and a petty revenger, a benevolent despot, a jealous father" (12) as well as a master magician and dramatist. They instance his control over sexuality, a control that empties it of spontaneity and renders it machine-like.[13]

If Eros is rendered mechanical in several senses in the film, it is also true that, in the making of the film, Greenaway thought of his relation to machines (especially computers running image processing programs) in erotic terms. The filmscript describes these programs as ushering in a new "Gutenberg revolution," and, to exemplify the "paintbox images" that play so large a role in *Prospero's Books*, Greenaway provides a double-page reproduction of two states –

a daytime and a night-time version – of one of the animated characters originally planned for the film. Though, in fact, she never appears in the finished film, this figure of "The Juggler" is worth discussing precisely because, in her melding of the erotic and the creative, she is so unlike the almost endless succession of naked figures, with their bobbing breasts, "wagging dicks" (as the *Village Voice* reviewer called them) and mechanical toylike movements in the film. She represents a spontaneous and unruly sexuality that is absent from the film:

> Prospero looked for jugglers. He looked for twinkling eyes and the smell of sweat and pepper. . . . After a quick appraisal, for Prospero could not be seen to spend too long on such a humble appointment, the most likely candidate proved to be a naked, bright orange bacchante with wide hips who juggled balls and fruit, scientific instruments, and defenceless small animals. . . . For Prospero this little laughing, orange, juggling creature played the juggling part during the day, but was a professional fornicator at night. Maybe the roles were interchangeable. She dyed her body orange by laying in a wet iron-pit and her partners soon knew each other. Every marked fornicator could see so many others on the beach the next each morning. The juggler's eagerness to please Prospero in her diurnal role eventually affected her nocturnal fee. For she asked her satyrical clients for objects to juggle with, preferably brightly colored, for she had a notion that Prospero had been colour-blinded by reading too many black-and-white books. She savoured the eccentric object: a potato shaped like a dwarf'd foot, a pebble with holes like eyes, a Venus fruit-nut scarred to suggest rape, a petrified apple bitten by Eve.
>
> And then a reversal occurred. She began to exchange her roles. Trying to annex quality in her nocturnal clientele by exhibitions of her skill, she juggled with mathematical solids, splashing herself with her own stale milk, fearful that her orange body could not be seen among the dark columned corridors. The clients grew bored and moved to other pastures to browse their sensual taste. . . . Continuing to confuse her responsibilities, she began to accept professional advances by day, especially from the lazy imitation scholars who ought to have been pretending to read the books in Prospero's library. Finally she perfected juggling and fornicating by day and by night as simultaneous activities. In disappointed exasperation, Prospero turned his head the other way and sought his fool elsewhere. (28–9)

"The Juggler" was invented to display and allegorize computer "paint" software, showing how discrete forms can be altered in shape and color with a stylus used in conjunction with a tablet or "palette" of colors. At a touch, colors – the orange body of the juggler, the dark blue of the night in which she works – can taint or bleed into one another, can be made to stain, as, in the story, her milk and her iron-oxide pigment stain adjacent figures. In Greenaway's description,

the paintbox is a medium that defies conventional categories, blurs boundaries, partakes of a freedom that is erotic yet "professional." The paintbox leads one away from the library and toward the iron-pit, a locus of creativity gendered female not only by its association with the independent and enterprising activity of the juggler/fornicator, but also the hint of uterine blood conveyed by its color and its iron-rich chemical composition. Yet – though the juggler allegorizes the very medium in which Greenaway has produced Prospero's marvels, and especially the computer-animated books that are the film's technical glory – Prospero disdains her, and does so at the precise moment at which she has achieved a complete interpenetration of day and night-time activities and realms. And Greenaway, as director, rejects this character, too, for she never appears in the film, and the meaning she carries, of the fusion, beyond conventional limits, of eros, creativity and skill, is rejected as well. Sex, in *Prospero's Books*, is either rigidly controlled or excremental. Women are either pure beings, like Miranda, foul witches, like Sycorax, or robotic naked dancers, whose movements follow the rhythms of Prospero's clockwork paradise like the animated dolls in *Coppelia*. The juggler, though no less literally an artifact of male imagination than Shakespeare's women or Greenaway's, is more lively invention than the female representations in the film. Like other contemporary *Tempests*, Greenaway's includes a Sycorax and, in addition, a wife for Prospero (named Susannah), and the many female dancers, spirits who serve Prospero's will.

But Greenaway's most interesting attempt to come to terms with female sexuality, that is, with the body of the mother, was invented to help explain the workings of his own electronic equipment. She exists under a kind of suppression, only in the (published) script. Greenaway's fertile vision of a world populated by books; his vision of Prospero's hand stroking the body of his wife, dying in childbirth in the pages of a lost work by Vesalius; the "textual" Cupids who prompt Miranda and Ferdinand in their love-making – all these are consigned to the medium of print, either by self-censorship or by the limits of a medium that seemed, in the planning stages, to have no limits.

It is easy to agree with Greenaway that we are in the midst of a new "Gutenberg revolution" in communication technologies. But we are in the early phases of that revolution, when it is also easy to overestimate the potential of new tools and to misjudge their power to liberate or to enhance creativity. Perhaps this is the reason that, despite the technological virtuosity of *Prospero's Books*, many of the boldest features of Greenaway's interesting and contemporary interpretation of *The Tempest* appear, it sounds strange to say, "only in the book."

NOTES

1 See Rodolphe Gasché's distinctions between deconstructive and non-deconstructive conceptions of "text" (Gasché 1986: 279–83).
2 See p. 172, and n. 3 below.

3 The hand that reaches *into* the artificial world and interacts with the represen-
tations of people and objects in it also evokes the "data glove" of virtual reality
experiments:

> What gives virtual reality its realism is, in part, the expansiveness of its scope,
> which is related to the universality of mathematics. But an even more
> important factor is our immersion in it, our ability to interact with an alter
> ego. Interfaces form bridges between the real and the virtual and back again.
> We cross them to inhabit a strange place that is both concrete and abstract.
> A human hand grasping a real sensor holds, at the same time, a virtual paint-
> brush or the controls of a virtual space vehicle. Since a hand can be described
> with numbers as readily as any denizen of virtual reality, we too can "live" in
> these synthetic universes. We visit a territory we can probe, inquiring about
> and interacting with its residents to bring to life with equal ease bizarre
> fantasies as well as sedate realities.
>
> (Binckley 1990: 18)

Like *Prospero's Books* the digital cinema literature is replete with puns that confound
the digits of the hand and those of mathematics. When Binckley met the digital artist
David Em at an exhibition and asked him what he had been working on lately, Em,
who had returned to sculpture, held up his hands and said – "digital art!" (13).

4 Prospero's insects and toads may remind us, in turn, of John Dee's "flying crab" and
other instances of artificial life in the world of the Renaissance magus. See Yates
1964: 147–48.

5 Malina's remarks on compassion were made in response to a paper by Sally Prior
not printed in *SIGGRAPH 90*.

6 It is also what distinguishes humans from replicants in *Blade Runner* and other works
of science fiction that deal with the cyborg–human boundary.

7 There are three Ariels in the film, of similar appearance but different ages.

8 See above, p. 173. "Compassion" was the issue raised by Sally Prior in regard to
artificial life at the Adelaide Conference. In this, as in other ways, Shakespeare's play
prefigures the terms of the continuing debate about the fate of "the human" in a
technological age.

9 See Orgel (1986) "Prospero's Wife": 64.

10 See Freedman (1991). Greenaway makes many explicit references to perspective in
the script of *Prospero's Books*, see, for example, Greenaway 1991: 42, 121.

11 The pipe through which Caliban descends to the pit is described as "like a tunnel
to a distant privy used by incontinent giants" (92). *The Book of the Earth* is Caliban's
"signature" text. When opened during the visit to Caliban's pit in the film, it is
spattered with raw eggs, urine and excrement.

12 The birth imagery in the script is again more detailed, and there is even a strong
suggstion, as in Stockholder's psychological scenario, that Ariel is Sycorax's child. In
addition, Prospero himself attempts to act as midwife at Caliban's birth (Greenaway
1991: 87–92).

13 It would be interesting to know why so much of this scene was altered in a film that
displays so much nudity. It may be that the very centrality of Miranda's body to the
design of the film, its blatant and underscored to-be-looked-at-ness could not be
filmed for a high-culture audience now at least partly aware of the feminist critique
of such cinematic displays. Yet, without this scene, the film seems not to make one
of its major interpretive points.

14 Some reviewers suggest a relationship between *Prospero's Books* and pornography
which may be worth developing. The group nude scenes may allude to group sex
scenes in one subgenre of contemporary film pornography, and perhaps ultimately

to Sade. At several points, Greenaway creates a unisex version of Felicien Rops's "Pornocrates," with male as well as female figures naked except for garters, scarves, gloves and hat. But Greenaway's is an orgy that never happens, and was never meant to happen, an orgy by allusion. In its mechanical approach to sexuality, *Prospero's Books* may be seen in the context of the recent history of "technoporn." Recent essays that provide a useful introduction to the discourses that connect computers and sexuality in the 1980s and 1990s include Springer (1991), D'Alessandro (1988) and Buckley (1991).

REFERENCES

Adelman, Janet (1992) *Suffocating Mothers: Fantasies of Maternal Origins in Shakespeare's Plays, "Hamlet" to "The Tempest,"* New York: Routledge.

Binckley, Timothy (1990) "Digital Dilemmas," in *SIGGRAPH 1990: Digital Image, Digital Cinema* Supplemental Issue of *Leonardo: Journal of the International Society for the Arts, Sciences and Technology.*

Buckley, Sandra (1991) "'Penguin in Bondage:' A Graphic Tale of Japanese Comic Books," in Penley and Ross: 163–96.

D'Alessandro, K. C. (1988) "Technophilia, Cyberpunk, and Cinema," paper presented to SCS, Bozeman, Montana, 1988, as cited in Springer, 1991: 305.

Freedman, Barbara (1992) *Staging the Gaze: Postmodernism, Psychoanalysis and Shakespearean Comedy,* Ithaca: Cornell University Press.

Gasché, Rodolphe (1986) *The Tain of the Mirror,* Cambridge, MA: Harvard University Press.

Gernsheim, Helmut and Alison (1968) *L. J. M. Daguerre: The History of the Diorama and the Daguerrotype,* New York: Dover.

Greenaway, Peter (1991) *Prospero's Books: A Film of Shakespeare's "The Tempest,"* New York: Four Walls Eight Windows.

Haraway, Donna (1989) "A Manifesto for Cyborgs: Science, Technology and Socialist Feminism in the 1980s," *Socialist Review* 80.

Malina, Roger (1990) "Digital Image – Digital Cinema: The Work of Art in the Age of Post-Mechanical Reproduction," in *SIGGRAPH 1990: Digital Image, Digital Cinema* Supplemental Issue of *Leonardo: Journal of the International Society for the Arts, Sciences and Technology.*

Orgel, Stephen (1986) "Prospero's Wife," in *Rewriting the Renaissance: The Discourses of Sexual Difference in Early Modern Europe* in (eds) Margaret W. Ferguson, Maureen Quilligan, and Nancy J. Vickers. Chicago: University of Chicago Press: 50–64.

Penley, Constance and Andrew Ross (1991) *Technoculture,* Minneapolis: University of Minnesota Press.

Sidney, Philip (1965) *An Apology for Poetry,* ed. Geoffrey Shepherd, London: Thomas Nelson.

Silverman, Kaja (1988) *The Acoustic Mirror: The Female Voice in Psychoanalysis and Cinema,* Bloomington: University of Indiana Press.

Springer, Claudia (1991) "The Pleasure of the Interface," *Screen* 32.3 Autumn: 303–23.

Stockholder, Kay (1989) "Sexual Magic and Magical Sex," unpublished paper presented at the Institute for the Psychological Study of the Arts, Gainesville, Florida, February, 1989.

Verostko, Roman (1987) "Epigenetic Painting: Software as Genotype," *Leonardo* 20.4.

Weizenbaum, Joseph (1976) *Computer Power and Human Reason,* San Francisco: W. H. Freeman.

Yates, Francis (1964) *Giordano Bruno and the Hermetic Tradition,* New York: Random House.

12

GROSSLY GAPING VIEWERS
AND JONATHAN MILLER'S
OTHELLO

Lynda E. Boose

From stage productions as well as the so-called film classics, audiences had been accustomed to seeing monolithic *Othello*s proportioned along the lines of the savage grandiloquence of the Burge-Dexter (Olivier) production or reverberating with the sheer epic scope of the Orson Welles. Such expectations – which undoubtedly originate in a director's desire to accommodate the exotic hyperbole of this play's title figure – would seem, *a priori*, to have made even the idea of a made-for-video *Othello* oxymoronic.[1] But in 1981 Jonathan Miller's rendition, made for the BBC/Time-Life series, gave us just that – an *Othello* consciously domesticated to the medium of television's 21-inch expectations.

I would not argue that Miller's *Othello* is an ideal production. For one thing, although hearing Anthony Hopkins speak of "the cannibals and the Anthropophagi" may have resonated with new meanings for a post-*Silence of the Lambs* audience, the film's failure to cast a black actor in the title role combined with the attempt Miller makes in his broadcast introduction to justify conceiving Othello as a "white Moor" seems – to a 1990s American audience, at least – suspiciously like an attempt to erase the racial issue from the play. But despite even this substantial drawback, I would still argue that, for the ways that Miller's *Othello* manages to work with rather than (as is too often the case) against the medium for which it was made, it represents a noteworthy instance of transferring/transforming Shakespeare to video. The Miller *Othello* has used the very constraints of the medium to generate some of its most inspired suggestions about not only the genesis of sexual violence and the complicity of the world coded in this play as civilized and normative (i.e., "Venice") but, finally, about the relation between the bedroom tableau to which the play leads and its voyeuristic viewers – between the spectacle of sexualized death and we the supervisors who have, by the time the play ends, indeed demanded to "grossly gape" on it.

FILM STRATEGIES

There are three particular production strategies through which I propose to read Jonathan Miller's BBC-TV *Othello*:

186

The first is its elaborate iconography of exclusively black and white costumes, through which the characters' psychological alignments and/or oppositions are dramatized via patterns of rhyming and antithesis. As an additional benefit, since the television screen is best equipped for the talking-heads camera shot, the costume rhymes have been largely organized around the heads, necks and collars of the actors. Watch in particular for how collar-ruffs and metal neck-plates signify, and how a male iconography of bald heads and similarly cut beards works progressively to define Iago as the true junior member and visual heir apparent to the play's all-determining boys club, the Venetian patriarchy.

The second strategy the Miller *Othello* relies on – here quite likely reflecting an Orson Welles influence – is its use of two distinctive, night-time lighting styles. The dominant one is that which is fused with Iago – a cold, harshly metallic, steely silver light that is also a synonym for the world of weapons, metallic neck plates, and male violence: it is the world towards which Iago inexorably draws Othello as he repeatedly pulls him out of the bedroom and the space of Desdemona. Against the Iago style is posed the play's Desdemona lighting effect – a warm, orange-toned glow of soft light visually associated with the candle and with the light that Othello cannot once again relume once he has "put out the light, and then put out the light" (5.2.7).[2]

Through the third strategy, Miller implicates his *Othello* in a larger framework of cultural meanings mediated through a series of visual quotations which refer to a group of early seventeenth-century paintings. The allusions include both general evocations of the world of seventeenth-century Dutch Protestantism made familiar to us by artists like Vermeer, and several very specific invocations of the paintings of the seventeenth-century French Carravagisti painter, Georges de La Tour.

To measure what in the BBC-TV version differs from the dominant tradition of *Othello* representation, one need only recall the sequence of visuals through which Sir Laurence Olivier's Moor was staged in the Burge/Dexter production.[3] Throughout that version, Othello was marked as an outsider. Amidst the elegant eminence of a Venice defined by its velvet and taffeta citizens draped in floor-length robes, not only was Othello the only one to clomp around Venice barefooted, in a mid-calf white gown with slave manacles on his wrists and ankles and flashing an ostentatious assertion of his adopted Christian status on his chest, but he was also the only character to be color-coded in black and white. Iconographically, Olivier's move from Venice to Cyprus in the play's second act was set up as a move from the backdrop of stately Venetian drapery to a landscape of mammoth stone pillars and the hot, sunny clime of striped caftans, scimitars, bare chests, and emergingly uncontrolled passions, all of which are visualized when Othello is pulled out of his wedding bedroom on Cyprus in the play's second act (see Jorgens 1977: 191–206, 275–90). After playing out the temptation scenes in black, Olivier reverted in the play's climactic bedroom scene to a gown that was again white but had now incorporated the passions and heat of Cyprus: his crucifix replaced by the sword as his

identifying accoutrement, Othello's gown is now defined by two, sword-shaped cuts that expose his chest and legs and converge in sight-lines towards his genitals.

By contrast, Miller costumes Anthony Hopkins in clothing that does not isolate but instead integrates him, quite literally, into the very fabric of Venetian society. Furthermore, the move to Cyprus is interpretively framed in such pointed contrast to the Burge/Dexter visual geography of Mediterranean passion as to articulate a conscious refutation of it. One of the most interesting cultural interpretations the Miller film offers, in fact, is its visual redefinition of the space in which misogynistic male bonding erupts and women get murdered in the bedroom. In Miller, the narrative shift from Venice to Cyprus is visually constructed as a psycho-spatial movement not to southern but to *northern* Europe, to a relocated "Cyprus" that is iconographically synonymous not with Mediterranean passion but with Dutch Calvinism.

Jonathan Miller's talking-heads show begins outside Brabantio's home in a night-time bathed in Iago's metallic silver light. In a Jack Spratt duet that poses the tall, skinny, effetely aristocratic Roderigo against the short, round and poachy underling who must always resentfully look up to his social betters, Bob Hoskins's Iago, wearing black leather (synonymous for a contemporary audience with sado-masochism) and a plain-spoken, bluntly honest, white starched collar, is juxtaposed in conference with the black-velveted Roderigo, who wears a white organza ruff that throughout the play is always slightly oversized and thus makes him look ever so much like the court jester.

In front of Brabantio's residence is an object that will reappear in the fore-ground of the space in which Othello, also called out into the street by Iago, will make his first entrance – a cistern, into which Iago gleefully splashes his hands. Besides anticipating Othello's later "cistern for foul toads/ To knot and gender in" (4.2.61–2), the prop provides an immediate visual metaphor that allows us to see Iago as moving from cistern to cistern across the city, the source whose poisoning of Brabantio's and later Othello's delight is visually suggested to us as the poisoning of the city's life fountain. As Iago departs from Brabantio's, behind the cistern and bathed in intense silver light his dark shadow appears, momentarily framed inside a cage-like shadow on the wall. Through this image, the film allusively connects its viewers to and simultaneously extri-cates its own narrative from the concluding image of the Orson Welles *Othello* production: the cage in which Iago was contained and hauled off – a cage from which, by implication, he has now clearly escaped.

The next view of Iago (1.2) introduces Othello. Behind the second cistern and here shown helping Iago put on a metal neckplate, Othello is posed against the warm light of the space from which he has just emerged. Othello, like Roderigo, wears black velvet; his ruff, however, is unostentatiously sized and is connected to an intricately ruffled bodice inset that distinguishes him from all the other male figures. Next arrives Cassio, who, like Othello, is lion-maned, and who is here shown wearing both ruff and metal neckplate. With Brabantio's

arrival and the mid-shot that poses Brabantio, Cassio, and Iago in sequence, we are for the first time confronted with a marked visual similarity between Iago and Brabantio. It is an unexpected identity, given both the social class differential as well as what I suspect is our profound desire to isolate Iago away from all contexts in which he might seem anything like us. But from the striking iconography created by the two bald heads, their similarly cut beards, their starched white collars, and their slice-cut black leather doublets, the production offers us its first identifying image of Iago as a slightly younger version of the respected Venetian elders. It is a connection that recurs in the Council scene of 1.3 to which the play next moves, where the talking heads shots of Brabantio and the Duke align them and define the look of the Venetian patriarchy – a look that Montano, Venetian governor on Cyprus, will likewise share. Color Iago's hair white and add some years, and, visually, he would be one of them.

When Desdemona in a black velvet dress enters the council, Miller's investment in a principle of costume rhyming becomes unmistakable. Here, Othello and Desdemona are set into a special, shared intimacy that is visually carried by the textured and patterned neck/bodice insets that so definitively isolate them from everyone else and endow them with something unique. Behind Desdemona, a blurred painting evoking the graceful sensuality of Venetian art glows in the warm light that will repeatedly be connected with her, much as it is later in this scene when Desdemona – visually excluded by the male interchange in which her father warns Othello against her – appears surrounded by a near halo of such light. But perhaps the most impressive use that Miller's production makes of the play's pervasive light imagery is the proleptic staging of Desdemona's murder that it dramatizes at the conclusion of 2.3: Iago, having just successfully engineered the cashiering of Cassio, is left alone on stage, the scavenger to the evening's banquet who gleefully plumps himself down in Othello's vacant seat and contemplates how he may turn Desdemona's virtue into pitch. As the plotting Hoskins focuses his energies on the candle before him and sadistically toys with snuffing out its flame, the moment visually synthesizes a metaphoric staging of Othello's ultimate putting out the light – the moment to which this play so relentlessly leads.

When the play shifts to Cyprus, what defines the space in which the so-called temptation scene will be played out is a large, cold, and bleakly empty rectangular box of a room covered by the kind of black and white checkered floor evocative of the world of Dutch Calvinism familiar from Vermeer and other Dutch painters of the era. In Miller's *Othello* the Vermeer floor will function as a chess-board: when Othello moves, Iago subtly checkmates. As the scene begins, Othello and Iago are costumed in a black and white exact antithesis. Behind and between them, close to Othello, is the warm-colored door that leads to the bedroom; on the long wall of the room is an opaque window, divided into panes by a web-like design. In front of the window is the single piece of furniture that exists in the room besides the desk, a plain-spoken and unornamented love seat. Except the bedroom to which this unwelcoming room leads, this distinctly

masculine space grounded in Iago's gameboard is, in this production, the only room in the Cyprus palace. There are no alternative spaces. When either Desdemona or Emilia enters it, not only do the women seem like foreign presences but they themselves radiate a distinct unease within this space. On the morning after the catastrophic bridal night and Cassio's dismissal, Desdemona enters in a dress that no longer exactly rhymes with Othello's and instead suggests a beginning antithesis. Asked by an oddly preoccupied Othello to "leave me but a little to myself" (3.3.85), Desdemona, holding the fatal handkerchief, self-consciously retreats with Emilia into the bedroom, the site implicitly marked as "female" in the gendered spatiality that this production recognizes as crucial to Shakespeare's text. Waving the handkerchief as she departs, she leaves Othello to Iago's tutelage with the unwittingly prophetic words, "Be as your fancies teach you; / What e'er you be, I am obedient" (88–9).

Iago's displacement of Desdemona as the figure who metaphorically marries Othello and becomes his "own forever" (3.3.480) is a point that Shakespeare's play dramatizes through the men's climactic exchange of vows in what has been called the "marriage scene" at the end of 3.3. In Miller's *Othello*, the parodic nature of this displacement is emphasized by the use the film makes of the room's furnishings, the love seat and web-like window behind it. Simultaneously, this set-within-a set is at work throughout Acts 3 and 4, giving concrete visual statement to the poisonous seduction metaphor that dominates the film's conception of the Othello/Iago relationship. It is Iago that lures Othello onto the love seat. As they sit, Othello initially holds his seducer at arm's length, spatializing an attempt to resist being drawn into the web of his poison. But the deadly black widow spider that Iago here represents reels his victim in, stroking him lovingly as he visually entraps Othello within the figuration of the net that will ensnare them all. Later, in the so-called brothel scene of 4.2 in which Othello accuses Desdemona of being a strumpet, it is she who is isolated within this space, a forlorn figure wearing a paniered dress who, as Othello exits, is left visually enclosed within the web, seated before a window whose opacity closes off rather than opens toward any potential escape or reference to an outside world. When the plump, black-suited Iago scurries in and sits down beside her, the entire *mise-en-scène* before us, including the design of Desdemona's dress, instantly fuses with some half-remembered, Mother Goose picture-book image to make an Anglo-American audience immediately recognize exactly what creature it is that sits there beside her.

When Othello appears in the play's fourth act, the new costume he sports is an ingenious psycho-physical externalization. He is now dressed in Iago's black leather doublet, but – having replaced Roderigo as the dupe whom Iago uses as his fool – he appropriately now wears Roderigo's court jester ruff. The most defining feature of his clothing, however, is the extraordinary pair of black trousers decorated with metallic silver stripes that wind sinuously up his legs toward a huge silver codpiece complete with leather thongs tipped with metal points – a sartorial accessory of the Jacobean era that, to modern eyes, looks like

a leather cat-o'-nine-tails attached to a sheathed silver knife. He will shortly shed the doublet and ruff; but from now on the genital half of Othello's body remains framed as a metonymic inscription of phallic sadism, his sexual self now synonymous with poisonous serpents and instruments of torture and hate, and offering modern audiences a telling iconography of wife-murder.

In Shakespeare's text, the bedroom, though constantly alluded to, remains off-stage and unseen until the final act. In Miller's production, we violate that space in Act 4. At the moment that Iago directs Othello to "strangle her in her bed, even the bed she hath contaminated" (4.1.207–8), Miller's staging produces a powerful sense of violation by having Iago yank open the door and lead Othello (egregiously, an ass) into the heretofore inviolate, offstage space of private sanctity that is synonymous with Desdemona. At precisely this moment, a mirror on the wall – a common filmic device for coding a viewer's complicity and referential awareness of his/her own participation – suggests that we, the viewers, no longer stand outside that violence. As Iago points to the bed – the signifying space of the sexual act – we discover that our gaze is blocked and we can see what he points to only by peering voyeuristically into the reflective mirror that hangs above the dresser, illuminated by a candle. The staging implications are brilliantly insightful. Unfortunately, however, it is here that television fails as a medium. For instead of the kind of voyeuristic recognition that the mirror in the bedroom could provoke on a cinema screen, with the picture shrunk to television size the more likely audience response is supreme annoyance at trying to see something in a frame too small to encompass the various crucial objects it contains. In all *Othello* productions, the foreknowledge of Desdemona's murder with which this scene narratively burdens its audience is deeply disturbing (in the most famous example, impelling one playgoer to start shouting at Othello that Iago had the handkerchief). In Miller's production, acquisition of that knowledge is made synonymous with our entrance into the bedroom space as participants in the male bond within which the play has almost exclusively constructed us. When next we enter the bedroom space we will do so in the company of Emilia and Desdemona. Against the knowledge we then bring with us of the fate that awaits Desdemona in that space (and, though we do not know it, likewise Emilia), the collocation seems designed to make an audience feel uncomfortably complicit in the gendered violence that hovers almost tangibly around the "willow song scene" of 4.3 and, by contrasting with it, illuminates the moment between the two women as one of special poignancy.

Outside, as the play's brewing tensions break into the open streets and all of its male bonds are vitiated in murderous competition, against that outside, masculine location Shakespeare has juxtaposed the play's one brief, warm, and intimately feminine scene in the elliptical exchange between the two women who will both tonight be murdered in the inside space by their husbands. To stage this moment, Jonathan Miller drew directly upon the Caravaggisti painter, Georges de La Tour. Visually, the camera leads us into the bedroom through focusing on the image of a red skull and a lit candle sitting on a table. These

items and the scene's final image of Desdemona are direct quotations from two of the de La Tour Mary Magdalene paintings: in one, the Magdalene, hand on cheek, stares at a glass and candle; in the other, hand on cheek, she fixes meditatively on the red skull. In Miller's film, as Desdemona's gaze turns toward the red skull and her cheek meets her hand to consummate the replication of de La Tour's Magdalene, the warm colors of the Desdemona light that outline the arc of her head suddenly fade, displaced before us by the silver, Iago lighting style. As bedroom transforms into outside street, the outlined shape of Desdemona's head metamorphoses into a silver archway under which stands the ominous shadow of Othello's murderous Ancient, poised to enact his own "business of the night."

When Othello enters from the outside space into the room where the sleeping Desdemona lies surrounded by candles, he is figured as a shadow whose entrance floods the room with darkness. The camera also makes us aware at this moment of how pervasive Iago's control over space truly is: for the chess-board floor – the masculine game space that Iago manipulates and likewise the sign that tacitly reimposes a Calvinist ethos – extends into even the marital bedroom and defines the ground upon which all action must be played out. Whenever Othello's desire for Desdemona begins to sway him, always beneath him extends that foundation. Ultimately, besides serving as synechdoche for a Calvinist ambience, its black and white patterns of racial antithesis, of unambiguous binary opposition, and of desires understood through checkmate and competition could also be said to figure Othello's own implication in masculine ideologies which, in degrading marriage to sexual ownership, finally reduce Desdemona into physical territory under occupational dispute.[4] As Othello – surrounded by candles but always standing on the chess-board – bends over the sleeping Desdemona and contemplates putting out the light, here is where the audience is given its one and only direct look at the voyeuristic spectacle to which the desires of the entire play have led: the bed and the woman on it. From now on, when the camera is not focused in mid-shot on Othello, it slides to long shots and visualizes nearly everyone/everything in the room except the object that synecdochically defines the space. But in this final scene, the camera that seems designed almost to mock its audience's voyueristic desires once again works to exclude us too completely: the only view of the bed it allows is one that we keep frustratedly seeking by squinting into our television sets even to find the mirror in which the bed is distantly reflected.

As Shakespearean critics have previously noted, by comparison to the other "big" tragedies, the forces signifying social and moral authority in *Othello* have a notably late ascendancy. Moreover, any control they may attempt to exert is strikingly ineffectual. When Montano, Lodovico and the delegation from Venice finally arrive in the bedroom, Iago in custody, perhaps the point is not simply that even the Venetian authorities seem unable to halt the misogynistic violence that continues unabated, spreading beyond one husband's murder of his wife to infect every one of the play's three heterosexual bonds. Perhaps the real question

(the question not to be asked) is whether the Venetian authorities, the signifying figures of a patriarchal system, ever really *try* to contain the particular violence with which the final bedroom scene confronts them. To try to stop it would be to recognize and acknowledge its existence. Iago may be the catalyst for the misogyny that explodes in the play's final act and he may indeed inspire the play's repeated violence against women, but his provocations fall everywhere on fertile soil. While Desdemona is being strangled inside, out in the streets, Iago's accusation sends Bianca to prison on capital charges while even her bedmate Cassio (whose life has actually been saved by her arrival) implicitly joins the Venetian elders and stands silently by, saying nothing on her behalf. Inside, with Desdemona's body as backdrop, the drama of wife-murder plays an encore performance while a roomful of able-bodied Venetian authorities stands by and watches Iago savagely silence the strident accusations of his wife. Confronted with the problem of rationalizing just how this second murder could have happened under the very aegis of Venetian authority, *Othello* productions (including to some degree Miller's) invariably react by producing an action script that seems designed to cover up and essentially excuse the state's lack of preventive/protective action. The most frequent way such rationalizing gets dramatized involves staging a struggle in which a superhuman Iago breaks free of his guards and, despite the best efforts of all the men on stage to corral him, nonetheless manages to kill Emilia. The dialogue in the text itself, however, seems notably free of any language from which such a struggle might be inferred. In the text, the authorities intercede to protect Emilia only to the extent that Gratiano's disjunct query, "Fie, your sword upon a woman?" (5.2.222–23) may be considered an intervention. Eighteen lines later, after Emilia has staunchly refused to stop testifying even though Iago has several times openly threatened her, the stage directions read, *The Moor runs at Iago; Montano disarms Othello; Iago kills his wife*, followed only by Gratiano's laconic remark: "The woman falls; sure he hath kill'd his wife" (236). Two lines later, his comment, "He's gone, but his wife's kill'd" (238) sums up the last mention anyone ever makes of Emilia.

Although Miller, too, seems finally unable to resist including a struggle to check Iago, the iconography of his staging nonetheless implicitly (and perhaps unwittingly) illustrates just what social investments lie behind the failure of the Venetian patriarchy either to prevent the spillover of misogynistic sadism or, for that matter, even to define Iago's murder of Emilia as a criminal act. For although the authorities spend a great deal of time in 5.2 determining various legal dispositions, the murder of Emilia – which they all witnessed and for which unequivocal evidence against Iago exists – is never mentioned again nor is Iago indicted or so much as chastised for having committed it.[5] Throughout this production, Iago, whose prurient lewdness is complicit with a distinctly puritanical sexual morality that "hates the slime / That sticks on filthy deeds" (5.2.148–49), has repeatedly been visualized as an integral part – albeit an unacknowledged one – of the society from which he comes. He is, in terms of the way Shakespeare codes him, both this society's "Ancient" and its "Ensign."

Moreover, the costuming of Miller's final scene makes it eminently clear that Iago and the Venetian authorities are all cut from the same cloth, which in this production is the plain spoken garb of Dutch Calvinism. In the final scene it will thus be Othello, not Iago, who is visually the odd man out, the isolated one in a white shirt, implicitly now defined as "Other" to the black-doubleted Venetians and spatially aligned in opposition to their clustered group. But while the final scene images Othello as everything the Venetians wish to cast out, Iago is still iconographically an included force within their bond. In this production, the society cannot rid itself of Iago by carting him away in an Orson Welles's cage, nor is it ever clear that the society wants to. Neither can it resolve the problematic bond between Iago and Othello by assuring us of its dissolution. When Iago promises he "never will speak word" (5.2.304), the line is given not as a contemptuous refusal to cooperate with the Venetian authorities but as a loving personal promise to Othello. As Iago leans even closer to Othello, thereby effectively preventing the figure of Lodovico behind them from driving a visual wedge between, he delivers his enigmatic words almost as an assurance that he will never betray Othello or disclose some ugly and shared secret that he here manages to suggest into existence.

As Jim Siemon has impressively shown in some detail, Othello's suicide is inevitably a staging problem (Siemon 1985). Among other things, it necessitates figuring out where Othello will discover no less than three weapons in the scene, two of which must be concealed from and come as a surprise to the audience. The acting tradition that dictates having Othello kill himself by a stab wound in the neck – while admittedly awkward to perform – is a logical extension of an important discursive issue concerned with voice and voicing, and is consonant with Desdemona's strangulation, the move to silence Emilia, Iago's final refusal to speak more, and the cuing reference in Othello's suicide speech: "I took by the *throat* the circumcised dog / And smote him – thus" (5.2.356–57, my italics). And thus Olivier discovered his final concealed knife inside his slave bracelet and (like Salvatini), enacted his suicide by stabbing himself in the neck. Jonathan Miller's staging of the line leads in a different direction toward another crucial discourse of this play – that which collates male sexuality and violence. Seeming to take his cue from "*circumcised*," Anthony Hopkins appears to discover the suicide weapon inside his silver codpiece. With a downward thrust of his arm that disappears below the camera shot, he implicitly brings the play's sexual meanings to horrific climax by enacting his death as a self-emasculation that tropes itself by reflexively figuring the phallus as both aggressor/agent and victim of its own aggressions.

As Lodovico gives the final voyeuristic order of the play to "look on the tragic loading of the bed," Bob Hoskins leans forward to look, his face wreathed in loving smiles. For us, however, the watchers peering into our 21-inch sets, Miller's staging of the injunction to "look" only reminds us of our position as frustrated voyeurs: for here, in the voice of the play's concluding authority, we are directly enjoined to look at what has been blocked from direct view

194

throughout most of the play and almost the entire bedroom scene. Everyone in the room on Cyprus may get to look at that object that is said to poison sight – everyone but the viewers of this production, whose aesthetic satisfaction has nonetheless by increments been strategically bound up in getting to *see* the spectacle of erotic violence around which the play is structured. But the production's failure to show us the bed is not, as some critics have erroneously assumed, evidence of the director's having misunderstood the dynamics of Shakespeare's play. To the contrary, Jonathan Miller's *Othello* gives evidence of having recognized the extent to which the very play is crafted by the strategy of withholding. By translating that strategy into a film technique, Miller's camera essentially situates its audience as Othello while it plays Iago, inviting and exacerbating voyeuristic desire by the deployment of designs meant to frustrate it. From the perspective of the Miller production viewers, Lodovico's concluding injunction, "Let it be hid," must seem distinctly ironic.

The Miller production closes with the Venetians beating a hasty and nervous retreat out of this space, away from its signifying violence and heading quickly "aboard and to the state." Not even at their departure does the camera relent and provide the expected concluding pan shot of the bed – the tableau that, in the theater, usually defines an audience's final vision of the stage. Instead, the camera shot that concludes Jonathan Miller's film leaves us positioned in the bedroom looking out – not escaping to return back to Venice with the other Venetians but left in the bedroom along with the bed and its "tragic loading." As the sign that all too clearly now embodies something crucial about the nature of the society itself, the bed that had been the play's object of voyeuristic gratification has now become that which poisons sight – the sign of all that the society wishes not to know about itself and all that must therefore be hid. But as the play abandons its audience on "Cyprus" within the interiorized space identified with the feminine, the camera aligns its vision directly with ours, from which vantage point we watch the Venetians make a long, slow, and laborious exit across the omnipresent game-board that lies drenched in the preemptive silver light of a masculine world. Iago goes with them, alive and well, the only Shakespearean villain neither to be killed nor repent his crimes, and in this production still visually synonymous with the male bond and identifiably a part of the highly civilized world from which he came. It is, moreover, a world whose plans for Iago are perhaps best defined by the deeply ambivalent meanings that compete for dominance in Lodovico's pronouncement. There is no intent to kill Iago, and the only punishment or retribution we can expect from the moral and legal authorities of Venice is thus carried by Lodovico's ambivalent assertion that they will "torment him much, and hold him long" (334).

NOTES

1 See, for instance, the review in *Choice* (Feb. 1982), which attacked the Miller production for "lacking [in] verbal music, passion, and epic tragic scale. . . . It is

certain to alienate the public and students from . . . Shakespeare." Quoted in Bulman and Coursen 1988: 276.

2 *Othello* quotations are from Evans 1974.

3 This production began on stage at the National Theatre and, after moving Maggie Smith into the role of Desdemona, was then transferred to film with few other changes. For detailed pictures of the progression in Olivier's costumes see Tynan 1966.

4 Though many of the effects in this film lend themselves to a feminist reading, I would readily concede that such effects, while present in the film, were undoubtedly conceived without a feminist intent. Miller's association between Desdemona and the painting of Mary Magdalene offers a magnified case in point. Behind that connection might lie either a feminist or a rather antifeminist point; such contradictory readings are possible because each would begin from mutually excluding assumptions about what the evocation of Mary Magdalene means as a signifier, or about what and how the term "whore" means (etc.)

As to how to read Jonathan Miller on this issue, as Scott McMillin makes clear, the span of Miller's productions hardly fits the definition of a feminist consciousness. The misogynist implications are weighty in several of Miller's BBC-TV productions (most notably, *The Taming of the Shrew*, which McMillin rightly calls a "straightforward piece of shrew-bashing"). In the theater, Miller is known as something of an iconoclast. But in McMillin's assessment, much of Miller's asserted opposition to traditional interpretation is in reality an "opposition [that is] personal and stubborn, determined to cross authority in the interests of male-centered individualism, mindful of the opportunity for gaining effects at the expense of women. . . . " See McMillin 1988: 81.

5 This issue is one that operates in the space where gender intersects with social class. It would be an overstatement to argue that murdering one's wife is a wholly inconsequential matter in this play – the authorities do plan, for instance, to return Othello to Venice for legal examination in the matter of Desdemona's death. But Desdemona is a patrician daughter and Gratiano, her kinsman, a member of the Venetian hierarchy. The inference that I am holding up to question is the one that most *Othello* productions (and indeed most critics) energetically encourage: that the reason Iago is able to murder his wife so easily lies in the sheer inconceivability of his act – and that if the authorities fail to prevent it, it is because they are so surprised when he actually moves into action that they do not react quickly enough. The explanation – which rings hollow even when Gratiano serves it up in the form of chivalrous disbelief – self-servingly defends (male) authority while begging the real question and ignoring the rather striking implications of the text. What is striking about the final act is the remarkably parallel fate of the three women. What needs to be recognized is that Iago's murder of Emilia, by being so clearly a repetition of the play's central tragic action, removes wife-murder from the realm of the merely aberrant and situates it instead as a larger, more common social pattern (domestic abuse statistics in 1990s America ought by themselves to convince any skeptic of how widespread, how frequent, and how concertedly ignored this particular crime really is). The suppressed question (the question not to be asked) is one that necessarily leads back to issues of gender: why is it that a society – then or now – would want to ignore so prominent a source of social disruption, and what interests are served by ignoring it?

REFERENCES

Bulman, J. C. and Coursen, H. R. (eds) (1988) *Shakespeare on Television: An Anthology of Essays and Reviews*, Hanover N.H.: University Press of New England.

Evans, G. Blakemore (ed.) (1974) *The Riverside Shakespeare*, New York: Houghton Mifflin.

Jorgens, Jack J. (1977) *Shakespeare on Film*, Bloomington, IN: Indiana University Press.

McMillin, Scott (1988) "The Moon in the Morning and the Sun at Night: Perversity and the BBC Shakespeare," in Bulman and Coursen 1988.

Siemon, James (1985) *Shakespearean Iconoclasm*, Berkeley and Los Angeles: University of California Press.

Tynan, Kenneth (1966) *Othello: the National Theatre Production*, London: Rupert-Davis.

13

AGE CANNOT WITHER HIM
Warren Beatty's Bugsy as
Hollywood Cleopatra

Katherine Eggert

Shakespeare's *Antony and Cleopatra* has never been produced as a big-budget film, in Hollywood or elsewhere. This fact should probably not surprise us: in the sound era few Shakespearean plays have received big-budget treatment, and a mere handful have been filmed by Hollywood studios. But unlike, say, *Love's Labor's Lost*, both the Cleopatra story and specifically Shakespeare's version of the Cleopatra story saturate Hollywood history, beginning with an undeterminable number of silent productions that incorporate Shakespeare's version of the character, and entering the sound era with Cecil B. De Mille's 1934 *Cleopatra* (Ball 1968). For all of these films, however, Shakespeare's play maintains a peculiar status, considering its author's reputation and Hollywood's penchant for touting any of its high-culture associations: *Antony and Cleopatra* serves as a submerged source – for character, for situation, and even for the occasional line or phrase – but never, in whole or in part, as a script.

This essay, then, is less concerned with Shakespearean representation than with its evasion. On the one hand, Hollywood of course carries on the Western obsession with representing the Cleopatran legend, but on the other, it curiously does not fully exploit Western literature's most celebrated author of that legend.[1] Hollywood's evasion of Shakespeare's Cleopatra, I will argue, has to do with its aversion to Shakespeare's drastic reformulation of the relation between gender and creative self-presentation, a reformulation that has even more radical implications for a popular cinema than it does for theater. While Shakespeare's play provides the occasion for reproducing the nexus of femininity and power in which Hollywood has always been interested (and that has become even more alluring in box-office terms as feminism gains ground in mainstream culture), its extreme treatment of that nexus is one that Hollywood hopes not to entertain. As a result, *Antony and Cleopatra* can claim two branches of genealogical descent in late twentieth-century filmmaking. First, feminist avant-garde filmmakers and feminist film theorists, on or beyond the margins of Hollywood, have indirectly taken up Shakespeare's Cleopatra as a model for a *cinémathèque féminine*. But second, and more interesting for my purposes, Hollywood itself

continues to approach and then retreat from – in an implicit, unacknowledged, and probably largely unconscious way – its own history of constructing Shakespeare's Cleopatra. My primary example will, in fact, be a film for which *Antony and Cleopatra* is not even remotely an overt source: Warren Beatty's *Bugsy* (1991), which uncannily reproduces Shakespeare's play even while its producers, director, and screenwriter do not acknowledge and no doubt did not seek Shakespearean inspiration. But I will be arguing that Bugsy is the exactly the kind of production that *Antony and Cleopatra* necessarily spawns in mainstream cinema: a film that, while fascinated with the play's premises, veers from and revises its conclusions. To the extent that Warren Beatty's career is intertwined with Hollywood's efforts to film the Cleopatra story, on the one hand, and to cope with cultural anxiety about American masculinity, on the other, he may be argued to be, whether he knows it or not, a new filmic Cleopatra.

The plot of *Bugsy* is, to put it baldly, exactly the plot of Shakespeare's *Antony and Cleopatra*. The primary characters and the sequence and rhythm of events are the same. Benjamin "Bugsy" Siegel (Warren Beatty), an erratic but appealing dreamer/warrior, is one of a powerful Mafia triumvirate that also includes Meyer Lansky, who in contrast to Bugsy is methodical and unemotional, and Charlie Luciano, a relatively minor third partner who is exiled from the scene not long into the story. Bugsy, who has a dutiful, Octavia-like wife back home in New York, is sent by the triumvirate to consolidate their syndicate's claims in the exotic, Orientalized kingdom of Los Angeles. But instead of attending strictly to business, Bugsy alarms his partners and especially Lansky by romancing the sluttish but beguiling starlet Virginia Hill (Annette Bening), with whom he establishes a visionary realm in a desert oasis – together they plan and build the Flamingo, Las Vegas's first large-scale casino – and by whom he is eventually betrayed into death.

The parallels between *Bugsy*'s plot and that of Shakespeare's play continue. Not only has Virginia been the mistress of another prominent gangster before becoming involved with Bugsy, but in James Toback's filmscript (1991) Bugsy obsesses about her previous affairs with dialogue that matches Antony's "I found you as a morsel, cold upon / Dead Caesar's trencher": when the couple quarrel over her previous affairs, Bugsy responds to her remark that his dinner will get cold by pointedly looking at her and commenting, "It's already cold."[2] Their shouting matches over her control of him ("You made me look as if I were your fucking puppet," he says [103]), like Antony and Cleopatra's, always end with Bugsy inexplicably forgiving Virginia, even when she confesses to having embezzled two million dollars from the Flamingo. Her misdeeds cause Bugsy's final break from his partner Lansky, who realizes, despite lingering fondness for his friend, that the syndicate's code of loyalty demands he arrange Bugsy's death. Bugsy goes with uncharacteristic passivity to his end, which, like Antony's, is both messy and slightly dishonorable: defenseless, he is murdered by Lansky's unseen hit men. Like Cleopatra, Virginia responds to her lover's death by killing herself.

How can we account for this unusual parallelism? If we describe *Bugsy* as unconsciously reproducing a generic Cleopatra plot, rather than as enmeshed (as I will shortly argue) with Shakespeare's version of the story, we might resort to several theoretical models to explain the phenomenon of narrative replication. Given the film's portrait of Bugsy as chronically overpowered by desire for Virginia, we might easily label this particular repetition compulsion – the repetition of the femme fatale – as precisely a component in the Freudian uncanny, in which the (tacitly masculine) unconscious manifests its fear of castration in the form of preternaturally replicated images and events (Freud, "The Uncanny," *SE* 17: 219–52). We might then marry such an explication to a Northrop Frye-inspired notion of archetypal plots (Frye 1957): the Cleopatra story recurs, with minimal alterations, because castration anxiety recurs. And along with Mary Anne Doane we might then suggest that film, whose mechanics require an "absolutely repeatable ordering of temporality," is the ideal medium in which to represent the femme fatale as "a repetitively fatal historical force" (1991: 124).

On the other hand, to understand why the story of Antony and Cleopatra has particular appeal in the early 1990s we might turn to Fredric Jameson, who argues in response to Frye that particular narrative forms are invented and revived according to the demands of a particular historical moment: for example, that the late medieval genre of the romance reemerges in the nineteenth century as a magic-saturated antidote to capitalism, imperialism, and revolution (Jameson 1981: 103–50). Jameson argues that narrative structures respond to historical turbulence by repressing it. Similarly, we might assert that in the wake of cultural anxiety over feminism's fundamental alteration of societal structures, the Cleopatran seducer and betrayer is irresistibly resurrected, only to be condemned and defeated. This plot structure has, of course, governed a number of prominent Hollywood vehicles in the 1980s and 1990s, from *Fatal Attraction* (1987) to *Disclosure* (1995); *Bugsy*'s version of this paradigm is to stress the Cleopatra character's willfulness, promiscuity, and deviousness only to redeem her through her ultimate confession of wrongdoing.

Jameson's theory, however, is in other respects inadequate to an account of narrative revival, since it fails to account for narrative's particularities, the elements that differentiate one version of the Cleopatra story from another – Shakespeare from Plutarch, *Bugsy* from Shakespeare. In particular, Jameson accounts only for a reincarnated narrative's repression of its own historical moment, and not for its repression of elements that emerged clearly in one of its previous lives. What we need, especially in order to establish *Bugsy*'s relation not only to a generic Cleopatra story but also to Shakespeare's version of it, is a marriage of Jameson's political unconscious to a notion of a narrative unconscious, in which all previous, culturally available versions of a story are in unacknowledged play, ripe for selective repression and emendation according to the demands of a new historical era, whenever that story is revived. This simultaneous free play and repression of narrative elements would have something in common on the one hand with Barthes' sense of lexical expansion – all words participate at all times

in all their semantic functions – and on the other with Foucault's sense that a topic like sexuality is most discussed when it is most kept secret (Barthes 1974: 92–3; Foucault 1978). More specifically, I have in mind something like the process described by Dominick LaCapra as "displacement": that is, the recurrence at different historical moments of a distinctive literary device, such as a particular image or trope, that "poses the problem of the relation of psychopathology and art to each another [sic] and to larger historical sociopolitical processes" (1991: 143). One of LaCapra's instances of displacement derives from Paul de Man, who in his landmark reading of Baudelaire's *De l'essence du rire* consistently ignores Baudelaire's explicit tropes of sin and redemption – a pratfall puns on the Fall of humankind, for instance – tropes on which de Man's diction nevertheless depends (LaCapra 1991: 141–43). De Man's repression of this particular trope ostensibly works in the service of expunging the sociohistorical problem of religion from his formalistic argument, but only to beg the question of why religion's rhetoric remains powerful in de Man's own sociohistorical context.

If we replace the literary *trope* of LaCapra's theory with elements of literary *narrative*, and if we take LaCapra's use of "repression" in its psychoanalytic sense, we can more clearly articulate the relation between Shakespeare's and Hollywood's reproductions of the Cleopatra story. Like de Man, Hollywood can be charged with repressing the disquieting elements of a text whose broad outlines its projects nevertheless find indispensable, and as in LaCapra's analysis of de Man, that repression serves to mask the conjunction of psychic anxiety and historical trauma that the missing elements would otherwise highlight. *Bugsy*'s reading of Shakespeare is more mediated than de Man's of Baudelaire, since it occurs via its makers' immersion in earlier Hollywood productions, the makers of which, in their turn, flourished their having read Shakespeare. But in this case, then, we are dealing with a *double* repression: first the deliberate one of 1930s and 1960s filmmakers, who in treating Cleopatra's story reduce her Shakespearean power; and then the unconscious one of 1990s filmmakers, who despite ostentatious homages to every other element of their Hollywood heritage turn a blind eye to the downscaled Hollywood Cleopatra they nonetheless replicate.

What must be repressed in a filmic Cleopatra? The answer has to do with the play's extraordinary conjunction of female authority with authorial and directorial control. I have argued elsewhere that the power of Shakespeare's Cleopatra resides, finally, not merely in her command over men, but in her capacity for imaginative projection (Eggert 1991: 173–237).[3] By this I do not only mean her obvious histrionic skills or her playful references to the material conditions of Renaissance playacting, both of which have hardly gone unnoticed in critical and popular perceptions of the play. Rather, in my view Cleopatra's theatrical power extends beyond her practice and awareness of overt dramatic techniques, beyond her emotionalism and her self-referentiality, even beyond such conscious self-stagings such as her costuming herself for her dramatic suicide ("Show me, my women, like a queen: go fetch / My best attires" [5.2.226–27]). Periodically throughout the play, Cleopatra arrests the stage action to indulge in an act of

imaginative reverie that demonstrates, in small, what she defines theater to be: not merely a place of feminine changeability, but a place where mere supposition comes to happen. In the first such moment, for example, Cleopatra indulges in thoughts of what Antony might be doing at that instant: "Stands he, or sits he? / Or does he walk? or is he on his horse" (1.5.21). This is mere query – but it ripens from wish into certainty. From wondering what *might be*, Cleopatra shifts effortlessly to declaring her last guess to be what *is*: "O happy horse to bear the weight of Antony! / . . . He's speaking now, / Or murmuring, 'Where's my serpent of old Nile?' / For so he calls me" (1.5.21, 24–6). In another such moment, Cleopatra transmutes "feminine" moodiness from a simple fit of dissatisfaction into a complex act of re-creation. She first asks for music, then wants to play billiards, then says she'll go fishing:

> Give me mine angle, we'll to the river there,
> My music playing far off. I will betray
> Tawny-finn'd fishes, my bended hook shall pierce
> Their slimy jaws; and as I draw them up,
> I'll think them every one an Antony,
> And say, "Ah, ha! y'are caught."
>
> (2.5.10–15)

Cleopatra offers up a vampish picture of herself, snaring an unwitting Antony with a deceitful hook; but she does so only to modify this image of seduction into one of imaginative power. The line "I'll think them every one an Antony" grants "to think" a transitive, transformative status: thinking each hooked fish an Antony, she makes each thought of each fish into the man she desires. Once Cleopatra imagines an initial deceit, she can move past this conjecture to a kind of imaginative experience, marked by its acceptance of unexpected consequences. Egyptian fish, tawny and slimy, become a Roman Antony; many fishes become a single lover, who nevertheless appears to multiply as each fish, one after another, is caught. Theatrical imagination, for Cleopatra, involves calling up a moment as a tangible entity, but its tangibility does not preclude calling up another, alternative vision, equally seductive and equally satisfying. Every fish may be an Antony. And finally, the second asp she seizes so lovingly may be Antony as well: "O Antony! Nay, I will take thee too" (5.2.311).

In the end, I would argue, the stage is inadequate to the range and complexity of Cleopatra's theatrical imagination, which insists on realizing what the stage cannot show, from the "Emperor Antony" for whom "realms and islands were / As plates dropp'd from his pocket" (5.2.76, 91–2) to Cleopatra herself, who is both "fire and air" and "marble-constant," both "no more but e'en a woman" (4.15.73) and a queen with "nothing / Of woman" in her (5.2.237–38). Despite its emphasis on physical ornament and physical desire, Cleopatra's dialogue overreaches embodiment. Hence we might find in Cleopatra her own protest against being appropriated for a theory of a feminine language based in or analogized upon the body; to this extent, Shakespeare's character fully anticipates the

sense in which many scholars of theater have taken Judith Butler's assertion that gender for modern Western persons is not essential, but performative (Butler 1990: 139).[4] Certainly Cleopatra "derives pleasure from [her] gift of alterability," as Hélène Cixous has contended about the Medusan woman writer, but her *jouissance* stems from more than anything her corporeal pleasures may suggest (Cixous 1976: 889).

If Cleopatra's projective dialogue cannot be embodied on the stage, however, it might logically offer itself for film. Kaja Silverman has argued that one school of experimental feminist film, in fact, distances itself both from the classical cinema – and from filmmakers who have absorbed Shakespeare's Cleopatra via Cixous's description of her as writing the feminine body (Cixous 1986) – precisely by *dis*-embodying the feminine voice:

> Rather than forging closer connections between the female voice and the female body, Bette Gordon, Patricia Gruben, Yvonne Rainer, and Sally Potter have all experimented boldly with the female voice-off and voice-over, jettisoning synchronization, symmetry, and simultaneity in favor of dissonance and dislocation. Some of these filmmakers . . . have so multiplied and mismatched voices as to problematize their corporeal assignation. Others have assigned the female voice an invisible location within the fiction, or have detached it from the diegesis altogether.
>
> (Silverman 1988: 165)

A stage Cleopatra's dialogue cannot, of course, exist apart from her person as these filmic women's voices do, but her imagery suggests precisely what Silverman describes: a voicing, disconnected from the current action, that is neither merely a localized autobiographical reminiscence (as are female voice-overs in classical cinema) nor an omniscient testament of singular truth (as are male voice-overs in classical cinema, e.g. in documentaries). As Silverman sees it, however, this disembodied woman's voice-over as women filmmakers currently employ it is far from liberating: it generally is concerned with the condition in classical cinema against which it reacts, that is, "[t]he female subject's unhappy relation to the gaze" (1988: 174). No longer, in the terms of Laura Mulvey's classic and much-discussed essay "Visual Pleasure and Narrative Cinema," an object "to-be-looked-at," the woman nevertheless remains obsessed with what it means to be merely such an object (Mulvey 1989).

If even feminist avant-garde film has not yet fully adopted the Cleopatran mode, we should hardly be surprised, then, that Hollywood films that draw upon Shakespeare's Cleopatra seek to restrict her power – though complexly and interestingly so – within precisely those bonds of feminine embodiment against which the feminist voice-over protests. Most famously portrayed in American silent film by the stunningly fleshy Theda Bara (whose stage name was anagrammatic for "Arab Death"), a Cleopatra scripted from blended "historical" and Shakespearean sources provided Cecil B. De Mille with the chance to merge his most successful film genres to that date, epic and sex comedy (Essoe and Lee

1970: 55–147). Although Claudette Colbert, the star of De Mille's *Cleopatra* (1934), was just about to launch her more-genteel screwball-comedy career with *It Happened One Night* (also 1934), the audiences of *Cleopatra* would have had in mind her recent portrayal of Nero's nymphomaniac wife in *The Sign of the Cross* (1932), a film that inaugurated a Cleopatran set-piece by featuring Colbert bathing provocatively in an entire swimming pool of asses' milk. Colbert's Cleopatra is hence a strange hybrid. She speaks some of the wisecracking dialogue of the screwball heroine, but is all the while garbed – barely so – in clinging costumes that reveal her midriff, legs, and cleavage. Generally, her barbed dialogue goes merely toward establishing her as the kind of "fast" woman for whom sexual seduction is the only imaginable mode of feminine authority. Indeed, Cleopatra's creative powers in this film are largely devoted to matters of costume and cosmetics; various scenes show her choosing gowns, applying make-up, and striking poses while she arranges her dress. One can hardly help but think of Cleopatra's endless parade of costumes when Antony (Henry Wilcoxon) speaks his version of Enobarbus's "infinite variety" speech: when Cleopatra asks why he doesn't find another woman, he replies, "Because you are another woman. New. Always new. Completely new" (De Mille 1934).

Costuming is specifically allied to theatrical seduction in a scene that always proves telling for *Antony and Cleopatra*-based films: the vision of Cleopatra on her barge, which Shakespeare tantalizingly ascribes to male fantasy by locating it in the mesmerizing recitation of Enobarbus, but which filmmakers cannot resist embodying as spectacle. When Colbert's Cleopatra awaits Antony on her barge, she reclines on a stage-like platform whose backdrop of feathers looks like a band shell. "Do you see the way I'm dressed?" she says to Antony, "I'm dressed to lure you" (De Mille 1934). The scene continues with Cleopatra cuing an extraordinary Egyptian floor show, complete with writhing dancing girls, falling glitter, and female tumblers dressed as leopards leaping through blazing hoops. Mary Hamer reads those hoops – as well as an earlier moment in which Antony is asked to draw up a netful of "clams" from the side of the barge, only to find in his net a heap of undulating women in scanty, mermaidish costume – as emblematic of the overpowering female sexuality to which Antony is abandoning himself (1993: 129). But that sexuality has its limits: insofar as involves merely the spectacular, it confines itself to the realm of the fetishized female body, a body ultimately defined in Hollywood terms as arranged by and for men. Hamer reports that Colbert was actually "highly skilled in film technique. . . . to the point of having sets designed to permit her entrances from the side that flattered her" (1993: 118), but Colbert's Cleopatra gives no such hint of possessing such an extra-corporeal directorial skill. In fact, as Hamer herself points out, the enormously successful product tie-ins for *Cleopatra* were exclusively adornments of seduction, from gowns and perfume to hair-curlers meant to give a woman "Cleopatra bangs" (1993: 122). Far from being a full-scale menace, Cleopatra becomes a means to occupy women's attention only with the physical accoutrements of attracting men's desire.

One result of this film's cordoning off of Cleopatra is to leave more space for masculine artistry. De Mille not surprisingly devotes considerable screen time and special effects to one of his epic specialties, the battle montage. Hand-to-hand combat, shot against a rear projection of hurtling chariots, gives way to an elaborate sea battle that includes not only model ships set ablaze, but also innovative underwater shots of men sinking to the sea floor. But De Mille's script makes clear that what is at stake here is not merely substitution – masculine filmed battles for feminine staged interiors – but also *displacement* in LaCapra's sense of a tellingly repeated but deracinated textual element. Antony's final challenge to Octavian (De Mille's Anglo palimpset for "Octavius") from the parapets of Cleopatra's palace, where Antony is alone and defeated, becomes the occasion for removing Shakespeare's dialogue from a feminine to a masculine locus of invention. When Antony taunts him, "Come up and get me," Octavian retorts with confidence in his own Cleopatran ability, "I can think of easier ways for you to die" (De Mille 1934). No longer Cleopatra, but rather Octavian plans scenarios of "easy ways to die" (5.2.354); left behind is Cleopatra's verbal penchant for pursuing "conclusions infinite," imaginative scenarios both concrete and multiple.

Despite its publicized "allegiance to classical sources" via the Carlo Maria Franzero novel on which it was based, Joseph Mankiewicz's 1963 epic *Cleopatra* also displays a faithful allegiance to De Mille's film, not only in minor script and production touches but also in that it similarly indulges in battle scenes that prove a point more about reappropriating power for masculinity than about fidelity to history. Abandoned by all his men, Richard Burton's Antony ultimately takes on Octavian's legions single-handedly, riding swiftly into their midst as a gallant but doomed warrior. Similarly, his suicide is not so badly botched as is that of Plutarch's and Shakespeare's Antony; Burton's aide refuses to kill him but does not then kill himself, and hence does not upstage his commander. Burton's manly Antony finally instructs Cleopatra herself in noble ways to die; expiring in her arms, he tells her, "We'll make of dying nothing more than one last embrace." Elizabeth Taylor's Cleopatra, most unlike Shakespeare's (the incident is not in Plutarch), does not interrupt him in his dying speech. Rather, she limits herself to one remark after he draws his last: "There has never been such a silence." Like De Mille's film, then, Mankiewicz's *Cleopatra* conspicuously shadows its Shakespearean source, but in a way that curiously deflates its heroine's capacity for imaginative subversions. Shakespeare is most evident in Cleopatra's death scene, in which the film script nearly parallels the playscript line by line, but in the process domesticates Cleopatra into a spectacular mannequin who intends to give pleasure only to her man. Instead of costuming herself for posterity ("Show me, my women, like a queen"), Taylor's Cleopatra costumes herself for Antony: "I will wear – I want to be as Antony first saw me. He must know at once, and from a great distance, that it is I." For me, this narrowing of Cleopatran audience counters the perception of Lucy Hughes-Hallett, who calls Taylor's Cleopatra a "camp queen" who is in on the joke of her own excess and hence authors her own effeminized mode. The decisive sequence for Hughes-

Hallett is one in which Cleopatra, hearing that Caesar is on his way, replaces the recitation of Catullan poetry to which she has been listening with yet another display of dancing girls flanking a nearly naked reclining Cleopatra (1990: 277–79). "We must not disappoint our visitor," she says as she orders the shift in scene. But we must not equate knowingness with power. Taylor's Cleopatra is surprisingly less involved than even Colbert's in carrying out the self-presentations that feature her. Unlike Colbert, for example, Taylor before her death scene is not shown planning her designer costumes; instead, she merely appears in them as a fashion model would – just as she was to appear, silent but dressed in a series of exotic costumes and make-up, as Faustus's envisioned objects of desire in Burton's and Nevill Coghill's *Doctor Faustus* (1967). Once again the dress seems to be the point, as when an ongoing argument between Cleopatra and Antony is filmed as a montage: the words flow seamlessly from one shot to the next, but Cleopatra's costumes change. Like Colbert, Taylor's Cleopatra repeatedly appears in stage-like spaces, either on a raised platform or emerging from behind curtains. But she is displayed in that space as a piece of stage dressing, not as its designer. We never learn, for example, whether the famous scene of her entry into the Roman forum is her idea, or Caesar's – and because we are not told, we think of it as neither, but rather as a triumph of the director's, cinematographer's, and set designer's art.

One could even contend that in this version of *Cleopatra*, Shakespeare as theatrical imprimatur serves as yet another means of limiting its female lead's influence. Unlike the film's director (Mankiewicz) or male stars (Burton, Rex Harrison), Taylor could not claim any credentials in the theater, much less in previous productions of Shakespeare. Rather, at this point of her career Taylor was an asset to a film precisely not for her actorly versatility, but for her status as a star persona – that is, a figure that remains largely the same from film to film, and that tends to merge the details of the actor's private life, real or constructed, with the outline of his or her film roles. While in some cases the activities of the female star persona can be allied with those of the auteur, here the blurring of distinctions between Taylor's personal life and her film role tends to locate her even more firmly within the boundaries of her physicality, a physicality that she does not even properly manage. The 1963 *Cleopatra* was famous for two forms of excess: the profligacy of its budget, and the profligacy of its stars' scandalous off-screen adulterous romance. Hughes-Hallett details how, in the Burton–Taylor affair, financial and physical debauchery tended to run together: "They ate, they drank, they fought, they made love, above all they shopped" (1990: 290). The public seems to have supped full enough of the Burton–Taylor scandal in the tabloids not to have wanted to see its fictionalization on screen. Considering its staggering costs, the film was a flop. But those who did attend would have seen physical and fiscal excess figured most centrally by Taylor's body, a body displayed both in dress and undress, a body that unaccountably seems to gain and lose weight from scene to scene. An audience that had been reading about Taylor's drinking bouts with Burton might have understood her weight gain as alcoholic bloat – not pregnancy, exactly, but nevertheless a mark of

physical incontinence. Even more literally than in De Mille's version, Cleopatra's body is the only site of "infinite variety."

Given the permeability between the Burton–Taylor love affair and Antony and Cleopatra, then, one of the modes of entrapment afflicting Burton/Antony might have been perceived as his participation in the Taylor version of the embodied female star persona: a body that is paradoxically displayed both as a constructed object and as doomed to repeat, in film and in life, an essentialized pattern of corporeal desires. Their ongoing passion for sex and drink, for example, drove the publicity behind other Taylor-Burton film pairings, notably *The Taming of the Shrew* and *Who's Afraid of Virginia Woolf?* (both 1966). But as Steven Cohan has noted, this slippage between male and female star persona has always been the danger posed by the Hollywood star system (1993: 220–21). Warren Beatty, who came onto the Hollywood scene during the years that Mankiewicz's *Cleopatra* was in the works, himself advanced his career not only by displaying a pretty face, but also by carrying on widely public romances with his leading ladies – among them Joan Collins, who was approached to play Cleopatra when salary demands and illness endangered Taylor's participation, and Natalie Wood, whose adulterous affair with Beatty coincided with the making of *Cleopatra* and led gossip columnist Sheilah Graham to label the couple "the poor man's Taylor and Burton" (Parker 1993: 64–5, 81). Beatty's career has spectacularly oscillated between feminine and masculine modes in this regard. On the one hand Beatty, unlike other male stars of similar vintage like Paul Newman or Robert Redford, has largely eschewed the buddy film in favor of roles that almost exclusively center around male–female romantic pairings. Moreover, Beatty has notoriously lived out the reiterated conjunction of these romances with his off-screen sexuality, most conspicuously in his portrayal of the playboy hairdresser in *Shampoo* (1975). On the other hand, however, Beatty has sought to evade the exigencies of the embodied star persona, first by shunning the interviews and other publicity that typically serve to fuse the star's private and public lives, and second by devoting himself, since his early film *Bonnie and Clyde* (1967), to producing, writing, and directing films, activities that abstract the auteur from his physical body.

Though Beatty did not write or direct *Bugsy*, his concerted involvement in the film, his long history in Hollywood, and, most important, his status as a jack-of-all-cinema-trades (from beefcake boy to powerful producer) thus pose Beatty's own history, as *Bugsy* either airs or suppresses it, as a kind of film industry masculine unconscious. In fact, the director and writer Beatty hired for the project themselves pair to form the Beatty dilemma as the Hollywood dilemma. Writer James Toback's most prominent earlier vehicle, *The Pick-Up Artist* (1987), details the career of a man enslaved by sexual desire. Director Barry Levinson's films both before and after *Bugsy*, in contrast, are notable for their devotion to the buddy mode, and their consequent relegation of women to minor roles – for example, *Diner* (1982), *Tin Men* (1987), *Rain Man* (1988), *Jimmy Hollywood* (1994), and *Sleepers* (1996). (Levinson's only film besides *Bugsy* to feature a female lead, *Disclosure*, portrays a sexually and professionally rapacious business executive, a

kind of Roman nightmare of Cleopatra.) In this light, *Bugsy's* replication of the *Antony and Cleopatra* plot serves as a corporate vehicle for raising and ameliorating the issues brought forth by earlier Hollywood uses of the play: how can feminine creativity be limited to a spectacularized female body? How can masculine creativity avoid her fate? The risks run by Beatty's own ambivalently constructed masculinity are once again articulated in *Bugsy's* unacknowledged treatment of Cleopatra, but with a twist: in this case, the crisis of the male lead is amplified by his taking on both gendered roles, not only Antony's but also Cleopatra's.

At first glance, Beatty's film follows its Hollywood *Cleopatra* predecessors by pointedly recontaining the feminine power that its plot and characterizations might unleash: both its filmmaking techniques and its external publicity redefine the female lead not as a creative agent, but as a manageable object. Although Annette Bening's Virginia Hill has aspirations to design and control Bugsy's Las Vegas casino, she is filmed in classical Hollywood style as merely a lovely spectacle, and not one of her own making. Like Taylor's Cleopatra, Virginia is always beautifully dressed but is never shown choosing her elegant outfits. Like Colbert's Cleopatra, her best dialogue goes toward acknowledging her status as the object of the desiring male gaze. Bugsy and Virginia meet, for example, on a movie set where she is playing a bit part, and amidst the clutter of filmmaking equipment they have this interchange:

BUGSY: Light your cigarette[*?*] . . .
VIRGINIA: [*Laughs.*] The way you were staring at me, I thought you were
 gonna ask me for something a little more exciting.
BUGSY: Like what?
VIRGINIA: Use your imagination.
BUGSY: I'm using it.
VIRGINIA: Let me know when you're finished. [*Turns and walks away.*]
 (36–8)[5]

In a turn on Cleopatran convention that corresponds to Steven Cohan's analysis of the male film star, however, Beatty's Bugsy is much more the object of the gaze than is his inamorata. Bugsy has ambitions to be an actor: while in Los Angeles he pals around with George Raft, wangles a gangster-film screen test that he then watches in home screenings, and plans a star-studded opening for his Las Vegas casino. He constantly recites a line from an elocution lesson, "Twenty dwarves took turns doing handstands on the carpet." A newspaper headline asks the question, "Gangster or Star?" These associations threaten to demote Bugsy from deadly Mafioso to laughable, feminized spectacle. Bugsy is seen taking pains over his appearance in ways usually reserved for women – he sits under a sunlamp, wearing a hair-net and a mask of facial mud, with cucumber slices on his eyes. Virginia's initial rejection of him asserts that his actorly desires will grant him the status, at best, of the starlet on the casting-room sofa: "you're just another good-looking, sweet-talking, charm-oozing, fuck-happy fella with nothing to offer but some dialogue. Dialogue's cheap in Hollywood, Ben" (39).

At the same time, however, both the script and the camera of *Bugsy* recuperate mastery for the male star persona by suggesting that Bugsy's objectification is not at all incompatible with his directorial power. The camera repeatedly views Bugsy, for example, in relation to window panes: in shot/countershot the camera first frames Bugsy from outside the window as the object of its gaze, but then moves to view the scene from the inside of the window out, making Bugsy's point of view equivalent to the camera's own. Bugsy also commands the producer's power of the technological voice: he is constantly on the telephone, barking orders, making deals. Finally, Bugsy in several scenes seems to be engineering celebrated Hollywood scenarios. Evoking the most famous scene in *Deliverance* (1972), for example, he disciplines one of his subordinates for stealing from the syndicate – *raping* the syndicate, he says – by forcing the man on all fours to grunt like a pig. And when he first conceives the idea for his casino, he commands that the car driving him through the desert stop so that he may stride into the landscape, silhouetted against the dramatic sunset like Scarlett O'Hara declaring she will never go hungry again. "It came to me like a vision," he says as he returns to the car (104). Bugsy both *has* visions and *is* a vision; he can be both author and object of a spectacle that is both his own and posterity's.

When Bugsy dies, the film suggests, so does filmmaking itself. He is murdered while re-viewing his screen test, and the gangsters' bullets come through the window, the metaphorical film screen, to puncture his body even as they puncture his image on the literal film screen. The scene then cuts from Bugsy's bloody corpse on the floor to the projector also on the floor, knocked on its side, as its soundtrack slows and garbles. Nor does *Bugsy* allow Virginia to fill Bugsy's absence. Virginia responds to the news "Bugsy Siegel is dead" in a literalized version of Taylor's Cleopatran line, "There has never been such a silence": an open-mouthed, speechless closeup. The final shot of her is outside the casino, as the camera cranes back to reveal Bugsy's vision, the Flamingo sign and the desert sky. Her own suicide – all of *Antony and Cleopatra*'s glorious Act 5 – is reduced to white titles on a black screen: "Virginia Hill committed suicide in Austria." The next set of titles tells us that "By 1991 the six million dollars invested in Bugsy's Las Vegas dream had generated revenues of 100 billion dollars" (Levinson 1991). Then we see Bugsy's vision realized: a shot of the Las Vegas strip, circa 1991, with the vastly enlarged Flamingo glittering in the foreground. Bugsy, not Virginia, is Cleopatra, the one who makes dreams into palpable truths.

Bugsy's publicity follows in the Burton–Taylor tradition of blurring art and life, but it nevertheless also paradoxically resolves the dilemma of Beatty's masculinity by transferring Cleopatran power from the female to the male lead. Beatty's much-publicized marriage to Bening soon after the film's completion led to speculation about the promiscuous Beatty's ability to remain faithful to his spouse, speculation that once again reduced Beatty's Hollywood cachet to the level of his sexual desires. At the same time, however, Bening's willingness to take on the marital role of a domestic Octavia – an Oscar-nominated actor content, for three years following *Bugsy*'s release, to suspend her career in favor of homemaking and

motherhood – erases the challenge posed to Beatty by his equally publicized romantic partner in *Dick Tracy* (1990), the film he directed just previous to his starring role in *Bugsy*: that is, Madonna, whose career uncompromisingly establishes that a woman, even while she celebrates her own sexual objectification, might become one of the most powerful behind-the-scenes dealmakers in Hollywood. Although Madonna's *Dick Tracy* role as Breathless Mahoney, the gangster's moll, is hardly unconventional, the film nevertheless betrays an anxiety about the role women *might* play in late twentieth-century Hollywood when it ultimately reveals that Breathless has, in fact, been the informer arranging the confrontations between Tracy and the gangsters. That informer is not a slinky blonde: it is a face with no features at all, a fedoraed creature in a black overcoat, holding a black telephone. It is a disembodied voice.

The end of *Dick Tracy* seeks to meliorate Breathless/Madonna's directorial role by suggesting that it is, in a woman, still incompatible with her status as sexual object. Breathless is unmasked as only a pretty face, after all; her dying words, as she shifts from her gravelly informer voice to her luscious Breathless voice, are in reply to Tracy/Beatty's "It was a good plan, Breathless." "Yeah," she agrees, "you were my only mistake" (Beatty 1990). This scene enacts the reembodiment of the feminine voice as that which seeks not to direct her man but only to please him. Such a resolution is highly disingenuous, however, considering Madonna's own ease at combining the functions that in the Breathless character are declared mutually exclusive. Quite unlike Beatty, Madonna seems to derive no anxiety whatever from collapsing private sexuality and public persona, since in her terms this merging energizes rather than limits the range of her power and success. In Alex Keshishian's documentary *Truth or Dare* (1991), Beatty is portrayed both as caring deeply about his own appearance on camera and as perturbed about Madonna's desire to do *everything* on camera, a camera to which *she* gives orders. As E. Deidre Pribham has noted, Beatty's remark in the film that Madonna "doesn't want to live off-camera, much less talk" is made during a sequence in which she orders him where to stand and what to do: "She retains control of the image of their respective personae and the presentation of their relationship" (1993: 205).

E. Ann Kaplan makes the point that in Madonna's "Blond Ambition" phase, the period of both *Truth or Dare* and *Dick Tracy*, Madonna's bewilderingly multiple images of herself follow the Judith Butler-inspired program of "mobilizing for the purposes of subverting the constitutive categories of gender" (Kaplan 1993: 156). I would argue, however, that whatever Madonna possesses of subversive potential derives not from her sexual pyrotechnics but, as with Cleopatra, from her confident projection, whether on or off stage or film, of a world in which her directorial vision comes to pass. Beatty's work subsequent to *Bugsy*, in contrast, demonstrates a discomfort with *Bugsy*'s seeming accommodation in one man of traditionally masculine and feminine film functions, the coexistence of an embodied sexual persona and a directorial presence. One problem, of course, is that with advancing age Beatty is becoming increasingly less probable as an object

of sexual desire. As the character Suzanne Sugarbaker (Delta Burke) remarks in one episode of the late 1980s situation comedy *Designing Women*, Beatty "isn't as cute as he used to be. I think he's been with too many women. He's starting to get that used look." Nevertheless, his films continue to propose him as a sexual lure, even while they worry at the prospect of his failure. *Love Affair* (1995), directed and co-written by Beatty, in fact is scripted to read much like Beatty's sexual autobiography. For its flashbacks of Beatty's playboy character in previous relationships, the film uses archival footage of Beatty and his famous procession of actress lovers; only the women's faces have been technologically altered so that he, not they, is the only recognizable constant, the eternal lust object. At the same time, however, the film demands that we notice Beatty's declining leading-man status and the narrative's resulting improbability. When Beatty's character meets his lover-to-be, again played by Annette Bening, on a plane flight, they discuss whether his failure to remember that he's already slept with her is due to advancing age. (Meanwhile the movie on the plane's screen, wishfully, is *Free Willy* [1993].)

As the couple's love affair commences, however, the film generally forgets its ironic stance via the crucial device of regressing into blatant Hollywood homage. Of course, *Love Affair* itself is a trigenerational Hollywood homage, a remake of the 1957 film *An Affair to Remember*, starring Cary Grant and Deborah Kerr, itself a remake of the 1939 *Love Affair* starring Charles Boyer and Irene Dunne. But when Beatty's and Bening's characters fall in love the film responds by employing an excess of recognizable elements from Hollywood's Golden Age, from the outrageous cliché of showing time's passage with pages blowing off a calendar, to Bening's Katharine Hepburn-inspired costumes (palazzo pants and high heels from *Bringing Up Baby* [1938]), to the appearance of Hepburn herself in a minor role. Yet even as it seeks to place its characters in a classic past undimmed by time, *Love Affair* shows the strain. Most notable is the camera's obsessive evasion of Beatty's face. Whereas Bening's closeups are luminous and loving, Beatty's are uniformly shot in shadow. What the camera hides, it points up as hidden: one is encouraged to align Beatty not with his leading lady, but with Hepburn, whose famous cheekbones have lost their definition at last. Beatty's displacement of his own face acts as a fissure through which his repressed age, and its threatened conveyance of impotence, nearly returns. As Mark Antony admits of himself, Beatty is "lated in the world" (3.11.3), and the technological apparatus of his medium knows it.

Beatty's decision to remake a late 1950s Cary Grant film is telling. At first glance, *Love Affair* seems to indulge a strenuous nostalgia for the Hollywood that was beginning to dissolve just as Beatty arrived there, and even as Burton and Taylor were having their gaudy nights – a Hollywood dominated not by Madonna, Barbra Streisand, or Roseanne, but by male-headed studios. Those studios implemented the star system that Richard Dyer has argued originated with famous players of Shakespeare and that Richard DeCordova describes as having been appropriated by cinema to lend high-culture patina to its endeavors; its aim was to regulate the private lives of actors and actresses in a way that

neither Cleopatra nor Madonna would stand (Dyer 1979: 102; DeCordova 1991: 22). Though a product of the star system, Beatty seems throughout his career to have aspired to the power of the studio head who shapes the stars' personae (Parker 1993: 1). But Beatty's occupancy of the Cary Grant role erodes this unproblematic masculinity in two ways. Not only is Grant's own onscreen sexuality famously enigmatic (think of his chiffon bathrobe in, again, *Bringing Up Baby*), but Grant's appearance in *An Affair to Remember* marks the point at which Grant's last stands as a leading man were giving way to a generation of male actors whose sexuality was even more ambiguous – Montgomery Clift, Marlon Brando, and James Dean, for example.

Linda Charnes has argued that Shakespeare's Cleopatra succeeds at self-representation insofar as she musters and manages her own story's iterability, its existence as preexisting inscription and future story (1993). Beatty's case is similar – his penchant for remakes tends to rewrite Beatty's own life as the history of American sound film. But in Beatty's instance each iteration necessarily under-mines the goal of healing a fractured late twentieth-century masculinity, since no past reference can regress far enough in time. Beatty's career, we must remember, is marked by films featuring his character's sexual and professional compromises, from *Splendor in the Grass* (1961), where his frustrated desire for Natalie Wood's character causes him to marry the wrong woman; to *Bonnie and Clyde*, which suggests murder and mayhem as a compensation for sexual impotence; to *Shampoo*, where the playboy is finally spurned; to *Reds* (1981), whose hero dies with promise unfulfilled. In this regard *Bugsy*'s historical setting, the years 1941–47, bears special attention: it sustains nostalgia for the moment before American masculinity began its postwar travails, exposed in its fragility on the one hand by the strains of returning from war, and on the other by the Kinsey reports, which revealed adult women's sexuality to be more capacious than men's (Silverman 1992; Cohan 1993: 211). But on the other hand, *Bugsy*'s repetition of a familiar form once again does nostalgia in. As J. Hoberman notes in his *Village Voice* review of *Bugsy*, in the middle 1940s the gangster films in which Bugsy longs to act were a tired genre, and gangster-film stars like Bugsy's friend George Raft were themselves becoming passé (1991).

Thus, although Beatty's producing and directorial efforts aspire to portray their male lead as mythic overachiever, we should keep in mind André Bazin's advice: "Myths are ageless; but films can only appear to be myths. Instead they are thoroughly cultural and historical phenomena, even when what they express repudiates culture and history" (quoted in Andrew 1993: 130). In 1972 Charlton Heston directed himself in a very low-budget, independent version of *Antony and Cleopatra* that to date remains the one wide-screen film based entirely on Shakespeare's script. Though in most ways dreadful, this *Antony and Cleopatra* engages with great clarity precisely the questions that Beatty's displacement of Shakespeare raises and then attempts to fob off. Although the film's visuals insistently recall Heston's *Ben Hur* salad days of Roman galleys and bare male torsos, at the same time Heston lets his slightly softening muscles

and increasingly immobilized expression dominate the scene, as if daring us to see him as he is, while we remember him as he was. Warren Beatty is not so revealing. He is still ageless, unwrinkled deep in time, at least insofar as the shadow of a Dick Tracy fedora or the soft focus of a romantic remake will allow him to be. No wonder, then, that when Beatty remakes *Antony and Cleopatra* it is as an elegy not to Cleopatra, but to himself.

NOTES

1 For Western history and literature's revisions of Cleopatra, see Hughes-Hallett (1990).
2 Shakespeare 1954: 3.13.116–17; Toback 1991: 83. Both *Antony and Cleopatra* and Toback's *Bugsy* scripts are hereafter cited parenthetically in the text.
3 I borrow some material from my dissertation in this paragraph (Eggert 1991).
4 However, Butler's sequel to *Gender Trouble*, *Bodies that Matter*, repudiates the suggestion that gendering is analogous to a theatrical actor's assumption of persona (1993: 7).
5 Virginia's last line in this conversation does not appear in Toback's published script.

REFERENCES

Andrew, Dudley. 1993. "History and Timelessness in Films and Theory." *Meanings in Texts and Actions: Questioning Paul Ricoeur*. Ed. David E. Klemm and William Schweiker. Charlottesville: University Press of Virginia. 115–32.

Ball, Robert Hamilton. 1968. *Shakespeare and Silent Film: A Strange Eventful History*. New York: Theatre Arts.

Barthes, Roland. 1974. *S/Z*. Trans. Richard Miller. New York: Hill & Wang.

Butler, Judith. 1990. *Gender Trouble: Feminism and the Subversion of Identity*. New York: Routledge.

——— 1993. *Bodies That Matter: On the Discursive Limits of "Sex"*. New York: Routledge.

Charnes, Linda. 1993. "Spies and Whispers: Exceeding Reputation in *Antony and Cleopatra*." *Notorious Identity: Materializing the Subject in Shakespeare*. Cambridge, MA: Harvard University Press. 103–47.

Cixous, Hélène. 1976. "The Laugh of the Medusa." Trans. Keith Cohen and Paula Cohen. *Signs* 1: 875–99.

——— 1986. "Sorties: Out and Out: Attacks/Ways Out/Forays." Hélène Cixous and Catherine Clément. *The Newly Born Woman*. Trans. Betsy Wing. Minneapolis: University of Minnesota Press. 63–132.

Cohan, Steven. 1993. "Masquerading as the American Male in the Fifties: *Picnic*, William Holden and the Spectacle of Masculinity in Hollywood Film." *Male Trouble*. Ed. Constance Penley and Sharon Willis. Minneapolis: University of Minnesota Press. 203–32.

DeCordova, Richard. 1991. "The Emergence of the Star System in America." *Stardom: Industry of Desire*. Ed. Christine Gledhill. London: Routledge. 17–29.

Doane, Mary Anne. 1991. *Femmes Fatales: Feminism, Film Theory, Psychoanalysis*. New York: Routledge.

Dyer, Richard. 1979. *Stars*. London: British Film Institute.

Eggert, Katherine. 1991. "Ravishment and Remembrance: Responses to Female Authority in Spenser and Shakespeare." Diss. University of California, Berkeley.

Essoe, Gabe, and Raymond Lee. 1970. *De Mille: The Man and His Pictures*. South Brunswick, NJ: A. S. Barnes.

Foucault, Michel. 1978. *The History of Sexuality Volume I: An Introduction*. Trans. Robert Hurley. New York: Random House.

Freud, Sigmund. 1953–74. "The Uncanny." *The Standard Edition of the Complete Psychological Works of Sigmund Freud*. Trans. James Strachey. 24 vols. London: Hogarth. 17: 219–52.

Frye, Northrop. 1957. *Anatomy of Criticism: Four Essays*. Princeton: Princeton University Press.

Hamer, Mary. 1993. *Signs of Cleopatra: History, Politics, Representation*. London: Routledge.

Hoberman, J. 1991. "Learning from Las Vegas." *Village Voice*, 17 Dec.: 65.

Hughes-Hallett, Lucy. 1990. *Cleopatra: Histories, Dreams and Distortions*. New York: Harper & Row.

Jameson, Fredric. 1981. *The Political Unconscious: Narrative as a Socially Symbolic Act*. Ithaca: Cornell University Press.

Kaplan, E. Ann. 1993. "Madonna Politics: Perversion, Repression, or Subversion? Or Masks and/as Master-y." *The Madonna Connection*. Ed. Cathy Schwichtenberg. Boulder, CO: Westview. 149–65.

LaCapra, Dominick. 1991. "The Temporality of Rhetoric." *Chronotypes: The Construction of Time*. Eds John Bender and David E. Wellbery. Stanford: Stanford University Press.

Mulvey, Laura. 1989. "Visual Pleasure and Narrative Cinema." *Visual and Other Pleasures*. Bloomington: Indiana University Press. 14–28.

Parker, John. 1993. *Warren Beatty: The Last Great Lover of Hollywood*. New York: Carroll & Graf.

Pribham, E. Deidre. 1993. "Seduction, Control, and the Search for Authenticity: Madonna's *Truth or Dare*." *The Madonna Connection*. Ed. Cathy Schwichtenberg. Boulder, CO: Westview. 189–212.

Shakespeare, William. 1954. *Antony and Cleopatra*. Ed. M. R. Ridley. London: Methuen.

Silverman, Kaja. 1988. *The Acoustic Mirror: The Female Voice in Psychoanalysis and Cinema*. Bloomington: Indiana University Press.

—— 1992. "Historical Trauma and Male Subjectivity." *Male Subjectivity at the Margins*. New York: Routledge. 52–121.

Toback, James. 1991. *Bugsy: An Original Screenplay*. New York: Citadel.

FILMS VIEWED

Caron, Glenn Gordon, dir. 1994. *Love Affair*. Warner Brothers. With Warren Beatty, Annette Bening, and Katherine Hepburn. Sound, col., 108 min.

De Mille, Cecil B., dir. 1934. *Cleopatra*. Paramount. With Claudette Colbert and Henry Wilcoxon. Sound, b/w, 100 min.

—— 1932. *The Sign of the Cross*. Paramount. With Claudette Colbert and Charles Laughton. Sound, b/w, 118 min.

Designing Women. 1986–93. Prod. Linda Bloodworth-Thomason and Harry Thomason. Mozark Productions for CBS Television.

Heston, Charlton, dir. *Antony and Cleopatra*. Rank. With Charlton Heston and Hildegard Neil. Sound, col., 150 min.

Keshishian, Alex, dir. 1991. *Truth or Dare*. Miramax. With Madonna. Sound, b/w and col., 118 min.

Levinson, Barry, dir. 1991. *Bugsy*. Columbia/Tristar. With Warren Beatty and Annette Bening. Sound, col., 135 min.

Mankiewicz, Joseph, dir. 1963. *Cleopatra*. 20th Century Fox. With Richard Burton, Rex Harrison, and Elizabeth Taylor. Sound, col., 246 min.

14

ASTA NIELSEN AND THE MYSTERY OF *HAMLET*

Ann Thompson

From April 1994 to April 1995 the National Film Theatre in London ran an extended season devoted to Shakespearean performances on film and television under the inspired title *Walking Shadows* – a title which occasionally transmuted in inter-office memos and e-mail to "Shadow and Substance", "Idiot's Tale" or even, on a bad day, "Signifying Nothing". *Walking Shadows* was also the title of an annotated catalogue of Shakespeare holdings in the National Film and Television Archive edited by Luke McKernan and Olwen Terris which was published by the British Film Institute to coincide with the beginning of the season (McKernan and Terris 1994). The month of June 1994 saw the screening of twelve different versions of *Hamlet*; as McKernan and Terris put it in their programme note:

> *Hamlet* is the world's most filmed story after *Cinderella*. The figure of Hamlet, his agonised choices, his revenge and his fate (not to mention the literary kudos) have attracted filmmakers and actors from 1900 onwards, when Sarah Bernhardt became the first person to play the Dane on film. Since then he has been played by a woman three more times (Asta Nielsen, Joy Caroline Johnson and Fatma Girik), and the men have included Georges Melies, Sir Johnston Forbes-Robertson, John Barrymore, Jack Benny, Laurence Olivier, Maurice Evans, Hardy Kruger, Maximilian Schell, Christopher Plummer, Richard Burton, Innokenti Smoktunowsky, Nicol Williamson, Richard Chamberlain, Derek Jacobi, Mel Brooks, Mel Gibson and Arnold Schwarzenegger. He has been animated at least twice, portrayed as twins (Anthony and David Meyer) and turned into a cowboy (*Johnny Hamlet* and *Lust in the Sun*). India, Ghana, Japan, the USSR, Brazil, Turkey, Greece and Denmark have all produced their versions of the story.

The season ended with a wonderful programme of spoofs, parodies and comic turns called "You've Got to Give 'em Shakespeare Every Time" which included versions of the "To be or not to be" soliloquy by Tony Hancock, the Monty Python team, Morecambe and Wise, Tommy Cooper and Rowan Atkinson. It was an extraordinarily rich season, both in these unexpected moments of

hilarity and in the impressively sombre experience of a film such as Akira Kurosawa's *The Bad Sleep Well* (Japan, 1960) which translates elements of the Hamlet story into a modern tale of Japanese urban corruption and contains a very fine central performance by Toshiro Mifune to add to the list of screen Hamlets above. But one of its greatest pleasures for me was the opportunity to see Asta Nielsen in the 1920 silent version directed by Svend Gade and Heinz Schall on a large screen with a fine piano accompaniment by Ena Baga. (This film was subsequently shown again during the "Everybody's Shakespeare" International Festival at the Barbican, London in November 1994 with a new score by Richard McLaughlin, performed by his Cine-Chimera sextet, and it was screened in Los Angeles during the World Shakespeare Congress in April 1996.)

When Asta Nielsen's film was released in the United States in 1921, *Wid's Daily* (later to become the *Film and Television Daily*) made the following suggestion in its regular "Box Office Analysis for the Exhibitor" column which carried advice on how to market particular films:

> A little teaser campaign using the line "Was Hamlet a man or a woman?" is sure to arouse interest, especially among better class audiences. In college towns this picture should go over big.
>
> (*Wid's Daily* 1921)

Exhibitors were also encouraged to stress the centrality of Nielsen herself:

> Your big talking point is the star, Asta Nielsen, the famous Danish actress. Mention the fact that many of Europe's best critics have acclaimed Asta Nielsen as one of their greatest tragic actresses. You can safely play up her acting to the limit. At this no one will be disappointed.
>
> (*Ibid*)

Nielsen (1881–1972) had established herself as a stage actress with the Royal Theatre of Copenhagen before moving into the cinema. Since Danish was spoken by less than three million people at this time, the silent cinema clearly gave her the opportunity to develop her talent on the international scene. She made a total of seventy-six films between 1910 and 1932 with a number of Danish and German directors including Ernst Lubitsch, G. W. Pabst and Urban Gad whom she married in 1910. She appeared as Strindberg's Miss Julie and as Wedekind's Lulu. By 1914 she was the most popular film star in Germany and was known all over the world. There were "Asta" cigarettes, pastries and hair-styles in Germany, and Asta Nielsen cinemas in San Francisco, Dusseldorf and Nagasaki. Her picture decorated trenches on both sides during World War I. Guillaume Apollinaire wrote of "Nielsen ecstasy":

> She is all. She is the drunkard's vision and the hermit's dream. She laughs like a girl completely happy, and her eyes know of things so tender and shy that one dare not speak of them.
>
> (Quoted by Allen 1973: 205–6; see also Luft 1956)

She played an enormously wide range of roles, from young girls to old women, in comedy, tragedy and melodrama. She also played male roles, and roles of women playing men, but these were generally in comedy. In 1916 for example she starred in a film called *Das Liebes ABC* or *The Alphabet of Love* (directed by Magnus Stifter) in which she was disguised as a young man who takes a friend on a tour of the bars and nightclubs of a city to introduce him to "life". Her performances were regularly acclaimed as "modern", "adult" and "mature", as compared with the more simplistic and melodramatic style of acting associated with the early silent cinema.

In 1920 she formed her own production company and chose to make *Hamlet* as its first venture. Its relation to Shakespeare's play is complex and, if you read the publicity, reviews and standard accounts, paradoxical. In his authoritative 1968 book, *Shakespeare on Silent Film*, Robert Hamilton Ball calls it "the best silent *Hamlet*. . . . [but] a sweeping adaptation". He quotes a contemporary account in *Exceptional Photoplays*, the organ of the National Board of Review (January–February 1922): "the story moves logically and forcefully through the course of action that Shakespeare has made so familiar, losing much that enriches the Shakespearean version and gaining much that Shakespeare never thought of" (Ball 1968: 272, 277). Robert A. Duffy, writing in 1976, remarks that it takes "outrageous liberties with the text" and that "a sense of fidelity to Shakespeare is nowhere evident in the film", but concludes that it is nevertheless "the most effectively filmed *Hamlet* of the silent era" (Duffy 1976: 142).

At nearly ninety minutes in its original German release (seventy-three minutes in the surviving viewing copy at the National Film and Television Archive), it was an unusually ambitious venture and something of a commercial risk for the distributors, at least outside Europe. The American company Vitagraph had released thirty-six Shakespeare films between 1908 and 1915, but they were all short fifteen-minute versions, aimed primarily to counter the "low" peep-show image of the early cinema or nickelodeon with a "quality" product promoting Shakespeare as the respectable symbol of cultural assimilation, as William Uricchio and Roberta E. Pearson have demonstrated (Uricchio and Pearson 1993: 65–110). Of the forty-one *Hamlet* films and extracts from the silent period listed by Luke McKernan in his (unpublished) *Hamlet* filmography (including, of course, much material which is *not* available in the National Film and Television Archive), only two others are of feature film length: the British version of 1913 directed by E. Hay Plumb and starring Johnston Forbes-Robertson (sixty-three minutes on release, fifty-nine minutes in the surviving print) and the Italian *Amleto* of 1917, directed by Eleuterio Rodolfi and starring Ruggero Ruggeri (eighty-four minutes on release, fifty minutes in the surviving print).

Wid's Daily rather nervously advised distributors of Nielsen's film in the USA to:

Tell your people that this is not Shakespeare's story of the melancholy Dane, but a version taken from the old legend and presented with a good

deal of heart interest and thrilling intrigue. Advertise the picture as a big
European production employing large mobs and armies. Show them stills
of some of the sets using hundreds of extras.

<div align="right">(Wid's Daily 1921)</div>

Asta Nielsen's nationality is often alluded to in discussions of the film, as for
example in James Card's salute in 1979:

> In many ways Asta Nielsen's performance as Hamlet is far more moving
> than that of Laurence Olivier. Even with the advantages of Shakespeare's
> verse, Olivier was far less a haunted and melancholy Dane than was Asta
> Nielsen in 1920.

<div align="right">(Card 1979: 57–8)</div>

What is moving is precisely the sexual ambivalence that the actress brings to the
role. As Wid's Daily continues encouragingly:

> This version of Hamlet is certainly not as doleful as Shakespeare's play. The
> picture goes back to ancient legend and employs the modern theory that
> Hamlet was a woman and in love with Horatio.

<div align="right">(Ibid.)</div>

The "modern theory" alluded to here is that of Edward P. Vining who in 1881
(the year of Asta Nielsen's birth) had published a book called The Mystery of
Hamlet. An Attempt to Solve an Old Problem (Vining 1881). The problem, as
Vining sees it, is "the bundle of contradictions" in the character of Hamlet:
"weak and vacillating as he is, there is yet some quality which forbids that any
should despise or condemn him". He addresses the reader:

> As Hamlet lacks the energy, the conscious strength, the readiness for
> action that inhere in the perfect manly character, how comes it that
> humanity still admires him?

<div align="right">(Vining 1881: 46)</div>

The solution is wonderfully simple (and in this context breathtakingly obvious):

> There is not only a masculine type of human perfection, but also a
> feminine type; and when it became evident that Hamlet was born lacking
> in many of the elements of virility, there grew up in him, as compensa-
> tion, many of the perfections of character more properly the crown of the
> better half of the human race. All mankind has recognized the deep
> humanity of the melancholy prince, and many have been puzzled to find
> that they are instinctively compelled to bow before him in admiration,
> while still finding in him so many faults and weaknesses. The depths of
> human nature which Shakespeare touched in him have been felt by all,
> but it has scarcely been recognized that the charms of Hamlet's mind are
> essentially feminine in their nature.

<div align="right">(Ibid.: 46–7)</div>

Vining's book contains, it will already be apparent, a rich storehouse of information on Victorian gender stereotyping at the same time as it exemplifies a massive anxiety about its own definition of manliness and the "instincts" which might cause one man to "bow before [another] in admiration". It traces the history of "the contradictions in Hamlet's character" through eighteenth- and nineteenth-century criticism, and argues that "the art of Shakespeare was used to reveal the character yet conceal its real nature" (5). It is a serious and in many ways scholarly study, not easily dismissed as mere eccentricity of the kind manifested in, for example, the perennial obsession with authorship. The whole of Vining's book is of interest in the context of the study of the appropriation of Shakespeare, but I shall concentrate here on his theories about the history and development of the story which are, it turns out, relevant to modern textual scholars as well as to Asta Nielsen and her team.

Vining's book was published in Philadelphia by J. B. Lippincott and Co., a company still familiar to us as publishers of the Variorum Shakespeare. The dedication reads:

> To Horace Howard Furness,
> By whose unrivalled
> Variorum Edition of Shakespeare
> All America is Honored,
> And to whose work the writer is indebted for the quotations
> presented in support of his views,
> this essay
> is respectfully dedicated.

Furness's massive two-volume Variorum *Hamlet* had appeared four years earlier, in 1877. His generous selections from the critical history of the play provided Vining with the material he needed to put his particular gender-based spin on "the mystery of Hamlet's character". Moreover, his discussion of the history of the three texts of the play (the 1603 First Quarto had been rediscovered in 1823 and is considered by Furness alongside the 1604/5 Second Quarto and the 1623 Folio) allowed Vining to develop a theory of authorial revision whereby Shakespeare rewrote the play over a lengthy period of time, making radical changes to the plot and to the character of the hero, who became increasingly feminine with each rewriting. The issue of whether Hamlet actually evolved into a woman is delicately put:

> The Question may be asked, whether Shakespeare, having been compelled by the course and exigencies of the drama to gradually modify his original hero into a man with more and more of the feminine element, may not at last have had the thought dawn upon him that this womanly man might be in very deed a woman. . . . It is not claimed that any such thought was in our immortal poet's mind when first he conceived and put the drama into shape. . . . It is not even claimed that Shakespeare ever fully

intended to represent Hamlet as indeed a woman. It *is* claimed that in the gradual evolution of the feminine element in Hamlet's character the time arrived when it occurred to him that so might a woman act and feel, if educated from infancy to play a prince's part, amd that thereafter the changes in the character and in the play were all in the direction of a development of this idea.

(*Ibid.*: 59)

Vining thereupon sets out the thesis that, on the day Old Hamlet fought Old Fortinbras, news of the struggle reached Elsinore in the form of rumours that Fortinbras was dead but Hamlet was injured, perhaps fatally. Gertrude in fact gave birth to a daughter, but decided to pass the child off as a son in order to protect the succession, and once taken this decision could not be reversed. Hence Hamlet is brought up as a boy, and the broad basis for the speculative narrative that ensues is very similar to that of Nielsen's film, including the unrequited love for Horatio.

Vining bases his argument about the "gradual evolution of the feminine element in Hamlet's character" on some detailed comparison of the three variant texts. For example, he notes the disparity between the texts on the question of Hamlet's age: in the First Quarto there is nothing to contradict the impression that Hamlet is a youth of about twenty, whereas in the Second Quarto and the Folio there is an insistence that he is thirty. Vining asks:

Is not Hamlet's extreme maturity of mind, combined with his youthfulness of appearance, notwithstanding his actual age of thirty years, strong proof that here was a woman masquerading in a manly part? [T]he natural brightness and freshness of [a woman's] complexion, combined with absence of beard, will give her a boyish appearance, making her look far younger than her real age.

(*Ibid.*: 81–2)

He also observes that in the "To be, or not to be" soliloquy, the expression that appears in the Folio as "The pangs of dispriz'd love" does not appear at all in the First Quarto and appears in the Second Quarto as "The pangs of despiz'd love". He argues that this change "with the delicate shade of new meaning in the new word ['dispriz'd'] , makes the phrase peculiarly applicable to the love that we may imagine Hamlet to have had for Horatio". He quotes Furness: "A love that is disprized falls more frequently to the lot of man, and is perhaps more hopeless in its misery than a love that is despised", and concludes:

Horatio did not despise the affection of Hamlet, but he can have had but the dimmest apprehension of the depth of Hamlet's whole-hearted love and never suspected the true cause of the latter's confidence in him. Hence Hamlet could not but have felt that his love was and must ever remain "disprized" (64–5).

Vining is extremely concerned about Hamlet's apparent love for men and contempt for women:

[A]ll his admiration is for manly strength and manly virtues, while upon feminine peculiarities, upon womankind in general, and upon his mother and Ophelia in particular, he pours out all the bitterness of his detestation. Here is an anomaly almost against nature. The Creator has planted in humanity a subtle attraction towards the opposite sex, which in a man, and particularly in a man of Hamlet's age, invests all woman-kind with a tender charm. Each sex admires the characteristic virtues of the other and thinks slightly of its own good qualities. . . . In Hamlet, however, we find an entire inversion of what we should have expected. His admiration is expended upon men and masculine perfections alone . . . (55).

There is a question here as to whether we interpret "inversion" as a code-word of the period: Is Vining really concerned with an "inverted", that is homosexual reading of *Hamlet* and if so how? What Furness made of Vining's book and its dedication is not recorded, but when he addressed the Phi Beta Kappa chapter at Harvard in 1908 he ended by proclaiming:

Lastly, let me entreat, and beseech, and adjure, and implore you not to write an essay on *Hamlet*. In the catalogue of a library which is very dear to me, there are about four hundred titles of separate editions, essays, commentaries, lectures, and criticisms on this sole tragedy, and I know that this is only the vanguard of the coming years. To modify the words, on another subject, of my ever dear and revered Master, the late Professor Child, I am convinced that were I told that my closest friend was lying at the point of death, and that his life could be saved by permitting him to divulge his theory of *Hamlet*, I would instantly say, "Let him die! Let him die! Let him die!"

(Quoted in Kerrigan 1994: x)

The Nielsen film sets up the same rationale for the plot as Vining, but it also draws for later material on Saxo Grammaticus and other pre-Shakespearean versions of the story. It contains some lively comedy in its earlier scenes – Hamlet as a student, disguising her sex in her friendships with Horatio and the boisterous Laertes – which make the later discoveries of the death of her father and the treachery of Gertrude and Claudius all the more painful. The early encounter with Fortinbras (at the fencing school) and their mutual decision to bury their fathers' enmity gives resonance to the later meeting when Hamlet arrives in Norway (as if accomplishing the journey to England) and cheerfully shrugs off the forged command to execute Rosencrantz and Guildenstern. The complicity of Gertrude in the murder of Old Hamlet is chilling, as is her decision to poison her daughter in revenge for the death of Claudius who is killed in a fire deliberately started by Hamlet.

The terms of the debate about Hamlet's gender have however shifted from 1880 to 1920, and from 1920 to 1995. Vining seems to be addressing a male readership which has some serious anxieties about its own virility and its love affair with the problematically effeminate Hamlet. In Lawrence Danson's 1992 reading, Vining's book exhibits a kind of displaced homophobia, "a fear of being gay, thus being femininized" (Danson 1992: 42). Analysed from the perspective of Laura Mulvey's influential essay on the power of the male spectator's gaze in the cinema (Mulvey 1975):

> Vining's Hamlet is a man emasculated by another man's competitive scrutiny. . . . you can turn the nineteenth century's great symbol of intellectual power into an object of sexual pleasure, a woman. You can simultaneously unfix the restrictive binary of sexual identity while reaffirming the hierarchy which puts the male spectator on top.
>
> (Danson 1992: 42)

This hierarchy is also inescapable in the 1920 film, according to Danson:

> Up to a point, [Neilsen's Hamlet] is a figure of a woman transcending woman's social role. Simultaneously, however, she is also a cautionary figure of the lonely fate presumably awaiting the masculinized woman; her bisexuality is a source of pathos and circumscription. The woman playing a man making love to a woman is allowed that scope only on the terms that she is really pining for a man.
>
> Unfulfilment with either man or woman is the cost of her bisexuality. For all its bold – its characteristically Weimar – polymorphous indulgence, the Nielsen *Hamlet* still works to gratify male heterosexual fantasy. Its infamous final scene shows Horatio cradling his dead friend Hamlet in his arms [see Plate 14.1]. Horatio strokes Hamlet, beginning at the head; his hand reaches Hamlet's chest; and in the greatest scene of anagnorisis Shakespeare never wrote, the mystery of Hamlet is solved by a man's discovery of a woman's anatomical secret. (48)

Perhaps. But such a reading seems to me to belittle the film, its central performance, and its female spectators. Nielsen was popular with female audiences as well as male ones, and while her Hamlet relates to the self-conscious sophisticated decadence of Weimar, it also evokes the concept of the New Woman, the post-World-War-I emancipated flapper. There is indeed a wistfulness in the impossibility of heterosexual pairing in the film, but there is also considerable pleasure (at least for the audience) in the sensuality of an attractive androgynous performance. Nielsen's Hamlet is no ineffectual dreamer but a woman of action and decision dominating the screen with her alert energy and her ironic intelligence. On four recent viewings, I did not find the "infamous" final scene comic, as Danson seems to have done; nor did the public audiences with whom I saw the film on two of those occasions. Rather, Hamlet's death, as played by this woman of forty, is as moving as I have ever seen it performed by "e'er a scurvy young boy of them all".

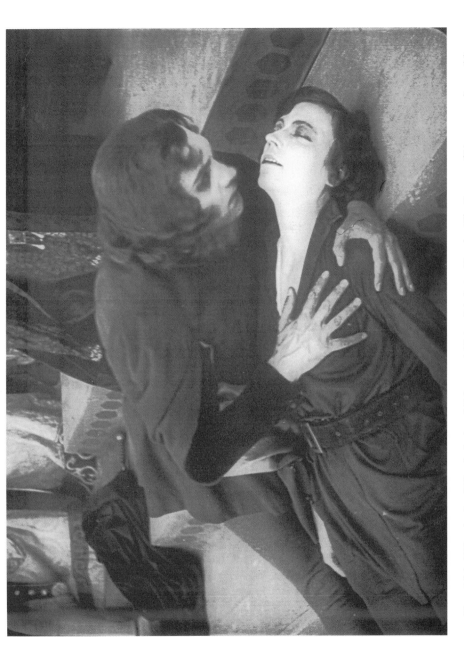

Plate 14.1 "The death of Hamlet": Asta Nielsen and Heinz Stieda in *Hamlet: The Drama of Vengeance*, directed by Svend Gade and Heinz Schall, 1920

REFERENCES

Allen, Robert C. (1973) "Asta Nielsen, The Silent Muse", *Sight and Sound* 42,4: 205–9.

Ball, Robert Hamilton (1968) *Shakespeare on Silent Film*, London: George, Allen & Unwin.

Card, James (1979) "The Screen's First Tragedienne: Asta Nielsen", in Marshall Deutelbaum (ed.), *"Image" on the Art and Evolution of the Film*, Rochester, NY: Dover/International Museum of Photography: 57–8.

Danson, Lawrence (1992) "Gazing at Hamlet, or the Danish Cabaret", *Shakespeare Survey 45*: 37–51.

Duffy, Robert A. (1976) "Gade, Olivier, Richardson: Visual Strategy in *Hamlet* Adaptation", *Literature Film Quarterly* IV, 2: 141–52.

Kerrigan, William (1994) *Hamlet's Perfection*, Baltimore and London: Johns Hopkins University Press.

Luft, Herbert G. (1956) "Asta Nielsen", *Films in Review* VII,1: 19–26.

McKernan, Luke and Olwen Terris (1994) *Walking Shadows: Shakespeare in the National Film and Television Archive*, London: British Film Institute.

Mulvey, Laura (1975) "Visual Pleasure and the Narrative Cinema", *Screen* 16,3: 6–18. See also the revised version in Mulvey's *Visual and Other Pleasures* (1989) London: Routledge.

Uricchio, William and Roberta E. Pearson (1993) *Reframing Culture: The Case of the Vitagraph Quality Films*, Princeton, NJ: Princeton University Press.

Vining, Edward P. (1881) *The Mystery of Hamlet: An Attempt to Solve an Old Problem*, Philadelphia: Lippincott.

Wid's Daily (1921) Issue cited is Sunday, 13 November, vol.xviii, 43: 7.

15

THE FAMILY TREE MOTEL

Subliming Shakespeare in
My Own Private Idaho

Susan Wiseman

SHAKESPEARE IN IDAHO

Where is "Shakespeare" in *My Own Private Idaho?* Who, what or where is the
work undertaken by the bard or the shadows of the bard? This is the question
this essay poses. The director, Gus Van Sant, has asserted that "the reason Scott's
like he is is because of the Shakespeare, and the reason Shakespeare is in the film
is to transcend time, to show that these things have always happened, every-
where" (Fuller 1993: xlii). This seems more like a retrospective claim for the
transcendent qualities of Shakespeare than a consideration of the specific place
of the *Henry IV* plays in the film. What place do the Shakespearean sections
claim, and what implications do they have for the way the film organizes its
subjects and viewers? In finding Shakespeare in the film this essay aims to tease
out some of the implications of the film, concentrating on paternity and the
family tree, visual versus verbal signifiers and the uncanny/sublime as these are
deployed through the narrative.

It does not take much probing to find that *Idaho* is dealing with – or stylishly
commodifying – some of the Big Questions of contemporary culture; questions
around the family, paternity, place, home, maternity, sexuality, status and all the
elements of the masculine filmic *Bildungsroman*. Since the fatal overdose of one
of the film's two stars, the twenty-three year old River Phoenix, it is as if Phoenix
and the film have become reciprocally "about" one another. Phoenix's death, as
well as his acting style, his work on the script (Van Sant describes him working
"furiously" on the fireside scene) and the improvised style of the scenes where
the groups of boys discuss their lives seem to refer the film back to a social world
and to substantiate Van Sant's claim that those parts of the film "come directly
from a number of people that I've known", "I'm not being analytical" (Fuller
1993: xli).

But *Idaho* is also full of textual markers and pointers; "Shakespeare" is far
from the only cultural marker in the film. It is richly intertextual – not to say
overbearingly knowing – in its deployment of cultural references from popular
culture to quasi-Freudian symbolism (for example the "family metaphor" that

Van Sant speaks of in interview [Fuller 1993: xxxix]). "Narcolepsy", glossed for us in a pre-credit sequence, is the symptom which the film takes as the key to or metaphor for the irresolubility of violent trauma. It opens in the middle of America, in Idaho – the private, agoraphobic, landscape of the B52s song, but also the haunted place of mining ghost towns, migrant farmworkers, salmon rivers (Miller 1976). The visuals of empty farmhouses suggest the ghostly presences of Idaho's past and, in the present, the psychic importance of the farming crisis in the mid-80s (Duncan Webster reminds us of the 1986 Democratic Party slogan: "It wasn't just a farm. It was a family"; though in this case, it is more than a family – incestuous – but less than a farm; more of a migrant's trailer [Webster 1988: 28].) The film prompts nostalgia for other social forms and gestures towards the life of the cowboy – always loved, always leaving, always single – in references including the song "Cattle Call", a cowboy statue at a diner, and Mike's friend's disturbed parody of a quick draw. These remind us of other models of lonely, but still possible, masculinity.

In its focus on men in early adulthood, gangs, pairs or couples, even in its use of Portland Oregon and the gang leader called Bob, the film recycles Van Sant's obsessions from *Drugstore Cowboy* (1989). *Idaho*, however, uses a script generated from many sources rather than one novel and deploys layered visual and literary references. Van Sant has commented on the origins of Scott, "I didn't fully know who he was until I saw Orson Welles's *Chimes at Midnight*" (Fuller 1993: xxiii). But the central figures are also reminiscent of other American narratives. Mikey and Scott's journey is, as José Arroyo notes, reminiscent of road and buddy movies as well as *The Wizard of Oz* (Arroyo 1993). It even replays the drifting narrative of Twain's Huck and Jim, with Huck/Scott opting out of all those things Jim/Mikey can never have (Webster 1988: 118). And the film ends on (apparently) the same road with a replay of the story of the Good Samaritan. Indeed, *My Own Private Idaho* is a film that advertises its cultural claims. But the title also raises the question, what would it mean to live in one's own private Idaho, an internal, "private", terrain of loss and repetition, a past that can never be revistited but which, figured in spatial terms in the memory, can never be escaped either?

Amongst a plethoric and sometimes literary referentiality two elements occupy dominant and perhaps competing positions in the text: quasi-Freudian images of the past and a Shakesperean narrative of the transition to adult masculinity. As far as the Henry plays are concerned, the film seems to build on the words of Hal/Henry once he is king "I'll be your father and your brother too" (*2 Henry IV*, 5.2.57) to make an oedipal drama of fathers and brothers, past, present, and future. The ghostly presence of the Henry plays is also used to address the two adolescents' need for a path to adulthood. Even as the film carnivalizes or cannibalizes Shakespeare's texts, it uses them as a cultural anchor. In doing so, the film sets the "Shakespearean" text not only in but against the perilous journey Michael Waters (River Phoenix) makes towards resolving an impossible oedipal tangle. It would be overschematic to say that the film offers

two versions of oedipal narrative, Mike's story inviting reading as a version of the Freudian uncanny in terms of the family tree, and Scott's, using the *Henry IV* plays to chart Scott's rise to power. But these twin trajectories do allow us to begin to analyse the place of "Shakespeare" in the text, and how and why the film ties "Shakespeare" to a contemporary America in a way that announces both the seriousness of the text and its hipness.

The knowingness of the film, its setting among the street-boy hustlers of Portland, Oregon, and its evident desire to slum it with Freud and Shakespeare – even as it offers viewers the pleasures of having their cultural markers in place (and I shall come back to this at the end of the essay) – also interrogates sexuality and masculinity in late eighties America. Like Steve MacLean's first feature, *Postcards From America* (1994), *Idaho* analyses abuse and paternity in contemporary America. As MacLean has commented, "You look at the white male backlash in America at the moment, it is all about . . . fears of disenfranchisement" (Francke 1995: 7). Both *Postcards From America* and *My Own Private Idaho* are concerned with disenfranchisement and marginality, both use visual style to associate the disenfranchised with a version of the American landscape steeped in the associations of the American sublime. *Idaho* does this through analepses using different visual orders – home movies, landscape, time-lapse photography.

Although the Scott Favor narrative is the section of the film which rereads *Henry IV*, the film opens and closes on the story of Mike Waters; the rise of Favor and the fall of Waters are clearly parallel stories but it is arguably the Waters narrative which the audience follows. The story is, more or less, as follows: Mikey and Scott seem to be friends (Mike is in love with Scott) and each hang out, working as prostitutes and sharing the life of underclass adolescents in urban America. Scott is the son of the wheelchair-bound mayor of Portland, Oregon (no visible mother), whereas Mike is the product of no "ordinary family" – his "father" seems to have drowned himself and later he seems to actually be the son of his brother, Dick. Where Scott turns tricks for money only, Mike identifies as gay; where Scott's father searches for him and makes a contract with him for the son's reform and inheritance, Mike is attempting to untangle an impossible family tree by searching for his mother. The narrative follows first a trip back to Idaho (like a salmon returning upstream to the source of its life) to visit his brother–father, then a trip to the Family Tree Motel to search for his mother and then a trip to Italy in search of her, before ending on the return of Scott with an Italian wife to a new life in Portland. Here we have the rejection of Bob Pigeon/Falstaff in a restaurant peopled by the Portland City establishment and then the twin funerals – of Bob, conducted by street boys, and of Scott Favor's father, attended by Scott.

Such a film cannot really be considered as an adaptation of Shakespeare. It borrows from the bard, from Freudian and other narratives. Mike has a past, whereas Scott has a future and Mike's story is given a quasi-Freudian mediation, Scott's a Shakesperean. In the next sections I aim to elucidate and complicate

these alliances and to end by returning to my question – what work *is* Shakespeare doing in *Idaho*?

FROM HERE TO PATERNITY: MIKE'S UNCANNY REAL AND SCOTT'S ELECTIVE FATHERING

HANS: Where do you want to go?
MIKEY: I want to go home.

SCOTT: Where shall we go?
MIKEY: To visit my brother.

My Own Private Idaho opens with what turns out to be Mikey on a road, in Idaho. Voice and visuals are split: in a voice-over Mike tells us that he has been there before, on this road "like a fucked up face". As he finishes his thought the camera turns to the road, then to the sky and then switches to a fantasy/flashback from Mikey's point of view. These flashbacks are repeated throughout the film; characteristically they feature flimsy, uninhabited buildings – first the shed which, in this first sequence, is blown onto the road and smashed, then we see an abandoned gothic-style wooden bungalow, then the flimsy sixties bungalow which seems to have been Mikey's home in his childhood and next to which his brother–father Dick lives in a caravan. The habitations seem to become increasingly transient, migratory, as they move towards Mikey's homeless present.

Van Sant's *Drugstore Cowboy* featured visions of flying, cartwheeling, buildings, trees, animals, hats. In this later film the visions are at the core of the conundrum which they both pose and partially explain. During a flashback in Rome, the "home-movie" footage of Mikey's childhood with his mother and pubertal father–brother leads our eye to the door of the house where, in wrought metalwork, we find the H that stands for home. In his visions, Mikey goes "home" to his mother's house. What might in other circumstances be read as an emphasis on the homely qualities takes on richer connotations in association with other issues in the film. The link to sexuality and desire is made clear when, early in the film, Mike has a client who pays to suck him off. We see what Mikey sees behind closed eyes: an empty house or building is taken up as in a twister, and destroyed. In part this gestures towards *The Wizard of Oz*; it is after this that his quest begins. But in terms of thematics, Mikey is presented as attempting to escape from an impossible oedipal situation through a search for his mother and desire for his brother–lover, Scott, thwarted by Scott's desire for Carmilla.

These visuals, flashbacks, reveal a problematic past – in Freud's terms, the secret "known of old and long familiar" (Freud 1955a: 217–53). The Mikey section of the narrative takes us back to what should have been hidden; during the trip to Idaho the story of Mikey's paternity is replayed in his encounter with his brother–father. In these scenes "Dick" – the (comic?) name of Mikey's

brother – offers various versions of what might be interpreted as the primal scene. First, he shows Mikey a photo of "Me, you and mom": but this turns out to be mother–father–child, as well as a mother with two sons.

Inside the caravan where Dick lives surrounded by his paintings of individuals and families, Dick and Mike propose different versions of Mike's paternity. Dick claims that Mike's father was "a lowlife cowboy fuck", shot at the cinema by their mother during a performance of the Howard Hawkes western, *Rio Bravo*: "*Rio Bravo* on the big screen, John Wayne on his horse riding through the desert . . . " But Mikey interrupts: "I know who my real dad is . . . Richard, you are my dad. I know that." In refusing the elective/screen paternity of the "lowlife cowboy fuck" and by displaced association, John Wayne, Mikey is left with the literal incestuous situation, the uncanny doubling of father and brother.

Richard's elaborate story, in which an elective father is proposed by a real father, is interrupted by both Mikey's narcoleptic moments – figured for the audience as a combination of the sublime and memories of his childhood as if seen in a home movie – and by Mikey's refusals of the fantasy father in favour of the scandalous "truth". The clear narrative implication is that the narcoleptic visions, to which we also are given access, are the compensatory mechanism activated by ,the impossibility of any kind of successful negotiation of such a traumatic paternity.

Further signifiers suggest that the film itself may joke about the family drama, its secrecy and determining nature, in quasi-Freudian terms. When Mike and Scott leave Dick Waters (the father–brother) they are sent by their clue – a post-card – to The Family Tree Motel. Here Mikey is to begin his search to find his mother among the impossibly tangled and fused branches of his own family tree. But this is not all. As he and Scott arrive at the hotel, who should turn up but Hans. They met Hans earlier, after an evening with a female client, and he had offered Michael a lift in his car. This is Hans Klein, whose name coincidentally seems to translate as Little Hans – one of Freud's youngest patients, with whom he communicated through the parents, especially the father (Freud 1955b: 245). During the interview with the brother–father "Dick" and at other points – such as at the meeting with Hans at the Family Tree Motel and in Hans's interest in forms of transport and mothers – the film jokily, and apparently seriously, advertises its commitment to "the family metaphor" or Freudian narratives.

Reading the film in these terms involves a negotiation between two types of interpretation; one finds oneself at a mid-point between making a reading of the film which laboriously reads into it/makes explicit a subtextual narrative dynamic and a tracing of clues or jokes already highly thematized and framed as textual pointers. If the Shakespeare section is self-conscious in its use of *Henry IV* as a version of the family romance, then the Mike section might, too, be seen as deliberately narrating a version of the family story. The two stories *are* sharply distinguished and set apart in the viewer's experience, by their contrasting uses of visual codes and styles versus Shakespeareanized language.

What Mike's narrative teases out, visually, seems to be the impossibility of escape from the scandal of being fathered by his brother, a past for which he is not responsible but which leaves him without any place in a social world. His meaning is made in the past, in the conjunction of too many and contradictory meanings in the place of the "H", a home on which too many meanings home in. So what about that wrought metalwork "H" that we (and apparently also Mike) see during his visions? The sequence, as we focus on it, evidently names "home" – the house where he lived as a child, the place where he tells the German dealer in (car?) parts that he wants to go (Where do you want to go? I want to go home). In terms derived from Freudian discussion, though, we can also see Mike's visions, activated at moments of stress, as emerging from a genealogical crisis in terms of his exclusion from a place in American society, an exclusion which the café scene, a scene central to placing Mike's narrative in the context of his peers, indicates is part of a more pervasive disenfranchisement. In such terms, the "H" names the "homely" place from which Mike emerged. Freud discusses the fantasy of return to "the former . . . home of all human beings", the womb, reporting a joke in which "'Love is home-sickness'" and Van Sant, too, describes Mike as "trying to find the place where he was conceived" (Fuller 1993: xliii; Freud 1955a: 245). "H" names Mike's home, but also his history or genealogy. Accordingly, one narrative structure of the film takes us back into Mike's past, giving his impossible oedipus as a "source" for the things which prevent him from finding a full place in the social world.

In his visions, Mike and we, apparently from his point of view, see the home – bungalow or house – he lived in with his mother in his childhood. Mother's body and that signifier of mother's body, "home", are both present in the visions. These analepses also interrupt the forward movement of the narrative, providing a quite different aesthetic and visual texture, without words. These silent interludes appear when Mike's present experiences touch on events from the past, events which are too traumatic to be integrated into the social/cultural narrative of life, but yet determine identity.

Mike's paternity and his relationship with his mother, as in Freud's version of the uncanny, return to haunt him. The association, for Mike, between the female body, desire for the mother, or desired and feared return to an intimate maternity, is made clear in two incidents early in the film. He sees a woman who reminds him of his mother in the street; he collapses. He has a narcoleptic turn, too, when he is picked up by a female client. When Mike sees her he says, "This chick is living in a new car advert"; once at *her* home we and Mike are shown a luminous stained-glass panel of Virgin Mary and infant Jesus (the film offers us no chance to miss the point). When she tries to have sex with him, he sleeps. To be sure, later in the film Mike falls into a narcoleptic sleep when he is picked up in Italy; it is not solely the possibility of the return of the maternal that the film proposes as insurmountable. Nevertheless, these elements are present and enable – even, perhaps, invite – an audience to read Mike's predicament in terms of the specific "family metaphor" of the Freudian uncanny.

230

The experiences of repression and lapse are elaborated in Freud's writing on the traumatic moment when something "secretly familiar" emerges (Freud 1955a: 245). Freud plays, as the film itself appears to, on the way the German word *heimlich/unheimlich* tends to collapse into itself in such a way as the domestic, secure, familiar is also simultaneously dangerous and strange. Freud associates this feeling with the adult response to the childhood wish to return to "intra-uterine existence" and to questions of the resolution of Oedipus (Freud: 1955a: 244). The homely/unhomely implications of the mother's body, for Mikey are redoubled, as it were, because of the tortuous and traumatic relations between his mother, himself, and his brother–father. This cultural confounding and excessive doubling of roles is figured in the text at the level of plot as a narcoleptic reaction to impossible stress and trauma.

This is signalled visually: the spectator sees a vision of landscape, the sublime hallucination of the barn in the wind. The "narcoleptic" gaps in the narrative are inhabited by visions which could be characterized as an aestheticization of crisis as the sublime. Such interruptions of the present by the partially repressed forces of the past are discussed by Mladen Dolar in terms of a refusal to relinquish the past (Dolar 1991: 59). Dolar's reformulation of Freud offers a way to read Mike's quest for his mother in terms of just such a feared and desired return to the past. The quest is doomed but is also apparently Mike's motivating purpose. The present – adulthood, desire and ironically economic exchange – is interrupted either by narcoleptic moments figured as sublime or by the heterosexual union of Scott and Carmilla at the time and place when Mike hopes to find his mother.

Idaho offers a case study in this aspect of the Freudian family romance, twice: in Scott's rigid "success" and Mike's apparent failure. The constant interruption of Mike's present by the past is contrasted with the other oedipal drama; Scott's election of an "unknown, greater" father in Bob. Whereas Mike is unable to escape the paralyzing knowledge that his father is his brother, when Scott's father dies he inherits massive social and economic power, some of which is in any case destined for him on his twenty-first birthday. After the boys leave the Family Tree Motel the separation of the destinies of the two boys becomes increasingly clear; the motel, with its contradictory name, only temporarily houses both boys and the contrasting narratives which they inhabit.

FROM THE *UNHEIMLICH* TO HENRY

The name, The Family Tree Motel, suggests the permanent inescapability of the family tree – however scandalous. But a "motel" is a quintessentially postmodern transient location. The name combines the film's contradictory interests in what Jean Baudrillard has called "the lyrical [American] nature of pure circulation. As against the melancholy of European analyses" (Baudrillard 1986: 27; Fuller 1993: xliv). Yet as Baudrillard's comparison suggests, the two chains of association – circulation/surface and analysis/ – imply each other, and so in a similar

way to the pairing of the Michael and Scott narratives. They are buddies, almost siblings, almost lovers, and Mike's narrative of the psyche contrasts with Scott's ability to turn situations to his advantage.

Where Mikey is made socially placeless by a traumatic paternity which cannot be overcome, Scott is bound in to paternity and inheritance but also free to select amongst possible fathers. Through drifting he acquires the necessary accessories of his future rule. We see Scott as initially having a complicated relationship with his biological father, the mayor ("My dad doesn't know I'm just a kid. Thinks I'm a threat") and the narrative implies that it is the unsatisfactory nature of this paternity which has propelled him into street life and rebellion.

The pairing of the narratives uses specific aspects of the Henry plays. In Mike and Scott's distinct careers *Idaho* also reworks those of Hal and Hotspur. When the film opens, Scott Favor is indeed the opposite of the Percy described in *Henry IV* as "the theme of honour's tongue" (*1 Henry IV* 1.1.80) – but he, like Hal, is "Fortune's minion" (*1 Henry IV* 1.1.83). Scott's narrative of succession is set out in terms of the Hal/Falstaff/Henry relationships of the Henry plays and like Prince Hal, Scott is a cold pragmatist. He is on the street but not of it, because from the start, he is going to inherit. And, as in the Henry plays, the question of merit and money is foregrounded in Scott's unearned inheritance of his father's status. We know he is going to inherit and that he plans to transform his life; for the audience, the question is how and when this will happen.

It is through Scott's transition to adulthood that Shakespeare's history plays resonate in *Idaho* as the film reworks the play's thematization of father–son and peer relations. In Portland City we see him choosing street baron Bob Pigeon as his "real father". This is no uncomplicated paternal electivity; Scott tells Mike, that Bob "was fucking in love with me". But soon after, in a monologue to camera that explicitly parallels Hal's "I know you all" first soliloquy in *1 Henry IV*, Scott vows to reform in a way which implies his eventual rejection of Bob:

PRINCE HAL: I know you all, and will awhile uphold
The unyoked humour of your idleness.
. . .
So when this loose behaviour I throw off,
And pay the debt I never promised,
By how much better than my word I am,
By so much shall I falsify men's hopes.
(*1 Henry IV* 1.2.194–212)

Or, in the *Idaho*/Reeves version: "All my bad behaviour I will throw away to pay a debt". Scott's comedic election of fathers, both dead by the end of the film, contrasts with the incestuous nightmare inflicted on and implicitly determining Mike. Not only does Scott get to choose fathers, but – perhaps the ultimate triumph in oedipal struggle – when he rejects them they die.

Both Scott's fathers flawed – the mayor has money and power but no body (he is in a wheelchair) and Bob is all body, like Falstaff, but has nothing else. In

questioning paternal potential *Idaho* reworks the paternal drama of Hal/ Henry/ Falstaff. The arrival of Bob in Portland, Oregon (where Scott's father is mayor, and therefore, ostensibly "greater") is accompanied by Scott's election of Bob as his "real" father. However, we hear Bob describing himself as Scott's dependant: he needs Scott for a "ticket out" of street life. Bob's status as a father is predicated on a reversal of oedipal relations with "father" as suitor to son: Scott's possession of all the powerful cards in the relationship makes him partly self-fathering or self-produced. For him, fathers are a matter of temporary choice, a feature which emphasizes his potential to switch from rent boy to king, but also contrasts with Mike's paternal narrative.

Idaho presents a disintegration of economic structures into psychic and social chaos, and this differently marks the paternal and filial bodies and psyches it presents. Bob's boys, his "family" of street boys, act as an index of impossible identities being forged beyond the social margins – in economic as much as sexual terms. And the boys' clients, generationally the same as Scott's fathers and, like him, notionally part of a functioning society, are figured as parasitic upon the position of these outcasts. This is explored in the café scene in Portland where the boys tell their stories, and in the interludes in which Mikey services clients. The street offers the boys no social potential beyond prostitution; their carnival world is delimited by money and clients. Through these scenes, the film's dominant interest in the canny/uncanny sexualized buddy (and sibling) narratives of Mike and Scott, is connected to a more general questioning of the economics of masculinity in contemporary America.

A superficially similar range of issues is articulated in the *Henry IV* plays in terms of the relations of usurpers to feudal lords, states to servants, fathers to sons. Both parts of *Henry IV* are set against a background of rebellion and social unrest; in *2 Henry IV*, Act 4 the Earl of Westmoreland describes rebellion's proper (true) appearence as "boys and beggary", and the film suggests this, as do specific scenes (*2 Henry IV* 3.2; the Gads Hill episode; the rejection of Falstaff). The Shakespearean section of the film is (tenuously) connected to social critique because Bob represents the leader of the boys, and it is with Bob that the Shakespeare-derived style and dialogue arrive.

Bob first appears staggering and swaying out from beneath a network of flyovers when the boys have reached Portland, Oregon. The reworking of *2 Henry IV* 3.2 also echoes the opening (and indeed the title) of Welles's *Chimes at Midnight*. His comment, "Jesus, the days we have seen", simultaneously signals Welles, Shakespeare and the hard life of the streets. Bob's arrival inserts a Shakespearean linguistic presence into the colony of boys as the figures he speaks with are drawn into pastiche "Shakespeare". The new rhetoric "Shakespeareanizes" the hotel, making Bob's scenes there significant because of their attatchment to Shakespeare, perhaps, but without "Shakespeare" ever being the language in which the boys discuss their own situation. The hotel scenes use Falstaff's relations to his boon companions to code them, in part, as a social space beyond the bounds and rule of law; but in its organization at this point the story is not of the rent boys, but

scenes from Shakespeare as reworked and improvised. In a sense, one doesn't need to "know Shakespeare" to read them as intertextual. Indeed, during the editing, Van Sant cut some Shakespeare sections because, he claimed they were "becoming like a movie within a movie" (Fuller 1993: xxxviii).

Bob (landless knight) may be King of the Street, but the street is dangerous; it involves the boys making themselves vulnerable in cars, rooms, houses, and offers no status or income. The film interrogates the difficulty of crossing the threshold from adolescence into adulthood, gay or straight, in a moment when models of mature masculinity have vanished with cowboys and the only route to power, even safety, is through inheritance. In figuring the failure of masculinity in terms of the underworld of the *Henry IV* plays the film is far from "imperial Shakespeare" (Wilson 1992: 34–37). To this extent the film could be said to be using Shakespeare to make a political point, or to ask, where is the place of the young male in America, now? But the boys themselves get few Shakespearean lines, and the Shakespearean dialogue tends to have a life of its own – as "Shakespeare".

Where the sublime impossibility of Mikey's situation is rendered visually, the *Henry IV* plays enter the film as stylized rather than improvised talking, dialogue, drama and as "Shakespeare": they do seem to introduce "a movie within a movie", or to produce two cohabiting styles one dominated by visuals, the other by voice (Chedgzoy 1995). Jack Jorgens wrote of early Shakespeare silents "struggling to render great poetic drama in dumb show", but *Idaho* replaces visuals with talk: the scenes slow down and give themselves over to words (Jorgens 1977: 1). Shakespeare marks the text as a demand that the audience transfer attention to the spoken, Shakespearean, word. The film's contrasting of visual and verbal signifiers and sequences organizes, too, the differentiation of the narratives of the doomed Michael Waters and the rising Scott Favor; Michael's past is signalled in visions, Scott's control of the situation is shown in his Prince Hal-like control of dialogue and its placement in relation to Shakespeare. Unlike Mikey, who can barely speak, Scott talks to the camera on several occasions, in a *gestus* when the boys are covers for porn mags, and in the soliloquy when he explains that he will give up this course of life. He talks: to other characters, to us, to Carmilla in Italy. Indeed, the volte-face predicted in his address to the camera has an important linguistic aspect to it. He returns to Portland leaving Mikey in Italy, a country whose language he cannot understand but which is figured as potentially maternal (he has gone in search of his mother) (Chedgzoy 1995).

To summarize: we can see the film as inviting empathy and producing Mike as the central emotional focus of the film; as José Arroyo points out, "the homosexuality that *Idaho* values the most is Mike's". Mike is the audience's empathetic focus (the fact that his narrative opens and closes the film, style of acting, the fact that we get "inside his head" rather than Scott's monologues to camera all contribute to this); the Scott–Carmilla heterosexual coupling of Carmilla and Scott replaces Mike's quest for maternity; and Scott plays a self-interested pragmatist against Michael's romantic hero. Indeed, such a reading is suggested

by the popularity of the film, and as Arroyo notes, posters from the film, in gay circles (Arroyo 1993). However, the place of Shakespeare in all this is complicated, even troubling, in its connection primarily to the Scott story. The question of which of the twin narratives should dominate was, it seems, hotly debated during the production of the film. Van Sant has claimed that New Line, the independent American distributors were "totally against the Shakespearean scenes" but the foreign distributors "wanted as much Shakespeare in there as we could get" (Fuller 1993: xxxviii).

As Van Sant's comments indicate, the film has a metarelationship to Shakespeare. Even as it thematizes the struggles between fathers and sons, and to an extent offers a social critique of these issues, *Idaho* could be figured as in an oedipal relationship to the material out of which it produces itself, particularly "Shakespeare", and to be articulating its relation to "Shakespeare" in a way which invites closer analysis. How does the putting of the play through "Shakespeare", or the self-fathering of the narrative upon "Shakespeare" work in the text which narrates the failed and successful adventures in self-paternity and/or family romancing of the two boys? The film both fathers itself upon Shakespeare's text and uses the text as a moment to intervene in the questions of fatherhood, and of begetting and growing up a modern (or postmodern) man.

Marjorie Garber traces the uncanny return of Shakespeare in the way "his" ghosts haunt "our" present; she analyses Shakespeare's uncanny returns, suggesting that "he" is used in various cultural actings out of the family romance. As she puts it: "For some . . . 'Shakespeare' represents . . . a monument to be toppled . . . A related phenomenon follows the pattern of Freud's family romance, which involves the desire to subvert the father, or to replace a known parent with an unknown, greater one" (Garber 1987: 7). At first sight, it seems that this is how "Shakespeare" is working here; that, just as Derek Jarman's reworking of *Edward II* radicalizes the play's potential for a late twentieth-century audience, so putting *Idaho* through Shakespeare "radicalizes" Shakespeare, giving Shakespeare's texts new meanings in a modern world. We could see "Shakespeare" as claimed for a set of non-dominant values, wrested back from the theatre audiences and returned; the conservative Shakespeare toppled, the film sets about putting a new "radical" version into place. However, as Richard Burt has argued, the only intermittent adaptation of Shakespeare's play is itself part of the film's "critique of the repressiveness of oedipalization" (Burt 1994: 338). It refuses to be fathered, exactly, but borrows and reworks.

Moreover, a reading of *Idaho* as turning Shakespeare towards a critique of sexual and economic disenfranchisement becomes more problematic when we consider the precise placing of the dialogue pastiche from the Henry plays, rather than a more general effect. Bob Pigeon speaks in "Shakespeare", and those involved in prolonged conversation with him are drawn into it. Mike, though, is not drawn into it. Nor is Bob present when the boys are telling their stories; the desperate side of the underworld is either untouched by Shakespearean language or, when it is, this results in an annexation of the Portland hotel to

Shakespeare's scenes, not vice versa. The entry of "Shakespeare" into the text produces, or emphasizes, the visual/verbal split and initiates the "movie within a movie" effect derived as much from the way "Shakespeare" as a cultural anchor takes over the text as by the text's carnivalizing or radicalizing of Shakespeare.

Indeed, Mike's story is the one which might be seen as more strongly expressing social critique, and his story – although it is the centre of our attention and empathy – is isolated from Shakespeareanized language. Rivers is given few Shakespearean lines and, in the scenes where he plays against Scott and Bob not only do they have most of the dialogue, but though they are together visually and acting ensemble, it is as if there is a line down the script dividing the types of speech offered to each. Indeed, in these scenes, Mikey is virtually an audience to the exchanges of Bob and Scott.

Moreover, on a larger scale, the pairing of the two narratives of Scott and Michael tends to undermine the sense that the Henry plays are radicalized by the things they are linked to. Even though most of the parts used by *Idaho* are comic scenes suggesting the subversion of dull order, the acting out of a joyous sub-versiveness does not seem to be how Shakespeare is being used in *Idaho*. Where Welles – who played Falstaff – commented "Comedy can't really dominate a film made to tell this story, which is all in dark colours" there is little sense in *Idaho* that we are invited to laugh at the comic scenes, even at Bob's deception over the robbery, though these are the scenes incorporated into the film from the plays (Pearson and Uricchio 1990: 250; Cobos and Rubio 1966: 60). Rather than failing to be comedy (a criticism levelled at the Welles film) even the comic moments of *1 Henry IV* and *2 Henry IV* are incorporated in *Idaho* in order to generate seriousness and to tie the film to the "classic" narrative of Shakespeare; the comic scenes are there to be recognizably Shakespeare; Shakespearicity, not comedy, is their function.

The Henry plays do not only outline the shape of a society in crisis, they also delineate the transfer of power and control to Henry V, perhaps augmented and deepened by his knowledge of street life. It is this contrast that *Idaho* seizes upon to open up the question of what it means to be a man in contemporary America, fusing the mythic pasts of *Henry IV* and the cowboy community to raise the question of the possibility not only of any fulfilling resolution of Oedipus but of finding any kind of place – to live, let alone work. It retells the *Bildungsroman* of masculine achievement both ways: once in Scott's transition to power, and again in the failed paternity of Bob and the rigorous exclusion of not only Bob but Mike from Scott/Hal's transformation in the final scenes. (This worked rather differently in the script for the film, where it was explicitly stated that in the final scene, "Scott is driving the car" [Fuller 1993: 187].) And when we look at the work done by Shakespeare in the light of the pairing of the two narratives, a rather different pattern is suggested.

Scott gets to choose Bob Pigeon as his father in a paternal/sexual relationship. And then he is allowed to dispose of him – along with his own father – at the end of the film. Of course, the use of the dialogue from and referring to

Shakespeare's *Henry IV* plays underlines Scott's coldness, his pragmatic prince-hood, and the Machiavellian utilization of experience of the underworld/underclass in making a successful entry into a "political career". Nevertheless, his trajectory is contrasted by the film with Mike's in terms which imply that, in attaining the world of money, politics, restaurants Scott is making some kind of, superficially, "successful" transition to adulthood. The mediation of his "coming of age" through the chosen key moments in the Henry narratives – the scenes in the hotel, the robbery, the rejection – underline the unearned, inherited, and therefore arbitrary, nature of his rise from street boy to public power. However, the use of the Henry plays at these moments also serves to mark them out as tracing a rising and socially sanctioned trajectory.

The contrasting narrations of the stories of Mike and Scott is further emphasized by the way in which Mike's being locked into adolescence is figured by a verbal non- or pre-linguistic realm. His narcoleptic visions are not accompanied by dialogue, in that sense they are virtually "silent". Moreover, the trauma marks Mike's speech which, though meaningful (in both senses), is tangential, fragmentary. We find out about his story – the past – through visual materials; Scott's narrative, tied to the future, is worked out through dialogue-heavy scenes and through a formal, set-piece, rejection or murder of Bob Pigeon. This contrasting of chains of association can, at a cost, be put schematically:

visual / silent / homosexual / adolescent (storyline: family romance with echoes of Freud)

versus

verbal / dialogue / heterosexual(?) / adult (storyline: family romance from Shakespeare).

Such an organization of significances troubles an understanding – which the film simultaneously seems to invite – of the film's emphasis on the centrality of the figure of Mike. It invites empathy for Mike, whose story takes up much of the film. Moreover, though vulnerable, he is still alive at least and taking his chances at the end of the film. More particularly, though, such associative links, combined with the splitting-off of the Shakespeareanized sections of the film, suggest that, although the film does address the issue of sexual identity and disenfranchisement in post-rural and post-industrial America, and does produce an ending for Mike which, in its reworking of the story of the Good Samaritan leaves the future of that narrative open to some extent, it does not use the Shakespeare sections of dialogue and performance to do so.

In the light of these layered connections, the place occupied by "Shakespeare" in *Idaho* can be reassessed. On the one hand, and this is registered in the initial response of critics, the film seems to be bringing out a subtextual or latent amusing perversity in the plays. In terms of its general use of the *Henry IV* plays the film can be said to be reworking relationships in terms of a greater indeterminacy. Certainly, *Idaho* points up the potentially

sexual charge of boy gangs and makes explicit the homoerotic potential to be found throughout the Henriad. And it appears to be using the most carniva-lesque, anti-authoritarian, potentially *politically* subversive moments of the Shakespeare texts.

But this questioning use of Shakespeare at a general level in the film is not precisely underpinned or reproduced in its detail. Our understanding of *Idaho*'s use of Shakespeare changes when we concentrate on the twin details of the actual use of Shakespearean language and the twinning of the narratives. For all that elsewhere in the text the film seems to be bringing to the surface subtextual sexual implications from the Henry plays – "boys and beggary" – the specific work of Shakespeare is to mark out the narrative of Hal's rise and to give it the cultural weight of "Shakespeare". Combined with the associations traced above, for all the questioning attitudes suggested by the rest of the film, this puts "Shakespeare" in an anchoring position; tying interpretation of the film back to cultural (intertextual) knowledge, it conserves and separates the storyline of Scott's transition from prince to King. The other Shakespearean figure, Bob/Falstaff, dies, thereby removing any "alternative" Shakespearean route. By way of micro-conclusion, the film may indeed present a critique of modern life and of the disenfranchisement of sexual identity, and one in which the future is left open. But it is not Shakespeare's language that it uses to do so; Shakespeare in *Idaho* stands by the heterosexual potential of the Henry plays and is kept separate from and contrasted with Mike's oedipal narrative.

CODA

My argument so far has been about the place of Shakespeare in a particular filmic text, not about the use of Shakespeare in film in any general sense. In 1910, Shakespeare on film was described: "it elevates and improves the literary taste and appreciation of the great mass of the people" (*Moving Picture World*, February 1910, p. 257, quoted in Pearson and Uricchio [1990]). Shakespeare began his film career by making film respectable. Was Shakespeare rendered quintessentially American by film, or was America's link with Englishness reaffirmed and enriched by contact with Shakespeare? How was Shakespeare to be appropriated as cultural capital?

Obviously, the answer would depend on film and audience, but it is a question that recurs in a range of films that are not adaptations of Shakespeare but that use Shakespeare as a cultural marker. I have argued for a specific use of Shakespeare in *Idaho* but another context for this film is an emerging arthouse/mainstream narrative cinema about male homosexuality. These films – from *Philadelphia* to more avant-garde expositions such as *Postcards From America* – are working with a problematic cultural capital and weaving tropes, songs, images into a set of patterns which do have generic relationships. Moments and tropes include the sublime American landscape, country music, fashion – all the elements that the first round of critics identified as "stylish" in

Idaho; this emergent style and use of cultural capital is a wider context for the claiming and deployment of Shakespeare as cultural capital in *Idaho*.

REFERENCES

Arroyo, José (1993) "Death, Desire and Identity: The Political Unconscious of 'New Queer Cinema'", in Joseph Bristow and Angelica R. Wilson, *Activating Theory: Lesbian, Gay, Bisexual Politics*, London: Lawrence & Wishart.

Baudrillard, Jean (1986) trans. Chris Turner *America*, London: Verso.

Burt, Richard (1994) "Baroque Down: The Trauma of Censorship in Psychoanalysis and Queer Film Re-Visions of Shakespeare and Marlowe," in *Shakespeare in the New Europe*, ed. Michael Hattaway, Boika Sokolova and Derek Roper, Sheffield: Sheffield Academic Press: 328–50

Chedgzoy, Kate (1995) *Shakespeare's Queer Children*, Manchester: Manchester University Press.

Cobos, Juan and Rubio, Miguel (1966) "Welles and Falstaff," *Sight and Sound* 35 (Autumn): 159–60. Quoted in Jack J. Jorgens, 109.

Dolar, Mladen (1991) "'I Shall Be With You on Your Wedding Night'; Lacan and the Uncanny", *October* 58: 5–23.

Francke, Lizzie (1995) "Postcards from the Edgy", *Guardian*, London, 6 April.

Freud, Sigmund (1955a) "The Uncanny", *The Standard Edition of the Complete Psychological Works*, ed. James Strachey, London: Hogarth, vol. XVII: 217–53.

—— (1955b) "Analysis of a Phobia in a Five Year Old Boy", *Standard Edition*, vol X: 3–149.

Fuller, Graham (1993) "Gus Van Sant: Swimming against the Current, an interview by Graham Fuller", in *Even Cowgirls Get the Blues and My Own Private Idaho*, London: Faber.

Garber, Marjorie (1987) *Shakespeare's Ghost Writers*, London: Methuen.

Jorgens, Jack J. (1977) *Shakespeare on Film*, Bloomington & London: Indiana University Press

Miller, Donald C. (1976) *Ghost Towns of Idaho*, Colorado: Pruett.

Pearson, Roberta E. and Uricchio, William. (1990) "How Many Times Shall Caesar Bleed in Sport: Shakespeare and the Cultural Debate about Moving Pictures", *Screen* 31:3 (Summer).

Webster, Duncan (1988) *Looka Yonder: The Imaginary America of Populist Culture*, London: Routledge.

Wells, Stanley and Taylor, Gary (eds) (1988) *The Oxford Shakespeare*, Oxford: Clarendon Press.

Wilson, Robert F. (1992) "Recontextualizing Shakespeare on Film", *Shakespeare Bulletin*, vol. 10, no. 3 (Summer): 34–7.

THE LOVE THAT DARE NOT SPEAK SHAKESPEARE'S NAME

New Shakesqueer cinema

Richard Burt

LOOKING FOR WILLIAM
(IN ALL THE QUEER PLACES)

In 1977, Neil Simon's film *The Goodbye Girl* staged a parodic New York theatrical production of *Richard III* with Richard Dreyfuss playing a straight actor being directed to play Richard III as a gay character. The director explains his interpretation to the assembled cast as follows:

> Richard III was a flaming homosexual. So was Shakespeare for that matter. But the angry mob at the Globe theater wasn't going to plunk down two shillings to see a bunch of pansies jumping about on the stage. It was society that crippled Richard, not childbirth. I mean read your text. He sent those two cute little boys up to the tower and we never saw them again. Oh, we know why, don't we? See, what I want to do here is to strip Richard bare, metaphorically. Let's get rid of the hump. Let's get rid of the twisted extremities and show him the way he would be today: the queen who wanted to be king.

In 1995, Ian McKellen, an openly gay actor who has fought Britain's homophobic Clause 28, played Richard straight in Richard Loncraine's film of *Richard III*.

I open with this juxtaposition to foreground what I take to be the non-identity of gay politics, a non-identity I take to be insurmountable and which complicates any Whiggish narrative of progress about gay representations in popular film. Some critics might wish to see a progression from the jokey *The Goodbye Girl* to the serious Loncraine *Richard III*, the end point of which would be a unified, non-contradictory, gay-saturated *Richard III*: a gay actor playing a gay Richard, filmed by a gay director, produced by the gay head of a major film studio, all of whom would uncloset a gay Shakespeare. It seems to me that such a narrative forecloses the queering of Shakespeare rather than proliferates a queer utopia

(where everyone, even the audiences would turn out to be gay, and where a gay Shakespeare would no longer be a joke but a source of joy). This foreclosure of what might be called a queer Shakespeare film occurs precisely in a literal-minded attention to gay content and an attendant policing of particular films in terms of their positive or phobic representation of gay sexuality; moreover, it often issues in contrasts between different means of film production and distribution: realist film, studio-financed, mall-distributed, easily available on video versus avant-garde film, independent, art-house-distributed, perhaps unavailable or barely available on video. To be sure, such contrasts are significant. Lindsay Kemp's gay affirmative adaptation of *A Midsummer Night's Dream* (dir. Celestino Coronado, 1984) in which Demetrius and Lysander and Helena and Hermia end up in gay and lesbian couples is available on video only though one distributor in England, and the lesbian-saturated *Playboy Twelfth Night* (1972) which gained a second life when aired on *Showtime* in 1991, circulates now only among an academic underground of Shakespeare scholars. Neither film is widely known, even to many professional Shakespeareans. Moreover, cinematic popularizations of Shakespeare can take a clearly homophobic turn. The film of *Rosencrantz and Guildenstern Are Dead* (dir. Tom Stoppard, 1991), for example, eliminates almost all of the gay references in Stoppard's play to the players (particularly to the character Alfred, who acts the part of the Player "Queen"), apparently in the belief that the censored version of the film would be more widely receivable.

What is interesting about the present moment of the late 1990s, however, is the convergence of a mainstreaming of Shakespeare into popular film and of a gayed Shakespeare produced by straight and gay directors and actors whose very cinematic range begins to put into question what it means to do a gay Shakespeare. In 1987, Aki Kaurismaki, often called the gay Fassbinder, released his noir *Hamlet Goes Business*, which he defined explicitly as an expression of an alternative, prole subculture, not as an art film (1991: 94–5). In his 1989 *Henry V*, Kenneth Branagh foregrounds the fact that the traitor Lord Scroop was Henry's "bedfellow," using a number of shots of Henry on top of Scroop and close-ups of Henry, on the verge of tears, his face nearly touching Scroop's, as he exposes what he clearly feels is a personal betrayal (Plate 16.1). In *Much Ado About Nothing*, Branagh plays up a gay sadomasochistic relationship between Don John (Keanu Reeves in black leather pants) and Conrade (who serves as Don John's masseur). Similarly, Branagh plays Iago in Oliver Parker's 1995 Snoop Doggy Dog-style *Othello* as a gay man who loves Othello but cannot admit it and so destroys him and his wife. (When speaking to Roderigo of Desdemona's "foul lust" for Cassio, he places his face immediately next to Roderigo's and then gropes his genitals ("lechery, by this hand?") while a heterosexual couple has vigorous intercourse on a cart above them; Emilia demands sex in return for the handkerchief and Iago turns her over on her stomach before having what appears to be anal sex with her; and after Othello kills himself, Iago crawls onto the bed and lies at Othello's feet.)[1] 1991 saw the premiere of Gus Van Sant's *My Own Private Idaho* and Peter Greenaway's *Prospero's Books*, in

Plate 16.1 Ken Doll Branagh laments another fall of man in *Henry V*

Plate 16.2 Starred-crossed buns at the Capulet drag ball in *William Shakespeare's Romeo and Juliet*

Plate 16.3 The Nurse and Juliet as lesbian lovers in *Tromeo & Juliet*
(Photo courtesy of Troma Entertainment)

which a gay dancer plays Caliban. The same year Oliver Stone opposed gay conspirators to the Shakespeare-citing prosecutor Jim Garrison in *JFK*. Sally Potter's *Orlando*, the film adaptation of Virginia Woolf's novel which in turn queers *As You Like It* by making Orlando a transsexual character, appeared in 1992.[2] As I noted earlier, Ian McKellen acted in *Richard III* (1995). In Trevor Nunn's 1996 *Twelfth Night*, Orsino's diminished interest in the revealed Viola suggested that he preferred her when she was a he; and the Baz Luhrmann 1996 *Romeo and Juliet* portrayed Mercutio as a bi-sexual, gun-toting, cross-dresser who "consorts" with Romeo (Plate 16.2).[3] (It is worth noting that Leonardo di Caprio, who played Romeo, is a gay icon and that the actor who played Tybalt, John Luguizamo, had appeared the year before as a character in drag in *To Wong Foo: Thanks for Everything Julie Newmar*, dir. Beeban Kuron.) Over the past decade, four pornographic versions of *Romeo and Juliet* have made the Nurse lesbian (see Burt, forthcoming) and 1996 saw the release of Troma Entertainment's *Tromeo and Juliet* (dir. Lloyd Kaufman) in which Juliet and the Nurse also have a lesbian relationship (made clear in a soft-core porn sequence) (Plate 16.3). A character declares "Murray was a fag" with amused astonishment upon witnessing Murray Martini, based on Mercutio, ask Tromeo for a kiss after being mortally wounded by Tybalt. Several hard-core pornographic adaptations of *Romeo and Juliet*, *Hamlet*, and *A Midsummer Night's Dream* released in the late eighties and later 1990s contain lesbian scenes. As of this writing, Peter Sellars is reportedly directing a film version of theatrical production of *The Merchant of Venice* in which Antonio is overtly gay.

Making sense of the present moment of a gay and popular Shakespeare requires, I believe, that we contextualize it within the present struggle over gay representation in general and gay cinematic representations in particular. In recent English and American legal controversies over gay rights, the issue is often less about actual gay sex than it is about the mainstreaming of representations of it. Homophobes tend to legislate against representations which view gays in a positive light. Within this historical context, debates over gay cinema tend to be framed by those who favor films which are assimilationist, sentimental, fairly widely distributed, non-sexual, and practically non-gay, such as *Philadelphia* (dir. Jonthan Demme 1994), *It's My Party* (dir. Randal Kleiser, 1995), and *The Birdcage* (dir. Mike Nichols, 1996), on the one hand, and those who favor the new queer cinema of sexually explicit, anti-assimilationist, narrowly distributed films such as *Swoon* (dir. Tom Kalin, 1993), *The Living End* (dir. Greg Araki, 1993), *Edward II* (dir. Derek Jarman, 1991), *Poison* (dir. Todd Haynes, 1992), *Heavenly Creatures* (dir. Peter Jacks 1994), *Totally F***ed Up* (dir. Greg Araki, 1996), on the other.

What happens to this opposition when Shakespeare, who until recently, at least in the US, might well have lost his high cultural status approval if his plays were construed as gay precisely because he would stand for decadent high "art," becomes a mainstream signifier of queer sex *and* of popular culture? How do the horizons of the elite, the contemporary, popular American reproductions of

Shakespeare, and gayness all intersect? My point in raising these questions is to emphasize that formally and thematically there are variously queered Shakespeares, not a single gay Shakespeare. The 1980s and 1990s Shakespeare films I listed above evince a marked heterogeneity: avant-garde and realist; art-house films and mall films; films with straight and gay actors playing gay or straight characters; films made by straight and gay directors. Shakespeare may be aligned with a variety of theatrical modes of reproducing his plays to signify gayness: with the popular, contemporary, innovative, and avant-garde or with a realist, costume drama; with theater or with film.

This heterogeneity of representations generates a host of even broader questions about the project of gaying Shakespeare. What is required to gay Shakespeare? Would only an explicitly gay adaptation in films by openly gay directors cast with gay actors do? Or do gay moments of straight productions, either consciously done or as symptoms of the film's queer unconscious, whether the director is queer, straight, or bi-sexual, count as well?[4] Can an exhaustive survey of gay Shakespeare films, a chronicle of the Shakespeare celluloid closet, be undertaken? Would that undertaking be worthwhile given that some gay directors like George Cukor, Gus Van Sant, Aki Kaurismaki, and Derek Jarman have directed Shakespeare films which either blur sexual identities or leave out overtly gay content altogether?[5] In *Hamlet Goes Business*, for example, Kaurismaki makes Hamlet much stronger than he is in Shakespeare's play (all of the soliloquies are cut) and focuses on a heterosexual romance between the chauffeur and the maid, who kill Hamlet and happily walk off with a bunch of cash at the film's close. But does this exclude this film from being gay Shakespeare? Or would one want to attend then to a homosexual gaze, a cinematic technique, gay or lesbian auteurship (of the director and/or star), and privilege them over gay content? If so, would there be an evaluative criterion for determining a good or bad use of them?[6] If so, what would it be?

A related, equally broad series of questions arise over how gay sex is represented in films of Shakespeare, over what counts as gay. Is a gay reading of a Shakespeare play as obvious as it is to the director in *The Goodbye Girl* ("I mean, read your text"), or is it something that has been forced on the play? Would it be better to violate transgressively a straight text or to honor and respect a canonical gay text? Is Lindsay Kemp to be lauded, to take one example, for making the Athenian couples at least temporarily gay in the Coronado film of his theatrical production, thus moving beyond Woody Allen's decision in *A Midsummer Night's Sex Comedy* to keep the play's compulsory heterosexuality consistently in place? Or is a gay Shakespeare redundant within American popular culture, merely a confirmation of a populist image of Shakespeare as something for prissy art fags?

What, if anything, is being disrupted or subverted through gay Shakespeare films? What kinds of deeds can gay sexuality also figure? (Similar to Branagh's *Henry V*, the BBC *Richard II* used gay sexuality to figure political corruption as a gay Bushy and Greene sat in a hot tub with Richard II discussing how they will carve up England.) Does the sexual identity of audiences or critics matter

significantly in terms of what they will consider to be a queer Shakespeare film or in terms of the pleasures or politics they are likely to find in a Shakespeare film they agree to call gay? Consider *Kiss Me, Kate* (dir. George Sidney, 1953), a musical in which a group of actors put on a production of *The Taming of the Shrew*. The leading characters, Fred Graham (Howard Keel) and Lilli Vanessi (Katherine Grayson) are divorced when the film begins and appear to reconcile at the end as a result of performing the play. Cole Porter, the lyricist and composer, was gay and Hollywood musicals in general were gay- or lesbian-produced or -inflected (Doty 1993: 11–13). This film contains a series of *double entendres* focusing on Vanessi/Kate's ass and Graham's inadequate penis size: offstage Graham tells Vanessi he knows that she left him because he wasn't "big enough for the role"; Petruchio and Kate struggle over sausages and Petruchio plays with a banana (Carmen Miranda had already established the banana as dildo equivalence in a lesbian number, "The Lady in the Tutti-Frutti Hat," of *The Gang's All Here*); Graham acknowledges that Vanessi prefers a Texan, who drives a large sedan with a set of Texas longhorns on its roof, because of his cattle meat; Graham's difficulties in the theatrical production with Vanessi (who walks out during a performance) activate a pun on Petruchio's line "I know she will not come" (though delivered when Petruchio waits for Kate after he has called her after wagering on her obedience, the line seems to express Graham's inability to get Vanessi off); and two gangsters advise Graham to kick his future girlfriends "in the Coriolanus" if they are disobedient (advice which seems beside the point given that Vanessi left during the performance because he spanked her on stage). These puns inscribe a closeted, gay critique both of the theatrical adaptation of *The Taming of the Shrew* in the film and of the male characters who play the Shakespeare parts (despite what might be thought to be a misogynistic characterization of the women – the Bianca character promiscuously loves her boyfriend "in her own way" and the Kate character, who sings a song entitled "I Hate Men," is frigid – the failure of the domestic relationships is laid squarely at the feet of the men). Precisely because this critique was written from the closet, it is more likely to be recognizable as gay to gays and lesbians, who might have knowledge about a film's genre and/or the film director's, actors', and actresses' sexual orientations, than it is to straight audiences. But this gay critique may nevertheless be readable to straight audiences. Would their knowing or not knowing that it is gay make a difference? Is the film's reception more or less queer if the straight audience receives the critique without knowing that it's gay? Would not knowing constitute a kind of homophobic disavowal and discrediting of gay readings? Or is the gay reading saved precisely by being connoted, thereby escaping the kind of homophobic policing that may be called up by more explicit declarations of gay sexuality?

Shakespeare's canon, derived from an all-male transvestite theater, raises one last set of questions. Are we speaking of a strictly gay Shakespeare? Are there any female homoerotic relations, as opposed to homosocial relations, in Shakespeare or did the fact that Shakespeare's theater was a transvestite theater close off those

relations? (See Traub 1992a; Traub 1992b.) If not, is a gay Shakespeare just a reconfirmation of a masculine Shakespeare, a gay version of the Arnold Schwarzenegger as Hamlet sequence in *The Last Action (Boy) Hero?*[7]

These broad questions arise out of what I have called the non-identity of gay sexuality within Shakespeare films, a non-identity I, like many others, take to make gayness irreducibly queer. By distinguishing between "gay" and "queer", I distinguish between a legible, secure identity and position, on the one hand, and a disorienting of such an identity and position, on the other. I am not interested in answering the questions raised above but in examining how gay non-identity generates queer effects. Of course, identities and positions are assigned to people practicing particular sexual acts and assumed by them. Moreover, specific values accrue to those identities and positions. For a knowing audience, a straight man playing a gay character may be significantly different from a gay man playing a straight character.

I insist on the term "queer" in distinction to "gay" not because of its greater inclusiveness but because of its greater representational fluidity. As Michel Foucault (1989/1996) and, more recently, Judith Butler [1993] have argued, it is precisely the performativity of any identity or position that allows its meaning to be contested and resignified. Leo Bersani (1994, 42–55) has objected that this notion of gayness as a queer performance despecifies homosexuality, de-gays gayness, by taking the sex out of being gay, and thus ironically does what homophobes hope to accomplish: eliminates gays. Yet gay sexuality is not something that simply can be outed, nor is being gay identical with having gay sex. As Michael Warner (1993: vii) writes, "Sexual desires themselves can imply other wants, ideals, and conditions." To be explicitly recognizable, gayness has to be represented, coded. Moreover, at stake in gay identity for theorists like Foucault is a critique of normalization: if the point of being queer is to become rather than to be gay, why take on an identity? Why assume a fixed position which is subject to pathologization by a normalizing culture rather than resist it? I would argue that representations of gay sexuality, no matter how explicit or literal-minded, will always be more or less queer.

What is crucial for an analysis of Shakespeare as gay signifier in film, then, is attention not only to the means of production and distribution but above all to the coding and recoding of gayness. This has a particular bearing on the popularization of gayness. Consider the difference between *The Goodbye Girl* and *Prospero's Books.* One knows that Richard is gay because he is "flaming": Eliot holds his wrist limp, has a slight lisp, adopts "feminine" postures, pinches a fellow actor on the butt, and wears platform shoes and a pink chiffon shirt (Plate 16.4). An audience of Greenaway's film, however, would not necessarily know that the actor playing Caliban was gay (Plate 16.5).[8] Perhaps his odd latex harness, which constricts and contorts his testicles, marks him for some as an s&m, taste-of-latex boy. It is precisely the way he is not legible as gay, however, that makes this leather boy love-slave of Prospero seem so queer. The 1983 comedy *Strange Brew* (dir. Dave Thomas and Rick Moranis), more a spin-off of the metadramatic spin-off

Plate 16.4 Richard III, "Queen" of England, in *The Goodbye Girl*

Rosencrantz and Guildenstern Are Dead than a spin-off of *Hamlet*, offers perhaps an even more bizarre example of Shakesqueer cinema. In a moment of what might be called "metacinematic" queerness, the leading characters, two brothers played by SCTV's Moranis and Thomas, stumble upon their parents having sex, who are also played by Moranis and Thomas.[9] Illegibility and queerness do not go together in any straightforward way, however. Consider Franco Zeffirelli's version of Cassio's dream (as narrated by Iago) in his film of Verdi's *Otello* (1986). Zeffirelli shows Cassio back-lit, naked in bed, masturbating (just off-screen) and mouthing the lines sung in a voice-over by Iago, which narrate Cassio's sexual fantasies about Desdemona (Plate 16.6). Is this a gay moment? Is the gaze of the camera getting off on the spectacle of a man masturbating? Or is this a hetero-sexual moment about a man fantasizing about a woman? Or is it necessarily both? If so, would that make it a queer moment?[10]

In making a distinction between gay as legible and queer as illegible, a distinction that in some significant respects is always already compromised, I do not want to suggest that popular films can be aligned with a normalization of gayness and avant-garde films with an anti-normalizing queerness.[11] I want rather to attend to a variety of popular films in which the very clarity of

Plate 16.5 Caliban as Prospero's taste-of-latex love slave in *Prospero's Books*

Shakespeare as a signifier of gayness produces queer effects. At the risk of seeming perverse, I will focus primarily not on Shakespeare films that are self-identified as gay nor on ones made by self-identified gay directors, but on films made by straight male directors about either heterosexual men or male adolescents: *Porky's 2* (dir. Bob Clark, 1986), *The Goodbye Girl* (dir. Neil Simon, 1977), and *Dead Poets Society* (dir. Peter Weir, 1986). All are realist films made for popular, mainstream audiences.[12]

My point in doing so is to show that the least visibly gay Shakespeare films can paradoxically be the queerest films.[13] One could of course legitimately look for gay representations in more obvious places and codes: avant-garde and art-house films (Jarman's *Tempest*); camp (Coronado's *A Midsummer Night's Dream*); the melancholy and the pathos of AIDS, hustling, and the closet (*My Own Private Idaho*; *The Dresser*). Yet this kind of project has the liability of keeping gayness in its predictable, proper place (and in the more paranoid account of D. A. Miller [1992: 18], of enabling the policing of gays). By contrast, the very legibility of gayness in the straight films I will discuss makes them unexpected sites of a proliferating queerness. The degaying of Shakespeare may paradoxically function as a solicitation to gay Shakespeare. As films about the "homosexual panic"

Plate 16.6 Getting off on Iago getting off on Cassio getting off on Desdemona
in Zeffirelli's *Otello*

(Sedgwick 1989) of straight men, these three films are a useful site for a critique of what Michael Warner (1993) calls "heteronormativity." All three films are about acting Shakespeare on stage and thus highlight what Butler (1990, 1993) calls the performative status of gender. Finally, as popular films, they reach a presumptively heterosexual audience. In this regard, a queer "eruption" in a straight film targeted to a straight audience may prove more dis*orient*ing, as it were, than a film marked as gay.[14]

In saying that these films are disorienting, I am not saying that they are subversive or transgressive. Indeed, the reverse is true. The films take up older readings of Shakespeare's comedies as heteronormative: one goes through homosexuality on the way to heterosexuality. To be sure, in *Porky's 2* and *Dead Poets Society* Shakespeare is partly a metaphor for a rebellious, passionate, nonconformity, and productions of his plays are supported by teachers and students opposed to political and religious corruption or to bureaucratic, patriarchal discipline. Though the films are not homophobic, they are nevertheless about heterosexuals becoming better heterosexuals; in short, they do enforce hetero- (and pedaro-)normativity. Though these films may not be subversive or transgressive, they may at the same time be quite interesting and provocative.

250

What may be interesting has nothing necessarily to do with a film's politics. Indeed, the film I take to be the most repressively heteronormative, namely, *Dead Poets Society*, is, in my view, by far the most disorienting. This is not to say that the films I am examining are equally interesting, however. Indeed, they may be placed on a spectrum of the more or less interesting. They do not display, then, some essential gay "eruption," but different ways of responding to the heteronormalization of gayness.

At the close of this essay, I consider the work that the concept of the popular does within academic criticism and turn to a popular video, the *Playboy* production of *Twelfth Night*, (dir. Ron Wertheim, 1972). The video rewrites Shakespeare to put lesbian sexuality on display, presumably for straight male viewers.

In focusing on the signification of gayness, I adopt a critique of gay identity politics formulated by Michel Foucault (1989/1996: 332–35, 382–90), Lee Edelman (1994), and Judith Butler (1990). According to Butler, gender is performed, cited and hence capable of being resignified in a subversive way. Thinking about gayness in terms of Shakespeare draws our attention to other problems, namely, how they may be allied to a political agenda and how to determine which kinds of representations will be politically effective. Moreover, making such determinations can be, in themselves, paradoxical, problematic. As Marjorie Garber (1992) has pointed out, gay coding is complex because the codes must be legible to gays and lesbians but opaque to straights.

For some queer theorists and activists, there is an even more significant problem about coding for gays as well as for straights: normalization. Queer critiques of normalization may themselves become normalized and normalizing. To avoid this problem, a breakdown in codes, or what might be called the "queer sublime," can be politically and aesthetically efficacious (Burt 1993). According to Butler (1994: 38), the subversive act is a certain kind of act to be distinguished from other kinds of routinized political acts. Subversion turns out to be an aesthetic category insofar as it is aligned with a breakdown in reading:

> You can't plan or calculate subversion. In fact, I would say that subversion is precisely an incalculable effect. That's what makes it subversive.... I think that subversive practices have to overwhelm the capacity to read, challenge conventions of reading, and demand new possibilities of reading.

Butler gives examples of Act Up die-ins. One couldn't read them, she says, know if people had Aids or not, were dead or not, sick or not. And to them Butler contrasts what she considers to be the more legible acts of Queer Nation:

> What I worry about are those acts that are more immediately legible. They are the ones that are most readily recuperable. But the ones that challenge our practices of reading, that make us uncertain how to read, or make us think that the way in which we read public signs, these seem really important to me. The Kiss-Ins Queer Nation did at malls were quite

outrageous. . . . They worked for awhile, but they always run the risk of becoming tropes. Once they've been read, once they're done too often, they become deadened tropes, as it were. They become predictable. And it's precisely when they get predictable, or you know how to read them in advance, or you now what's coming, that they just don't work anymore.

<div align="right">(1994: 38)</div>

Valued here is not clear recognition of codes but their breakdown. (It is significant that Butler's "you" appears to include gay as well as straight audiences.) In the discussion of films that follows, I want to examine the paradoxical queerness of heteronormativity: the process of gaying Shakespeare may be part and parcel of degaying Shakespeare and vice versa.

SMELLS LIKE QUEEN SPIRIT

I would like to begin my examination of the ways in which Shakespeare may queer heteronormativity with the simplest, least interesting of the films under consideration, *Porky's 2*. The film is set in the closeted 1950s, at a white-trash high school on a beachfront town of Florida. Students mount a production of scenes from Shakespeare, including *A Midsummer Night's Dream*, which foregrounds a particular American signifier of gay sexuality: "fairy" (Chauncey 1994).[15] Some of the boys initially resist playing Shakespeare because he appears to signify being gay. One boy is teased by the others about playing Oberon:

TIM: Hey Billy. What kind a role you playing? . . .
BILLY: Oberon. . . .
MEAT: What's he?
BILLY: He's sort of like a forest ranger.
MICKEY: A forest ranger? In Shakespeare?
BILLY: Yeah. He looks after the woods. . . .
TIM: Sounds like a fairy to me.
BILLY: He's not just a fairy. He's the king of the fairies.
TIM: Oh, you mean like a really big fairy.

The same teasing returns in a subsequent scene. One boy leafs through a copy of *A Midsummer Night's Dream* and asks:

MICKEY: What the fuck's a Puck?
BILLY: He's a character. He's a friend of Oberon's. He's like a little forest ranger.
MEAT: Un hum. Puck, a little forest ranger? Who plays that part?
BILLY: Pee Wee.
TIM: Oh, so Pee Wee plays a little fairy and you play a big fairy. That's a lot of fairies. You guys get to run around in the woods together?

And the Reverend Bubba Flava, who attempts to stop the production on grounds that it is obscene, cites from *A Midsummer Night's Dream* "Lovers to

<div align="center">252</div>

bed. 'Tis almost fairy time" and comments "God, it's enough to make a real man sick!" On a similar note, he cites the exchange between Petruchio and Katherine in *The Taming of the Shrew* ending with Petruchio's rejoinder "What, with my tongue in your tail?" and explodes: "What kind of a man would do a thing like that?" (Many male students happily raise their hands.)

Despite the teasing of the students and the homophobia of the Reverend and his flock, all the boys end up playing parts in the review, and, strikingly, the most phallic character, Anthony, nicknamed "Meat", cross-dresses as Thisbe. But *Porky's 2* plays it safe by contrasting Shakespeare as art to Shakespeare as obscenity. Amid the teasing of Billy, one student pauses to say "Hey, come on guys. Let's get serious. This is art here." Similarly, when the Christian fundamentalist preacher Reverend Bubba Flava and his flock try to stop the production, the teacher directing it insists: "This is Shakespeare. It is not filth."

To be sure, this opposition is compromised in a confrontation between the preacher, Reverend Flava, and the principal, Mr Clark, who shout out dirty parts of Shakespeare and dirty parts of the Bible. Clark wins, but by making a bawdy pun on "flock." Flava concludes: "Shakespeare must go. So saith the shepherd. So saith the flock. What saith you Mr Clark?" Clark answers: "Get the flock [fuck] out of here." And, of course, the film itself is marketed for male adolescents whose main pursuit, like the characters', is to get laid.

Yet in using Shakespeare to make a critique of censorship, political corruption, racism, and religious bigotry (and perhaps implying a tolerance of homosexuality), the film is actually far less carnivalesque, far less "politically incorrect," and far less queer than it might be. It is by far the tamest of the four *Porkys* films, with hardly any T and A. Some might lament it for not being properly carnivalesque. But the problem is not that it is insufficiently political; it is rather the way its desire to be liberal (some might say "politically correct") disciplines its carnivalesque energies. As Don Hedrick points out, the film's sentimentality may make it unappealing to its intended teen audience.[16] Moreover, the film's liberal-mindedness is premised on the absence of gays from the student body and general population. One student teases Billy, "So you're playing a big fairy? Yeah? Well, that's good casting." But the joke is harmless because Billy and everyone else is straight. "Hey Turner suck my wand!" Billy quips, in a witty version of that weird heterosexual way of asserting one's heterosexuality by inviting another man to engage in gay oral sex. Shakespeare may be a signifer of gayness precisely because his plays are art, not filth. What is particularly queer about the film is its attention to gay desire in the absence of gay characters. In this high school, homophobia is not only unnecessary, it is impossible since there is no one about whom anyone could be homophobic. By the same token, homophobia seems to be inescapable: precisely because gayness can't be localized, it can be anywhere.

TOTALLY F***ED UP SHAKESPEARE:
LOO*KING* FOR *BITCHARD*

A more complex example of the way a gay Shakespeare may disorient hetero-normativity lies in *The Goodbye Girl*, a film about a straight actor, Eliot Garfield (Richard Dreyfuss), who gets fucked, as it were, but who nevertheless comes out on top through a Shakespearean prosthesis. The film begins with Garfield's discovery that a friend who sublet Eliot his New York apartment failed to tell his just dumped girlfriend, Paula McFadden (Marsha Mason), and her daughter, Lucy (Quinn Cummings), to vacate it. This difficulty is resolved by an agreement between Eliot and Paula to share the apartment, but it is quickly followed by another humiliation: though Eliot has come from Chicago to make it big in New York, he learns to his great discomfort that he must play Richard III as gay (his reaction shots to the director's gay interpretation of Richard rather than the interpretation are what really generate the film's comedy).

In opening with a story that appears to be about Eliot getting fucked over, the film stages a solution to the breakdown of the nuclear family, namely, the heterosexual "sensitive guy." But the film also discloses a problem with its solution: insofar as the sensitive guy is defined against the "macho, macho man," he is vulnerable to being read or to reading himself as symbolically castrated (in this film, read feminized, read gay). If he has to play Richard III as gay, Eliot protests, he might as well be a transvestite and play a woman: "You want this kind of performance? Let me play Lady Anne." Similarly, after the performance, Garfield conflates gay and transgendered roles: "I was an Elizabethan fruit fly. I was the Betty Boop of Stratford on Avon." Moreover, Eliot voices his fear about how the public will respond by using slang that links him to gayness. He's afraid he is an asshole:

ELIOT: The critics are gonna crucify me and gay liberation is gonna hang me
 from Shakespeare's statue by my genitalia. . . .
MARK: Do you feel foolish?
ELIOT: I feel like an asshole. I passed foolish on Tuesday.

The reviewers in turn code Eliot's performance as gay and as transgendered:

ELIOT: *Times* review said: "Eliot Garfield researched *Richard III* and discovered
 him to be England's first badly dressed interior decorator." *Daily News* said
 that. Here, read it: "It never occurred to us that William Shakespeare wrote
 The Wizard of Oz. However, Eliot Garfield made a splendid Wicked Witch
 of the North."

After the failed performance, then, Eliot appears to be totally fucked, both as an actor (who will do what the director wants because he wants to make it big in New York) and as a lover (Lucy tells him that he is not sexy like Tony, the guy who dumped her mother).

Paradoxically, however, Eliot's transgendered, gay Shakespeare is the means of his romantic and theatrical success, not his failure. Like "Springtime for Hitler" in *The Producers*, what appears to be an absolute disaster turns out to be the opposite. Eliot wins the hearts of Lucy (who asks to go see the performance) and of her skeptical, hard-to-get mother; moreover, his performance makes his acting career. After the failed *Richard III* (it closes after the first night) he is asked to join an improv group, and a Hollywood director in the audience is struck by Garfield's daring and invites him to act in his film.

How does the film get to this happy ending? Richard III is crucial since this character provides Eliot with what he needs: a prosthesis to defend against what might be called his symbolic castration anxiety. The prosthesis emerges through an implicit pun on "hump", meaning hunchback and sex:

MARK: How do you see Richard? Mr. Macho? Is that it?

ELIOT: I don't see him as a linebacker for the Chicago Bears, but let's not throw away one of his prime motivations.

MARK: Oh? What's that? He wants to hump Lady Anne!

The hunchback returns not as the macho linebacker but as a hump. Although Eliot follows the director and plays Richard as gay, he fights to keep the hump and the twisted fingers and eventually he and the director reach a compromise:

MARK: Do you see where I'm headed?

ELIOT: I'm trying Mark.

MARK: Richard was gay. There's no doubt about it. But let's use it as subtext. We'll keep it but now we can put back the hunchback and the twisted fingers.

Eliot is ecstatic. Once he has his props, he can allay what he otherwise experiences as symbolic castration. The hump functions as the phallus. With Richard stripped bare to his metaphorical hump, Eliot can still hump women, even if he acts the part of a gay transvestite too. Eliot learns how to perform on stage and to perform in bed. Though the film is not overtly homophobic, it does suggest that Eliot frees himself up by unconsciously equating the stigma of being gay with the stigma of being a cripple.

Eliot has the phallus, and thus the film concludes with a reconstructed, "normal" nuclear family. Yet the process of normalization itself is anything but normal. Like Richard's fingers, the narrative is a bit twisted. What might seem like two separable plots – one about the actor's career, the other about a romance – instead prove to be linked through Shakespeare, kept as subtext, as it were, to the heterosexual romance. Though the film never doubts that Garfield is anything but heterosexual, at the heart of his heterosexual romance is a gay character and anality. Anality crops up in a number of places: not only when Eliot comments that he is an asshole, but when he walks out on a rehearsal (in a wonderful combination of gay lisp and Elizabethanese he says "Thisith maketh me a horseth ass") and in his remarks to Paula. When she rebuffs him the day

after they sleep together, Eliot exclaims to her: "You are one large pain in the arse. If you weren't such a horse's rectum . . . " Anality is marked most notice- ably in the moment Eliot and Paula hook up, the night of his performance. Eliot comes home so drunk he falls on the floor. Paula picks him up and with her arms around his stomach she pushes him forward to his room, and then onto his bed. After he asks her if she thinks he is upset about fourteen negative reviews and answers "You bet your ass I am!" they fall on the bed face down, and she falls on top of him (Plate 16.7). Feeling as if she were humping him, Garfield comments: "Sorry, this apartment is rated PG." This sexualized moment suggests that their romance is a really a story about two assholes falling in love: whereas initially she fucks him up, now she fucks him – up the ass.

The film's anality does not suggest that Eliot is gay, then, but it does raise a problem with the way his Shakespearean prosthesis can serve as a compromise- formation, namely, its mobility and transferability. The prothesis is metaphorical rather than literal, a phallus, yet it functions like a dildo. The phallus/penis equation that would link Eliot's gender to a symbolic mastery is disturbed by the phallus/hump equation. The scene with Eliot and Paula on top of him on the bed confirms their interest in each other but raises the question, "Who has the phallus?" The film's answer appears to be a promiscuous "pretty much

Plate 16.7 Eliot bottoms out in *The Goodbye Girl*

everyone": Paula's ex-lovers; Paula; the daughter; the director; the theater audiences. At one point or another, all have the symbolic mastery Eliot lacks.

Eliot's solution to the promiscuity of the phallus is theater. Theater, and to a significant degree, specifically gay theater, offers a compensatory mechanism for adjusting an inequality between Eliot and Paula. By making it as an actor, Eliot hopes he can be desirable to Paula in the way she is desirable to him. Through much of the film, Eliot is presented as a romantic loser. He has to assert that he is the wooer, the one who kisses first. He's at least third in line for Paula (he says he hates the "other guys" who have left her, inviting one to ask "how many?"). When he works temporarily as a barker for a strip show on 42nd Street, he is floored by a drunk he isn't able to bounce.

The film's conclusion, while quite sappily making Eliot as desirable to Paula as she is to him, nevertheless cannot quite realize the dream of a reconstructed, "normal" nuclear family. Acting keeps the two lovers separate instead of uniting them: Eliot goes off to make his film alone; rather than go with him, Paula decides to stay home to "spend his money" to decorate their apartment. Their union remains deferred, promised. Love may be better the second time around, but we don't know for sure.[17] To emphasize the pathos of Eliot's potentially broken promise to return, the film closes with the melancholic pop song of the film's title. This lack of closure signals, I suggest, a residual anxiety about Eliot's ownership of the phallus, a fear his gay cripple theatrical protheses, Shakespearean and otherwise, can't quite fill a fundamental lack of heterosexual symbolic authority.

THE STORY MUST BE TOLD: SHAKESPEARE'S FAIRY QUEENS

While *Porky's 2* and *The Goodbye Girl* more or less succeed in normalizing Shakespeare, *Dead Poets Society* displays a much more complex process in which degaying Shakespeare opens up the contrary possibility. Set in an elite, New England boys prep school during the 1950s, this film stages a pedagogical scene at once far more repressive and far more daring than does *Porky's 2*. In one class, the teacher John Keating (Robin Williams) codes Shakespeare as gay and contrasts a British theatrical production he brands as effeminate with two straight American, cinematic productions:

> Today we're going to be talking about William Shakespeare. Oh God. I know a lot of you look forward to this about much as you look forward to getting a root canal. We're going to talk about Shakespeare as someone who writes something very interesting. Now many of you have seen Shakespeare being done like this: "O Titus, bring your friend hither." [Williams lisps the line and holds his right wrist limp.] But if any of you have seen Mr. Marlon Brando, [you] know that Shakespeare can be different: "Friends, Romans, countrymen." [Williams imitates Brando's slurred speech.] You can also imagine maybe John Wayne as Macbeth

going "Well, is this a dagger I see before me?" [Again, Williams imitates Wayne, this time producing laughter in the students.]

Keating degays Shakespeare by moving him from the gay English theater to the (hyper)straight American cinema.

But Keating's degaying ironically works as a solicitation to students to gay Shakespeare and even to become gay while appearing to disavow doing so. The theatricality of Shakespeare is here disorienting: Keating's mimicry of John Wayne, for example, undoes his contrast between straight and gay ways of doing Shakespeare. Wayne becomes an hysterically funny, over the top, parody of heterosexual masculinity. Keating makes it possible in a number of ways for his students to like Shakespeare, and to like him. And precisely because nothing is going to happen, the homosocial relation between teacher and student can be eroticized: students and teacher permit themselves to have unacknowledged, mutual crushes on one another. The film focuses on one student, Neal (Robert Sean Leonard), who appears to be solicited by Keating. Neal organizes the reconstitution of the Dead Poets Society and decides to disobey his overbearing father, taking to heart Keating's admonition to "seize the day." Neal auditions for a play, *A Midsummer Night's Dream*, and, perhaps predictably, gets the part of Puck. His father forbids him to act in the play, but Neal goes ahead with it anyway. Unexpectedly, his father shows up looking ominous at the performance. In a series of cross-cut reaction shots, Neal appears to deliver the play's epilogue to his father, as if asking his pardon. Neal gets a standing ovation and Keating tells him that he must stick with acting. But nothing is mended. The father is intransigent, furious at Keating, and takes Neal home directly, informing him that he is to be withdrawn from school and enrolled in a military school. Neal is crushed and commits suicide. The film concludes with Keating being unfairly blamed by the parents and administration for the suicide and his subsequent dismissal. The boys go along with the administration. Yet in a last stand, as it were, they proclaim their loyalty by getting up on their desks and addressing him as "Captain, my captain" before he leaves their classroom for the last time.

The film allows one reasonably to conclude that Neal committed suicide because he is gay and can't come out to his father. (Few adolescents commit suicide because their fathers refuse to let them major in acting, but many do because they are gay.) More directly, Neal plays Puck, in a production at a girls' school (his performance is quite traditional, not an imitation of Brando or Wayne). As in *Porky's 2*, playing a fairy appears to be code for being gay. After Neal gets the part, he is filmed walking down the hall of his dorm happily reciting the line: "broom faerie, here comes Oberon." This shot is followed by one of his father waiting in Neal's room to forbid Neal from acting. The repressed returns. Moreover, Neal is a fan of Keating. He digs up a yearbook with Keating's photo in it; he leads the Dead Poets Society; he has Keating's copy of his book, *Five Centuries of Verse*, from which the members of the original Dead Poets Society read aloud; he is the first to address Keating as "captain, my captain," a title Keating invited his students to call him their first day of class.

The Whitman/Lincoln analogy for the student/teacher relation is reinforced by a photograph of Whitman at the front of the class above the blackboard and by a crucial pedagogical moment for Neal's roommate, Todd (Ethan Hawke): Todd learns how to recite poetry aloud to the class when Keating first coerces him and then encourages him to talk about the Whitman photograph.

One might nevertheless argue that a reading of Neal as gay is forced. To be sure, there is no direct evidence for it and the film is, after all, clear about Keating's and the students' heterosexuality, even heterosexism. Keating affirms that "the Dead Poets Society . . . wasn't just a bunch of guys. We weren't a Greek [read gay?] organization. Women swooned." The class on Shakespeare is preceded by a conversation about language and love: "Language was developed for but one endeavor," Keating remarks, "to woo women." Similarly, the first poem he teaches is Herrick's love lyric, "Gather ye rosebuds while ye may." The film piles on more evidence: one boy brings two girls to a meeting of the Dead Poets Society; Keating has a girlfriend; and a male and female student hook up while watching the performance of *A Midsummer Night's Dream.*

The absence of direct evidence of gayness and the presence of what looks like counter-evidence can, however, easily be read as disavowal. Keating's girlfriend, he says without explanation, is in London: "Makes it difficult." And he jokes about the school's "monastic oath. [They] don't want worldly things distracting us from teaching." In addition to his interest in acting, Neal shows no romantic interest in any of the women in the film. The Herrick love lyric, which Keating ventriloquizes and locates in the previous, now dead students (Keating himself is a former student of the school) makes the teacher/student relation a homosocial one and levels the distinction between teacher and student: everyone is a student teacher (rather incredibly, the boys' favorite pastime appears to be meeting in study groups). Moreover, heterosexuality is represented in distinctly unflattering terms. The one student who does hook up with a female student is very much a stalker/harasser.

But if closeted gayness makes sense as an explanation of Neal's suicide, it isn't a secret the film seems particularly interested in disclosing. Rather, *Dead Poets Society* insists on the queerness of death in general and of Neal's death in particular. In the first class, Keating teaches them that they will all die. They will become "food for worms," as did the other boys who went to this school, boys whose photos Keating has invited them to look over. "Did they wait until it was too late?" Keating asks them, "You can hear them whisper their legacy to you. Carpe diem." This is a conventional enough lay existentialism: live fully because your time is limited. But a weird conclusion to this scene unsettles the conventionality of Keating's lesson. A sequence of shot reverse close-up shots establish mirroring images of two students in the photographs and the roommates Neal and Todd. "That was weird. Spooky, if you ask me," two students comment after class. This weirdness and spookiness is emphasized later by a shot of the boys disappearing into fog at night when they first go out to meet as the Dead Poets Society. And eerie music plays just before Neal commits suicide.

259

Rather than simply outing Neal, the film seems interested in a much more ambiguous kind of queer pedagogy. While opening up a critique of normalization, the film does not make an overt critique because to do so would itself be normalizing: let's all be nonconformist the same way. This is actually what threatens to happen in a scene where Keating has the boys walk in a circle (one boy doesn't join in because he wants to be independent), and more pointedly in the final scene of the film. In order to save a queer critique, the film risks lapsing into a touchy feely *Mr. Chips*-like bathos. The film ends by replacing one triangle with another: Todd stands on his desk and replaces Neal, while Nolan, the repressive headmaster now filling in as English teacher, replaces Neal's controlling father. An easy binary opposition between teacher and students (some of whom remain seated) is installed.

This opposition might appear to affirm the boys' heterosexual masculinity. Though they earlier betrayed Keating, giving him up to their parents and headmaster, now they appear to seize the day and demonstrate that they have learned the meaning of Keating's teaching. But this opposition is disturbed in a number of ways. The scene isn't really about the boys' demonstration of their loyalty and respect for Keating. The scene is more about their loss of someone they love. An inverse disturbance is that Keating contradicts his own teaching. He does not fight his dismissal, as if he has attained a Christ-like wisdom that places him above petty school politics. But this wisdom, insofar it is achieved, contradicts his *carpe diem* lesson. He is sizing up the other side, the odds against winning, and thinking ahead: he is most pointedly not seizing the day. (The other possibility is that Keating wimps out because he sees himself as a student being expelled, the fate of the one student who does defend him by decking the student who first betrays Keating and then urges the others to do likewise.)

Perhaps more interestingly, the melodramatic opposition between good and bad teachers, strong and weak students, is disturbed formally by a triangulation between the viewer, Keating, and Todd. The last shot of the film, held for fifteen seconds, is of Todd, framed through the crotch of another boy who is also standing on his desk (Plate 16.8). It is close to being a reaction shot of Keating, who stands across the room from Todd, but the angle of the shot is so far away from Keating's line of sight that it positions the spectator as the observer, not Keating. This triangulation is literalized by the shot itself. The boy's legs form a triangle. The shot calls attention to a structure of triangulated desire that has been present throughout the film: Neal and Keating's relationship is mediated not only by Neal's father but by his roommate Todd (who at a certain point sides with Neal's father and at another with Keating). Todd's relationship to the Dead Poets Society and to the class is mediated by Whitman.

Though the film ends by clearly enforcing heteronormativity, the triangulation foregrounded in the closing shot also calls attention to a disorientation that cannot be put right, much less straight. The film's triangles register a desire to reanimate the dead, a process begun when Keating teaches his first class and

Plate 16.8 Boys stand up for teacher in *Dead Poets Society*

invites the boys to look at students who have previously gone through the school. (Todd's older brother, a distinguished former student, serves as a ghost whose memory makes him an oppressive burden for Todd.) Dead poets are reanimated in Keating's original society. Keating appears to reanimate himself as a student by teaching other students about dead poets. Neal reanimates a dead dead poets society. He has to die for there to be a story about Keating. The desire to reanimate produces an imperative to narrate: Keating will tell the stories of dead poets, of dead students; Todd will tell Neal and Keating's story. But the triangulation highlighted in the film's closing shot also suggests that narrative here is propelled by a process of continual displacement and deferral: the story that must be told is never the story that can be told. In reanimating the dead poets, Keating doesn't tell the story of his desire to reanimate them for himself, for his students. (Why did he quit his London teaching job and return to this school? Why did he leave his girlfriend in London?) The story of his teaching is displaced and deferred in turn, told by a student whose own story will have to be told by yet another student.

And what doesn't get told is what doesn't get mourned. The film is an instance of what Judith Butler calls "heterosexual melancholy":

the heterosexual refusal to acknowledge the primary homosexual attachment is culturally enforced by a prohibition on homosexuality. . . . Heterosexual melancholy is culturally maintained as the price of stable gender identities related through oppositional desires.

(1990: 70)

In *Dead Poets Society*, however, melancholy arises because of a narrative problem rather than because of a repressed primary homosexual identification. The triangular structure which propels the reproduction of heteronormativity means that there there will always be a remainder that cannot be narrated, or, to put it another way, that can be narrated only after the person the story is about is dead or otherwise lost.

BRINGING OUT BILL

In analysing these straight mall films, I have intended to show ways in which Shakespeare as a signifier of gayness in popular, mall-house films may be more queer, more disorienting than gayness in self-identified gay Shakespeare films. In marking themselves as gay, these latter films are in some ways paradoxically quite straight. My queer reading of Shakespeare as a disorienting gay signifier in straight films may, however, produce some skepticism. Can a gay or a queer Shakespeare be popularized without being pathologized in straight, mall films? None of these films suggests an affirmative answer to this question. As I conceded at the outset, the films are all heteronormative. Moreover, each links a gay Shakespeare to disaster, even though none of them is homophobic. In *The Goodbye Girl*, the director's assertion of the accuracy of his interpretation – "I mean read your text" – is funny because he thinks gayness is obviously in the text whereas most readers of the play will find his reading totally unconvincing. His production of a gay *Richard III* bombs. A student reads a copy of *A Midsummer Night's Dream* in *Porky's 2* and, bewildered, asks, "What the fuck's a Puck?" The Shakespeare production turns unintentionally into a burlesque, a mannequin's leg at one point replacing Macduff's sword. And in *Dead Poets Society* reading Shakespeare as gay leads to a student's suicide. Learning how to read Shakespeare differently may allow the boys to read Keating differently from his adult peers, but the boys fail even to present their different reading of Keating – "you don't know him like we do" – to their parents, much less manage to persuade them of its validity.

If these films make a difference, that difference has to do with a certain kind of failure rather than a successful assimilation of gayness. But that is not necessarily a bad thing. The failure of these films is not, in my view, reducible to a typical homophobic disavowal or repression, but registers rather the queer ways in which what I have called gay eruptions exceed the codes by which gayness is signified in heteronormative culture. The success of these films, such as it is, lies in moments of disorienting breakdown rather than in moments of clear-headed, utopian affirmation.

262

SHAKESPEARE'S INCREDIBLY QUEER WILL(Y)

An American scholar recently achieved wide popular attention in *People Magazine* and the front page of the *New York Times* for appearing to argue (at an academic conference) that he could tell that a certain poem was written by Shakespeare because Shakespeare was bi-sexual (Anonymous B 1996; Honan 1996). Though it may produce some controversy or titillation, the idea of a bi-sexual (or gay) Shakespeare is now considered perfectly normal inside and outside of academia. Some might applaud the release of a Shakespeare's queer will in film as a way to normalize gayness. Given the degree to which a country like the United States remains virulently homophobic, it would be hard to disagree. Alan Sinfield (1994: 1–20) regards Shakespeare as something imposed by a dominant culture on subordinated groups and their subcultures (Jews, women, gays, and other minorities). A popular gay Shakespeare might seem like relief from the burden of having to enjoy Shakespeare by imagining oneself as other than who one is. The failure of a popular Shakespeare, the failure to imagine a gay Shakespeare in terms other than disaster, might make some more comfortable with the terrain of the avant-garde, openly gay arty versions of Shakespeare on film. Even if Jarman or Van Sant can do less with the popular because it is in a clearly marked gay camp context, so the argument might go, they are at least free of the constraints on gay representations put in place by the Hollywood system.

While normalizing films may have its social benefits by lessening homophobia, my concern is less with those benefits than it is with the way queer theory and practices may be normalized in academic work. What, I would like to ask in closing, is the value of a Shakesqueered cinema? What happens to Shakespeare's legacy, to his will, if he is perceived to be gay or queer (Fineman 1991)? I would like briefly to address these questions by yoking the problem of normalization to Shakespeare's popularization in the cinema. Cultural critics now fantasize that their work can be popularized and so reach a wider non-academic audience, but this fantasy is disturbed by the fact that a gay Shakespeare won't signify much of anything progressive. The distinction I am making between gay and queer, much less the concept of the queer sublime, is pretty much meaningless for hetero-sexual culture outside academia. Moreover, even if the films were subversive in popular terms, saying so would be rather uninteresting in academic terms. (The subversion/containment debate, though played out by the late 1980s, appears to be where much cultural criticism still seems stalled.) Rather than ask how can academics popularize a gay Shakespeare, then (my answer is that they can't), I want to ask how the fantasy of a popular gay (or queer) Shakespeare functions in academic work. At stake in a gay as opposed to a queer Shakespeare is the kind of critical work done in Shakespeare's name. Gaying Shakespeare may allow scholars to do little more than the most everyday kinds of textual criticism, deciding what is or is not part of the canon, what is or is not authentic, all on the basis of a presumed gay sexual identity that is most certainly anachronistic. Even

an anti-authenticity performance criticism which opens up what counts as Shakespearean, as this volume does, to include all reproductions as worthy of study, secures its legitimacy by relating the reproductions to Shakespeare's identity. Laurie Osborne (1996: 124) notes, for example, that non-academic reproductions of *Twelfth Night* "respond more obviously to the homoeroticism in the play." Osborne says she would include as performance editions of *Twelfth Night* "modern crib sheets like *Cliff Notes* and *Shakespeare Made Easy* or *Twelfth Night by William Shakespeare: The Cartoon Shakespeare Series. . . .* The dismissal of these versions, either because of their audiences or because of their failure to be faithful to the 'original,' actually registers a perception of the play. *Twelfth Night* has a recognizable identity partially because of the reproductions that challenge that identity" (174). Shakespeare's identity works to secure a textual identity: what appears as a threat to identity turns out to be, in one view, the opposite.

A queer Shakespeare, in my view, is precisely not defined in the terms by which we orient ourselves: gay, straight, or bi-sexual. It's the very lack of such categories in the plays that allows for queer transformations and adaptations of them and which threatens their textual identities. The force of a Shakesqueer as opposed to a gay Shakespeare may be underlined by turning to one final film, the *Playboy* production of *Twelfth Night*. This film, "based on the play by William Shakespeare," is a soft-core porn version of the comedy, closer to the pornographic *Alice in Wonderland* than it is to the *Playboy*-funded production of Roman Polanski's *Macbeth* (1971). The sex scenes are generally heterosexual while the homosexual ones are lesbian rather than gay. Olivia's desire for Caesario is rewritten as a desire for Viola. While Caesario sings to her, she fantasizes having sex with Viola (this sequence is intercut with shots of Olivia's dead brother riding a white horse which walks towards the camera). On the other hand, gay male sexuality is pretty much written out of the film's authentic coupledom. Antonio and Sebastian are made into a racially mixed heterosexual couple: Antonio becomes Antonia, and she is played by a black woman. Feste appears, however, to be gay (in a pointed *double entendre*, Olivia tells him he is "much too gay"). While some critics might want to argue that the film is a classic instance of encelluloiding of the pornographic male gaze, others might want to argue that this *Playboy* version of a sixties adaptation of Shakespeare (the play is about sex, drugs, and rock and roll) is bizarre, if not queer.[18] Malvolio, for example, ends up with a bare-breasted mermaid. And though Antonia and Sebastian are portrayed as a heterosexual couple, their heterosexuality is "performed" through sound: Sebastian is played by the actress who also plays Viola, and her male gender is a function of a dubbed male voice. Lesbianism thus remains visually inscribed within the heterosexual couple.

My concern, however, is not in deciding how Shakesqueer this video is, but with its reception among Shakespeare scholars. It occupies a strategic position in Osborne's argument, for example. She says that we should regard all reproductions as part of the "original": "A particular text's claim to the signifier, to

the name *Twelfth Night*, inevitably calls the play into question. Ron Wertheim's soft-core film . . . has only the loosest connections to the Folio text, yet, by claiming that title, the film announces itself a reproduction of Shakespeare's comedy" (1996: 174). The use of this film as the key example raises several questions. Why should a soft-core porn version of *Twelfth Night* be the key example in an argument confirming Shakespeare's unity rather than multiplicity? Does the porn sex make it straight or lesbian? In closing with these questions, I wish not simply to defend the merits of a Shakesqueer as opposed to a gay Shakespeare but to suggest that queering Shakespeare on film is a way putting the canonical in question rather than opening it up. A greater inclusiveness of specifically Shakespearean reproductions merely reinforces existing textual and sexual identities. More broadly, the heterogenity of film authorship – director as auteur, star as auteur – and of reception – gossip, scholarship – risks merely confirming an identity politics in which some texts could be read as gay or lesbian rather than opening up a queer space of overlapping kinds of fan knowledge and reading practices (queer in the sense of being shared by straights, gays, and lesbians alike).[19] The sublime breakdowns of a Shakesqueered reproduction question the legibility and identity of what is gay, what is Shakespearean, such that Shakespeare's cultural capital does not necessarily save a given queer reproduction, nor does a queer reading save a given Shakespeare reproduction. One person's reading of a Shakesqueer text may be another's failure to read a Shakespeare text at all; one person's reading of a Shakespeare text may be another's failure to queer it.

NOTES

1 Whether Branagh could be considered a "queer" director/actor is something of an open question. Though married for a time to Emma Thompson, Branagh's films suggest a certain gay preoccupation. He directed and starred in *Peter's Friends* (1991), for example, a comedy about a male character whose sexuality is indeterminate until he reveals at the end that he has been celibate because he has AIDS (from gay sex).

2 The film includes a staging of Othello's final soliloquy with a transvestite Desdemona and a reading of Sonnet 30.

3 One reviewer quipped that the Capulet ball was done as *Priscilla, Queen of Verona* (Maslin 1996: C12). It is also worth noting that the success of *Clueless* and other Jane Austen adapatations led to a transgendered recoding of Shakespeare. *Time* ran two stories, one entitled "Shakespeare: The Old Jane Austen" (Anonymous A 1996) and the other "Shakespeare is the New Jane Austen" (Corliss 1996: 3). For a third, see Lane 1996.

4 On Laurence Olivier, for example, see Garber 1995.

5 Aki Kaurismaki (1991) is opposed to representing any explicit sex in his films, regarding it as a Hollywood tendency.

6 The probablity of a failure in this regard may be glimpsed in a controversy over Franco Zeffirelli. One critic reads him as insufficiently political (van Watson 1992); another reads in him a critique of patriarchy (Donaldson 1990). For attempts to theorize gay authorship, see Dyer 1991 and Mayne 1991.

7 One possibility for lesbian relations lies in the spin-off mentioned above, *Tromeo and Juliet*. (The film has a soft-core porn sequence of the two making love.) The pornographic films *Juliet's Desire* (1988) *Juliet and Romeo*, (1994), two *Romeo and Juliets* (1987), and the *Playboy* production of *Twelfth Night* also explore lesbianism. The Paul Czinner *As you Like It* (1939) with Laurence Olivier and Elizabeth Bergner also holds some promise for a homoerotic reading of Rosalind and Celia.

8 Probably, to know one would have to have read gay journalistic coverage about the actor/dancer. See Chunovic 1991 for example.

9 I would like to thank Josh Ruddy for drawing my attention to this film.

10 Some critics might like to answer in the affirmative. "Queer" in this sense includes readings by straights as well as gays and lesbians, and includes gays and lesbians of all political affiliations (see Doty 1993: 15). But the very inclusiveness of the meaning of "queer" would appear to empty of it specificity, hence empty it of meaning.

11 This opposition can itself be deconstructed. In his *Tempest* (1979), Derek Jarman, for example, brings popular culture into his avant-garde adaptation, closing the wedding festivities near the end of the film by bringing in Elizabeth Welch, a black singer famous in the 1930s, to sing "Stormy Weather" after the sailors from the shipwrecked boat have done a musical number.

12 In addition to these examples, *So Fine* (dir. Andrew Bergman, 1981) and *Withnail and I* (dir. Bruce Robinson, 1985) deserve a mention. And for another example of the way Shakespeare signifies gayness in American popular culture, see *Beverly Hills, 90210* rebroadcast Dec. 20, 1996.

13 In making this argument, I take issue with Miller 1991 and Doty 1993, for whom connotations of queerness constitute a homophobic practice, the consequence of a closeted homosexuality. For me, queerness is precisely what cannot be denoted.

14 To be sure, this kind of project risks turning out to be a version of the very gay identity. Though queer theory has made the notable contribution of making heterosexuality a problematic, in practice this sometimes amounts to seeing a gay foundationalism everywhere. For an example of such an approach, see the essays in Burston 1995. For thoughtful accounts of queer visibility in mass culture, see Doty 1993 and Straayer 1996.

15 It is worth noting that in the less directly homophobic *Fame* (dir. Alan Parker, 1980) Shakespeare is used in an equally normalizing way. The first shot of the film is of a poster of Olivier playing Othello. The camera moves down to give a close-up of a teen giving an audition. He is obviously gay. Later, a particularly stupid applicant reads Juliet's lines from the balcony. The teacher tells him as he leaves "You were reading the girl's part."

16 I would like to thank Don Hedrick for drawing my attention to *Porky's 2* and for giving me a copy of his unpublished essay on the film.

17 In this respect, the film stages a problem already present in marriage as represented in screwball comedy. As Stanley Cavell (1981) has noted, these films represent falling in love as an experience that has to be repeated.

18 On the complexity of representations of lesbian sex in pornography meant to be consumed by straight men, see Williams 1989: 139–40.

19 Knowledge of homosexuality by gays or lesbians may lead in a variety of directions, including criticizing closeted directors whose films were less queer than those of contemporary straight directors, as well as simply dismissing knowledge about directors as beside the point (identifications with gay or lesbian stars being the point). See Doty 1993: 19–21.

REFERENCES

Anonymous A (1996) "Shakespeare: The Old Jane Austen," *Time* September 9, 148: 16, 63.

Anonymous B (1996) "Living Will' *People Magazine*, January: 7.

Bersani, Leo (1995) *Homos*, Cambridge, MA: Harvard University Press.

Burt, Richard (1993) "Baroque Down: the Trauma of Censorship in Psychoanalysis and Queer Film Revisions of Shakespeare and Marlowe," in *Shakespeare and the New Europe*, eds Michael Hattaway, Derek Roper and Boika Solinka, Sheffield: Sheffield Academic Press, 328–50.

—— (forthcoming) "Deep Inside William Shakespeare: Pornographic Film and Video 'Classics' and Academic Fantasy" in *Shakespeare Without Class: Dissidence, Intervention, Countertradition*, ed. Don Hedrick and Bryan Reynolds.

Burston, Paul and Colin Richardson (1995) *A Queer Romance: Lesbians, Gay Men, and Popular Culture*, New York and London: Routledge.

Butler, Judith. (1990) *Gender Trouble: Feminism and the Subversion of Identity*, New York: Routledge.

—— (1993) *Bodies That Matter: On the Discursive Limits of Sex*, New York and London: Routledge.

—— (1994) "Gender as Performance: Interview with Judith Butler," *Radical Philosophy* 67, Summer, 32–9.

Cavell, Stanley (1981) *The Pursuit of Happiness: The Hollywood Comedy of Remarriage*, Cambridge, MA: Harvard University Press.

Chauncey, George (1994) "The Fairy as Intermediate Sex," in *Gay New York: Gender, Urban Culture, and the Making of the Gay Male World, 1890–1940*, New York: Basic Books.

Corliss, Richard (1996) "Suddenly Shakespeare," *Time*, Nov. 4, 148: 21, 88–90.

Chunovic, Michael (1991) "Tied Up in Knots," *The Advocate*, November: 96.

Donaldson, Peter S. (1990) *Shakespearean Films, Shakespearean Directors*, Boston: Unwin Hyman.

Doty, Alexander (1993) *Making Things Perfectly Queer: Interpreting Mass Culture*, Minneapolis: University of Minnesota Press.

Dyer, Richard (1991) "Believing in Fairies: The Author and the Homosexual," in *Inside/Out: Lesbian Theories, Gay Theories*, ed. Diana Fuss, New York: Routledge, 185–201.

Edelman, Lee (1994) *Homographesis: Essays in Gay Literary and Cultural Theory*, New York and London: Routledge.

Fineman, Joel (1991) *The Subjectivity Effect in Western Literary Tradition: Essays Towards the Release of Shakespeare's Will*. Cambridge, MA: MIT Press.

Foucault, Michel (1989/1996) *Foucault Live: Interviews, 1961–1984*, ed. Sylvere Lotringer, New York: Semiotext(e).

Garber, Marjorie (1992) *Vested Interests: Cross-Dressing and Cultural Anxiety*, New York and London: Routledge.

—— (1995) *Vice Versa: Bi-sexuality and the Eroticism of Everyday Life*, New York: Simon & Schuster.

Honan, William H. (1996) "A Sleuth Gets His Suspect: Shakespeare," *New York Times Sunday*, January 14: 1, 20.

Kaurismaki, Aki (1991) *I Hired a Contract Killer*, Zurich: Haffmans.

Lane, Anthony (1996) "Tights! Action! Camera!: Why Shakespeare Became this Year's Jane Austen," *New Yorker*, November 25, 128: 36, 65–77.

Maslin, Janet (1996) "Suddenly Shakespeare," *New York Times*, November 15.

Mayne, Judith (1991) "Lesbian Looks: Dorothy Arzner and Female Authorship," in *How Do I Look? Queer Film and Video*, ed. Bad Object-Choices. Seattle, WA: Bay Press.

Miller, D. A. 1991. "Anal Rope," in *Inside/Out: Lesbian Theories, Gay Theories*, ed. Diana Fuss, New York: Routledge, 119–41.

—— (1992) *Bringing Out Roland Barthes*. Berkeley: University of California Press.

Osborne, Laurie (1996) *The Trick of Singularity: 'Twelfth Night' and the Performance Texts*, Iowa City: University of Iowa Press.

Rothwell, Kenneth S. and Annabelle Henkin Melzer (1990) *Shakespeare on Screen: An International Filmography and Videography*, New York: Neal-Schuman Publishers, Inc.

Sedgwick, Eve. (1989) *Epistemology of the Closet*, Berkeley: University of California Press.

Sinfield, Alan (1994) *Cultural Politics: Queer Readings*, Philadelphia: University of Pennsylvania Press.

Straayer, Chris (1996) *Deviant Eyes, Deviant Bodies: Sexual Re-Orientation in Film and Video*, New York: Columbia University Press.

Traub, Valerie (1992a) *Desire and Anxiety: Circulations of Sexuality in Shakespearean Drama*, New York and London: Routledge.

—— (1992b) "The (In)significance of Lesbian Desire in Early Modern England," in *Erotic Politics: Desire on the Renaissance Stage*, ed. Susan Zimmerman, New York and London: Routledge, 150–69.

Van Watson, William (1992) "Shakespeare, Zeffirelli, and the Homosexual Gaze," *Literature Film Quarterly*, 20: 4, 308–25.

Warner, Michael (1993) "Introduction," in *Fear of a Queer Planet: Queer Politics and Social Theory*, Minneapolis: University of Minnesota Press, vii–xxxi.

Williams, Linda (1989) *Hardcore: Power, Pleasure, and the "Frenzy of the Visible,"* Berkeley and Los Angeles: University of California Press.

INDEX